NEW YORK RICANS
FROM THE HIP HOP ZONE

NEW DIRECTIONS IN LATINO AMERICAN CULTURES,

a series edited by Licia Fiol-Matta & Jose Quiroga

New York Ricans from the Hip Hop Zone
by Raquel Z. Rivera
The Famous 41: Sexuality and Social Control in Mexico, 1901
edited by Robert McKee Irwin, Edward J. McCaughan, and Michelle
Rocío Nasser
Velvet Barrios: Popular Culture & Chicana/o Sexualities
edited by Alicia Gaspar de Alba and Frausto Ybarra, with a foreword
by Tomás
Bilingual Games: Some Literary Investigations
edited by Doris Sommer

NEW YORK RICANS
FROM THE HIP HOP ZONE

Raquel Z. Rivera

palgrave
macmillan

First published 2003 by
PALGRAVE MACMILLAN™
175 Fifth Avenue, New York, N.Y. 10010 and
Houndmills, Basingstoke, Hampshire, England RG21 6XS.
Companies and representatives throughout the world.

PALGRAVE MACMILLAN is the global academic imprint of the
Palgrave Macmillan division of St. Martin's Press, LLC and of Palgrave
Macmillan Ltd. Macmillan® is a registered trademark in the United
States, United Kingdom and other countries. Palgrave is a registered
trademark in the European Union and other countries.

ISBN 1-4039-6043-7 hardback
ISBN 1-4039-6044-5 paperback

Library of Congress Cataloging-in-Publication Data
available at the Library of Congress.

A catalogue record for this book is available from the British Library.

Design by Letra Libre, Inc.

First edition: February 2003
10 9 8 7 6 5 4 3 2 1
Printed in the United States of America.

CONTENTS

ACKNOWLEDGMENTS

This book is dedicated to all of those whose stories are woven into these pages. In particular, I am grateful to Jorge "PopMaster Fabel" Pabón, Caridad "La Bruja" de la Luz, Anthony "Q-Unique" Quiles, Ana "Rokafella" García and Edward Sunez Rodríguez, whose vision, love and enthusiasm guided me through this project.

I am also immensely thankful for the support and help of Monse Torres, Fernando REALS, Cristina Verán, BOM5, TATS Cru, Edgardo Miranda, G-Bo the Pro, Christie-Z Pabón, W. D. Allah, Kahlil Jacobs-Fantauzzi, Jamel Shabazz, Henry Chalfant, Jerry Ruotolo, Erin O'Brien, James de la Vega, Vee Bravo, Clyde Valentín, Kofi Taha, Ray Ramírez of the Welfare Poets, Wanda Ortiz, DJ Charlie Chase, DJ Tony Touch, D-Stroy, Hurricane G, Diana Figueroa, Vico C, Jellybean Benitez, Juan Flores, Bill Kornblum, Philip Kasinitz, Angel Quintero Rivera, Jorge Duany, Frances Negrón-Muntaner, Agustín Lao-Montes, Arlene Dávila, Deborah Paccini Hernández, Mayra Santos, Sonia Sánchez, Carmen "Cape" Oquendo, José Raúl "Gallego" González, Gayatri Patnaik, Donna Cherry, Ella Pearce, Licia Fiol-Matta, José Quiroga, Rafael "Papo" Zapata, Bryan Vargas, Jorge "Georgie" Vázquez, Juan "Enemigo" Matos, Coo-kee, DJ K-Kemit, Welmo Romero Joseph, Julio Alvarado Aguilera, Ana Aparicio, Ernie Lee, Leroy Champagne, Joey Kotright-González, Chris Bonastía/DJ Nodd, Sonia González, Alano Báez, Melinda González, Erica González, Mixta Gallery, Tanya Torres, Yarisa Colón, Asiray, Mariposa, Sandra García Rivera, Iván "Kushka" Ferrer (Freddy Skitz, formerly of Boricua Bomb Squad), Pablo "Zulu" Ferrer, Frank Rodríguez (B-Girl Style), Alex Vale LaSalle, Manuela Arciniegas, Mercedes Molina, Richie Pérez, Marinieves Alba (Hip Hop LEADS), Martha

Díaz (Hip-Hop Odyssey Film Festival), The Point C.D.C., Juan Cartagena, Josiván Padilla and Laura Pérez.

Gracias a Rincón Criollo (La Casita de Chema), Carlos "Tato" Torres, and YerbaBuena, Alberto "Tito" Cepeda, the *Nonis,* Alexandra Vasallo, Tivo, Don Daniel, Micky Sierra, Michael Guarionex Sierra, Camilo Molina-Gaetán, Pa' lo Monte, Palo Mayor, Nina Paulino and all the other pleneros, bomberos and paleros who opened up my heart to a new meaning for *cypher.*

Special thanks to Anabellie Rivera Santiago and Peter Angel Díaz for hardcore intellectual stimulation and emotional support.

And I am especially grateful to my mom, Amalia Domínguez, who is always there.

PREFACE

W hy did New York's principal Spanish-language newspaper *El Diario,* "El Campeón de los Hispanos" (the Champion of Hispanics), wait until platinum-selling Bronx Puerto Rican rap artist Big Pun passed away in February 2000 to celebrate his achievements? Why had the paper, prior to his death, never featured him or other internationally known New York Latino rap artists like Angie Martínez, Fat Joe, Cuban Link, Tony Touch and Hurricane G? For the same reason that Jessie Ramírez, columnist for *El Diario,* draws a simplistic distinction between "American" and "Tropical" rap. He imagines the first category to be populated solely by African Americans and the second to include only Latino artists whose rhymes are mostly in Spanish. Thus, Ramírez completely neglects the existence of Latino rap artists whose lyrics are written mostly in English, like Big Pun as well as the others previously mentioned.

These artists don't fit easily into the currently acceptable mold of *latinidad* (Latinoness). Not only are their lyrics English dominant, but they participate in a musical realm considered to be African American. Unlike Jennifer López, Ricky Martin and Christina Aguilera, Latino rap artists are not on the safer ("white" and class-unidentified) side of pop. Therefore, they have been virtually ignored by most Latino-oriented media. Ironically, mainstream media outlets have in the last few years largely accepted and even capitalized on the notion that "Blacks and Latinos" are at the epicenter of U.S. rap music and the larger hip hop culture of which rap is part.

This is not a book about "Tropical" rap, "rap en español" or "Latino hip hop." These categories draw connections and boundaries that tend to cause confusion regarding the topic I am most interested in: the huge body of hip hop creativity primarily rooted in the joint practices of Puerto

Ricans, African Americans and West Indians. This book focuses on the experiences of New York Puerto Ricans who create and participate within the musical dimension of hip hop culture, a realm whose ethnic boundaries are diffuse and in constant flux. Accounts of cultural practices are infamous for imposing artificial borders, be they ethnic or otherwise, on cultural realities that overflow past the limits assigned to them. And it is precisely that tendency toward reductionism that I have aimed to steer away from.

Hip hop has been a central realm of cultural production and identity-building among Puerto Ricans of the second and third—and beyond—generations. It also has been a cultural zone of intense interaction and cooperation between young Puerto Ricans and other New Yorkers, particularly African Americans. Those are the aspects of hip hop musical history that I have chosen to reflect on—precisely because they have been so neglected.

To ignore the areas of cultural overlap among African Americans, Puerto Ricans and other Caribbean people in New York City is to distort history, which results in the marginalization of some of the richest forms of contemporary urban creative expression. To overlook that New York Puerto Rican culture and identities have long been intricately connected to those of their neighbors not only obscures these groups' shared history but prevents a sense of connection between past and present. Puerto Rican hip hop enthusiasts are described by some as having turned their back on their "traditions." Yet by the time hip hop surfaced in the early 1970s, there was already a long-standing tradition of Puerto Rican participation in genres most commonly identified as African American, such as jazz in the early decades of the twentieth century, doo-wop and rhythm-and-blues during the 1950s, and boogaloo and Latin soul during the 1960s and 1970s. Furthermore, the Puerto Ricans who have developed hip hop art forms alongside African Americans and West Indians often have been accused of being cultural defectors for allegedly doing a *moreno* thing—*moreno*, literally meaning dark-skinned, is used in this case as a synonym for African American. Yet rap music and hip hop-related dance forms bear as much resemblance to African American oral, musical and dance traditions like the dozens, the blues, jazz, the lindy-hop and the cakewalk as to the allegedly bona fide forms of Puerto Rican

musical and dance expression such as *salsa, bomba, plena* and *música jíbara.*

Incidentally, the commonplace use of "*moreno*" and "African American" by New York Puerto Ricans as interchangeable terms—within as well as outside the hip hop zone—speaks volumes about the tendency of Caribbean Latino people to deny our own blackness. We describe African Americans as *morenos* as if to prevent the term from being applied to us; as if we weren't part of the African diaspora in the Americas; as if plenty of Puerto Ricans weren't black—oftentimes even darker than African Americans themselves.

To complicate matters further, Puerto Ricans and other Latinos in New York are, to this day, still referred to as "Spanish" people. As if the Eurocentric bias of terms like Latino and Hispanic wasn't bad enough, it is not uncommon to hear *salsa* and *merengue* described as "Spanish music" or *cuchifritos* called "Spanish food." Never mind that these music genres are notable examples of Afro-diasporic music of the Caribbean or that most of those fried culinary delights were developed centuries ago by Africans and their descendants in Puerto Rico. Thus, once again language serves as an example of how the African dimension of Puerto Rican and other Caribbean Latino cultures is slighted.

The construction of Puerto Rican identities in New York City often has relied on drawing sharp distinctions between us and African Americans. While the European aspect of Puerto Rican heritage gets highlighted, African Americans are associated primarily with the African side of their ancestry. No wonder, then, that the relationship of Puerto Ricans to hip hop music and dance has been so often misunderstood. What to make of those Puerto Rican youngsters who started rhyming in English and dancing to *breakbeats* right alongside African Americans and West Indians in the 1970s? What to think of all those English-dominant "Spanish" kids with nappy hair and dark skin who no longer were easily distinguishable from the *morenos?* Unfortunately, many opted for the easy way out by ignoring the areas of cultural overlap—past and present—between African Americans and Puerto Ricans, choosing instead to explain the presence of the latter in hip hop as their treading on African American territory.

The myth of hip hop being an African American realm and representing a rupture in Puerto Rican tradition has served to weaken Puerto

Ricans' perceived entitlement to hip hop; it has prevented young African Americans, Puerto Ricans and other Caribbean folks from fully understanding their shared heritages; and it also has perpetuated frictions between these groups. This myth, in turn, is one of the many factors that make us all—whatever our ethnic background may be—more vulnerable to the dictates of the entertainment industry, which has turned the desire for roots, purpose, self-definition and collective identity of the hip hop generations into a multimillion-dollar empire.

Without an understanding of our communities' histories, not to mention an understanding of ourselves, we are perpetually looking for media images to model ourselves after; we are insatiable consumers of prepackaged "cool." We recognize and appreciate hip hop history when the media begins marketing it as a trendy badge of cool. We believe Puerto Ricans and other Latinos are uncool and marginal to hip hop as long as Latino images are not legitimized by the entertainment industry; and we accept the opposite once (certain) Latinos are branded as desirable objects of consumption and emulation. Meanwhile, the wealth of creativity, knowledge, direction and joy that lies within our immediate communities and within ourselves remains largely untapped. And tragically, at the same time that African American and Latino images are profitably sold as the epitome of hip hop ghetto chic, the spoils of the entertainment industry barely trickle down to the urban neighborhoods that three decades ago gave birth to hip hop.

I am not a hip hop "expert." If anyone deserves such a label, it is the many hip hop creators and enthusiasts whom I have had the pleasure of coming in contact with. "Expert" could only be someone utterly fluent in the practices and symbols of hip hop: someone who eats, drinks, sleeps and dreams hip hop. I am simply a captivated witness of and itinerant participant in hip hop's beauty, creativity and vibrant collective energy. I also have been profoundly moved and swept up by its neuroses and shadows, which are also my own.

I began writing journalistic and academic essays about rap music and other hip hop art forms in the early 1990s, while I still lived in Puerto Rico, because I saw an urgent need for them to be covered with greater historical accuracy. By chronicling hip hop's distinctiveness as well as con-

nections with earlier traditions, and by putting on paper some of its creative voices, I hoped to contribute to the construction of a more comprehensive sense of cultural history. Ten years later, I stand by my original purpose. But having a better sense of hip hop's aesthetics, energy and social dynamics has more than anything else highlighted for me its basic similarity to other forms of cultural expression: They are all connected to a profound collective desire for purpose, self-knowledge, communion and release, though frequently posing in latter-day rap music as a quest for "money, power, respect."

Our devaluing of vernacular expression and everyday culture (unless it is legitimized by the entertainment industry), our desperate quest for cool in commercial culture, our desire to lay claim to the latest trend that will make us feel good about ourselves, our willingness to pay huge quantities for items that supposedly represent our worth—those are the ways in which we short-circuit our connection to what we really crave. It happens with hip hop, just as it happens with *salsa,* jazz, blues and samba.

Veteran dancer, hip hop historian and Rock Steady Crew co-vice president Jorge "PopMaster Fabel" Pabón describes hip hop artistic expressions as "forms" taken by the "spirit" that has manifested itself through previous cultural expressions within African American and Latino communities. However, as he explains in the case of certain approaches to rap, hip hop dance forms and graffiti art: "The spirit took another form, but unfortunately some of the new forms have lost the spirit."

A few years back I would have dismissed such talk of transcendence and spirituality in art as delusion, fanatism or nostalgia. Today I try to sit still and really listen. I certainly have come to realize my involvement with hip hop has been linked to a frantic need to reclaim myself, feel part of a community and reconnect form with the unseen. And I also know I am not the only one for whom this is true.

Our dancing, scratching, rhyming, writing, witnessing bodies sometimes manage to stop being individual clumps of matter; then they generate enough beauty and energy to allow us to feel the presence of "the spirit" in hip hop through that unmistakable hair-raising shiver. But is that enough? Could that goosebump-inducing force felt individually be redirected to serve truly worthy cultural and political collective ends? Like

the many artists, activists and educators who struggle day in and day out to bring hip hop art forms and their enthusiasts closer to "the spirit," I also suspect the answer to the second question is yes. Inspired by the Zulu Nation's assertion that knowledge is hip hop's "fifth element," I trust this book will be a contribution to that struggle.

CHAPTER 1

INTRODUCTION

New York Puerto Ricans have been an integral part of hip hop culture since the creative movement's first stirrings in New York City during the early 1970s. They have been key players in the evolution of hip hop art forms—among them *MCing* or *rapping, DJing, breaking* or "breakdancing," and *graffiti*—from the beginning of the movement.[1] Furthermore, hip hop is as vernacular (or "native") to a great many New York Puerto Ricans as the culture of their parents and grandparents; in journalist Edward Sunez Rodríguez's words, hip hop is as much a part of their lives "as salsa and colonialism."[2]

The late Big Punisher, Christopher Ríos, described hip hop creative practices as being among his most ordinary childhood experiences: "For me, growing up in the Bronx, . . . I was surrounded by hip-hop. It was all around me. I was living hip-hop before I knew it was hip-hop. 'Cause graffiti, and dancing and music . . . that was just 'playing outside' to me. . . . But that was hip-hop culture. And that was my natural life, so I lived it . . . naturally."[3] His experience is far from exceptional. Having been the first Latino solo rap artist to achieve platinum sales, he is only the most famous among those New York Ricans whom journalist Clyde Valentín describes as having "gr[own] up on Hip Hop like kids grow up on Similac."[4]

Yet much too often the participation and contributions of New York Puerto Ricans to hip hop have been downplayed and even completely ignored. And when their presence has been acknowledged, frequently it has

been misinterpreted as a defection from Puerto Rican culture and identity, into the African American camp.

On one hand, accounts of Puerto Rican (and, more generally, Latino) cultural expressions sidestep New York Puerto Ricans in hip hop. This occurs because their hip hop stories challenge some of the prevailing assumptions regarding Puerto Rican creative practices and identities. The reigning assumption is that if Puerto Ricans participate in hip hop culture, they must be making some identifiably "Puerto Rican" or "Latino" version of it by, for example, injecting Spanish or Spanglish words into their rhymes or sampling so-called Latin music. If they don't, the assumption is that they have assimilated into "African Americanness." In reality, however, New York Puerto Rican artistic expressions often have been virtually indistinguishable from their African American counterparts, particularly for untrained eyes and ears. The reason has not been assimilation but the reconfiguration of cultural practices and identities so that Puerto Ricans and African Americans share common terrain.[5]

But that is only half of the story regarding the misinterpretation of New York Puerto Rican participation in hip hop. Whether mass-mediated or academic, accounts of hip hop's history tend to explore it either as an exclusively African American phenomenon or to mention Puerto Rican and/or Latino participation in passing but still end up focusing their analysis on African Americans. Puerto Rican stories and specificities are marginalized from these narratives because the cultural similarities and intersections between both groups are not sufficiently understood. African heritage or "blackness" in the United States is understood primarily through the African American experience. Therefore, although Puerto Rican culture is part of the African diaspora in the Americas, it is not usually imagined as being black. In sum, New York Puerto Rican hip hop artists have been shunned by some for being "too" African Americanized, and they have been shoved aside by others for not being black "enough."

Hip hop is part of a century-old history of cultural parallels, adaptations and joint production between African Americans and Caribbean people—among them, Puerto Ricans—in New York City. This history is rooted in their interactions and shared experiences in New York since the early years of the twentieth century. However, this history also is inti-

mately connected to dynamics that extend even farther back in time and beyond New York borders. This history of shared cultural expression between African Americans and Caribbean people in New York is related to common African sources and creolization processes dating to the early days of slavery in the Americas as well as to heavy migration within the Caribbean and between the Caribbean and the United States, particularly after the dawn of the nineteenth century.[6]

Afro-diasporic cultures of the Americas exhibit, in the words of Carlos "Tato" Torres and Ti-Jan Francisco Mbumba Loango, striking "common cultural threads"[7] that date back to the early colonial period and that are manifest to this day. Hip hop is a pattern woven out of some of those common threads, according to art historian and scholar of the African diaspora Robert Farris Thompson. He refers to these commonalties as the "Kongo qualities of sound and motion" present in African American and Caribbean cultural formations. Among his examples are jazz, funk, *samba,* mambo, bomba and—of course—hip hop.[8]

This book is built on the foundation laid by Thompson, the groundbreaking essays by Juan Flores devoted to dispelling some of the myths surrounding the role of Puerto Ricans in hip hop and, most important, the words—written, rapped and spoken—of hip hop artists and enthusiasts. I argue in these pages that New York Rican hip hoppers have certainly not abandoned but simply stretched the boundaries of *puertorriqueñidad* (Puerto Ricanness) and *latinidad* (Latinoness) and questioned the assumption that these categories do not intersect with blackness. During a conversation I had years ago with DJ Tony Touch— a.k.a. Tony Toca, a.k.a. the Taíno Turntable Terrorist—he insightfully expressed that internalized racism and its conjunction with class bias have accounted for much of the aversion to hip hop exhibited by many Latinos of Afro-diasporic cultures: "You got some Puerto Ricans who think they white and they ain't even trying to hear hip hop. They wanna be on some proper shit or etiquette. To them, hip hop is ghetto, street, it's oppression. They don't associate with that. You got a lot of Hispanics and Puerto Ricans who think they've got too much of the European blood in them and not enough of the African."

New York Puerto Ricans have long been battling the omissions and misconceptions surrounding their historical contributions and current

role in hip hop culture. The following accounts of hip hop history highlight some of the issues involved.

"A GHETTO THING"

Q-Unique (Anthony Quiles) is a South Bronx–raised MC and b-boy[9] who is a member of the rap group Arsonists and the Rock Steady Crew, a world-famous hip hop organization founded in 1977 and particularly recognized for its contributions to breaking. Committed to nourishing a historically grounded hip hop creativity, Q-Unique deeply resents being segregated, as a Puerto Rican, from a hip hop cultural core that often is assumed to be African American. That is one of his sources of artistic frustration today, just as it was the first time we met in 1995, thanks to DJ Tony Touch and D-Stroy,[10] who brought him to my home in Manhattan's Lower East Side. During that initial conversation, which given his gift for words and passion for the subject lasted for many hours, Q-Unique explained: "*Word Up* magazine did an article where they mentioned me and it was called 'The Latinos in Hip-Hop.' What's wack about that is that they have to separate us [Puerto Ricans and Blacks]. And I hated that. I was in the same article as Kid Frost, you know, [who did the song] 'La Raza.' And I was like, come on man, what do I have to do with Kid Frost? It's just totally different things and they're trying to funnel us all together. You never hear an article called 'The Blacks in Hip-Hop.'"

The problem that Q-Unique describes is twofold. First, hip hop is ahistorically taken to be an exclusively African American expressive culture. Puerto Ricans thus are excluded from the hip hop core on the basis of their being Latino. Second, as Latino population numbers and visibility increase in the United States, a variety of national-origins groups with different experiences of colonization, annexation and/or immigration as well as varied histories of socioeconomic incorporation and racialization are lumped under the Latino pan-ethnic[11] banner with little or no acknowledgment of their differences. This wider social phenomenon manifests itself within the hip hop realm when Latinos are grouped together on the hip hop margins under the presumed commonalties shared by Latino hip hop artists and enthusiasts.

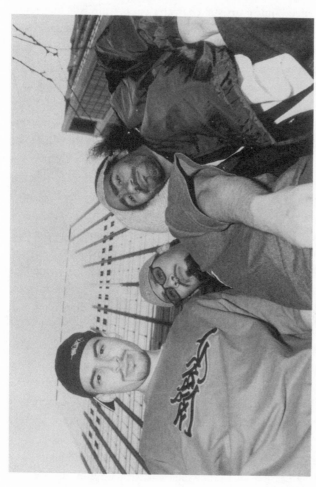

Q-Unique **Swel 79** **Jise**

ARSONISTS

The Arsonists, 2001. Photo by E. Victoria Toro.

www.matadorrecords.com/arsonists www.arsonists.net

What does a New York Puerto Rican MC like Q-Unique have in common with a West Coast Chicano rap artist like Kid Frost? Not necessarily more than what he shares with an African American MC from New York City, according to Q-Unique. The ethnic "funneling" that he criticizes relies on the assumption that Latinos will necessarily share certain experiences and/or artistic characteristics. Simplistic and questionable pan-ethnic connections are thus drawn—in this case, between Puerto Ricans and Chicanos on opposite coasts—that actually may serve to erase other more concrete, historically based, interethnic connections, such as those between Puerto Ricans and African Americans in New York.

Q-Unique also explained during our conversation: "We've discussed this in Rock Steady and when we've become approached with this situation we don't like doing the 'Latinos in hip hop' subject. I think that's tacky because we believe it's a ghetto thing. From the start it's separating us from the rest. Looking at us like we're the kids in the bubble. It feels wack."

But just as he resists being funneled into the "Latino hip hop artist" category, Q-Unique also opposes being subsumed under the African American "umbrella." He is not one to deny that Puerto Ricans are part of the African diaspora. What he objects to is the presumption that the black experience, defined primarily in terms of African Americans, can properly address the specificities of Puerto Rican life in the United States. Behind inclusion lies the specter of subsumption and dismissal. In Q-Unique's opinion: "The majority of [African Americans] don't even know who we [Puerto Ricans] are, what we are. They want to consider us Black. I beg to differ. I'm not ready to go under anybody's umbrella. I know we are our own kind. I know we are of many races, but so is every other nation."

Q-Unique also refutes the notion that ethnic and racial affiliation have or should have a bearing on an individual's participation in hip hop culture. Instead, he invokes hip hop's multiethnic and multiracial South Bronx origins to describe hip hop art forms as grounded in the creativity of young people from U.S. inner-city communities, primarily African American and Puerto Rican but inclusive of other groups as well: "We [Rock Steady Crew] just wanna keep it as a hip hop thing, as a ghetto

thing, 'cause there's whites and there's Japanese and there's other cultures as well."

Edward Sunez Rodríguez, a Puerto Rican hip hop enthusiast and journalist,[12] shares the class dimension of Q-Unique's argument. He also proclaims hip hop to be primarily the creative expression of urban youth in low-income communities. However, there is an important ethno-racial[13] component to Rodríguez's formulation: "Culture is a peoples' [sic] way of life. Hip hop culture thus is the way of life of urban Blacks and Latinos. . . . It is easily possible for anyone to contribute worthily and represent one or all of the aspects of hip hop culture. *However, they cannot have the same claim on the culture that an urban Black or Latino has on it.* For example, a white person may contribute enormously to an aspect of hip hop (i.e., graffiti, DJ-ing, MC-ing, etc.), and live in the South Bronx. Is he hip hop? Yes, but only to a certain extent."[14]

Whereas Rodríguez claims that hip hop "really is a black thing and that includes Latinos and all African peoples," Q-Unique has no interest in defining hip hop's ethno-racial scope. Rodríguez bases his argument not only on these groups' joint hip hop involvement but on a shared history among people of the African diaspora, which he defines as including African Americans as well as Latinos. This shared history encompasses socioeconomic exploitation and marginalization as well as cultural formations. In an article that criticizes what he perceives as the deepening wedges driven between African American and Latinos, he remarks: "Hip hop once united urban Blacks and Latinos through a common culture. It helped them realize that they had much more in common than hip hop. Latinos and Blacks learned they both suffer from oppression, poverty, and share common history and roots."[15]

Rodríguez has no qualms about including the New York Puerto Rican experience as part of the New York "Latino" experience. Neither is he reluctant to formulate the black experience in the United States as inclusive of Puerto Ricans. In his view, Puerto Ricans are both Latinos and black.

Q-Unique and Edward Sunez Rodríguez express only two of many divergent opinions regarding the relationship between ethno-racial affiliation and participation in hip hop art forms. The bearing of ethno-racial identity on emic or "insider" perceptions regarding "belonging," "entitlement" and

"authenticity" has been a site of contention within hip hop culture since its very beginnings in the early 1970s. As the chapters that follow illustrate, these perceptions have shifted along hip hop's three-decade history. These changes, in turn, have had an impact on Puerto Rican participation and representation in hip hop culture. Conversely, through their involvement in hip hop, young New York Puerto Ricans have influenced the way in which belonging, entitlement and authenticity have been defined within this cultural zone.

BETWEEN BLACKNESS AND *LATINIDAD*

This book is devoted to exploring the history of New York Puerto Rican participation and representation in hip hop culture, focusing on its musical dimension and paying particular attention to the role played by ethnoracial identities. How have New York Puerto Ricans navigated the murky waters of ethno-racial identification within the hip hop realm? How have they thought of their identity as Puerto Ricans vis-à-vis the larger panethnic Latino label? Have they constructed Puerto Ricanness as in association with or in contradiction to African Americanness? How has Puerto Ricanness been thought to be related to racial identity?

Puerto Ricans who have taken part in New York's hip hop culture have constructed their identities, participated and created art through a process of negotiation with the dominant notions of blackness and *latinidad.* The way in which Puerto Ricans have been represented through commercial hip hop culture also indicates a tension between blackness and *latinidad* in the construction of Puerto Rican images.

Puerto Ricans in the United States are commonly thought of as being part of this country's Hispanic or Latino population. But Puerto Ricans are also considered an exception among Latinos.[16] Their exceptionality is based on a history that diverges from what has been construed as the Latino norm and that bears much in common with the experience of African Americans. Furthermore, Puerto Ricans share common ground with African Americans not only because of their similar socioeconomic experiences as racialized ethnic minorities in the United States but also because Puerto Rican culture is as Spanish as it is African,[17] thus making

it part of the myriad group experiences that make up the African diaspora in the Americas. However, Puerto Ricans also are cast out of narratives of blackness, since in the United States blackness often is thought of only in terms of African Americans.[18] Caught between *latinidad* and blackness, Puerto Ricans may fit in both categories and yet also in neither.

Given the varied meanings that blackness can have—in some cases referring only to African Americans and in other cases to all Afro-diasporic people—I will be using "black" and "Black" as two distinct concepts: "black" as the "racial" or sociocultural category that refers to people of the African diaspora and "Black" as the U.S.-based ethno-racial category that refers specifically to African Americans. Although the terminology used varies, this conceptual distinction between African American (Black) and Afro-diasporic (black) is used by many hip hop participants as well as by some students of the culture,[19] and it is key in understanding the history of Puerto Rican participation in hip hop.

I believe that the meanings given to blackness and *latinidad* by the young New Yorkers involved in hip hop have had a complex relationship with those meanings common among the older Puerto Rican and African American generations as well as with media and academic representations of these ethno-racial identity fields. Through hip hop's creative expressions, young Puerto Ricans and African Americans, among others, have partly deconstructed and reconstructed "official" ethnic and racial categories. Simultaneously, they have been deeply influenced by the dominant formulations, by which they abide at times.

The bulk of this book consists of an exploration of various stages in hip hop's nearly thirty-year history. I aim to discuss how social constructions and experiences of ethnicity and race intersect with class and gender and affect the creative participation and representations of Puerto Ricans in hip hop culture.

This introduction establishes two basic ideas that underlie my exploration of Puerto Rican participation in hip hop's musical realm: rap music's relationship to hip hop culture and hip hop's simultaneous existence as a vernacular, community-based and mass-mediated expressive realm. This chapter also identifies the specific subzone of Puerto Rican participation within the larger hip hop zone that makes up this book's central focus of inquiry.

Chapter 2 serves as an introductory counterpoint to chapter 1, for it contextualizes hip hop culture within the history of Puerto Ricans in New York and their placement in the city's cultural history and its ethno-racial and socioeconomic hierarchies.

Part I, which includes chapters 3 through 5, is an exploration of hip hop history as seen through the lens of New York Puerto Rican participation. The history of New York Puerto Ricans within the hip hop zone serves as a way to illustrate how their identities are negotiated through navigations between *latinidad* and blackness—identity categories that themselves are constantly being redefined. This history is also a vehicle through which to explore how African American–Puerto Rican interethnic dynamics and identities manifest themselves within hip hop.

Chapter 3 discusses hip hop's early times as an Afro-diasporic community-based culture in the 1970s South Bronx. This chapter centers on issues of "authenticity" and cultural "entitlement" and the changes in those notions that ensued after the commercial recording of rap music in 1979 and the mass-mediated popularity of so-called breakdancing during the first half of the 1980s.

The latter half of the 1980s and the narrowing of hip hop's ethno-racial scope (in terms of participation and "entitlement") to the exclusion of Puerto Ricans is the subject of chapter 4. This narrowing is discussed through the exploration of the ethno-racial fissures between African Americans and Puerto Ricans that manifest themselves in hip hop, as a zone of urban community-based cultural production and as a mass-mediated cultural product. The chapter also explores the advent of "Latin hip hop"—which includes "freestyle" as well as "Latin rap"—as a segregated realm of musical production that developed partly in response to Latino marginalization from the "core" hip hop realm and that contributed further to the notion that Puerto Ricans and other Latinos were outside hip hop's scope of entitlement.

Chapter 5 delves into rap music's shift in emphasis during the 1990s from an entitlement based on an ethnic Blackness, which largely excluded Puerto Ricans, to one where blackness is defined primarily in class terms and where Puerto Ricans can be considered insiders. This chapter also discusses the contradictory effects of the *latinidad* pan-ethnic discourse

on the participation and perceived entitlement of Puerto Ricans involved in hip hop.

Part II, which includes chapters 6 through 9, centers around four themes that at the turn of the millennium have provided vivid examples of the ways in which Puerto Rican participation in hip hop can be described as a navigation between *latinidad* and blackness.

Chapter 6 addresses the commercial exploitation of *latinidad* within rap music since the latter half of the 1990s, paying particular attention to the role played by "tropicalizations"[20] in the construction of Puerto Ricans as entitled participants. Puerto Ricans are perceived to share a ghetto blackness with African Americans but nevertheless are presented and present themselves as a lighter ("brown" or "butta pecan") variation on blackness given their tropicalized and exoticized *latinidad.*

Chapter 7 delves further into the topic of tropicalizations by focusing on the participation and representations of Puerto Rican women in hip hop's commercial musical realm. This chapter explores how most such representations are premised on Puerto Rican women being portrayed as an exotic and tropical (i.e., Latinized) variation on black womanhood, thus illustrating the convergence of *latinidad* and blackness in gender-specific terms.

Chapter 8 discusses language use and wordplay in rap rhymes as tools used by New York Puerto Ricans to navigate between *latinidad* and blackness. This chapter questions the common association between the use of Spanish language (and even so-called Spanglish) and Puerto Rican ethno-racial identity through the musical production and experiences of young Puerto Ricans. It illustrates how the ethno-racial identity of New York–raised Puerto Rican youth has been expressed most often through rhymes that privilege English and connect them with wider Afro-diasporic ghetto-based linguistic practices.

Chapter 9 is dedicated to exploring the legacy of deceased Puerto Rican rap legend Big Punisher as someone whose commercial success was linked to the way in which he navigated the treacherous waters where *latinidad* and blackness meet.

Chapter 10 is a brief overview of the book's historical narrative, while the epilogue examines some recent trends in hip hop music in light of my main arguments. The Appendix consists of interviews and articles focusing on key issues and artists.

This book is, on one hand, an inquiry into the creative expressions of New York Puerto Rican youth. It is also a contribution to the understanding of how African American–Puerto Rican relations and identities have affected the realm of cultural production. I offer hip hop culture as an example of how youth artistic expressions sometimes challenge and sometimes reinforce traditional categories of ethno-racial affiliation. The result is that the cultural boundaries among Puerto Ricanness, African Americanness, *latinidad,* and blackness are in many cases fluid and cannot always be properly established. To ignore the way in which Puerto Rican and African American identities and artistic expressions have intersected is to neglect a crucial aspect of cultural history.

HIP HOP CULTURE AND RAP MUSIC

Rap music is largely considered by its participants to be part of hip hop culture, a broader phenomenon that includes other artistic expressions such as graffiti (originally simply known as writing) and the dance form known as b-boying/b-girling, breaking or "breakdancing."[21] Rap music may be described as the "aural" dimension of hip hop; graffiti and breaking, respectively, being part of its "visual" and "kinetic" expressions.[22] This aural dimension of hip hop involves two primary expressive elements: MCing—also referred to as rapping or rhyming—and DJing.

Although my focus is rap music, I have studied it as a component of hip hop culture. After the short-lived existence of breaking and graffiti as mainstream fads during the first half of the 1980s, rap has been the most visible, popular and profitable of hip hop art forms. Situating rap within hip hop culture allows for the construction of a more rounded and complex analysis that takes close account of rap's sociohistorical context.

Rap is today one of the most popular and profitable musical genres. It is the most rapidly growing segment of the music industry. The Recording Industry Association of America announced that in 1999, rap music sales accounted for 10.1 percent of the market share; of the top 40 albums of the year, 10 were rap recordings. At the same time, rap is a musical expression whose history, success and discourses are tied to poor Afro-diasporic urban communities in the United States. Rap, therefore, must be understood through the recognition of its intense technological and industrial media-

tion, its international popularity, its historical context and its continued rootedness in poor communities of color across the United States.[23]

New York inner-city neighborhoods were the cradle of what we know today as rap, and its first exponents date from the early 1970s. It is a music rooted in Afro–North American culture.[24] But in spite of being firmly situated in this cultural tradition, rap—like other genres such as jazz, rhythm and blues (R & B) and soul—has been fundamentally influenced by Caribbean cultures. Like other hip hop art forms, rap is a testimony to the cultural interaction among African Americans, Puerto Ricans and other Caribbean immigrants and their descendants in New York City since the early twentieth century.[25] Rap is also evidence of the cultural parallels that exist among the various ethnic cultures that are all part of the African diaspora in the Americas.[26] For example, in a *New York Times* article, Daisann McLane noted how rap's lyrical style recalls that of Trinidadian calypso, while Juan Flores in his essay "Rappin', Writin' & Breakin'" noted rap's resemblance to Puerto Rican *plena* and *aguinaldos*, and Robert Farris Thompson in "Hip Hop 101" related the importance of drum breaks and scratching records in hip hop to the role of drum breaks and certain percussion techniques in Caribbean music. Some of these parallels are explained in Chapter 2.

Rap music has evolved from a local musical style of New York City to being one of the strongest contenders in the international music market. This intense process of commercialization has had a profound effect on rap music, which began as an art form nourished and developed primarily through everyday experience. Initially it depended on the participants' physical presence at house parties, outdoor jams and neighborhood rhyme cyphers.[27] As time passed, that community-based everyday experience came to be complemented—and in many cases replaced—by the sounds and images of mass media.

HIP HOP AS VERNACULAR AND MASS-MEDIATED CULTURAL EXPRESSION

The process of mass mediation often occurs with no regard for the historical context, roots, function or "meanings," of the form being mediated,[28] and hip hop has been no exception. Its mass mediation has been

accompanied by the distancing of localized, neighborhood-based hip hop experiences and creativity from its commercial expressions.[29] Hip hop's multiethnic New York history and its artistic expressions that include music, dance and visual art often have been omitted in movies as well as television, radio and press coverage that limit hip hop culture to rap music and a commercially appealing slice of the African American experience.

Popular perspectives are profoundly informed by the reach and influence of these mass-mediated accounts, which at times prove more influential than community-based or vernacular knowledge. Thus, versions of hip hop history that have excised Puerto Ricans are sometimes accepted in the very New York neighborhoods that gave rise to hip hop, particularly by those who did not witness its early development firsthand. A good example is Gotti, whom I met in 1998 right after his performance at the 116th Street Carnival in East Harlem (El Barrio), Manhattan. During one of our later conversations, this New York–raised and English-dominant 18-year-old Puerto Rican rapper explained his preference for Island-based underground[30] music—rap and reggae in Spanish—in terms of ethnic property: "Hip hop [rap] belongs to the *morenos* [African Americans], but *underground* is ours."

Veteran b-boy and Rock Steady Crew president Crazy Legs (R. Colón) remarks, regarding the gaps in historical memory in the same New York neighborhoods where hip hop first developed: "The only thing you could get back in the day was ghetto celebrity status, and that's all most people wanted. *That* was our media. . . . Nowadays though, I know so many white people that know much more about Hip-Hop history than the average 'ghetto' person."[31]

Localized historical memories are influenced, and occasionally even usurped, by mass-mediated ones that tend to dehistoricize, oversimplify, romanticize and/or sensationalize. However, influence does not just run in one direction. Mass-mediated representations draw from New York native historical memories as well as from its thriving "underground" or "extra-commercial"[32] scene, particularly in the commercial race to remain connected to hip hop's street-based "authenticity."

For example, since the latter half of the 1990s, there has been a growing media recognition of hip hop as a "Black and Latino" form of cultural expression. Self-described "hip hop" or "urban music and culture" maga-

zines of wide circulation such as *Vibe*, *The Source* and *Rap Pages*, have made a visible effort to expand hip hop "entitlement" to Latinos. Television networks BET (Black Entertainment Television) and MTV (Music Television) have followed the same trend. This growing recognition of Latinos as partners in the hip hop project has not signaled an end to the marginalization of Puerto Ricans and other Latinos, but it most certainly points to an opening in the ethnically exclusive vision of hip hop. This shift may not, however, be a lasting one out of African American exclusivity but just a passing trend.

The recent phenomenon of greater inclusion of Latinos is one example, among many, of a cross-fertilization between the commercially successful (or "mainstream") end of the hip hop spectrum and its more vernacular, street-based, grassroots, localized or underground expressions. In an unending quest for the cutting edge that will boost sales—which in the case of hip hop translates into a perceived street "credibility," "legitimacy" or "authenticity"—record labels, magazines and television stations are constantly drawing from vernacular experience and creativity. After ignoring Latinos for decades, mass media outlets have taken their cue regarding inclusiveness from hip hop's more street-based expressions.

It is within this context of cross-fertilization between vernacular cultural expressions and mass-mediated ones that I place my discussion of Puerto Ricans and rap music.

THE HIP HOP ZONE

Hip hop is a fluid cultural space, a zone whose boundaries are an internal and external matter of debate. A profoundly diverse, translocal, multiethnic and multiracial cultural phenomenon, hip hop expressions also can present themselves as exclusionary, for aesthetic, regional, gender, sexual-orientation, national, ethnic, racial, class or myriad other reasons. The dynamic tensions within hip hop and its constant drawing and crossing of borders are better addressed by the somewhat ambiguous concept of a "hip hop zone" than by frequently adopted but more limiting (and, in my opinion, questionable) terms like "hip hop community" and "hip hop nation."

Within the larger hip hop zone exist a great many subzones, most of which are interconnected and/or overlap. There is a Boricua/Latino-centric rap scene in New York, which has been closely affiliated with the rap and *reggaetón* music of Puerto Rico (at times also called *underground*). Its most popular exponents, among them El Mexicano, Daddy Yankee, Chezina, Glori and Ivy Queen, tend to have been raised in Puerto Rico and be based there. Nevertheless, New York–based Puerto Rican (and, increasingly, Dominican) artists also abound in this sector of the hip hop zone: Mafa, a Dominican DJ, has released two albums; Enemigo, a Bronx-based Puerto Rican rapper, released his debut album in December 2000; Don Gato traveled to Puerto Rico to appear as a guest artist in albums by DJ Adams and Coo-Kee; and innumerable professionally aspiring artists and crews like BWP (Boricuas With Pride), Patota and Gotti are struggling for commercial recognition. Most of the New York–based artists who participate in the Island-style rap or *reggaetón* circuit are Spanish-dominant and either have been raised primarily in Puerto Rico or have spent substantial periods of their lives there.

In terms of musical and verbal aesthetics, these artists are much more closely tied to the rap and *reggaetón* music of Puerto Rico than to the "core" New York hip hop music subzone. Establishing the "core" and "fringes" of New York hip hop is a subjective and potentially sticky endeavor. However, an argument can be made (for this book's purposes) for the existence of a core New York hip hop music scene in which African Americans are the most commercially visible group but in which West Indians and Caribbean Latinos (particularly Puerto Ricans) have participated to a substantial extent. This core is regarded as such within most hip hop "insider" discourses, given its importance and its impact on the larger, translocal or international hip hop zone.[33]

The Puerto Ricans who have participated in this core New York hip hop music scene have been largely English-dominant youth. Among the better-known are DJ Charlie Chase of the Cold Crush Brothers, Master OC and Devastating Tito of the Fearless Four and Rubie Dee and Prince Whipper Whip of The Fantastic Five. All three of these music groups were popular in the early 1980s and are widely acknowledged as pioneers of rap music's early commercial era. The Fat Boy's Prince Markie Dee Morales and The Real Roxanne are two New York Puerto Ricans who at-

tained commercial popularity in the mid-1980s. Ivan "Doc" Rodríguez has been a key music producer and engineer since the later 1980s, the man behind the popular sounds of Erik B. and Rakim's *Paid in Full*, BDP's *Criminal Minded* and *By Any Means Necessary*, among many other classic hip hop albums. Among New York Puerto Rican artists of the 1990s and the early years of the twenty-first century are MCs like Hurricane G, PowerRule, Latin Empire, Kurious Jorge, Fat Joe, D-Stroy, the late Big Punisher, Thirstin' Howl III, A-Butta, Arsonists, Puerto Rock, La Bruja, Angie Martínez and Building Block, and DJs and producers like Frankie Cutlass, DJ Tony Touch, Doo Wop, G-Bo the Pro, Double R, Lazy K, DJ Enuff and Bobbito the Barber,[34] a.k.a. Cucumber Slice. This "core" New York hip hop subzone and the Puerto Ricans who participate in it are the topics of concern here.

The borders between the New York hip hop "core" and the Island-style subzones are porous. DJ Tony Touch, for example, is one of the few hip hop artists who comfortably weave in and out of these two subzones. His mixed tapes are popular among both audiences. Although Brooklyn-based, he travels frequently to Puerto Rico to spin records at rap and *reggeatón* events and clubs. He also works regularly at New York clubs that feature hip hop music, at times for mostly Latino audiences, at times for mostly African American audiences, at times for mixed audiences. His album *The Piece Maker,* released in 2000 by Tommy Boy Music, featured popular African American and U.S. Latino rappers like the Flipmode Squad, Wu-Tang Clan, KRS-One, Cypress Hill, Beatnuts and Big Pun. It also included the Spanish-language *reggaetón* track "P.R. All-Stars," featuring some of the Island's favorites such as Mexicano, Chezina, Rey Pirín, Yankee and Ivy Queen.

The collaborative album *Boricua Guerrero* (1997)—"Boricua" is another term from "Puerto Rican," derived from "Borikén," the Taíno name for the island—is another example of the porosity of these two hip hop subzones. As one of the album's executive producers, Stan "Cash" Stephenson, explained to me, this commercially successful album was directed largely toward a Spanish-speaking audience. However, the producers also sought to bridge the gap between these subzones by pairing popular rappers from the New York "core" scene with popular artists from the Island. The album included collaborations between Nas and Daddy

Uprocking at the Rock Steady Crew Anniversary, ca. 2000, Midtown Manhattan. In the forefront, left to right: Q-Unique and Crazy Legs. Background, left of Q-Unique, Bobbito Garcia. Photo by Fernando REALS.

Yankee, Q-Tip and Chezina, Fat Joe and Mexicano, and Big Punisher and Jahvia. Its executive producers were Cash Stephenson, a New York African American, and Elías de León, a Puerto Rican raised in Puerto Rico who relocated to New York.

Although *Boricua Guerrero* contributors Fat Joe and Big Punisher share the bond of Puerto Rican identity with their Island-based counterparts, their creative production is most comfortably lodged within the "core" hip hop music scene of New York. In the album, which as stated amid gunfire in the "Intro," seeks to bring together "two nations, two languages, one race," Fat Joe and Big Punisher in many ways stand closer to the New York African American artists than to the Island-based rappers and reggae singers.

For the Puerto Ricans who participate in "core" New York hip hop music, ethnic identity is not necessarily foregrounded in their hip hop–related activities. Neighborhood, borough, city, coast, gender, and sexual and class identity often take precedence as categories of affiliation within the hip hop zone. One reason for this is that Puerto Ricans who stress their Puerto Rican identity too intensely can be left out of the hip hop common territory shared with African Americans. (This idea is developed in later chapters.)

Some Puerto Rican hip hop enthusiasts do highlight their ethnic identity, but others do not. Some mention it in their lyrics, while others do not. Some incorporate *salsa, plena, merengue* and other Latino-identified genres into their hip hop beats; others choose not to. Some hang out, dance and/or make music mainly with Puerto Ricans or other Latinos; others may be the only Puerto Rican in an otherwise all–African American crew.

Unlike the Island-inspired rap and *reggaetón* scenes in New York where the participants are mostly Puerto Rican and almost exclusively Latino, the physical spaces where Puerto Ricans participate in "core" hip hop for the most part include other groups. At times, most participants in these spaces are African American. Other times, Latinos and African Americans comprise the majority of the participants, with smaller proportions of "whites" and Asians; sometimes these proportions are inverted.

New York hip hop culture has thrived during the last decade in diverse spaces, which have included streetcorner rhyme cyphers; "open-mic"

events like those hosted by Bobbito the Barber, Fareed Abdallah and Flaco Navaja at the Nuyorican Poets Café; community centers like The Point in the South Bronx where hip hop art forms are a central component of the classes, workshops and special events offered; schools like El Puente Academy for Peace and Justice in Brooklyn that have incorporated hip hop into their curriculum; small record stores like Fat Beats in the West Village (originally located in the East Village) and Bobbito's Footwork in the East Village (now closed); annual competitions like the DMC DJ battles; rap shows at the Apollo Theater in Harlem or clubs like Wetlands and SOB's in Lower Manhattan; Zulu Nation and Rock Steady Crew anniversaries that feature concerts, panel discussions and competitions; Internet radio shows like 88-Hip Hop and Queendom, which for years transmitted from a loft in SoHo; and traveling multimedia hip hop gatherings like Elevated and The Spot.

Hip hop has been one of the most vibrant products of youth culture at the turn of the millennium. This book is a contribution to the history of Puerto Rican hip hop artists in New York as well as a necessary—and largely neglected—angle from which the construction of Puerto Rican identities and artistic expressions must be explored.

CHAPTER 2

ENTER THE NEW YORK RICANS

The position of New York Puerto Ricans in hip hop culture must be understood within the historical context of Puerto Rican migration to New York City, their placement within the city's racial and socioeconomic hierarchies and their relationship with African Americans and other Latinos.

Puerto Ricans were for four decades (from approximately 1940 to 1980) the prototype and stereotype of a larger group variously referred to in the United States' Northeast as "Spanish," "Hispanics," "Latin Americans," "Latinos" or, derogatorily, "spics." Puerto Ricans, a group defined by their national origin, were for that time (and occasionally today) regarded as regional symbols or representatives of all immigrants from a variety of Latin American nations.[1]

Although Dominicans, Cubans, Mexicans and other Latin American immigrants have a history in New York City that dates as far back as Puerto Ricans', this latter group has been—and remains to this day—the largest Latino group in the area. In the public eye, *Nueva York* had a Puerto Rican face throughout most of the twentieth century.

The situation had shifted dramatically by the 1990s. The 1980s, dubbed the "Decade of the Hispanics" in the media, saw an acknowledgment of the diversification and growing numbers of the Latino population—a belated recognition, since this phenomenon actually had begun more than ten years earlier.[2] Large numbers of Hispanic Caribbean immigrants and other Latin Americans began arriving in the United States

after the repeal of the national origins quota in 1965, many of them set-
tling in New York City.

Puerto Ricans comprised 80 percent of the Latino population of New
York in 1960; by the 1990s, this number had dropped to 50 percent. Ad-
justed 2000 census figures put the percentage of Puerto Ricans at 38 per-
cent.[3] But although their proportion with respect to Latinos as a whole
has diminished, Puerto Ricans are still the largest Latino group in the
city.[4] Dominicans are today the second largest Latino group, followed by
Mexicans, Ecuadorians and Colombians.

With the growing plurality of Latino groups, numbers, experiences and
voices, the exceptional character of Puerto Ricans with respect to other
Latino groups became a hot topic among media and social analysts as well
as within popular discourses. Commentators noticed how many of the
same factors that make Puerto Ricans a distinct case among Latinos are
those they share with African Americans.[5] Not that there is anything new
in the association of African Americans and Puerto Ricans. Even during
the mid-twentieth century decades that Puerto Ricans were taken as the
"Hispanic" prototype, they were also closely associated with African Amer-
icans in the public eye. And with good reason, for, as will be discussed in
the sections that follow, the historical experiences of Puerto Ricans in New
York City have more in common with those of African Americans than
with those of any other ethno-racial group, Latino or otherwise.

MIGRATION AND SETTLEMENT

After being a Spanish colony for four centuries, Puerto Rico was granted
its autonomy from Spain in 1897. Only a year later, Spain was forced to
cede Puerto Rico, along with Cuba and the Philippines, to the United
States after losing the Spanish-American War. Thus, since 1898, Puerto
Rico has been a colony of the United States and subjected to its political
and economic power. The history of Puerto Rican migration to the
United States is directly related to the rise of the United States as an im-
perial and capitalist power at the end of the nineteenth century.[6]

With an economy structured to benefit U.S. corporations and a sector
of the Puerto Rican elite, the largest proportion of the island's population

was either overworked and underpaid or deemed redundant. Such was the case in the early decades of the twentieth century, when U.S. sugar companies dictated the course of the Puerto Rican economy, as well as during the 1940s with the launching of Operation Bootstrap, when the shift from a largely agricultural to an industrialized economy once again displaced large numbers of workers. The migration of workers was promoted as a safety valve for the impoverishment and social discontent generated by exploitation and insufficient employment but attributed by the authorities to "overpopulation."

Sizable Puerto Rican settlements in New York developed during the first two decades of the twentieth century. These early settlements included the Lower East Side and Chelsea in Manhattan, and the area close to the Brooklyn Navy Yard, particularly Red Hook. Puerto Ricans tended to live close to their primary sources of employment during this period, among these cigar factories, the New York docks, the merchant marine, the Nabisco Company in Chelsea and a rope manufacturer in the Brooklyn Navy Yard area called the American Manufacturing Company.[7]

In 1950, more than half (56 percent) of the 246,000 Puerto Ricans in New York City lived in three Manhattan neighborhoods: the Lower East Side, East Harlem and Washington Heights. East Harlem was, in the early 1950s, the neighborhood with the largest concentration of Puerto Ricans. Other settlements of the time included Williamsburg, Bushwick, Sunset Park and Carroll Gardens in Brooklyn (accounting for close to 14 percent of the city's Puerto Rican population) and the South Bronx (25 percent).

By 1960, the Puerto Rican population had increased dramatically, to 613,000, and its residential distribution had shifted. Numbers in Manhattan decreased, as they increased in the Bronx and Brooklyn. During the 1960s, many migrated out of the Lower East Side and East Harlem into the South Bronx and northern Brooklyn. New areas of settlement during this decade included the East and North Bronx, and Coney Island, Flatbush and East New York in Brooklyn. Since the 1960s, most New York Puerto Ricans have lived in Brooklyn and the Bronx, with the Bronx having the highest concentration.

Most of these residential areas have been either shared with or located in close proximity to African American neighborhoods. Predominantly

African American areas such as Harlem (Manhattan) and Bedford-Stuyvesant (Brooklyn) flow into largely Puerto Rican neighborhoods like East Harlem and Bushwick. African Americans and Puerto Ricans have lived side by side in areas such as the South Bronx.

The 1960 census illustrates the low degree of residential segregation between African Americans and Puerto Ricans. The index of segregation—which is the percent of individuals of one of two groups that would have to move to achieve an even racial distribution—between African Americans and Puerto Ricans was 62.2. The index of segregation between Puerto Ricans and whites during the same decade was 73; the same index for African Americans and whites was considerably higher, at 80.[8]

By 1960, the two-decade period of most intense Puerto Rican migration to New York City (1940–1960) gave way to a "reverse migration" spurred mostly by an economic recession. During 1961 and 1963, for example, more Puerto Ricans returned to Puerto Rico than migrated to New York. At the beginning of this decade, two-thirds of Puerto Rican workers were involved in semiskilled manufacturing work and were hard hit by the massive loss of manufacturing jobs that New York experienced during the 1960s and 1970s. Puerto Rican poverty levels rose dramatically during this period, placing Puerto Ricans among the poorest of city residents. African Americans were, along with Puerto Ricans, among the city residents most violently impacted by the changing economic conditions of the times.

During the 1970s, New York was no longer the primary destination of Puerto Rican migrants. Whereas in 1950, eight of every ten Puerto Ricans in the United States had settled in New York City, by 1980, less than half of Puerto Ricans in the United States lived there. A decade later, in 1990, New York accounted for only a third of Puerto Ricans in the fifty states. Nevertheless, Puerto Ricans continue to be a sizable presence in the city.

Puerto Ricans in New York were, during the 1960s, 1970s and 1980s, the city residents with the lowest income, home ownership rates and labor force participation, and the highest poverty and unemployment levels. Throughout the 1990s and into the beginning of the twenty-first century, they have remained a largely marginalized population living outside the economic mainstream.

"AN ALLIANCE OF SURVIVAL"

I remember the first time I went to the South with my friend Billy. I sat in the front of the bus and when the bus got to the Mason Dixon line, our driver got off and a new driver got on. Immediately, he said "all the colored to the back" and all the coloreds got up and went back and I just sat there. And he said "I want all of you colored people to go to the back" and I said "look I am puertorriqueño" and he looked at me and said "I don't care what kind of nigger you are" and he put his hand into his side pocket.

—Piri Thomas in Ilan Stavans, *Race and Mercy*

I'm smoking weed with my cousins in a car on 5th Ave and 120-something. A cop car blasts over the loudspeaker. "You niggers get out the car!" We kept smoking. Once again: "You niggers get out the car, now!" Suddenly somebody knocks loud on the window. I roll down the glass and a cop shouts: "I told you niggers to get out the car!" I say: "But we're Puerto Rican." He spits back: "I don't care what kind of nigger you are. Get the fuck out the car!"

—Comedian Herbie Quiñones as told by Pete Díaz

Puerto Ricans and African Americans, although having had a presence in the city since the late 1800s, were thought of as the "new" wave of immigrants during the 1920s. Both groups were incorporated into the lowest rungs of the labor structure under similar circumstances and, since then, have lived parallel experiences of racialization, marginalization and class exclusion.[9] Their histories of unemployment and underemployment, police brutality, negative portrayals in academic literature and media, housing and employment discrimination, residential displacement and racial violence have not only been similar but also linked. Puerto Ricans have come to be considered a native minority that shares the bottom of the socioeconomic structure with African Americans.[10] The histories of Puerto Ricans and African Americans in New York may not be identical, but they are certainly analogous, related and at times even overlapping.[11]

The colonial relationship between Puerto Rico and the United States is a prominent factor that sets Puerto Ricans apart from other Latinos and draws them closer to African Americans. For one thing, Puerto Ricans were granted U.S. citizenship in 1917. Given their colonial experience, Puerto Ricans are inserted into the racial, cultural and class

dynamics of the United States in a way more akin to African Americans and Chicanos than to immigrants from Latin America.

Puerto Ricans, as new immigrants to New York City, were initially a confusing case since, given the way in which blackness and whiteness had been historically defined in the United States, they could not—as a group—be easily cast as black or white. Eventually, Puerto Ricans became a new racialized subject, different from both but sharing with African Americans a common subordination to whites. Puerto Ricans came to be racialized as dark, dangerous others who, although different from African Americans, share with them a multitude of social spaces, conditions and dispositions.

According to Ramón Grosfoguel and Chloé Georas, low symbolic capital is one of the many attributes African Americans and Puerto Ricans share. They hold that the incorporation of Puerto Ricans into the New York ethno-racial hierarchy has operated in conjunction with what Pierre Bourdieu has termed symbolic capital. A group's symbolic capital (prestige, honor, public image) is positively correlated to the group's position in the ethno-racial hierarchy. Positive symbolic capital typically gives way to economic opportunities and access to economic capital. Low or negative symbolic capital usually leads to a negative public image, low economic opportunities and discrimination in the labor and housing markets. Grosfoguel and Georas argue that the initial incorporation of both Puerto Ricans and African Americans into the very bottom of New York ethno-racial and socioeconomic structures in conjunction with their extremely low symbolic capital have played a significant role in the perpetuation of their socioeconomic marginality.

Points of contention and separation arise between African Americans and Puerto Ricans, but there is a fundamental shared exclusion from the white, middle-class world. In the words of Andrés Torres, African Americans and Puerto Ricans in New York have been linked through an "alliance of survival." Their residential and work-related proximity, high poverty levels and similar historical experiences and cultural legacies have foregrounded the commonalties of their struggles. Puerto Ricans and African Americans in New York also share a history of political alliances.[12]

The two groups worked together throughout the 1960s and 1970s in the civil rights and the Black Power movements. Among the joint en-

deavors were the efforts to increase community control over public schools and antipoverty programs as well as the welfare rights movement. Many Puerto Ricans were part of the Black Power movement, not as merely sympathetic allies but also as core members.

The Black Power movement also served as an ideological and organizational example for Puerto Rican activists of the time. The Young Lords Party, for example, was modeled after the Black Panthers. Denise Oliver remembers that it was through the Black Panther newspaper that the group of activists who eventually became the Young Lords in New York first learned of the existence of young Puerto Rican activists from Chicago who called themselves the Young Lords Organization. Oliver, who was minister of economic development in the Young Lords Party from 1970 to 1971, is an African American and one of many who participated in Puerto Rican organizations. Since those times, electoral alliances as well as labor struggles and efforts against gentrification, police brutality and cutbacks in education and other social programs have seen joint African American and Puerto Rican participation.

The name of City College's Student Center sums it up by illustrating how past decades of shared struggles inform the political outlook of student activists of today. The Assata Shakur/Guillermo Morales Student Center honors jointly two New York revolutionary activists, one African American and the other Puerto Rican, both currently exiled in Cuba.

PUERTO RICANS AND AFRICAN AMERICANS: A SHARED STIGMA

Two early chroniclers of the Puerto Rican migration, Lawrence Chenault and Oscar Handlin, pointed out that Puerto Ricans insisted on distinguishing themselves from the African American population to avoid carrying the same racial and socioeconomic stigma. In an ironic turn of events, nowadays Dominicans, West Indians, Mexicans and other newer immigrants strive to distinguish themselves from both African Americans and Puerto Ricans.[13] Given the rising numbers of other Latino groups, Puerto Ricans have been increasingly described as the exception

within the Latino group or, in Juan Flores's words, "the 'problem' even among their own kind."

Linda Chávez's chapter "The Puerto Rican Exception" in her 1991 book *Out of the Barrio* offers a clear example of this singling out of Puerto Ricans from other Latinos. Chávez explains that "Hispanics"—except for Puerto Ricans—are "choosing" to become part of the "mainstream" of U.S. society. The problem posed by Puerto Ricans is not simply that a Latino group is suffering the repercussions of being left behind. Chávez fears that the upward mobility of Latinos as a whole actually may be hindered by the large sectors of the Puerto Rican population trapped in the "urban underclass" along with African Americans.

Based on extremely conservative assumptions, she explains how affirmative action and welfare benefits have made Puerto Ricans and African Americans feel entitled to special treatment; these "privileges" have been a disincentive to socioeconomic mobility. Chávez argues that citizenship has ended up being a liability for Puerto Ricans, since it has entitled them to "privileges based on disadvantage" provided by the welfare state. Lacking incentives for assimilation, Puerto Ricans have "chosen" to remain outside the mainstream.

Although Chávez denies that racism has played a role in Puerto Rican low socioeconomic status, she believes that race has influenced the construction of Puerto Rican identity in the United States. She holds that most "Hispanics" are of mixed native and Spanish ancestry but that miscegenation in the Hispanic Caribbean has involved primarily African and Spanish people. She argues that Puerto Ricans' relative high degree of African ancestry compared to other Latinos has led "white Americans" to think of Puerto Ricans as black, thus subjecting them to similar discriminatory treatment as African Americans. In explaining how blackness has shaped Puerto Rican identity, Chávez contradicts her initial statement that discrimination does not account for Puerto Rican social and economic marginality.

Chávez refers to Douglas S. Massey and Nancy A. Denton's 1991 study of residential segregation in making her argument about race and Puerto Ricans. She says their findings suggest that "Puerto Ricans may eventually come to identify themselves more in racial and less in ethnic terms, with darker Puerto Ricans absorbed into the American black community much as other Caribbean blacks, such as Jamaicans, have been over time."

Chávez's argument about Puerto Rican difference, with respect to the rest of Latinos, is based on the former's disadvantaged structural position (a marginalization that, she argues, is of their own making and stems largely from the entitlements derived from U.S. citizenship) and their African heritage—two characteristics that they share with African Americans. In short, what separates them from other Latinos draws them closer to African Americans.

Massey and Denton note that African Americans experience residential segregation to a greater degree than do Latinos and Asians. African Americans face high segregation levels that are not attenuated by upward mobility or suburbanization. For Latinos, on the other hand, rising socioeconomic status, acculturation and suburbanization do account for declining segregation. Puerto Ricans in New York, however, are the exception among Latinos. Their experience places them a lot closer to African Americans than to other Latinos.

Massey and Denton point to Puerto Ricans' African ancestry and low socioeconomic status as explanations for their exceptional position among Latinos. They conclude that with respect to residential segregation, "it is not race that matters, but black race" since "Blacks are apparently viewed by white Americans as qualitatively different and, by implication, less desirable as neighbors, than members of other racial or ethnic groups." According to these authors, low socioeconomic status initially ghettoizes Puerto Ricans together with African Americans, and antiblack prejudice cements their segregation and blocks their mobility.[14]

African Americans and Puerto Ricans, although seen as distinct, are frequently spoken of in the same breath in media representations and policy discussions. Both are perceived, written about and represented as the problematic native minorities of New York and other metropolitan centers such as Chicago, Philadelphia and Boston.[15] They have even become the standard against which the relative success of newer immigrants is most often measured.

OF "ALLIES" AND "TRAITORS"

Robert Smith has documented what members of a Mexican street organization, "gang" or *pandilla* in New York perceive as the distinction

between Puerto Ricans and the rest of Latinos. The purpose of the Organización para la Defensa de la Raza (ODR) was, avowedly, "to defend the Hispanic race" from Puerto Rican and African American youth. These two latter groups were presumed by the *pandilleros* to be violent, prone to vices and culturally inferior. A similar differentiation between Mexicans and Puerto Ricans was made by a Mexican youth group president who expressed the following to Smith: "Look at the blacks and Puerto Ricans, he told me, they have all kinds of problems: drugs, crime, teen pregnancy, disobedience to their parents, girls walking alone at night. . . . Look at this group, he said, pointing to the assembled Mexicans—Do you think the Puerto Ricans and blacks have this kind of community? This kind of culture? No, he answered, they do not, and this is the problem."[16]

Once again, Puerto Ricans are differentiated from other Latinos through their associations and similarities to African Americans. Interestingly enough, ODR distinguishes between Island-born Puerto Ricans and New York Puerto Ricans. The first are thought of as immigrants, the second as problematic locals in cahoots with African Americans.

This distinction proves to be significant given that, by the 1990s, most of the New York Puerto Rican population was of the second and third generation. Whereas in 1950 almost all of the Puerto Ricans living in New York City had been born in Puerto Rico, by 1990 the opposite was true. Therefore, the majority of Puerto Ricans in New York had been born in the fifty states, making Puerto Ricans the only Latino group in New York for which this was true.[17]

These differentiations between relatively recent Latino immigrants and seasoned locals are also made by Puerto Ricans themselves, particularly youths, who side with African Americans in teasing and "getting over on" (taking advantage of) "herbs"—often defined as new immigrants from Mexico and Central and South America, who are stereotyped as ignorant and easy to take advantage of.[18]

Red graffiti alongside the FDR Drive, on the easternmost end of El Barrio, denounces Blacks and Puerto Ricans ganging up on Mexicans. Among tags of local Mexican street organizations, the dripping and crudely written phrases "BLACK ABUSIVE" and "PR SON TRAICIONEROS" (Puerto Ricans are treacherous) tell a silent but still-vivid tale of youth

ethno-racial alliances and rivalries in New York. There is little doubt "PR" stands for Puerto Ricans, given the rest of the writings, particularly the phrase "PR y RD sangre" (PR and RD [Dominican Republic] blood), which refers to a link between Puerto Ricans and Dominicans—either a threat on the part of the Mexican writers or a call for Latino solidarity.

Using the Lower East Side neighborhood she studied as an example, Bonnie Urciuoli illustrates how in many New York communities there are no stable boundaries separating African American and Puerto Rican social life, particularly when it comes to young people:

> In this context, Puerto Ricans and African Americans do not make up entirely separate groups. They differ in how they define themselves and are defined by many of the things they do and in language. But in part through their shared history of class exclusion, they share a great deal of what they do, how they talk, and how they define themselves. They constantly interact. They make friends and sometimes enemies. They date and marry each other. They mix in adolescent cliques. Puerto Rican boys pick up slang, pronunciation, and grammatical phrasing from African American boys, who pick up Spanish phrases from Puerto Rican friends.[19]

Youth culture is one of the sites where cultural interaction and hybridization between African Americans and Puerto Ricans have been most intense. Urciuoli uses Pierre Bourdieu's concept of "habitus" to illustrate how the experiences and actions of Puerto Ricans and African Americans are "congruent," given that their lives are structured by similar conditions and result in similar understandings of themselves and the world. She points out that the degree of congruence varies, depending on other mediating factors such as gender, age, family role and generation. Adolescent boys exhibit the highest levels of congruence. Hip hop, as a youth cultural manifestation dominated by young males,[20] is the quintessential contemporary expression of this structural and cultural congruence—like doo wop and Latin soul were during the 1950s and 1960s.

Although the existing literature that documents Puerto Rican culture and arts has largely neglected the intense interaction and cooperation that has existed between young Puerto Ricans and African Americans, notable exceptions include Juan Flores and Max Salazar's writings on the

popular 1960s musical genre known as *bugalú,* Flores's essays on hip hop and Steve Hager's comprehensive account of early hip hop culture.[21]

Nuyorican poet Louis Reyes Rivera is pointing toward this convergence of African American and Puerto Rican youth cultural expressions and identities when he remarks that "interestingly enough, of all the 'Latino-Americans' living in the United States, Puerto Ricans and Dominicans—second generation—more easily identify with the Afro-United States scene than with the Anglo-United States scene. And that's not only because of the similarity in music but also because of the similarity in spirit and in social conditions. It's not just a cultural thing, it's an ethnic recognition. [*sic*] and it's a social response to similar conditions."[22]

Cultural congruence between African Americans and Puerto Ricans, however, does not translate into an absence of rifts, tensions and exclusions. The marginalization experienced by Puerto Ricans in the hip hop realm has not been haphazard but is related to the historical relations between the two groups and the particular position that each occupies in the city's racial and socioeconomic hierarchies. In Andrés Torres's view, African Americans and Puerto Ricans find themselves acting "often in tandem, occasionally at odds." Despite their long history of cooperation and alliances, African Americans and Puerto Ricans also have a parallel history of conflicts.[23]

RIFTS BETWEEN PUERTO RICANS
AND AFRICAN AMERICANS

Cultural identity, production and perceptions of entitlement have often been invested with the notion that Puerto Ricans, though having African heritage, are not "black" as African Americans are "black." Many believe Puerto Ricans might be *like* blacks but they are *not* black. Others assume Puerto Ricans *are* black, just not *as* black as African Americans, while others altogether deny Puerto Rican blackness. In Juan Flores's words, "cultural baggage and black-white racial antinomies in the U.S. thus conspire to perpetuate a construction of Puerto Rican identity as non-black."[24] Part of this cultural baggage is the Eurocentric bias of the dominant definitions of Puerto Rican and Latino identities.[25] Puerto

Rican *latinidad*, defined primarily in terms of Spanish heritage (cultural and racial), is most often constructed in such a way as to preclude its co-existence with Puerto Rican blackness.

Puerto Ricans in the United States most frequently state that ethno-cultural identification is of greater importance than racial identification,[26] even though ethno-cultural notions of Puerto Ricanness are racially constituted.[27] A self-described multiracial, culturally distinct group, Puerto Ricans have resisted compliance with the reigning system of racial classification in the United States, according to which, typically, any known African ancestry makes a person "racially" black.

Historically, the United States developed what has been termed a hypo-descent rule (where people of mixed ancestry are identified with the subordinate group) or one-drop rule (one drop of "black blood" makes a person black).[28] The system of racial classification that evolved in Latin America was different for it depended more on somatic characteristics and class than on heredity. In other words, Latin American racial categories depend more on "color" (and other physical characteristics) and class than on ancestry per se. In Latin America, skin tone, facial characteristics and hair type, along with such class markings as dress, body language and speech patterns, all have bearing on race. Members of the same family actually may be categorized differently. Another great difference between the two systems of racial classification is the white-black dichotomy in the United States, which contrasts with the recognition of a wide variety of intermediate racial possibilities in Latin America.[29]

The dominant Puerto Rican discourse of miscegenation, or *mestizaje*—in other words, the way in which most Puerto Ricans view and talk about our history of racial mixing—poses national cultural identity and racial makeup as a blend of African, Taíno and European (primarily Spanish) elements. Miscegenation is built into the language of community and nationality.[30] But to choose one race over the other, according to the way in which race is thought of in the United States, has been perceived as denying a part of one's self.

There is yet another reason why Puerto Ricans have largely refused to accept the one-drop rule and identify as blacks. Although an Afro-diasporic people, Puerto Ricans are still the bearers of strong antiblack prejudice.[31] Therefore, not only have many Puerto Ricans—regardless of

their color—not considered themselves black, but they have held their supposedly "blacker" African American neighbors in contempt. Antiblack sentiment was brought with them from Puerto Rico and bred within Puerto Rican communities in the continent; these attitudes were compounded with the adoption of U.S. prejudices against African Americans.

For many African Americans, the Puerto Rican insistence on identifying primarily by ethno-cultural affiliation or national origin and not along "racial" lines, combined with their racism, have not made Puerto Ricans dependable partners in race-based struggles. Suspicion and prejudices thus have run both ways.

CULTURAL PRODUCTION AND NEW YORK'S AFRICAN DIASPORA

Hip hop, as a realm of joint African American and Puerto Rican cultural expression, must be contextualized not only within these two groups' previously discussed common structural history but also within their long-standing history of joint cultural production in New York City.[32]

"Latin" music benefited from an interest by African American audiences on the wane of the Harlem Renaissance. In the 1930s and 1940s, Puerto Ricans participated along with African American and Cuban musicians in the production of Afro-Cuban jazz and Latin jazz. African Americans and Puerto Ricans also collaborated in rhythm-and-blues music of the late 1950s. One example is the greatly successful Frankie Lymon and the Teenagers. This group had two African American members, two Puerto Ricans and one Dominican. Other popular New York R & B groups with African American and Latino members included the Harptones and the Vocaleers.

The Latin *bugalú* of the 1960s, which mixed mambo with early black rock-and-roll, has been described by John Storm Roberts as "a genuine reflection of the impact of 1960s black music on young Latins."[33] Ricardo Ray and Willie Colón, both New York–born Puerto Ricans, were among its exponents. Hits like Joe Cuba's "Bang Bang"—which sold over a mil-

lion copies—and Héctor Rivera's "At the Party" were very popular among African American and Latino teenagers.

Latin soul, the broader musical tree of which *bugalú* was a branch, was developed by Puerto Ricans and African Americans. Joe Bataan, a musician of Filipino and African American ancestry and ex-leader of El Barrio gangs the Young Copasetics and The Dragons, and Jimmy Castor, an African American, were both central figures in Latin soul. Jimmy Castor's music later became a pivotal component of the hip hop soundtrack. "It's Just Begun," a b-boy and b-girl classic of the early 1970s, featured timbales breaks as well as stylistic influences from African American musician Sly Stone—further profession of Afro-diasporic hybridity involving African Americans and Caribbean Latinos. "My father was Filipino and my mother was African American, and my culture is Puerto Rican," says El Barrio–raised Joe Bataan, offering yet another example of the pre-hip hop cultural convergences among young New Yorkers of the African diaspora.[34]

The long-standing tradition of street drumming among New York Puerto Ricans and Cubans—in which African Americans also have participated—strongly influenced the music that was recorded as soul and funk, which was later played as *break-beats* at hip hop jams. Furthermore, not only did b-boys and b-girls develop hip hop's kinetic language to the beat of congas and timbales on popular records, but at least one of the dance styles that greatly influenced breaking—known as rocking, uprocking or Brooklyn rock,[35] and most notably nurtured by young Puerto Ricans—had been practiced outdoors since the late 1960s to the rhythm of live conga drums.

The Last Poets, a group of poets/musicians whose vocal approaches are direct precursors of hip hop's lyrical styles, were outspoken critics of the marginalization of African descendants in the Americas, Puerto Ricans included. Felipe Luciano, a New York Puerto Rican who was also a Young Lords Party leader—and later became a New York media personality—was one of the Last Poets' four original members.

Hip hop culture is yet another testimony to African American–Puerto Rican cultural production and sociopolitical action. Just as previous generations had done before them, Puerto Rican and African American

youngsters in the 1970s transformed their potentially forced joint segregation into a chosen partnership.

BUT . . . "WHY YOU TRYIN' TO BE BLACK?"

Hip hop, like other artistic expressions that preceded it, has in many senses transcended the interethnic rifts between Puerto Ricans and African Americans. Nevertheless, particularly in terms of hip hop's musical component, Puerto Ricans' cultural "entitlement" has been a realm of contention, even since the earliest days of record-spinning (DJing) and rhyming (MCing) as New York City vernacular creative expressions in the early 1970s. Part of the reason for the somewhat precarious position of Puerto Ricans within hip hop's musical zone has to do with the fact that understandings of blackness and Afro-diasporic cultural identity frequently are fractured along national or ethno-cultural lines. Thus, the cultural connections—past and present—among African Americans, Jamaicans, Puerto Ricans, Haitians, Trinidadians and Cubans, among others, remain virtually ignored. Accuracy in accounts of cultural change and interaction is often sacrificed when historical memory and analysis are circumscribed to national or ethno-cultural borders.[36] Much of the history of political thought, activism and cultural expression regarded as either discretely African American or Puerto Rican actually has been "generated by the broader experience of appropriation and transformation within the African diaspora."[37] However, academic, media and popular understandings all frequently fail to take into account the complexities of the African diaspora, relying instead on narrow visions of history and identity. The result, unfortunately, is that the connections between those populating what Paul Gilroy has termed "the black Atlantic" are camouflaged.

Hip hop music's ruptures in the rhythmic structure, syncopation, repetition of a certain rhythm and/or melodic phrase, call-and-response patterns as well as its heavy emphasis on lyrical competition, boasting, improvisation and commentary on current events are characteristic of most African-derived music in the Americas.[38] However, since hip hop music often is described only in terms of U.S.-based blues-derived tradi-

tions and African American oral practices—and from there the historical jump is made to West African cultural sources—the myth of separation between Afro-diasporic cultures in the Americas is perpetuated.

Daisann McLane in a 1992 article in the *New York Times* observes rap's "forgotten Caribbean connection" and explains that this music's "most obvious links are not to Africa but to the calypso and reggae styles of the West Indies." According to McLane, before one leaps across the ocean searching for roots in the West African troubadours known as griots, one must explore rap's musical forebears in the English-speaking West Indies, where for much of the twentieth-century calypso was the most commercially successful music, displaced in the early 1970s by reggae. McLane cites calypso's lyrical improvisation, boasting, sexual innuendoes and mocking social commentary as connections to rap.

Russell A. Potter, author of the article "Calypso: Roots of the Roots," reaches a bit farther back for rap music's roots in Trinidad's *calinda* songs, one of the precursors of calypso. In the late nineteenth century, groups of stick-fighters traveled the streets of Port-of-Spain. When two rival groups met, they engaged in a musical challenge with *calinda* songs, whose percussion was beaten out by the same sticks used as weapons. A similar African-derived musical/martial arts form existed in Puerto Rico, known as *cocobalé*—one of the many variants of *bomba*—where rivals used sticks as both weapons and percussion instruments. Other combat dances historically practiced by communities of African descent in the Americas include the *danza del maní* in Cuba, *capoeira* in Brazil and *knocking and kicking*—also known as *pushing and dancing*—in the southern United States.[39]

Just as the concept of an African-derived martial arts/musical tradition is not exclusive to Trinidad, neither is the term *"calinda."* In Puerto Rico, *calindá*, like *cocobalé*, is one of the many rhythms and dances that are today grouped as *bomba*. Furthermore, *calinda* and *calindá* (and multiple other variants, such as *kalinda, caringa* and *calendá*) have been the names of music and dances performed by black people in other regions of the Americas since early colonial times. *Calinda* was at one point very popular among Africans and their descendants in New Orleans. A music and dance called *calindá* (also *caringa* or *calinga*) existed in Cuba, while *calendá* was the name used to designate another dance in the Río de la Plata

region in South America; the variant *calenda* applied to dances in Haiti and other French colonies, while *calembe* and *calimbe* were used in Jamaica.[40]

The striking similarities between the cultural and linguistic expressions of African Americans, Puerto Ricans, Trinidadians and many others are evidence of the African roots they share. Just as important in the historical development of similar or parallel cultural practices throughout the Caribbean and in the United States was the heavy migration of plantation owners and slaves among the islands and between the islands and the New Orleans area, particularly after the triumph of the Haitian revolution in 1804. Musical and spiritual practices in Puerto Rico were particularly impacted by the migration of French planters and their slaves in the early nineteenth century; this migration is partly responsible for many of the similarities among cultural expressions in Puerto Rico, Haiti and New Orleans.

Now let us fast-forward to the development during the late 1960s and the 1970s—primarily by Puerto Rican young men—of the combat dance style called rocking or uprocking, which later became an important influence on breaking. Although rocking was most immediately influenced by the local Brooklyn gang culture and Asian martial arts via Kung-Fu movies, it was also a dance form that—however unconsciously—resurrected the long-standing martial arts traditions that have thrived among Puerto Ricans, African Americans and other African descendants and which I mentioned earlier.[41] Rockers, like their predecessors, confronted opponents by dancing one on one and by reacting with swiftness and inventiveness to counter and subvert their rivals' moves. In the newer dance style, just as in the older traditions, aggression and violence were often contained within the realm of performance but at times turned into real fights. And also like their ancestors, rockers battled in open-air spaces and to the beat of live drums.

The rise in the 1970s of the particular style of rhyming over a musical background that became known as MCing or rapping is another example of the existing similarities among various Afro-diasporic traditions and they way in which they feed into hip hop. David Toop has noted the variety among rap's forebears, including: "disco, street funk, radio DJs, Bo Diddley, the bebop singers, Cab Calloway, Pigmeat Markham, [. . .] acappella and doo-wop groups, ring games, skip-rope rhymes, prison and

army songs, toasts, signifying and the dozens, all the way to the griots of Nigeria and the Gambia."[42]

Not only have New York Puerto Ricans participated along with African Americans in many of these rap antecedents—such as funk, doo-wop groups and children's games—but island musical traditions like *plena, bomba,* and *música jíbara* can be invoked just as easily among rap's forebears. Verbal duels featuring boasting, trading insults, sexual innuendoes and improvisation are common in all three. Like rap, they are notorious for historicizing everyday events. DJs use their turntables as percussive instruments whose scratching sounds recall those of *plena's* and *música jíbara's* ever-present *güiro,* or gourd scraper.

Bomba shares with rap the use of the voice as an instrument that foregrounds tonality and rhythm as much as—and sometimes more than—meaning. A *bomba* singer often will repeat the same verse numerous times, varying the melody and rhythmic flow. At times, singers improvise verses. Each time the singer finishes a verse, the chorus is repeated, resulting in a call-and-response pattern. Meanwhile the drum or drums known as *buleadores* take charge of "locking" the basic rhythm of the *bomba* style being played, while a higher-pitched drum called *primo* improvises over the basic rhythm or engages in a percussive dialogue with a dancer. If this peculiar mix of repetition and improvisation sounds oddly like rap music, it's because they are remarkably alike. A similar reliance on repetition and improvisation is present in hip hop music's "looping" certain samples into a music track, verbally beat-boxing a repetitive rhythmic structure or a DJ repeating portions of a record, while the MC ducks in and out of the basic rhythm established, with lyrics whose meaning is just as important as their rhythm and tonality and often includes improvisation.

New York Puerto Rican youngsters have for decades joined their African American peers in verbal games and competitions that focus on improvising and trading insults, such as snapping, and which recall earlier word games known as sounding, toasting, boasting and the dozens. These games are part of the African American oral tradition that has nourished hip hop's lyrical styles. But Puerto Ricans have a parallel tradition of verbal duels, such as the joking games and joking contests which Anthony Lauria documented in Puerto Rico.[43] Island children of the hip

hop generations are no strangers to similar word games, such as *Te lo presento* (I present him/it to you), a competition of rhyming improvised insults and imaginative vulgarities practiced among the metropolitan-area teenage generation that popularized locally produced rap in the 1980s. How good a player was deemed to be depended on his or her rhyming skills, quick thinking, wit, outrageousness, silliness and level of vulgarity.

Poet José Raúl "Gallego" González[44] remembers having spent countless hours as a boy in Rio Piedras during the 1980s playing *Te lo presento*. González offers the following examples as possible exchanges in this game:

Person 1: *Te lo presento* (I present him/it to you)
Person 2: *¿Qué le das?* (What do you give him/it?)
Person 1: *Harina* (Flour)
Person 2: *¿Qué le metes?* (What do you stick in him/it?)
Person 1: *Un cañón de la Marina* (A Navy cannon)

Person 1: *Te lo presento* (I present him/it to you)
Person 2: *¿Qué le das?* (What will you give him/it?)
Person 1: *Agua sucia* (Dirty water)
Person 2: *¿Qué le metes?* (What do you stick in him/it?)
Person 1: *Japón, China y Rusia* (Japan, China and Russia)

Person 1: *Te lo presento* (I present him/it to you)
Person 2: *¿Qué le das?* (What will you give him/it?)
Person 1: *Ardilla* (Squirrel)
Person 2: *¿Qué le metes?* (What do you stick in him/it?)
Person 1: *El Hiram Bithorn con tó y bombillas* (The Hiram Bithorn Stadium, including the lightbulbs)

When New York Puerto Rican youngsters began participating alongside African Americans in the early development of MCing or rapping as a lyrical/musical style, they were not exactly "defecting" from Puerto Rican tradition. In terms of social function and aesthetics, Puerto Rican oral and musical styles can be invoked as precursors of MCing as much as African American ones. Also, by the early 1970s, there was nothing new about Puerto Rican cultural collaboration with African Americans.

Even the use of English lyrics among Puerto Ricans was nothing new, as evidenced through *bugalú*, Latin soul, doo wop and rhythm-and-blues. Yet, although in practice the lines between Puerto Rican and African American musical expressions have long been fluid, there seems to be a default setting for "Puerto Ricanness" to which narratives of cultural practice keep turning back.

The creative expression of Puerto Ricans through hip hop art forms cannot be easily incorporated into the traditional discourse of Puerto Rican nationhood.[45] Carlos Pabón points out that this *"discurso de la puertorriqueñidad"* (Puerto Ricanness discourse) is one that "reduces our nationality to an ethnic essence (Hispanicity) and/or a linguistic essence (Spanish). This is a discourse that proposes a homogenous and Hispanophilic nationality. In other words, it upholds a national imaginary that erases others, eliminates difference and excludes the vast majority of Puerto Ricans."[46] Although this Hispanocentric view of nationhood has been heavily contested,[47] it is so stubbornly ingrained among Puerto Ricans that it still remains the dominant discourse.[48]

While the African influences of Puerto Rican culture are routinely acknowledged, they usually are viewed as being more tenuous than Spanish and even Taíno influences. Africa is "celebrated"—and, at the same time, subordinated—as *la tercera raíz* (the third root) of Puerto Rican culture, constrained mostly to discrete musical expressions like *bomba* and *plena*. Largely unspoken, however, remains the widespread influence that African cultures—particularly Kongo/Bantu—have had on Puerto Rican music as a whole as well as on religion and language, among other cultural realms.[49] Also mostly unexplored are the striking parallels that exist between Puerto Ricans and other Afro-diasporic cultural groups of the Americas, particularly those in the non–Spanish-speaking Caribbean.

Given this narrow and dominant view of what *puertorriqueñidad* is, rap music goes beyond the confines of what has most often been defined as "Puerto Rican national culture" for various reasons. Rap is a genre that originated outside Puerto Rico[50] and that has been heavily based on Afro-diasporic traditions which are often perceived as incompatible with Puerto Rican musical tradition. It is a music strongly rooted in African American music and oral tradition, being informed by blues, jazz, funk, soul, signifyin', the dozens, scat and jive talk.[51] Jamaican sound systems,

dub poetry and reggae also have been primary sources for rap music.[52] This genre thus draws heavily from African-derived cultural traditions that not only break with the perception of an "essential" Puerto Rican Hispanicity but also transcend the borders ascribed to Puerto Rican national culture.

The 2001 Banco Popular–sponsored musical production entitled *Raíces*, dedicated to *bomba* and *plena*, has been widely criticized because of its inclusion of local rap and reggae artists like Welmo and Cultura Profética. Simultaneously broadcast through Island TV channels 2, 4, 6, 7 and 11 and in the United States through Univisión, and sold in video, DVD and CD versions, *Raíces* was truly a media extravaganza. A considerable amount of public commentary questioned the inclusion of allegedly "foreign" genres—rap and reggae—in a music special that was supposed to be dedicated to the "roots"—*bomba* and *plena*—of Puerto Rican music. Renowned composer Tite Curet Alonso praised *Raíces* for "narrating the history and development of our authentic rhythms, of Afro-Puerto Rican roots." However, he denounced the "inclusion of reggae and hip hop . . . since they are foreign genres which have nothing to do with bomba and plena."[53] In a letter to the editor published by Island daily *El Nuevo Día*, Raquel Ortiz made a similar point: "Bomba and plena are rhythms born in the island with their own spirit, so they cannot evolve or change, there can only be a fusion among them. But from there to undergoing changes and arriving at 'rap' is a way of ridiculing them, since this genre has its own root that has nothing to do with our island."[54]

As Angel Quintero Rivera has pointed out, salsa music is a genre that, like rap, also breaks with the notion that Puerto Rican national culture is circumscribed to the island's borders.[55] Salsa was born in New York and draws from diverse musical traditions, most notably from the Spanish-speaking Caribbean. However, rap's challenges to the Hispanocentric and island-bound definitions of Puerto Rican culture have proven harder to swallow, precisely because its links to African Americans and the non-Hispanic Caribbean are so pronounced.

Puerto Rican involvement in rap can be better understood through theories of culture that break with the dominant Hispanocentric and territorial mold. Paul Gilroy's exploration of a "black Atlantic" culture, although it largely ignores the Spanish-speaking Caribbean, still provides a

conceptual blueprint with which to extricate the discussion of rap from the Hispanocentric constructions that most often define the terms of the debate. Thus, instead of being posed as a "foreign" cultural product, developed by the U.S. black Other, rap can be contextualized within and related to other cultural formations in the African diaspora that includes the Spanish-speaking Caribbean. Gilroy's thesis and other theories of cultural expression as fluid transterritorial phenomena[56] are better equipped to grapple with the complexities of rap music and hip hop culture than the dominant national culture models, which disregard the cultural commonalties among African American, Puerto Rican and other Afro-diasporic cultures.

BLACK MUSIC/LATINO MUSIC

> . . . hip hop is typically labeled "Black music," thereby failing to acknowledge the Latino influence in the creation of hip-hop culture.
> —Miguel Burke, "Puerto Rico . . . Ho!!!"

Peter Manuel in his 1995 book *Caribbean Currents* includes a section on Latin rap. Considering the notions of purity that frequently guide discussions of national culture and the distaste with which rap is often regarded by Latin Americanist intellectuals, I was pleased to see the inclusion of this musical genre. Furthermore, Manuel recognizes that rap has "replaced salsa as the real voice of the barrio." However, in seeking to acknowledge the importance of rap for young Latinos, he explains that Puerto Ricans "adopted" hip hop—allegedly a cultural expression of African Americans. Manuel explains: "Among English-speaking Newyoricans in the 1980s who were growing up with ghetto blacks and *inundated* with hip-hop culture, there developed a widespread tendency to *adopt* contemporary Afro-American dress, mannerisms, and music."[57]

The rich history of African American–Puerto Rican cultural cross-fertilization is absent from this account. New York Puerto Rican hip hoppers are portrayed as having been "inundated" by this "Afro-American" culture, when in fact they were the willful, skillful and enthusiastic co-originators of it.

Manuel is far from the only one who has suggested that Latino hip hop artists and audiences are somehow participating in a cultural expression of the ethno-racial Other. George Lipsitz describes both New York Puerto Rican *bugalú* and hip hop artists as "devotees of African-American culture" who by displaying a "strategic anti-essentialism . . . bring to the surface important aspects of who they are by playing at something they are not."[58] In this manner, Lipsitz draws parallels among these Puerto Rican artists, the Mardi Gras black participants who dress up as "Indians" and Chicano punk rockers. Although the concept of "strategic anti-essentialisms" is potentially illuminating, the leveling of the practices of all three groups as "disguises" through which they play "at something they are not" disregards some crucial distinctions. Is there not a substantial difference between Chicano punk rockers who participate in a realm of cultural expression that started among young people in Britain and the New York Puerto Rican hip hoppers whose contributions and participation have made hip hop culture what it is? How can hip hop possibly be described as a "disguise" for the New York Puerto Ricans for whom it is a vernacular cultural realm?

Percussionist Johnny Almendra shares with Manuel and Lipsitz the idea of hip hop being the product of the non–Puerto Rican Other that Puerto Ricans have "adopted." But unlike the latter, Almendra attaches a negative connotation to the phenomenon: " . . . we're losing a lot of the kids to Hip Hop, because a lot of them don't speak Spanish. . . . These kids are being influenced by other musics, so was I, but I chose to listen to *my* music. And I listened to Elvis Presley, too, but something was calling me."[59]

Sergio George, a well-known Puerto Rican musician and producer, shares Manuel's and Almendra's assumption that hip hop is a foreign or outside influence on Latino youths. George, who grew up in East Harlem, recalls that before he got into Latino music—Willie Colón, Héctor Lavoe, Fania All Stars—he was "strictly into black music." In response to journalist Jorge Cano-Moreno's question regarding his perception, as a black Latino (meaning a dark-skinned Latino of African descent), of the possibility of Latino participation in "black music," George answered: " . . . I have decided to stick to my *own people* and use the influences I like from black music. . . . I feel I have to stick with *my*

people and by that I just don't mean Puerto Ricans that includes Domini-cans, Cubans, Colombians; it has to include all Latinos. We all share the same kind of struggles and hopes."[60]

George does not suggest that Latinos have no business doing African American ("black") music. On the contrary, he mentions rhythm-and-blues and even hip hop as some of his largest musical influences. What George does accept is the dichotomy between Latino and African Amer-ican music that pronounces hip hop as African American. This di-chotomy reaches beyond musical categories to the realm of lived relations, manifesting itself in definitions of community and political sol-idarities. He has opted to deal with these rifts between African Ameri-cans and Latinos by sticking with those he defines as his people, namely Latinos.

Manuel, Lipsitz, Almendra and George all share the assumption that hip hop is African American (Black) music—although they diverge in terms of the judgment attached to it. And although Latinos may enjoy and be influenced by this Black music, it is to them the music of the ethno-racial Other.

Hip hop culture, as a site of internal movement and contentions, has at times challenged and at other times supported these limiting under-standings of history and culture that slight the richness and complexity of the African diaspora. Although hip hop artistic expressions—save, ar-guably, for graffiti—in practice have been fundamentally Afro-diasporic cultural forms, their internal dynamics still have been affected by narrow understandings of blackness that result in the marginalization (sometimes in theory, sometimes in practice) of Puerto Ricans and other Caribbean Latinos.

Puerto Ricans are deemed Latinos—a category based on the shared history, culture and language of the territories colonized by Spain. But the history of Puerto Rican migration and racialization in New York sets this group apart from the rest of Latino immigrants and brings them closer to African Americans. African Americans and Puerto Ricans are New York's quintessential resident minorities. Certain historical factors pull Puerto Ricans into the dominant *latinidad* narrative—Spanish language, Catholicism and other cultural factors deriving from a history of Spanish colonization—but others seem to draw them closer to African Americans

and toward blackness—African influence in Puerto Rican culture, English language use among most members of the second and subsequent generations, citizenship, residential segregation, labor marginality, poverty, negative symbolic capital and public image.

The following chapters describe how these forces that pull Puerto Ricans in seemingly opposite directions have manifested themselves in a particular cultural phenomenon, namely the musical aspect of hip hop culture. What follows is an exploration of how New York Puerto Rican youths have articulated and negotiated their identities and cultural expressions within the hip hop zone by navigating between *latinidad* and blackness.

PART I

A HISTORICAL NARRATIVE

CHAPTER 3

"IT'S JUST BEGUN"
The 1970s and Early 1980s

It was sometime in the early 1970s. Ray Abrahante, a golden-skinned, freckle-faced Puerto Rican boy with a big afro, was riding around the Bronx on his banana seat bicycle. He saw a chubby black kid, a little older than himself, writing his tag up on a bridge. Ray stopped to talk to him and they immediately clicked; tagging was a passion for both.

The year before that, Ray had become a member of the kids' division of the Puerto Rican gang Savage Skulls. But he wasn't wearing his colors that day, and his being with the Savage Skulls didn't come up in the conversation. The other boy was a member of one of the Savage Skulls' rival gangs, the Black Spades, who were predominantly African American. But he wasn't wearing his colors that day either.

The next time they saw each other, however, their ethnic-based gang allegiances came up. Ray was passing by the Bronx River Houses as the other kid was hanging out in front with a bunch of other guys Ray knew to be Black Spades. Ray waved. The other kid waved back. Then Ray tauntingly gave them the finger as he started pedaling away at full speed. They threw rocks and bottles at him, but he was lucky enough to escape without a scratch.

Ray later found out that the chubby black kid's name was Afrika Bambaataa and that he was throwing a jam at the Bronx River Houses. Ray

wanted to go, but he was a little afraid, because of the finger incident. But he went anyway, with his mostly Puerto Rican crew, SMD (Sound Master Disco), for which he was a DJ. To Ray's surprise, gang rivalries were left to the side that night and they had a great time.

Little did Ray imagine then that Afrika Bambaataa would become internationally known years later as the godfather of hip hop or that those early jams at the Bronx River Houses in the South Bronx signaled the decline of intense gang-related conflicts in the city as well as the beginning of one of the most vibrant and popular forms of musical expression of the late twentieth century. Nowadays Ray is a veteran graffiti writer known as BOM5 and member of the Rock Steady Crew.

THE SOUTH BOOGIE DOWN BRONX

By the 1970s, the South Bronx was internationally known as the model of urban blight in the United States. The world watched in a mix of horror and fascination as a large proportion of the South Bronx's physical structures burned and crumbled. This area was said to be "the most famous slum in America," "the dark side of hell," the "international symbol of urban decay and devastation," "home of the poorest of the poor," "a disaster area," "like the bombed-out cities of Europe after World War II."[1]

In typical blame-the-victim fashion, responsibility was placed squarely on the shoulders of South Bronx residents. They were accused of being lazy, wild and violent. But in reality, it was capitalist urban development ventures, greedy slumlords looking to make a quick buck and discriminatory government policies that were most directly responsible.[2] It was during this period of Bronx history that hip hop, as we know it, was born.

The South Bronx is widely recognized in accounts of hip hop's history as the place where the art forms (or "elements") that make up the expressive foundation of hip hop—DJing, MCing or rhyming, breaking (b-boying/b-girling) and graffiti—first came together during the course of the 1970s. Afrika Bambaataa credits a DJ known as Lovebug Starski with the origination of the term "hip hop."[3] But the creative impulses behind hip hop and the actual practices themselves were not exclusive to the South Bronx. Young people in other city neighborhoods participated in expres-

sive phenomena related to what eventually became known as hip hop culture, at times unaware that these expressions were not confined to the borders of their immediate community. For example, Lee Quiñones, a famous Puerto Rican graffiti artist who grew up in Manhattan's Lower East Side, says that around 1974 he was still unaware that the park jams featuring MCs and DJs were not exclusive to his neighborhood. Back then he also did not realize that the media-propelled stereotypes of the South Bronx as a wasteland were not quite true: "I had no idea they were doing that shit in The Bronx and Spanish Harlem. I thought The Bronx was a place where trains were laid up and people were going nuts, you know?"[4]

Hip hop culture's main expressive elements, however, were not developed by the same people at the same time, nor do they all share common antecedents. Early forms of graffiti were being practiced in New York years before they converged with what later became known as the other hip hop art forms. Some graffiti writers—particularly white artists—did not and still do not see their art as connected to hip hop. The art of DJing has direct antecedents in Jamaican sound systems, while hip hop's dance element draws from a multitude of sources, including the Brooklyn-based combat dance called rocking and West Coast dance styles like popping and locking. Vee Bravo, senior editor of the now-defunct but highly influential *Stress* magazine, is emphatic in his objection to what he terms the "romanticized Big Bang theory" of hip hop where the "Holy Trinity" of hip hop music, dancing and visual art suddenly came to life in the South Bronx. Still, being careful not to fall into the "Big Bang theory" trap, we can trace hip hop as hip hop to the South Bronx.

Puerto Ricans made up the largest ethno-racial group in the South Bronx at the time.[5] Together with African Americans and other Caribbean people, they accounted for an overwhelming proportion of the population in this impoverished Bronx area in 1970. Consistent with these groups' class standing, hip hop was largely created by poor and working-class youth. It began as a "ghetto" phenomenon.

As is the case of any other culture, hip hop was intimately related to the socioeconomic and political realities of the time. The social conditions and economic prospects for young people living in poor urban communities during the 1960s and 1970s were appalling. African Americans and Puerto Ricans living in New York, in particular, shared similar

conditions and, quite often, the same workplaces and dilapidated neighborhoods, and were served by the same decaying schools and hospitals. As Bronx DJ, producer and MC KMX-Assault explains of Blacks and Puerto Ricans in New York during the 1960s and 1970s: "You lived next door; you shared the same cockroaches."[6]

Government "urban renewal" projects of the 1960s and early 1970s, including the construction of the Cross-Bronx Expressway, resulted in the dislocation of communities of color in the South Bronx.[7] Although there was a substantial Jewish population in these neighborhoods, Black and Puerto Rican residents were disproportionately affected by the construction of the expressway. To top things off, this was an expressway whose purpose was to make commuting easier for suburban residents, not to improve the quality of life in the inner city.

The South Bronx during these two decades saw an unprecedented flight of jobs and residents and a great decrease in housing options. In the decade beginning in 1970, the South Bronx lost 27,763 housing units, the equivalent of 10.5 percent of the total housing available. Certain health areas of the south-central Bronx actually lost 80 percent of both housing units and population.[8] The demographic composition of the area also changed radically. During that same decade, 87 percent of the white population moved. In 1970, 20.2 percent of the population was white, 33.9 percent Black and 35.1 percent Hispanic; by 1980, 91 percent of the population was Black and Hispanic.[9]

The plight of the South Bronx was connected to economic changes at both city and global levels. New York as a whole experienced a serious economic downturn in the 1960s and 1970s. This downturn was tightly linked to the shifting position of New York—and other U.S. cities—with respect to the global economy.[10] Historically a manufacturing center, the New York economy was turning more toward the financial and service sectors. The ensuing loss of manufacturing jobs had the most intense effect among African Americans and Puerto Ricans, whose livelihood depended heavily on industry. Puerto Ricans were even more dramatically affected since, unlike African Americans, their loss of industrial jobs was not offset by opportunities in service and clerical occupations, nor in the public sector.

As living conditions in the city deteriorated, there was growing middle-class flight toward the suburbs. As the primarily white middle class

left, the city's tax base suffered a severe setback. To compound the situation, these new suburbanites became commuters, keeping their jobs in the city and thus not opening up these positions for city residents. Between 1945 and the 1970s, New York City's white population decreased by 25 percent. Blacks and Puerto Ricans made up 33 percent of the city population by 1970.[11]

These changes for the worse in economic and social conditions in New York City had the greatest impact on people of color. Blacks and Latinos disproportionately occupied the bottom fifth of the income scale in the period 1978 to 1986. The proportion of households living at or below the poverty level during the same period was 40 percent for Puerto Ricans (30 percent for Hispanics) and 25 percent for African Americans.[12]

Tricia Rose in *Black Noise* explains that "early Puerto Rican, Afro-Caribbean and black American hip hop artists transformed obsolete vocational skills from marginal occupations into the raw materials for creativity and resistance." Graffiti writer Futura 2000, for example, attended a trade school that specialized in the printing industry. He wound up working at McDonald's after graduation, however, since much of the work he had been trained to do could be performed by computers. One of the "pioneer" hip hop DJs, Grandmaster Flash, applied the skills learned through training as an electrician to his musical craft, giving rise to developments such as homemade mixers that better served the needs of hip hop DJs and the "beat box," a precursor of the drum machine later used in rap records.[13]

Hip hop culture was born out of material deprivation, in the midst of dwindling income, educational access and job opportunities. Marshall Berman actually argues that hip hop perhaps did not arise *despite* these conditions but *because* of them: "Even in its greatest misery and anguish—and in some sense, I think, *because of* its misery and anguish—the Bronx became more culturally creative than it had ever been in its life. As a Bronx character in Grace Paley's short story "Somewhere Else" put it, 'The block is burning down on one side of the street, and the kids are trying to build something on the other.' In the midst of dying, it was busy being reborn."[14]

DJs, MCs, b-boys, b-girls and graffiti writers unleashed their "oppressed creativity"—as Pee Wee Dance, former member of the Rock

Steady Crew, calls it in DJ Tony Touch's *Tape #45*—extracting joy, beauty, music and poetry out of urban decay. They constructed a booming sound-scape out of old records and beat-up turntables; they converted drab sub-way cars into vibrant masterpieces that loudly testified to their skill and ingenuity; they made nimble bodies and quick tongues into tools for cultural construction.

Nelson George in his book *Hip Hop America* contrasts the mass media portrayals of the Bronx as a cultural wasteland in popular films such as *The Warriors* and *Fort Apache: The Bronx* with the vibrant creative scene that was actually the South Bronx in the 1970s. Contrary to these films, *Wild Style,* a low-budget 1982 production that was the first to document hip hop, actually concentrates on celebrating the beauty and energy of South Bronx youth culture. The film takes a critical stance regarding socioeconomic conditions, neither demonizing nor romanticizing the area and its residents. It was filmed on location in the South Bronx and featured key hip hop artists of the time—many of them Puerto Rican—who played roles very close to their own lives.

Fab Five Freddy, an African American graffiti artist from Bedford-Stuyvesant, Brooklyn, who portrayed Phade, a graffiti writer turned shady hip hop promoter, and who was also the film's associate producer and musical director, says regarding film portrayals of the South Bronx: "in the movie Fort Apache every Black or Puerto Rican person was either a pimp, a hustler or a criminal. We wanted to show there's a lot more happening in the Bronx."[15]

A particularly striking sequence from *Wild Style* has one of the film's main characters, a Puerto Rican graffiti artist named Ray—played by aerosol artist Lee Quiñones—riding alone in a train car whose walls are covered with graffiti. Ray had earlier told Phade that he needed to take a train ride to seek ideas and inspiration for his next graffiti piece. As Ray pensively stares out a window, the camera captures the empty lots, rubble, garbage and abandoned buildings that stand alongside the train's path. A song entitled "South Bronx Subway Rap" by the Cold Crush Brothers' Grandmaster Caz is heard in the background, asking the listener to look beyond the neighborhood's ruins, crime and pollution. Although a "living hell" for many, Caz reclaims the South Bronx "where I dwell" as a place for hope and opportunity.

The South Bronx landscape may have been in great part harsh, barren and burned; but for Ray and his peers, it was also the physical context for inspiration and creative energy. *Wild Style* compellingly documents how through graffiti, music and dance, young people in the South Bronx transformed that landscape "making things look all beautiful," as one of the movie's characters says.

Urban poverty was most definitely one feature of the environment where hip hop culture was developed. But it was only one of many aspects of that environment. Hip hop was not merely a response to poverty. The music the DJs chose to play, the moves displayed by b-boys and b-girls, the colors and designs that writers were spray-painting on the trains and the clothes they all wore—hip hop was influenced by and a response to pop culture and ethnic-based traditions. It was also about defining what was cool, fun and beautiful, about developing group identity and collective aesthetics and about attracting the attention of potential romantic partners.

As summed up amid laughter and nostalgia during an animated lecture/dialogue led by the Rock Stedy Crew's Jorge "PopMaster Fabel" Pabón[16] at the Brooklyn Museum of Art during its "Hip Hop Nation: Roots, Rhymes & Rage" exhibit in 2000:

> *Fabel:* They [hip hop artists] did it for the love of it, reputation, challenge,
> the competition . . .
> Male voice from the audience: Girls!
> *Fabel:* . . . girls, which is true . . .
> Female voice from the audience: Boys!
> *Fabel:* . . . and boys, I guess, if you were a b-girl. It's a reality.

BREAK-BEATS AND THE MEANINGS OF BLACKNESS

Jimmy Castor's 1972 song "It's Just Begun" is a perfect point of departure in exploring Puerto Rican musical participation in hip hop. Castor, a well-known African American musician, had been an important figure in the Latin soul genre heavily cultivated by Puerto Ricans and African Americans in the 1960s. His music also was central in the early years of

hip hop, particularly the timbales-heavy "It's Just Begun," which has become one of the early break-beat classics. It was because of songs like this one—along with James Brown's "Give It Up or Turn It Loose," "Get Up, Get into It, Get Involved," and "Sex Machine"; the Incredible Bongo Band's "Apache"; and Rufus Thomas's "Do the Funky Penguin"—and the fact that they became known as break-beat music that the dance style that developed to its rhythms was called breaking and the dancers became known as b-boys and b-girls. Initially just called "burning" or "going off," an influential Jamaican-born DJ from the Bronx known as Kool Herc is credited with giving the dance element of hip hop its name.[17]

Break-beat music provided an antidote to the perceived rhythmic blandness of disco, where the percussive break either was just one more element in the song or was masked or even altogether eliminated.[18] On the contrary, break-beat music foregrounded the rhythm. Most disc jockeys at the time weaved one disco song into the next. But the Bronx DJs at the forefront of the early development of hip hop sounds—among them Kool DJ Herc, Grandmaster Flash and Afrika Bambaataa—relied more on hard funk records and emphasized the breaks of the songs, meaning the point in a song when the rhythmic patterns created by the instruments are emphasized over the melodic and harmonic components.

Using two turntables and two copies of the same record, these DJs extended the breaks of songs and actually made them the tune's main feature. The breaks used ranged from the funk drumming of James Brown records, to the timbales of Jimmy Castor's songs, to the drum introductions of rock groups like the Rolling Stones.

Kool DJ Herc, a Jamaican who came to New York in 1967 as a twelve-year-old, is credited with popularizing the use of powerful Jamaican sound systems and toasting. Toasting is one of the precursors of MCing and consists of speaking and rhyming in witty and syncopated ways over records. Afrika Bambaataa became well known for parties where he would throw together all kinds of funky crowd-pleasers, from Jimmy Castor to James Brown, as well as unexpected sounds that included Japanese electronic music, the Rolling Stones, Beethoven and Malcolm X speeches. Grandmaster Flash—born in Barbados in 1958—is credited with developing several DJing techniques, among them the "backspin,"

where a record is quickly spun backward on the groove so that a certain phrase may be repeated.

Kool DJ Herc, the man known today as the godfather of hip hop—a title also attributed to Afrika Bambaataa—began DJing in 1973 and found out early in his career that playing "Latin-tinged funk" moved the crowd much better than the reggae beats he started out with.[19] This is not to say that early hip hop audiences openly embraced "Latin" music—a Latin tinge was one thing; straight-up Latin music was something else.

Bambaataa recalls that many in his mostly African American and Puerto Rican audience claimed to like neither Latin music nor rock. He used to get a kick out of making dancers groove to the music they claimed to dislike. He would throw on only the break part, and "you'd see the blacks and the Spanish [Latinos] just *throwing* down, dancing crazy."[20] Confronted with the fact that they just danced their hearts out to music they were supposedly not into, partygoers used to react either with surprise or just plain disbelief.

DJ Charlie Chase of the Cold Crush Brothers was one of the first famed Puerto Rican hip hop DJs. He began spinning records later than Kool Herc and Bambaataa, during the late 1970s. Like Bambaataa, he also talks of sneaking in Latin music at jams. He used to slip in elements like funky bass lines from Bobby Valentín and other Latino artists, concealing them just enough so that people could inadvertently enjoy them and not walk off the dance floor.[21]

The experiences of these DJs illustrate how, even though the early hip hop participants belonged to different ethno-racial groups—mostly African American, West Indian and Puerto Rican—their point of musical convergence was funk-based. David Toop in *The Rap Attack* points out that although reggae and salsa have been important influences in the development of hip hop, they have been "plundered but rarely met on [their] own terms."[22] The early hip hop sounds were known for their incorporation of diverse musical influences, among them were reggae and "Latin" music. These, however, were thought of as additions to the core: funk.

DJs like Bambaataa may have been particularly innovative and may have incorporated a variety of sources into the music they were spinning. However, there was still an African American–identified musical base from which additions and innovations could take place, namely funk.

African American, Puerto Rican and other Caribbean youths were not converging on just any musical style; funk was recognized as a black musical style. And, despite its heavy Caribbean influences, funk's blackness was very narrowly defined and was restricted to African Americans. Hip hop, an heir to the funk tradition, also became identified with this narrow view of blackness. Although Caribbeans—Puerto Ricans included—and African Americans were equally invested as hip hop participants, and despite their intersecting cultural histories, hip hop often was perceived to be lodged within an exclusively African American matrix.

"MORENOS"[23] AND "PORTO ROCKS"[24]

Hip hop began as an ethno-racially inclusive sphere of cultural production, where various Afro-diasporic groups interacted side by side. Davey D, who grew up in the South Bronx, explains from his popular website *Davey D's Hip Hop Corner:* "Hip Hop was multi-cultural in the sense that it was Blacks and Puerto Ricans who put this whole thing down. We lived next to each other and for the most part experienced the same urban problems. We also shared the same culture legacy of exploitation, oppression and colonization."[25]

The recollections of poet and recording artist Sekou Sundiata of growing up in East Harlem in the 1960s could very well be describing the social and cultural interaction of African Americans and Puerto Ricans during the 1970s—not only in East Harlem, but in other city neighborhoods like the South Bronx, Williamsburg and the Lower East Side: "Yeah, there were turf battles, bloodshed even. But the strongest move was unity. We dated each other, ate in each other's kitchens, wore the same gear, had the same local heroes, spoke the same hip language of the barrio in the neighborhood, understood in diverse flavors the philosophy of the cool & what it had to do with survival."[26]

During hip hop's formative years, "the strongest move was unity," but ethno-racial distinctions and tensions still manifested themselves. These distinctions and tensions varied depending on various factors, among them neighborhood and art form.

The participation and perceived entitlement of Puerto Ricans with respect to hip hop art forms was contingent on locality. The South Bronx

and East Harlem evidenced relatively subtle rifts among African Americans, Puerto Ricans, West Indians and participants of other Afro-diasporic groups; in these areas transethnic cultural interaction was strong. But the rifts seemed to be greater and transethnic interaction less pronounced in other neighborhoods, particularly those with greater ethnic residential segregation.

The seemingly innocuous move from the heavily multiethnic South Bronx to predominantly African American neighborhoods in Brooklyn proved to be significant for Puerto Rican DJ Ill Will (William Fratacci) of Electric Company. The South Bronx native—whom I met by chance in 1998 at Downstairs Records in Manhattan—told me he recalled no distinctions or tensions between African Americans and Puerto Ricans when it came to hip hop in the South Bronx: "We were all one race of people. We were all from the same area. Blacks and Puerto Ricans were together. Back then race was never really a problem between Blacks and Spanish."

It was in Brooklyn that he was first made to feel that Puerto Ricans were a separate group within the hip hop realm. His DJ ability was first questioned—based on his Puerto Ricanness and the assumption that Puerto Ricans were not good hip hop DJs—when he started spinning at parties there. The South Bronx, on the contrary, seems to have been one of the most active spots of joint cultural activity between African Americans and Puerto Ricans; there the latter had less explaining to do regarding their "belonging" or "entitlement" to hip hop.

As I mentioned previously, the perceived entitlement of Puerto Ricans to hip hop also depended on the art form. Whereas graffiti and breaking were largely taken to be multiethnic inner-city forms, MCing and DJing—although widely practiced by various Afro-diasporic ethnic groups—were identified more with one group, namely African Americans. While Puerto Ricans were, for the most part, welcome and active participants in hip hop, even during these early times, they had to step lightly on hip hop's cultural ground, particularly when it came to MCing and DJing. They were largely considered partners in creative production, although at times the bond was reduced to a junior partnership.

Rubie Dee, one of two Puerto Rican members of the popular group the Fantastic Five, tellingly raps in a song during the movie *Wild Style* that, though he is Puerto Rican, his listeners might think he's Black "by

"The Crew," Flatbush, Brooklyn, 1983, by Jamel Shabazz.

the way I'm speaking." A Puerto Rican raised in New York City, Rubie Dee speaks and rhymes like most other New York Puerto Ricans of the second and third generations: in a "Puerto Rican English" similar to or virtually indistinguishable from the African American English of their peers.[27] Nevertheless, Rubie's speech patterns, particularly within the context of what was often perceived as an African American lyrical/musical style, perhaps seemed to warrant an explanation.

DJs like Ill Will and Charlie Chase, of the Cold Crush Brothers, recall the times they were showered with multiple variants of the same double-edged compliment: "You're so good! I never would have thought you were Puerto Rican." Many times "Porto Rocks" found their presence and artistic skills questioned by African Americans intent on protecting what they perceived as their physical and cultural territory.

Wondering why Boricuas were prominent as breakers and graffiti writers but not as MCs and DJs leads to one of those chicken-or-the-egg queries. Was Puerto Rican "entitlement" more limited in MCing and DJing *because of* their low degree of participation and visibility? Or was their low degree of participation and visibility *due to* their perceived lack of "entitlement" to hip hop's musical element?

Rhyming and DJing were from the beginning more ethno-racially identified with African Americans and closed to perceived outsiders by virtue of their reliance on dexterity in the English language. Thus they were most easily traceable to the African American oral tradition[28] and primarily employed music considered to be African American. Hip hop's musical dimension seems to have been premised on an Afro-diasporic urbanity, where, although the participation of young people of Caribbean ancestry was pivotal, this music was often narrowly identified solely with African Americans. A distinction must be made, however, between the experiences within the hip hop realm of West Indian Caribbeans (primarily Jamaican and Barbadian) and Latino Caribbeans (primarily Puerto Rican).

West Indians are commonly thought to stand closer to African Americanness than Latino Caribbeans do.[29] That is the case even for black Latinos. Although West Indians may be perceived as not ethnically African American, they are, as a group, thought of as racially black.[30] Furthermore, whereas West Indians can "assimilate" into African Americanness, Puerto Ricans generally "assimilate" into New York Puerto

Ricanness, also known as Nuyoricanness. Given their relative proximity to an ethno-racial African Americanness, West Indian entitlement to hip hop has not been as much of an issue as it has been for Puerto Ricans, both from insider as well as outsider perspectives.

We can draw a useful example from the comparison of DJ Kool Herc's and DJ Charlie Chase's respective experiences. In 1967, twelve-year-old Herc moved to the Bronx from Jamaica. Initially, he had a lot of trouble adjusting to his new surroundings. But soon he started spending time with two young African Americans who befriended him. "I started hanging out with them and picking up the slang. Pretty soon, I was Americanized."[31] Chase, however, although born in New York, was always a comparatively easier target for outsider status. His ethnic markings couldn't be shed through "Americanizing," particularly because his light skin color and wavy but not nappy hair texture made those markings all the more visible, branding him an outsider to African Americanness.

In a conversation with Charlie Chase, I asked him why there were not that many Puerto Rican hip hop DJs compared to African Americans. He offered two related explanations. First, he said, a lot of the records used were funk-based; thus, the music used was African American. Second, since many Puerto Ricans are bicultural, they would have had to "give up a side of themselves" to get into hip hop.

I was intrigued by his second assertion and asked him to elaborate. Chase answered that since a lot of the rapping and DJing was derived from the Jamaican toasting tradition, it is seen as a "black" thing. Chase's statements illustrate how West Indian Caribbean cultures are seen as standing comparatively closer to blackness than Puerto Rican culture. Thus, the Jamaican toasting tradition is smoothly adopted and thought of as part of African American/black culture. Puerto Rican cultural traditions, conversely, are perceived as not as easily intersecting with African American culture.

Although hip hop is a hybrid culture where Caribbean contributions have been fundamental, its Caribbean aspects often were either unrecognized or perceived as mere sprinkles of flavor within an African American matrix. This narrow African American identification was not always the up-in-your-face kind. Most often it was not overt or obvious; nor was

it constant. It was usually the subtext, the fine print, what you come up with if you read between the lines.

At times hip hop's identification as a primarily African American expression entailed questioning Puerto Rican participation. For example, Charlie Chase nearly caught a "beat down" at a jam. "What the fuck are you doing here, Puerto Rican?" was the question posed to him for crossing into what was perceived as African American territory.[32] Like Chase, Puerto Rican hip hop participants of the 1970s, particularly MCs and DJs, usually have at least one or two stories of ethno-racial tension. However, hip hop's identification as African American largely meant that the territory of cultural convergence between Caribbeans and African Americans was identified solely with the latter.

This issue of African American identification transcends hip hop; New York's urban Afro-diasporic youth culture has historically been African American–identified. Caribbean youth are presumed to "assimilate" into African American youth culture without taking into account two important factors:

1. Much of what is called African American youth culture is profoundly hybridized and some of its strongest influences are related to Caribbean cultures.
2. "Assimilation" presupposes an original culture and an assimilated one, allowing no room for the concept of reconfiguration.

These mistaken assumptions are part of what George Lipsitz criticizes as "the inadequacy of binary models of assimilation."[33] These models rely on the presumption that there are two distinct cultures that are equally accessible to immigrants; it is just a matter of choice.

In the case of Puerto Ricans, Flores argues that "as Nuyorican modes of expression come to intermingle with others and thus distinguish themselves from those of the Island legacy, it is not accurate to speak of assimilation. Rather than being subsumed and repressed, Puerto Rican culture contributes, on its own terms and as an extension of its own traditions, to a new amalgam of human expression."[34]

Second- and third-generation Puerto Ricans in New York have a distinct cultural identity that cannot be accurately described as "assimilated," not into African American culture and even less so into "mainstream"

U.S. culture. Their creative expression may often overlap with that of African Americans, but their identity is distinct from that of their African American peers, from that of first-generation Puerto Ricans, and from that of their Island Puerto Rican peers.

Cross-fertilization and hybridization, as cultural phenomena, often are lost in narratives of "assimilation." When Puerto Ricans are said to have assimilated into African American culture due to their hip hop participation, it makes it seem as if Puerto Ricans were not co-participants in hip hop's very development, as if they were latecomers who belatedly embraced hip hop. When people speak of Puerto Rican hip hop participation as assimilation or cultural loss, or even as having been "adopted" or serving as a "disguise," they are forgetting that Puerto Rican culture is embedded into hip hop's most basic fabric. What would the art of breaking be without the quintessential Nuyorican martial arts moves of rocking (uprocking)? What would break-beats be without the decades-old influence of Puerto Rican and Cuban musical traditions on African Americans? What would the early hip hop sound have been like had it not been for the dance-floor presence of Puerto Rican b-girls and b-boys?[35]

These narratives of "assimilation" frequently employ stifling notions of tradition and origins based on strict ethno-racial and/or national categories. The strength of these categories and divisions often overpower sociocultural history as well as lived reality in accounts of cultural creation. It is as if cultural expressions have to be classified as African American or Puerto Rican, and the possibility of hybrid forms—not to mention shared cultural roots—is nonexistent.

Pointing to the long history of joint cultural production between African Americans and Puerto Ricans in New York—which includes Latin jazz, doo-wop, Latin soul and hip hop—Flores remarked in Mandalit del Barco's 1991 National Public Radio documentary "Latino Rappers and Hip Hop: Que Pasa": "You see there that it's not just Latinos doing a black thing, but it's really them jamming together and coming up with something that's not the same as either of the two they started with. Something new comes out of the picture." However, that history often is swept under the rug. It seems that in terms of cultural production, it is easier to go back to a default setting where origins can be made to align with ethno-racial and/or national categories. Hybrid cultural formations,

like hip hop, threaten those categories. What ends up happening is that either African Americans claim hip hop all for themselves ("it's a Black thing, you wouldn't understand") or the older Puerto Rican generations pronounce it a product of the black Other ("*esas son cosas de morenos*"). Puzzled African Americans want to know of Puerto Ricans who participate in hip hop: "Why are you fronting like you're Black?" Puzzled Boricuas (or Latinos) ask from the margins of the hip hop zone of those inside: "Why are you denying your Puerto Ricanness?"

Most "Porto Rocks" have been challenged at some point or another by their African American peers as to why they are "trying to be down." Their parents and older relatives have also gotten on their case for being into that "jungle," "nigger" or "*moreno*" music. The presumption is that hip hop is not "theirs." A related phenomenon has been the presumption that Puerto Rican cultural entitlement to hip hop is contingent on the "Latinization" of their creative expression through the use of Spanish lyrics and music deemed genuinely "Latin."

Although musical taste and style are not strictly ethno-racially predetermined, ethno-racial groups often do gravitate around music to which they feel they have a "claim."[36] Many of the tensions and dynamics in hip hop have to do with this association between style/aesthetics/creativity and ethno-racial cultures, a point that I will argue throughout this book.

THE EARLY COMMERCIAL RAP GAME

During the spring of 1979, a funk group called Fatback released what can be considered the first commercial rap record entitled "King Tim III (Personality Jock)." It managed to get regular play in record stores and on New York's disco station WKTU. But the record's popularity was no match for the wide commercial acclaim with which the song "Rapper's Delight" was greeted a few months later.

"Rapper's Delight," released on Sugarhill Records by a group that called itself the Sugarhill Gang, signaled the commercial rise of rap, reaching number 36 on the U.S. charts and becoming the biggest-selling 12-inch record ever.[37] MCing and DJing thus began their steep rise in commercial popularity with the release of "Rapper's Delight."

The success of this group of unknowns who were hand-picked by Sugarhill Records' owner Sylvia Robinson opened the door for artists like Grandmaster Flash, the Cold Crush Brothers and Afrika Bambaataa, who were already popular in the New York park, house party and small-club circuit. The Sugarhill Gang's success also generated a fair amount of resentment among these artists who had worked hard to build an underground reputation. Says Grandmaster Flash: "They [Sugarhill Gang] got a record on the radio and that shit was haunting me because I felt we should have been the first to do it. We were the first *group* to really do this—someone took our shot. Every night I would hear this fucking record on the radio, 92KTU, 98, BLS, rock stations. I was hearing this shit in my dreams."[38]

To add insult to injury, part of the Sugarhill Gang's hit song lyrics had been written by Grandmaster Caz of the Cold Crush Brothers. Big Bank Hank, one of the Sugarhill Gang's rappers, was a bouncer at a New York City nightclub. As Grandmaster Caz tells it, when the opportunity to record with Sugarhill Records came up, Hank asked Caz if he could use his rhymes. Caz said yes, figuring that if the lyrics were a hit, Cold Crush may be the group to "get on next." But that was not the case, and Caz never did get a dime for his contribution to "Rapper's Delight." In the words of Waterbed Kev from the Fantastic Romantic Five: "Sugarhill dogged a lot of people, but they also gave hip hop the opportunity to go worldwide."[39]

Most of the artists popular during rap's first five years as a large-scale commercial product (1979 to 1984) were African Americans and some of them West Indian—like Kool Herc and Grandmaster Flash. But Puerto Ricans were far from absent. DJ Charlie Chase of the Cold Crush Brothers, the Fearless Four's[40] Devastating Tito and DJ Master OC, the Fantastic Five's Prince Whipper Whip and Rubie Dee, Prince Markie Dee Morales of the Fat Boys and the Real Roxanne were popular figures in commercial rap's early days.

Other Puerto Rican recording artists of the time included Rammelzee, the Rock Steady Crew, Brenda K. Starr, and at least one of the members of Mean Machine. Graffiti artist Rammelzee and K-Rob had a hit record in 1983 called "Beat Bop," initially released by Basquiat—the Haitian–Puerto Rican graffiti artist who later acquired downtown fame as a "visual" artist—on Tartown Records, with later wider distribution by Profile Records. Brenda K. Starr recorded "Vicious Beat," which was in-

cluded in 1984's movie *Beat Street*. The Rock Steady Crew released the single "Hey You, the Rocksteady Crew" in 1983. The Mean Machine put out "Disco Dream" in 1981; some hip hop historians say it was the first rap record with bilingual rhymes.[41]

Despite strong Puerto Rican participation, as rap traveled beyond its New York home, Puerto Rican artists' ethnicity was most often not recognized, and often they were assumed to be African Americans. Rap was, in the words of Havelock Nelson and Michael A. Gonzales, the new "Black Noize"[42] coming out of New York, and it was not always clear how Puerto Ricanness related to blackness.

Since hip hop's early 1970s beginnings, Puerto Rican participation was questioned most often regarding MCing and DJing. But rap's birth as a commercial music genre in the late 1970s led to an even more intense ethno-racialization of rap as African American. If the cultural entitlement of Puerto Ricans to rap was sometimes ambivalent in the New York context, this ambivalence was magnified in other locations, with Puerto Ricans most often landing on the wrong side of the fence.

The New York context where African Americans and Puerto Ricans are neighbors, friends, and allies has been an exception and hard to conceive of in most other U.S. cities and towns. Hip hop's initial Afro-diasporic ghetto base, which included African Americans, West Indians and Puerto Ricans, was hard to translate into highly segregated contexts with no corresponding histories of joint cultural production among these groups.

B-BOYS AND B-GIRLS IN THE MEDIA LIMELIGHT

Notions of cultural entitlement were different when it came to breaking and graffiti. These art forms came into the media limelight in the early 1980s, a few years after the first rap album was released. But most important for our purposes, they entered the realm of mass media and remained more class-identified (ghetto-identified) than African American–identified.

One of the earliest newspaper articles to feature breaking was published by New York's *Village Voice* in 1981. Sally Banes wrote of a "local

dance form that's fast, black, Spanish, down and bad"—note the inter-changeability between "Spanish" and "Puerto Rican": "The heroes of these legends are the Break Kids, the B Boys, the Puerto Rican and black teenagers who invent and endlessly elaborate this exquisite, heady blend of dancing, acrobatics, and martial spectacle. Like other forms of ghetto street culture—graffiti, verbal dueling, rapping—breaking is a public arena for the flamboyant triumph of virility, wit and skill."[43]

Two years after that article was published, breaking had become a mainstream fad. Initially developed and practiced exclusively in New York ghetto basements, sidewalks, park jams and uptown clubs, breaking eventually became popular in hip downtown New York clubs.

Phase 2, today an African American veteran spray-can artist, reminisced in a 1996 article in *Stress* magazine about the early hip hop party venues like the Dixie, Tunnel, the Shaft, Black Door and Sparkle. He fondly recounts those early times when "colored folks" were "99%" of hip hop audiences and promoters—before hip hop was taken over by "them *other folks*."[44]

Phase 2 points to 1982 as the year when hip hop started having a presence in downtown clubs. The Roxy, Club Negril, Peppermint Lounge and Danceteria were among the clubs that b-boys and b-girls began frequenting. He proceeds to bitterly recount how hip hoppers were put on display for audiences hungry for an exciting glimpse of up-town ghetto life. "'Ooh Pointdexter, observe that adolescent defying the gravitational pull of the earth's core while rotating counter clock-wise on the base of his cranium.' It was something for them folks who weren't living it, to physically experience and orgasmically feast their eyes upon."[45]

Like Phase 2, DJ Ill Will observes that the acceptance and furor over hip hop in downtown clubs had much to do with the romantization and voyeuristic fascination with the "dark" ghetto. In Phase 2's words, "Chitlins' [African Americans] and plátanos [Puerto Ricans] were in style and demand back then."

Ill Will grew pensive and a touch of bitterness crept into his voice during a conversation as he recalled some of his not-so-pleasant experiences working at the Roxy and Danceteria: "It felt like a circus or like they were

A Kangol on his head, Cazals for his eyes, and the Virgin Mary around his neck.
"True Flavor," Downtown Brooklyn, 1985, by Jamel Shabazz.

The Rock Steady Crew at the show "Graffiti Rock," Downtown Manhattan, 1981. Dancing in the center is Crazy Legs. Photo by Henry Chalfant.

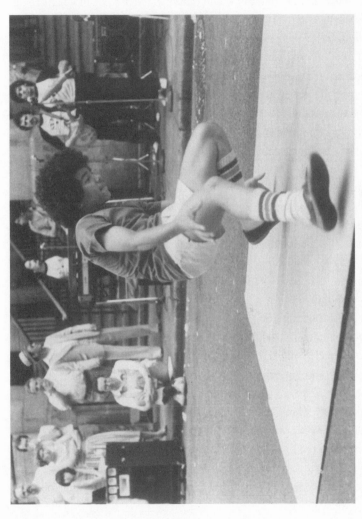

Breaking at a street fair in Downtown Manhattan, 1982, to the sounds of the band Alfa 5 (which includes a güira player!). Photo by Henry Chalfant.

looking at animals in the zoo. These people were so amazed at the simple shit we did all day long around our way. It made me aware and it made me proud that I could entertain them. But all this talent didn't mean shit. They only paid attention to me and talked to me because of what I could do on the turntables. If they didn't know who I was they wouldn't pay me no mind. I didn't like that."

Another Puerto Rican artist I spoke to, who lived through many of the same experiences, spoke bluntly of his feelings regarding the racial component of the power dynamics in the 1980s downtown hip hop scene: "I don't like white people. They tried to jerk us back in the day. And even here [where he works and our conversation took place] . . . You heard that guy asking me for [something] before? They talk to me like I'm stupid."

It did not take long before so-called breakdance fever spread nationally and internationally. Syndicated dance shows like *Dance Fever* and *Solid Gold* incorporated "breakdancers" in their programming. Burger King, Panasonic, Coca-Cola and Pepsi, among many others, made commercials that featured breaking.[46] Movies like *Wild Style* (1982), *Style Wars* (1984), *Beat Street* (1984), *Breakin'* (1984), *Breakin' II: Electric Boogaloo* (1984) and *Flashdance* (1984) were key in its national and international popularization.

With the barrage of media attention it received, even terminology started changing. "Breakdancing" became the catch-all term to describe what originally had been referred to as "burning," "going off," "breaking," "b-boying" and "b-girling." Dance styles that originated in the West Coast, such as popping and locking, were also grouped under the term "breakdance." Many dancers today, among them Rock Steady Crew members, say they prefer not to use that term. Even though many of hip hop's pioneers accepted the term for a while during the 1980s, they have since reclaimed the original terminology and rejected "breakdance" as a media-fabricated word that symbolizes the bastardization and co-optation of the art form.

As mentioned by Phase 2 and Ill Will, a large part of the national and international public's fascination with breaking had to do with its "ghetto" or "street" roots. The class origins of the dance form were constantly emphasized. Meanwhile, the ethnicity/race of its creators and performers— although a basic ingredient of breaking's ghetto mystique—remained

either unspoken or downplayed. Most coverage of the art form did not follow Sally Banes's straight-up description of its class and ethno-racial origins. "Ghetto" and "street" actually became coded references to race and ethnicity.

Dave Tompkins, in a 1996 *Rap Pages* issue dedicated to hip hop's dance element, wrote a scathing article blasting Hollywood's feeding frenzy over breaking. Entitled "Hollywood Shuffle," the piece examines this early aspect of "Hip-Hop exploitation history" and criticizes its contrived, watered-down approach to hip hop creativity. Concentrating his comments on the movies *Beat Street* and *Breakin'*,[47] he notes regarding the latter: "the dichotomy between White (Holly-would-they-not) and Hip Hop is evident in the mealy-mouthed glossed references to Latinos and Blacks as 'street kids.' In Special K's best condescending, Saturday-morning-with-Mom-with-the-Sunny-D Voice: 'Those street kids have more heart and soul . . .'"

The end of her line is: "than any dancer I know." Special K (Kelly) is the central figure, the white dancer-with-formal-training-and-with-a-heart-of-gold; it is through her that "street dance" is legitimized. Legitimization, in this case, equals recognition outside ghetto borders, especially by the professional dance world. Kelly embodies goodness and truth. She chastises the elitist "phony stuffed shirts" who dismiss street dance; she also sees through fellow dancer Ozone's (Orlando) street-macho cool pose that disguises his fears and insecurities. She is drawn to the passion and dedication of breakers and serves as their translator to the outside world.

The formula is an old one: White "missionary"—nun, doctor, teacher, cop, social worker, dancer—with great insights and good intentions tries, not always successfully, to save the nonwhite ghetto inhabitants.[48] Kelly the missionary thus defends the "innocence," creativity and passion of the African American and Latino youthful ghetto dwellers.

The same "mealy-mouthed" approach to the race and ethnicity of breakers is taken in *Dance Magazine*'s April 1984 "break dance" special. Not once do the four articles devoted to the art form mention race or ethnicity, instead disguising these through references to "street" and "ghetto." Particularly striking is the article on the Furious Rockers by Dan Cox. This article, which claims to explore "break dance roots in a breakneck

neighborhood" and whose subject is a Puerto Rican crew from a Puerto Rican neighborhood (Williamsburg, Brooklyn), manages to avoid even the slightest mention of ethnicity or race.

In the same *Dance Magazine* issue, breaking is enthusiastically described as "exciting," "disturbing," "vibrant, macho street dances"; "the most dynamic, gritty, visually exciting dance around today"; a dance form where people "can use their kinesthetic sense and not worry about the 'right' movements" and that "grows out of people's natural movement"; a ghetto form that can be practiced in the safety of the studio and where "Connecticut housewives" can get a vicarious sense of pleasure by "flinging their arms and saying, 'We bad.'"[49] The reference to Connecticut housewives is a loaded and coded reference to female white middle-class status, meant to stand in contrast to breaking's celebrated male ghetto nonwhiteness. Connecticut housewives are billed as the epitome of softness; breakers are deemed to be the exact opposite. And that's where breaking's excitement as commercial product lay.

Breaking has not been a male-exclusive domain. B-girls like Mamma Maribel, Sunkist Evie, Bunny Lee, Headspin Janet, Lady Doze and Baby Love left their mark on the dance form. Nevertheless, b-girls always have been overwhelmingly outnumbered. Adopting breaking's street warrior aesthetic was undoubtedly unappealing to many young women, who preferred to participate as spectators and engage in more "ladylike" behavior. But those for whom breaking was a passion found it extremely hard to be considered worthy competitive partners or rivals by their male counterparts. B-girls have had to struggle hard against an exclusion premised on rigid notions of masculinity and femininity.[50] Breaking's male dominance is not hip hop or ghetto-specific, but an extension of our society's general patriarchal norms.

The mass marketing of hip hop has had much to do with the exotization of dark ghetto "virility" as a temporary distraction from "white" suburban monotony.[51] The ways in which breaking tended to be described ("natural," "instinctive," "vibrant," "gritty," "dynamic," "exciting") bring to mind cliché exotizations of the ghetto—particularly the "black" ghetto—as primeval, exciting, dangerous, mysterious and cool. Breaking's magic resided in its purported primitive simplicity.

Dance Magazine's Margaret Pierpont, in the article "Breaking in the Studio," explains that "ordinary people" don't have to worry about the

"right" positions, they just have to follow their "kinesthetic sense," since breaking "grows out of people's natural movement." Pierpont never explains how spinning on your head or freezing into implausible-looking positions is somehow closer to human "natural movement" and "kinesthetic sense" than other dance forms. It sounds as if, in her haste to romanticize the form, she is undermining the artistic complexity, technical difficulty and specificity of breaking. Guillermo Gómez-Peña's thoughts regarding Latino artistic production in general can be applied to the role exoticism played in the commercialization of breaking: "our art is described as 'colorful,' 'passionate,' 'mysterious,' 'exuberant,' 'baroque,' etc., all euphemistic terms for irrationalism and primitivism."[52]

Breaking's commercial dark ghetto mystique was not ethno-racially circumscribed to African Americans in the manner that rap was. Puerto Ricans were deemed entitled participants and commercially packaged as the exotic dark Other. Whereas Puerto Rican DJs and MCs often were assumed to be African Americans or, if their ethnicity was known, had their artistic skill and cultural entitlement questioned, ethnicity was not as much of an issue for Puerto Ricans in breaking. They did not have to justify themselves as Puerto Ricans doing a "Black thing" or subsume their Puerto Ricanness under Blackness.

Breaking was not seen as narrowly articulating specifically African American traditions, identity and concerns. It was visibly nourished by Caribbean Latino dance forms such as rumba, mambo, the Latin hustle and rocking. Furthermore, Puerto Ricans had been and were still key in the development of the b-boy/b-girl dance style; most of the better-known breaking crews (Rock Steady Crew, the Furious Rockers, Dynamic Rockers, New York City Breakers) were primarily Puerto Rican.[53] All of these factors made it less tenable for Boricuas to be left out of the equation in breaking.

Perhaps another reason why breaking was not narrowly identified as African American may have been related to its short-lived existence as a mainstream media darling. Had breaking remained as sustainedly profitable as rap turned out to be, ethno-racial divisions may have been created to maximize profits through the marketing and romanticizing of the familiar ghetto African American "Baadman"[54] image.

As a national and international commercial product, breaking's Puerto Ricanness—although not denied—was not made into a big deal either.

However, back in the New York City neighborhoods where the dance form developed, breaking's commercial success was closely associated with Puerto Ricans and initially even boosted their status within the local youth culture. DJ G-Bo the Pro, who was then a teenage East Harlem resident, recalled during a conversation we had at the Manhattan studio he shared with another East Harlem–raised Puerto Rican DJ, Double R: "Remember *Beat Street,* all those movies? Yo, that was the hottest time to be Puerto Rican. I swear to God. Who did not wanna be Puerto Rican around that time? It was very cool to be Puerto Rican. Because it was that time. Dancing was the center of hip hop. It wasn't even so much the rap, it was the dance. You could get into a movie if you knew how to dance, if you were that hot."

But after a few years of heavy media exposure, young New Yorkers' perceptions started changing. G-Bo explains: "Breakdancing got corny. I mean, I don't wanna say it like that. But it wasn't cool no more. They were selling fucking linoleum on tv and [saying] 'you can do backspins on this!' They were selling things on t.v. and it got reaaaal corny. You know, Michael Jackson doing the moonwalk and all that. The secret was out. *It didn't belong to us any more.*"

By 1985, "most kids had STOPPED BREAKING and my Hip-Hop heart was broken," says Peruvian-born and New York–raised Cristina Verán, guest editor of *Rap Pages'* 1996 dance edition. Verán, during the 1980s an MC known as Dulce Love and a member of the Devastating Ladies, had to halt plans to conduct a "breakumentary" for the scene had gone from vibrant to deserted in the span of one year. She explains the decline of hip hop as the effect of overexposure and the media's watering down of the form: "'Breakdancing: The Fad' ultimately turned into a roller-coaster ride careening out of control—from fast food and candy commercials to 'you too can breakdance' videos geared to suburban mall junkies. Sacred traditions became trendified, and, like the dope fiend's ultimate junk high, they crashed just as quickly and just as hard."[55]

After breaking and graffiti had their time in the commercial limelight during the early to mid-1980s, these art forms faded into mainstream hip hop's background. Often they were perceived as "played out," pariahs within the hip hop culture that they had been intrinsic to. From time to time they have resurfaced as complementary to rap music in shows, videos

and magazines. Breaking actually made somewhat of a "comeback" in the media during the late 1990s.[56] But for the most part, after the breaking and graffiti craze of the first half of the 1980s, these art forms—as profitable commercial products—have been relegated to history, even though they still are actively cultivated in many circles.

Breaking is still passed on from generation to generation in New York nightclubs, schools, community centers and parties. Annual gatherings like the Rock Steady Crew and Zulu Nation anniversaries also promote the dance form. To take just one example, The Point, a hub of activism and arts geared toward young people in the South Bronx, has for years offered breaking workshops and classes. The Full Circle crew and Crazy Legs of Rock Steady have offered classes at the Point. Crazy Legs also has used its theater space as the locale for Breakbeats, a popular gathering of breakers held every few months.

Puerto Rican b-girl Daisy "Baby Love" Castro, one of the Rock Steady Crew's leading women during the 1980s, was prophetic in anticipating what eventually would happen to breaking: "It's gonna last in the hearts of the kids who've been doing it for a long time. . . . It's gonna go right back to the streets. I think it belongs there. It belongs in people's hearts. . . . It's gonna stay here but not everybody is gonna keep on making money out of it."[57]

With the passage of time, hip hop culture became increasingly identified with the more commercialized branches of rap music. Given that hip hop culture started being perceived as practically synonymous with rap music, and that rap is the aspect of hip hop in which Puerto Ricans have had comparatively less media visibility, perceived skill and cultural entitlement, it is not surprising that hip hop was reimagined leaving Puerto Ricans out of the picture. Stripped of history and context, hip hop became "a Black thing you wouldn't understand"—as stated in the ubiquitous late-1980s phrase that was not only on many a lip but also printed and flaunted on T-shirts, baseball caps and stickers. Hip hop's ties to the Afro-diasporic urban vernacular culture that originated it had been distorted and sometimes altogether severed. "The secret was out," as DJ G-Bo the Pro says, and nothing would ever be the same.

CHAPTER 4

WHOSE HIP HOP?
The Late 1980s and Early 1990s

After breaking and graffiti crash-landed in terms of commercial popularity around 1985 following their brief but dramatic media-propelled flight, hip hop became synonymous with the one art form that had from its inception been most intensely identified with African Americans, namely rap. Subsequent creative developments and mass marketing strategies—which did not operate independently of each other—further intensified this identification.

The explicit voicing of African American concerns by popular rap artists through rhymes, samples[1] and public statements was another one of the factors that contributed to the ethno-racialization of hip hop as exclusively African American.[2] In other words, the voicing of African American-identified perspectives and concerns led to the increasingly narrow identification of hip hop with this specific group.

Run DMC's "Proud to Be Black" in the 1987 album *Raising Hell*[3] is an example of rap's explicit identification with African Americans during this late 1980s period, from a group that was not particularly known for its Black nationalism or Afrocentricity. Other rap groups that were well known for their Afrocentric politics were Boogie Down Productions, Public Enemy, X-Clan, Poor Righteous Teachers and Brand Nubian.

Rap music has manifested, throughout its history, different approaches to and articulations of blackness. Explicit references to blackness in the earlier 1980s were not omnipresent. The late 1980s and the early 1990s, however, saw an explosion of Afrocentric sentiment.[4]

The ideological and aesthetic reverberations of this period are still being felt, for they set the stage for creations and transformations to follow. The "Afrocentric," "Black nationalist" or "pro-Black" school of rap had a lasting impact on the hip hop collective imagination—its faddish qualities notwith-standing.[5] These formulations of an exclusively African American agenda cloaked hip hop in an ethno-racial garb that seemed several sizes too big— or too small, depending on how one looks at it—for Puerto Ricans.

The celebration from within hip hop of African American history and culture, and the denouncing of conditions in urban ghettos, had a great impact on young Puerto Ricans. The Arsonists' Q-Unique recounted, during a conversation we had, the influence on his life of hip hop's pro-Black era and the sustained organizing efforts of the hip hop–based com-munity organization the Zulu Nation (founded and, to this day, led by Afrika Bambaataa):

> Groups like Public Enemy, KRS-ONE, X-Clan and Poor Righteous Teachers, they made me aware of the fact that I needed to know who I was as a Puerto Rican. Zulu Nation just put the icing right on the cake 'cause when I became a member in 1990 they gave me the details and the lessons that just added more to what it meant to be Puerto Rican here in Amer-ica. They showed you the little details, the little tricks of what was going on out there and lessons and ways of keeping up with what's going on out there. At the same time teaching me more about myself and religion and all types of things. That's what I learned from the Zulu Nation, a lot of things, even how to eat right. They taught us about the bad things in cer-tain foods or whatever have you . . . pork, that contained pork. Even down to like toothbrushes and hair combs that contained pork. I'm just using pork as an example. All that to me was necessary, big time, 'cause before all of that I was this little wild spic running in the streets not knowing what the fuck was going on.

I prodded him: "So you're attributing to the Zulu Nation you getting your head straight?" He answered: "Them plus a lot of hip hop music."

Louis, a New York–raised Puerto Rican teenage rap fan during rap's Afrocentric phase, recalls that when he first heard Public Enemy it was like a revelation. He says he went straight to the library to look up who was this Huey Newton (a Black Panther leader) they were talking about. That was when it really hit him that this rap group was talking about important African American historical figures and events. His first reaction to the information he was being exposed to was pride in "us black people." But then it started dawning on him that he was not exactly black, given the way blackness was being formulated by African American artists. That blackness was not inclusive of his side of the Caribbean because it did not fully acknowledge the cultural diversity and hybridity of the African diaspora in the Americas. Louis realized that he and "his people" were not quite part of the history Public Enemy was talking and rhyming about. This point was driven home by many of his African American friends who teased him with the question: "Why can't *your* people make good hip hop?"[6]

The question actually was referring to the rap music "his people" were making: in his friends'—and his own—eyes, "corny shit" by Latin Empire, Kid Frost and Mellow Man Ace. Like Louis and his friends, many New York rap music fans claimed to dislike these Latino artists because their lyrics and beats were allegedly dull and overly derivative. But could it also be that many listeners did not deem the music acceptable or "hot" enough because these artists were stepping out of rap's acceptable parameters of blackness? In fact, it may be too difficult to separate the perception of arrested musical pleasure and lack of talent from the straying from the African American–identified formula. Often a negative aesthetic judgment automatically was attached to bringing into rap music "too much" of an artists' Puerto Rican/Latino background. Many fans felt that by "overly" stressing their Latino background, artists were breaking with the common cultural ground that united them with African Americans.

Q-Unique's and Louis's experiences illustrate the ambivalent position that Puerto Ricans—and other New York Caribbean Latinos—held during this time, given hip hop culture's growing sole identification with rap and its leaving breaking and graffiti on the sidelines. To compound the situation, rap was also being increasingly perceived as an exclusively African American musical expression. Boricuas could be included or excluded,

depending on the situation. Q-Unique's experiences of inclusion are probably very much related to his South Bronx upbringing and his involvement with the Zulus, a historically ethno-racially inclusive hip hop organization. However, even he has his own stories of exclusions to tell.

As mentioned, it was both creative developments and marketing decisions that worked together in the ethno-racialization of hip hop as African American. So the issue was not as simple as Run DMC, Public Enemy, X-Clan and others deciding to write African American–centric lyrics. The identification of hip hop as African American must be contextualized in hip hop's growing commercialization and international popularity, and thus its expansion outside of territory where Puerto Ricans are a familiar presence, whether as neighbors, lovers, family, playmates or artists. As hip hop's scope of influence, consumption and production grew, new players integrated themselves into the scene—players who were decidedly unfamiliar with Puerto Ricans as participants in hip hop. The imagined links between what was variably referred to as the hip hop community or the hip hop nation were increasingly premised on African Americanness, and the vital role that Puerto Ricans played in the New York hip hop scene became increasingly obscured, even in its New York breeding grounds, which remained a fertile and influential site of hip hop creativity.

Hip hop's African American identification also must be contextualized in the simultaneous vilification and romantization of African Americans in U.S. popular culture and the profitability of its commercial packaging.[7] One of the hottest selling points of hip hop has been its association with a raw, outlaw, ghetto-based, black—particularly male—experience and image.[8] E. Allinson points to the relationship between rap's appeal and "a long-established romantization of the Black urban male as a temple of authentic cool, at home with risk, with sex, with struggle."[9]

Be it in the realm of public policy, media representations, sociological and historical analysis or popular culture, Puerto Ricans, although considered black—or at least virtually black—for some purposes are considered outside the scope of blackness for others. Within the U.S. context, they always have had their ghetto and nonwhite credentials up to date; their relationship to blackness, however, has not always been clear. Therefore, since hip hop's commercial popularity had been closely connected to a ro-

mantization/exotization of blackness, the rap industry gatekeepers were reluctant to put their resources behind Puerto Rican artists. As Alano Báez, lead singer of hard-core band Ricanstruction and whose musical influences range from punk to salsa to hip hop, once put it to me: Why would they risk investing in a lighter or unstable version of blackness—in the form of a Puerto Rican—when they can have the "real thing"?

Puerto Ricanness in rap was deemed a potential commercial liability. Numerous Puerto Rican MCs recount being explicitly told by A&Rs (Artists & Repertory representatives) and other industry people that they were talented but their ethno-racial background worked against them. Fat Joe, for example, recalls the countless times he was told that "rap ain't Puerto Rican" when he was first looking for a record deal.[10] During a recent interview at the Arsonists' studio in Bedford-Stuyvesant, Brooklyn, Q-Unique recounted to me one specific incident that took place in the early 1990s and the impact it had upon him:

> I told you the story about the A&R who told my manager: "He's an incredible rapper, but I wouldn't touch him because Puerto Ricans just can't sell." You see, my manager at the time called me and said: "I'm gonna call this guy. I want you to hear what he says. Don't say a word, keep your phone on mute and just listen, even if it pisses you off, just shut up." So he called and . . . "Yeah, yeah, he's good; but Puerto Ricans can't sell, it's impossible." When I heard that . . . You know how that feels? I remember crying 'cause it was like there's no way. I would have been able to take it more if he said "he needs to work on his skills." But to say what you were born as ain't shit, so forget it, kid. You sit there . . . I'm crying. Yo, there's nothing I can do about my appearance or my background. I can't change it. I wouldn't change it. It was a very hard realization to come to.

It is relevant to note that Fat Joe and Q-Unique's experiences are undoubtedly also influenced by the fact that they are light-skinned Puerto Ricans who can "pass" for "white." Within rap music, particularly of this period, the further removed an artist was from a perceived African Americanness—both racially and culturally—then the greater the chances at being marginalized.

This belief that Puerto Ricans were, for commercial purposes, not black enough seems to have extended beyond rap, to the dance element

Latin Empire's Krazy Taíno and Puerto Rock at Henry Chalfant's fiftieth birthday party, 1990. Photo by Henry Chalfant.

of hip hop—where, ironically, Puerto Ricans had previously held center stage. B-girl Rokafella (A. García-Dionisio), an El Barrio native prominent in the New York breaking scene as part of Full Circle, recalls being turned down for dancing in rap music videos because "we're looking for Nubian sisters." For her, as a Puerto Rican of visible African heritage, it was apparent that part of the problem was that these video producers "were only considering this much [her thumb and index fingers separated a quarter of an inch] of what black is."

"So what was driving this narrow vision of blackness?" I asked her over lunch one day, right before heading over to her dance crew's practice. "Was it media-driven or was the media responding to 'grassroots' notions?"

She answered: "That's one of those chicken-or-the-egg situations. I'd like to think it's the people up on top imposing their vision on everyone else. But it's not just that. In the neighborhood people be saying 'Oh, you ain't down!' What? I carry the cross, but I ain't down?"

Rokafella says she understands why it happens, though. "African Americans don't get props for what they've done. Look what happened with other music they created, like rock."

Akanni Humphrey, an African American breaker who has been part of the crews 3D, Crazy Breakers and Floor Lords and who, like Rokafella, was a member of the 1990s hip hop dance company GhettOriginal, expands on that idea. "As Black people, we've had so much taken away from us that we get really defensive. We stop remembering Latinos, even Asian people, are also 'people of color'—just as creative as we are. We have such a pride now that we think we invent every damn thing. We may have invented it, but not every little facet. The Latin people were right up there with us, from the beginning. They didn't take something away from us. They were *with* us."[11]

Puerto Rican marginalization in hip hop also can be connected with purist and narrow definitions regarding what constitutes African American and Latino culture. While rap often was viewed as a new expression along a continuum of African American musical tradition, it was most commonly thought of as a breaking away from "Latino" music.

Rap presented similar problems for the perceived boundaries of Latino musical expression to those presented by Latin soul, and particularly

bugalú, of the late 1960s. Although many of the critiques of Latin soul emphasized the musical inexperience of its musicians and its faddish qualities, much of the discomfort with this genre harked back to a deviation from "tradition." Unflatteringly described by bandleader Willie Rosario as "American music played with Latin percussion,"[12] *bugalú* violated the bounds that kept distinct what was deemed African American from what was thought of as Latino/Puerto Rican.

Hip hop's "African Americanization" to the exclusion of Puerto Ricans was not a product of circumstance. Neither can it be explained away by invoking only African American creative will. The increasing Black identification of hip hop must be understood within the steadfastness of ethno-racial categories in the United States. These categories translate into what is perceived as a limited potential for transethnic cultural production, solidarity and political organizing. Cultural hybrids like hip hop threaten those categories and the comforting, simplifying and profitable myths built around them.

Cultural production often is circumscribed by limitations imposed through the equation of ethno-racial affiliation with a certain range of cultural expression. To step outside of that range is viewed as betrayal. Thus, Puerto Rican hip hop artists have found themselves chastised for engaging in creative practices that are, allegedly, not "their own." But sometimes cultural production—and hip hop is an example of this—breaks with the strict ethno-racial mold and expands the boundaries of expression. However, these challenges frequently pass unnoticed because "commonsensical" modes of analysis force their subject of inquiry to conform to stifling ethno-racial categories and their surrounding myths. In poet Sekou Sundiata's words, the unfortunate outcome is that " . . . each group gets its own ghetto, its own impenetrable turf. A dangerous distancing of the Others from one another."[13]

"DOC" RODRÍGUEZ

Ivan "Doc" Rodríguez has been working as engineer, producer and mixer in hip hop recordings since 1987. His contributions to hip hop include classics, such as Erik B and Rakim's *Paid in Full,* Boogie Down Produc-

tion's *Criminal Minded* and *By Any Means Necessary;* Biz Markie's *I Need a Haircut;* all EPMD albums, three MC Lyte albums; and Das EFX's first two albums. However, Doc's contributions to hip hop have largely gone unacknowledged because engineering and mixing are not high-profile crafts within rap and because often he has not been given full credit for his work—at times he has not even been paid.

In an article subtitled "A Decade of Getting Jerked in the Game as Told by Engineer Extraordinaire Ivan 'Doc' Rodriguez" by journalist and hip hop historian Cristina Verán, Rodríguez mentions his ethnicity as yet another factor contributing to his invisibility: "My purpose for people knowing who I am is to earn more respect for my Latino people because I'm in a pro-Black industry and I work a pro-white job."[14]

In an interview for *Stress* magazine by Clyde Valentín, Rodríguez remarks: "The main issue that I want to touch on is that I stepped into this game as a broke Puerto Rican, born in Santurce, PR and raised in Hell's Kitchen, NY. I grew with a soul, I cried, I screamed and I hurt. I pushed forward and got out of that community—but returned to it. I was able to get rid of the evil that tried to control me while I was in there. I never saw the inside of a jail. . . . When I walked into this industry, I walked in with a clean heart and a clean mind and I'm still clean, ten years later."[15]

Remarkably, Rodríguez is not drowning in bitterness. His painful experiences in the industry inform his critical vision of hip hop but do not override his treasuring hip hop as a beautiful expression of an urban Afro-diasporic culture that African Americans, Puerto Ricans and other Latinos share: "Hip Hop instead of making us grow as a people has hindered our people, because we fight each other over little pennies that people throw at us. Our culture is a very jealous, insecure culture. . . . If *you're Black or Latino, you are somehow a part of me,* and instead you are being threatened by me or me being threatened by you, we should be able to grasp hands instead."[16]

Although perhaps "jerked" quite a few times, Rodríguez remains full of hope. As he told Clyde Valentín: "I've been hurt and I've been offended, but that's not gonna change me." Like Rodríguez, invaluable contributions of many more Puerto Rican hip hop cultural workers have gone unnoticed, particularly during the late 1980s period of greatest Puerto Rican marginalization in hip hop.

WHAT IS THIS "LATIN" IN "LATIN HIP HOP"?

Freestyle

A twist in the story of Puerto Ricans in hip hop's musical sphere came with the popularity of two Latino-identified genres: *freestyle* in the late 1980s and Latin rap in the early 1990s. Terminology here may cause a bit of confusion, since both were also often referred to as Latin hip hop—and within rap, freestyling means improvising. But this apparent terminological confusion actually proves to be illuminating. The term "Latin hip hop" points to the fact that "freestyle" and "Latin rap" were somehow related to, yet distinct from, hip hop; and a key to their difference from hip hop was a shared "Latin" element.

David Toop describes freestyle as "faithful to the old electro sound of [Afrika Bambaataa and the Soul Sonic Force's] 'Planet Rock' adding Latin percussion elements and an overlay of teenage romance."[17] Others describe it in starkly unflattering terms as the "synth-heavy bubble-salsa of Lisa Lisa and her big-haired descendants" and "bubble-gum ballads over drum-machine beats."[18] On the contrary, enthusiasts like DJ G-Bo the Pro react excitedly at the mention of this musical genre and celebrate it not only as a source of pleasure but as a point of ethno-racialized pride. "Freestyle was hot! It was Puerto Rican," he told me the moment I broached the subject. Groups like Cover Girls, Exposé, TKA and Latin Rascals and artists like George LaMond, Sa-Fire and Brenda K. Starr were among the best-known freestyle artists. The overwhelming majority of these were New York Puerto Ricans. Freestyle's local audience was heavily Puerto Rican; the music was also very popular among other Latinos and Italians.

In terms of vocal style, lyrics and sound, freestyle was very different from the rap music of the time. Freestyle vocalists sang (rather than rapped) sticky-sweet (at times bittersweet) lyrics centered on the vagaries of love, whereas hip hop MCs were broaching topics more concerned with ghetto life, racial strife and personal/artistic prowess. Freestyle's sound was electro-pop, while hip hop usually was backed by harsh funk with powerful bass lines.

That is not to say that there has been no overlap between the freestyle and the hip hop scenes. In New York, certain clubs provided spaces

where the boundaries between the two were blurred. Some hip hop clubs used freestyle songs as interludes, and vice versa. Latin Quarter, then a club located in the Times Square area, featured freestyle some nights and hip hop on others. Freestyle artists like the Latin Rascals, who were originally hip hop radio mix DJs, produced music for the Fat Boys. Some freestyle singers like members of TKA and Brenda K. Starr had first tried their hand as MCs. Years after freestyle's commercial success plummeted, one of TKA's members, K-7, launched a solo rap career that yielded the modest—if fleeting—hits of the early 1990s "Come Baby Come" and "Zunga Zeng."

David Toop in *Rap Attack 2* talks of a division arising between African American and Latino audiences in 1987. Toop attributes the division to Latinos' continued preference for hip hop's earlier electro sound in the form of freestyle while African Americans followed the new sounds of the increasingly African American–identified rap music of the time. But he offers no possible explanations and leaves one wondering: Why did that separation happen?

One of the factors at play in the late 1980s' schism along ethno-racial lines between hip hop and freestyle audiences had to do with notions of cultural property and entitlement. The growing African Americanization of hip hop during the 1980s—largely media-driven, premised on a reductive notion of blackness as exclusively African American and suffering from severe cultural-historical amnesia—prefigured the increasing alienation of Puerto Ricans from hip hop.

Freestyle, as a new genre, was in great part young Latinos' response to media marginalization. Andy Panda, a key songwriter, producer and media personality of what he terms "the freestyle movement," recounted the beginning of freestyle for a largely teenage audience at 1995's Muévete Boricua Youth Conference held at Hunter College:

> In 1985 I came out of college and I wanted to pursue a career in the music business. I was DJing my way through college. I spent a lot of time at the clubs that your older brothers and sisters may have hung out at: clubs like the Roxy, the Fun House, Latin Quarter, clubs like First Class up in the Bronx. . . . But one thing that I noticed, much to my dismay, was that all these records that were being played in clubs and

predominantly Latino clubs, were not represented by any Latino artists. You know, and I said "Damn! I know we got talent. How come we have no Latino artists out there?" And I would scan the credits of the records that I played and, you know, you'd see a remix here and there, but there weren't a great many Latino songwriters. There weren't a great many Latino record producers. . . . So me and a bunch of other people, we shared that same mentality, and we began writing music and producing records in whatever limited facility we had and getting the people who we knew, from our neighborhoods, who we thought had talent, to sing on those records. As a result there was a movement, if you will, that was created.

Discussions of the emergence, popularity and cultural significance of freestyle must take into account this desire of Puerto Ricans and other Latinos to see "our own" in the limelight, to have a music that was "ours." Freestyle singer George LaMond[19] recalls in a joint interview with Andy Panda published by *Urban Latino Magazine:* "I felt like I was representing my hometown and my Puerto Rican people. It made me that much more proud of being a Latino." Andy Panda adds: "I think it gave kids a sense of identity because finally we had something that was ours. We didn't have much of a cultural identity in the music industry other than Spanish-language music."[20]

Such desires were clearly a response to Latino invisibility in mass media, in general, and to the prevailing notion at the time that hip hop was African American cultural property, in particular. They also must be understood as an expression of the will of New York–raised Puerto Rican and other Latino youth to expand the bounds of collective expression outside of Spanish-language "Latin" music.

What these youths perceived as culturally "ours" exceeded the bounds of "Latin" orthodoxy that considered Spanish-language lyrics and Latin America–"originated" sounds as a necessary component of music worthy of the label "Latin." Many regarded Latinos and "American" [*sic*] music as disparate partners, in terms of both cultural "legitimacy" and commercial viability. In that sense, the participation of Puerto Ricans and other Latinos in doo wop (during the 1950s), Latin soul (during the 1960s and early 1970s), freestyle (during the 1980s) and hip hop all presented similar challenges to the dominant notions of *latinidad.*

The backlash against these challenges to *latinidad* took many forms: Willie Rosario's insistence on identifying *bugalú* as "American" music[21]; Puerto Rican parents complaining of their children's fascination with hip hop "nigger" music; A&Rs refusing to sign Latino MCs because "Puerto Ricans don't sell"; George García being persuaded by his label to launch his freestyle career as George LaMond, for his last name was considered a commercial drawback.

Although grassroots perceptions are often more responsive to innovations and changing conditions than market-oriented ones, both had difficulty in grappling with the younger generation's desire to embrace their New York–based, English-infused, Afro-diasporic lived cultural experiences. Freestyle was in this sense an artistic liberation from culturally stifling parameters of conformity with the reigning notions of *latinidad*.

At the same time, while it advanced the power of Puerto Rican second- and third-generation identities and artistic production, freestyle also reproduced other reductive notions of identity, experience and solidarity. It reinforced the myth of pan-Latino commonality and the drawing of *puertorriqueñidad/latinidad* as identity categories in great part defined through nonblackness.

Robert Orsi proposes that the fissures and conflicts between racialized groups have much to do with anxieties regarding group definition. According to Orsi, "strategies of alterity" have served, among certain groups, to define "self-constitution through the exclusion of the dark-skinned other." His study of East Harlem reveals how Italians struggled to separate themselves from the "dark" African Americans, Puerto Ricans and other Caribbean immigrants. "Proximity—actual and imagined—to the dark-skinned other was pivotal to the emergence of the identity 'Italian American.'"[22] Similarly, Puerto Ricanness and *latinidad* have been informed by a desire to distinguish Latino groups from the "darker" African Americans.

These anxieties regarding ethno-racial identity affect understandings of artistic production in peculiar ways. Not only can a certain mode of expression, such as freestyle, be said to be Latino because New York Puerto Ricans are the most distinguished, popular or numerous participants. A certain genre also can be said to be Latino because it is informed by specific modes of speech or experiences that are identified

with Latinos living in the United States. But certain myths based on a stereotypical ethno-racial ethos also come to define what may or may not be Latino. Andy Panda, for example, explains that freestyle singer George LaMond "never sounded black" but sounded "uniquely Latino." As Panda describes it, whereas African American artists "sing with soul," Latinos "sing with passion," "sex" and "emotion."[23]

Panda's belief in a self-evident soulful black sound distinct from a Latino sex-heavy sound is by no means peculiar to him, to freestyle or to those of his generation. Similar essentialized and naturalized identity markings are constantly thrown around in the media, in streetcorner cyphers and in domestic conversations. These essentializing myths serve to cement difference, as further "strategies of alterity."

Given the construction of these myths, the list of areas where difference is purportedly clear thus grows. Ethos, aesthetics, themes, ideas, language, musical references and sources thus are pointed to as examples of group difference. What is African American can then be considered easily distinguishable from what is Puerto Rican or Latino.

Whereas certain audience segments and critics celebrated the dawn of "Latin hip hop," those who felt themselves part of an urban Afro-diasporic hip hop culture exhibited a strong feeling of suspicion and betrayal. Journalist Edward Sunez Rodríguez bitterly explains the appearance and popularity of freestyle as a denial of Latino African heritage: "The unifying concept of hip hop is that it is for all people of color of African descent who created a culture to reflect their richness and flavor despite living in extreme poverty. However, many Latinos had trouble embracing this concept as their own ignorance and racist attitudes would not let them realize their own kinship with African Americans. Latinos wanted to see *their own* performing on stage and in the spotlight and thus Freestyle or, as it was called at the time, club music."[24]

Freestyle began as an artistic outlet and challenge within a context of Latino media marginalization and a prescribed *latinidad* orthodoxy. Ironically, it also had ghettoizing and stifling consequences in terms of media perception and popular cultural identity. Many Puerto Ricans distanced themselves from hip hop to pursue something that was truly "their own": freestyle. But then freestyle ended up experiencing a commercial popularity decline that affected not only its artists but also Puerto Rican MCs.

Freestyle, as "Latin hip hop," cemented even more the idea that Puerto Ricans were somehow marginal to the hip hop core.

The terminology is again instructive. While some celebrated the nominal interchangeability of "freestyle" with "Latin hip hop" as a rightful emphasis of freestyle's ties and debts to hip hop, others condemned it.[25] Edward Sunez Rodríguez, for example, argues that considering freestyle synonymous with Latin hip hop "lead[s] to the idea that Latin hip hop was different from real hip hop" and "separated Latinos from real hip hop."[26]

Of course, this notion of "real" hip hop music brings up a whole new set of problems regarding who defines and the criteria for defining, yet it does point to certain prevailing "insider" notions where participants view the boundaries between center and periphery, although porous and contested, as commonsensical. In this case, the core was hip hop music deemed to be appropriately African American–matrixed, and the periphery included "other-ethnic" hip hop, such as "Latin hip hop."

Latin Rap

Freestyle was only one side of "Latin hip hop." So-called Latin rap fell under the same rubric. Compared to freestyle, Latin rap stood a lot closer to hip hop in terms of form and style. Vocal flows were rapped; topics were ghettocentric. It was basically rap music done by Latinos, often code-switching between English and Spanish, with topics and references particular to inner-city Latino communities.

Contrary to freestyle, whose artists were overwhelmingly New York Puerto Ricans, Latin rap came largely out of the West Coast and had few Puerto Rican exponents. Kid Frost, a Los Angeles Chicano who released his first album, *Hispanic Causing Panic*, in 1990, was one of the first Latino rappers to receive wide media recognition. Other artists who came out under the commercial Latin rap rubric were Mellow Man Ace (a Cuban, also from Los Angeles), Latin Alliance (headed by Frost) and the infamous Gerardo (of Ecuadorian descent, a.k.a. Rico Suave).[27]

New York Puerto Ricans never ceased being active in the local hip hop scene. But in terms of Latin rap's commercial exposure, they were nearly invisible. Latin Alliance had two New York Puerto Rican members,

Rayski and Markski. The Nuyorican duo Latin Empire had garnered local exposure in the 1980s and even landed a deal with Atlantic Records. But they never achieved the commercial popularity of later Latin rap artists.

"Latin rap" is not a self-explanatory or unproblematic label. Is it simply rap done by Latinos, regardless of style or content? Is it rap done by Latinos that is also necessarily related to Latino life or a Latino aesthetic? How could that reality or that aesthetic possibly be defined? Whose definition do we use? Can non-Latinos who use Spanish in their rhymes or other elements of that hypothetical "Latino aesthetic" also make Latin rap?

The term "Latin rap" has been used to categorize artists like Kid Frost, Mellow Man Ace, Gerardo, Latin Alliance and Latin Empire—all U.S.-based Latino artists whose music, rhymes and themes include elements "commonsensically" identifiable as Latino. It also has been used to describe Latin America–based artists like Vico C., Lisa M. and El General, whose rhymes are in Spanish but sometimes incorporate words in English.[28] For my purposes, the most difficult questions regarding definition and inclusion within the Latin rap category have to be asked when U.S.-based Latino artists create music that does not conform to the most commonly accepted bounds of Latino identity, experience or creativity.

Cypress Hill, for example, was criticized for being too "Anglocentric."[29] This L.A.-based trio was made up of two Latinos, Sen Dogg (Cuban) and B-Real (Mexican-Cuban), and DJ Muggs, an Italian American who spent his early childhood in Queens, New York. The assumption seems to have been that since two of its three members were Latinos, Cypress Hill had to conform to a certain mold of *latinidad.* The group, however, did not claim to be doing Latin rap. In fact, the members scoffed at the thought and explicitly resented being boxed into the category. Asked if their approach to music-making was a "Latin thing," Sen Dogg answered: "A lot of groups out there are like pro one culture and shit, like Kid Frost—he caters just to the Latin, 'cause that's his thing. If you ask me—I'll tell you that [Frost] is a sucka and he can't represent my thing, that's where we step in. We feel you can all be down with your own, but not when it comes to the music; you all got to be together."[30]

Sen Dogg and B-Real were largely deemed by audiences and other artists to be part of the hip hop core—as opposed to the fringes, which

Latin rap artists occupied. They were also extremely successful in terms of record sales, being the first Latino artists to achieve platinum status in rap music. These discussions of how "Latino" or "Anglocentric" their artistic production is or is not slight other aspects of their music that are more directly relevant to the social milieu in which rap is produced and consumed.

Journalist Ed Morales defined "Latin hip hop" in a 1991 *Village Voice* article as "the polyphonic outburst of recent rap-oriented records" like *Latin Alliance* (Virgin), *Dancehall Reggaespañol* (Columbia), and *Cypress Hill* (Columbia), which is "in step with the world-wide Afrocentric cultural revolution that will carry us into the next century." One of its virtues, according to Morales, was its "development of a nationwide Latino/Americano hip hop aesthetic" that permited artists from both coasts who were once strangers to "become one nation kicking Latin lingo on top of a scratchin', samplin' substrate." He argued for an inclusive notion of this aesthetic so that Cypress Hill did not have to be dismissed as "de-Latinized, stoned-out Beastie Boys." Although their rhymes were mostly English, Morales noted, they still kicked some bilingualism, and their "relative Anglocentrism" did not necessarily "mean they're not reaching *vatos* in the hood."[31]

Instead of questioning the stifling assumptions regarding ethno-racial identity and artistic expression that underpin this charge of Anglocentrism, Morales explained what he saw as Cypress Hill's redeeming qualities. Seeking redemption through these means seems less pertinent than asking why Latino artists are, in the first place, expected to adhere to a certain orthodox Latino aesthetic—in terms of language, topics and/or music—or to cater specifically to a Latino audience, particularly when artists are actually being responsive to the cultural realities of the Latino second and third generations.

This issue becomes particularly relevant in the case of Puerto Ricans in New York, whose cultural production and identity have been so tightly linked with that of African Americans. The experience of New York Puerto Ricans then begs the question: Why assume the naturalness or necessity of a Latino aesthetic and cultural product over and against Afrodiasporic ones? If a Latino aesthetic is supposed to be informed by cultural expressions and lived experiences that are identified with Latinos

living in the United States, then why exclude from that *latinidad* the vernacular cultural production of New York Puerto Ricans who have been living, loving, playing and making music together with African Americans since the early decades of the twentieth century?

The Hispanocentric bent of the dominant definitions of *latinidad* often has led to Puerto Ricans placing themselves or being placed by others outside the bounds of *latinidad.* A cornerstone aspect of the Latin rap aesthetic was the use of Spanish. However, many Puerto Rican participants who rejected what they perceived as the Latin rap pigeonholing sought to emphasize a U.S.-based Afro-diasporic identity according to which rhyming in Spanish was either unnecessary or a threat.

In a 1995 interview, Edward Sunez Rodríguez explained to me why some MCs refused to go the Latin rap route: "MCs don't wanna come out as exclusively Spanish 'cause they don't wanna exclude people. Black people are their people." Then there's also the issue of New York–raised Puerto Ricans and other Latinos expressing themselves more comfortably in English than in Spanish. As Fat Joe said in Mandalit del Barco's 1991 National Public Radio documentary on Latino rappers, even though promoters expected him to rhyme in Spanish because he was Puerto Rican, "I can't really kick it in Spanish, I couldn't really feel the vibe, so I'm not even gonna try and make myself look stupid." In the same documentary, Prince PowerRule (Oscar Alfonso) added: "There's so many Latino people in the United States that don't speak Spanish, so they don't wanna hear that bilingual rap. They're just like us; they're Americans."[32]

As in the case of freestyle, the appearance of so-called Latin rap as a Latino-specific realm within rap music had a dual effect. On one hand, it expanded the bounds of participation and expression of Latinos in hip hop, but on the other hand, it also ended up making the existing schisms between Puerto Ricans and African Americans even deeper. The non-black *latinidad* that "Latin hip hop" was based on shrouded the Afro-diasporic dimension of Puerto Rican identities.

CHAPTER 5

GHETTOCENTRICITY, BLACKNESS AND PAN-*LATINIDAD*

The Mid- to Late 1990s

The people of Puerto Rico are African descendants, in the same way that the so-called slaves that they brought to [the United States of] America. That's why we understand we are the same people and we are happy to see our brothers representin' themselves [in hip hop].

—*Dead Prez*, In the House Magazine

Journalist and poet Kevin Powell poured out a heartfelt lament in the pages of *Vibe* magazine in which he grapples with the contradictions inherent in what he identifies as one of the 1990s' hottest trends in U.S. popular culture in general and commercial rap music in particular: the mass marketing and glamorizing of the violence and pain of black "ghetto" life. It distresses him that poor people's real-life tragedies are being packaged and sold through music, television and film. But what haunts him the most is what he perceives as a dangerous trend among young black people: the upholding of a stereotypical "ghetto" mentality as a badge of honor and the equating of that mentality with blackness. "Suddenly, it's the move to be from the ghetto (even if you aren't), to speak the

ghettocentric language (even when it sounds like you frontin'), and to proclaim the ghetto as the true source of black identity—some of us call it 'representin'."[1]

Written from the point of view of a hip hop participant, Powell's article is an indictment of the pervasiveness within rap of a discursive and performative blackness defined through a stereotypical "ghettocentricity."[2] He concludes by stating that if blunt-smoking, gun-packing, 40-ounce drinking and calling one another "niggas" and "bitches" are what the ghetto and, by extension, blackness are about, then "we're participating in our own self-destruction, in true ghetto style."

Powell's article speaks to a change in rap's commercial trends. The Afrocentric emphasis in rap of the late 1980s started shifting toward a more ghettocentric approach in the early 1990s.[3] African Americanness did not cease to be a crucial identity marker within rap's discourse, but it became more narrowly identified as a ghetto blackness: "Rap's agenda since PE's [Public Enemy's] heyday has shifted largely from a generic concern for chronicling the 'black' experience to one specifically about the black underclass in the ghetto. . . . In rap's dominant market paradigm, blackness has become contingent, while the ghetto has become necessary."[4]

Focusing on West Coast "gangsta rap" during the earlier half of the 1990s, Robin D. G. Kelley ponders the confluence of class and race within the genre through artists' usage of the term "nigga":

> More common, however, is the use of "Nigga" to describe a condition rather than skin color or culture. Above all, "Nigga" speaks to a collective identity shaped by class consciousness, the character of inner-city space, police repression, poverty, and the constant threat of intraracial violence fed by a dying economy. Part of NWA's "Niggaz4Life" on *Efil4Zaggin,* for instance, uses "Nigga" almost as a synonym for "oppressed." In other words, "Nigga" is not merely *another* word for black. Products of the postindustrial ghetto, the characters in gangsta rap constantly remind listeners that they are still second-class citizens—"Niggaz"—whose collective lived experiences suggest that nothing has changed *for them* as opposed to the black middle class. In fact, "Nigga" is frequently employed to distinguish urban black working-class males from the black bourgeoisie and African Americans in positions of institutional authority.[5]

Although Kelley focuses on the commercially dominant West Coast sound of the earlier 1990s and Smith on the East Coast–based rap of the mid- to late 1990s, both describe the same class-based narrowing of the concept of blackness as expressed through rap.

Commercial rap's focus shifted from a blackness primarily defined through (a narrow, nondiasporic take on) African American history and ancestry to one based more on contemporary socioeconomic conditions and lived culture (as opposed to "traditional," "inherited" or "ancestral" culture). As this shift was taking place, a slight relaxing of the ethno-racial scope of blackness also occurred. The blackness formerly restricted by the bounds of an ethno-racialized African Americanness began expanding to accommodate *certain* Latino groups as a population of ethno-racial Others whose experience of class and ethno-racial marginalization is in many ways virtually indistinguishable from the ghettocentric African American experience. Such Latinos could even be perceived as closer to this class-based blackness than so-called bourgie (bourgeois) blacks, particularly in the case of Caribbean Latinos such as Puerto Ricans, given the growing acknowledgment that they are also part of the African diaspora in the Americas.

While during the late 1980s and early 1990s hip hop frequently was described by African American participants as "a Black thing, you wouldn't understand," starting in the mid-1990s it became increasingly common to hear hip hop explained in everyday conversation, as well as in mass media and academic forums, as a "Black and Latino" phenomenon.[6] Today's near-dominant convention of describing hip hop culture—and within it, rap—as "Black and Latino," and the increased commercial visibility of Latinos/Latinas within hip hop, would not have come about had it not been for this shifting conception of blackness that emphasizes the ghetto experience.

The short-lived MTV animated series *Station Zero,* which first was broadcast in 1999, is only one of many manifestations of this move toward the reinclusion of Latinos as core participants in hip hop culture. The TV show featured both African American and Latino teenage characters who engaged in different facets of hip hop creativity. Journalist Joel Sosa described the character "Chino" as "definitely not afraid of his Latino heritage, he freely uses Spanish without translating for the

Spanish impaired."[7] What a change from the late 1980s and even the early 1990s! What would have probably been considered back then a Latino segregationist tactic and a gesture of linguistic exclusion toward African Americans was by the late 1990s being celebrated as a sign of hip hop authenticity. New York Latinos began being acknowledged as tightly linked to hip hop's history and subsequent development. Chino was not only a "Hip Hop conscious character" struggling for artistic freedom and integrity in the face of commercial exploitation; he was also a South Bronx Latino from the very Soundview housing projects that have been central in hip hop history.

The movie *Whiteboyz*, released in 2000 and starring Danny Hoch, presents another good example of the closing hip hop legitimacy gap between Puerto Ricans and African Americans. Slick Rick, Mic Geronimo, Doug E. Fresh, Snoop Dogg, Fat Joe and Dead Prez represent the hip hop ghetto "realness" that white, rural Iowan main character Flip Dog fantasizes about. From Flip's point of view, there is no difference between Fat Joe and the rest of the rappers, even though the first is a light-skinned, green-eyed Puerto Rican and the others are dark-skinned African Americans. Flip views them all with equally adoring eyes.[8]

By the 1990s, young people of all ethno-racial affiliations, including whites, were hip hop producers and consumers. Furthermore, blackness as signified through class-specific "nigganess" was being celebrated by many hip hop enthusiasts, regardless of their ethno-racial background. As KRS-ONE ironically commented in his popular 1995 song "MCs Act Like They Don't Know," nowadays even white youngsters call themselves "nigga." But KRS does not let his listeners forget that "white kids'" appropriation of black language and their participation in hip hop culture takes place within a context of white supremacy, where still "the crosses burn."

By the latter part of the 1990s, rap was a central part of mainstream U.S. pop culture, a genre with multiethnic audiences all over the globe and immersed in the politics of the transnational music industry. Still, hip hop "authenticity"—based on a class-identified blackness/nigganess—continued to be contentious ethno-racial territory, and its borders were zealously policed by its participants. The ethno-racial scope of "authenticity" expanded somewhat, but only to incorporate—

although not always smoothly—the "Latino" experience. This expanded ethno-racial scope was tightly woven in with contemporary socioeconomic structures.

Pee Wee Dance in DJ Tony Touch's *Tape 45* described hip hop culture as an expression of Black and Latino creativity, but warned that rap was a "white manifestation" of a longing to profit from that expression. Through his brief contribution to this 1995 mix tape, Pee Wee Dance highlights the ethno-racialized economic contentions between the Blacks and Latinos at the axis of hip hop creativity versus the "white" power structure that has taken one element of hip hop (rap), pulled it from its sociohistorical context and profited from it more than the main creators themselves.

During the second half of the 1990s, Latinos commonly were attributed a proximity to blackness that was thought of as a product of social, political and economic circumstances, circumstances that have led to shared lived and historical experiences in the ghetto with African Americans. David Pérez, a Bronx Puerto Rican who has directed videos for rap artists A Tribe Called Quest, Cypress Hill, House of Pain, Brand Nubian, Diamond D, Beastie Boys, KRS-ONE and others, explains how his growing up as a working-class Puerto Rican in New York granted him authenticity in the hip hop realm: "I look sort of white so I have to establish myself. Gotta let *them* know where you're coming from, what you saw when you were growing up. Then all of a sudden, they look at you, and you're light-skinned. You could be Italian, Jewish, Greek. Then after you establish yourself, you become *authentic*."[9]

But Latino authenticity was not only conceived within hip hop in terms of socioeconomic structures; it was also constructed as related to Afro-diasporic ethno-racial identities, cultural history and cultural formations. The Off-Broadway production *Jam on the Groove*[10] by Ghett-Original provides a pertinent example. The cast of this hip hop theater production consisted mostly of African Americans and Puerto Ricans, and included some of New York City's better-known Puerto Rican dancers—Crazy Legs, Ken Swift, PopMaster Fabel, Honey Rockwell, Mr. Wiggles, Rokafella and Kwikstep. One of its pieces, entitled "Concrete Jungle," celebrated hip hop's dance element as an expression of joy and an outlet for creativity in a context of urban blight and police brutality.

In "Concrete Jungle," a b-boy and b-girl battle is the venue where technique and inventiveness are displayed as well as a site where tensions and rivalries between African Americans and Puerto Ricans are manifested. The battle is interrupted for a moment as the offstage voice of a police officer demands that they disperse, calling them "a bunch of savages" and "nothing but shit." The dancers ignore the cop and the battle continues. The voice bursts out with another string of insults and threats, but the dancers still refuse to disperse. Gunfire rings out, as the dancers try to escape. All but one are gunned down. The sole survivor proceeds to bring everyone back to life with the beat of a drum. "Concrete Jungle" is partly an indictment of the racialization and marginalization of Latinos and African Americans as the "savages" that inhabit the New York inner-city "jungle." It also celebrates the common Afro-diasporic cultural ground of African Americans and Latinos—the drum is upheld as a symbol of tradition as well as a tool for joint present-day struggle.

But these Afro-diasporic identities shared by African Americans and Latinos involve only a sector among Latinos, namely Afro-diasporic ones. To talk about shared experiences and identities in U.S. ghettos means we must distinguish the intense similarities between African Americans and Puerto Ricans in New York from the comparatively more distinct experiences of Chicanos and African Americans in Los Angeles or Chicago and from the completely divergent experiences of African Americans and Cubans in Miami. This may seem all too obvious, yet it is another example of the specificities that are smothered under the seductive weight of the pan-Latino discourse.

The sense of a Black and Latino "us" in hip hop is intimately related to the experiences of African Americans and Caribbean Latinos—particularly Puerto Ricans—in New York City. In the words of El Barrio–raised Puerto Rican DJ and producer Frankie Cutlass: "Puerto Ricans, we grew up with Blacks. I go to the housing projects that's all you see . . . a lot of Puerto Ricans and Blacks. . . ."[11] That is why, he says, ghetto-raised Blacks and Puerto Ricans are so similar that often they are virtually impossible to distinguish one from the other. In response to a question about the similarities in the experiences of Blacks and Latinos in the United States, Cutlass extricates his experiences from those of the

Latino aggregate since he does not feel he can "speak for another culture." He feels he can talk only from his Puerto Rican vantage point.

Cuban Link, a rapper and member of the Bronx-based Terror Squad (whose most popular members are Puerto Rican rappers Fat Joe and the late Big Punisher) answered a journalist's inquiry regarding "Latino involvement" in hip hop by discarding presumptions of pan-*latinidad* and narrowing down the concept to refer only to Caribbean Latinos: "It's the Caribbean Connection, baby. Puerto Ricans, Dominicans, Cubans, all. We're coming together and it's something you've got to see to believe."[12]

The explicit avowal by popular rap industry personalities and media— magazines like *The Source*, *XXL*, *Blaze*, *Stress* and *Ego Trip* and rap video shows like BET's *Rap City*—of the historical presence and importance of New York Caribbean Latinos within hip hop has been crucial in the process of widespread Latino legitimation as bona fide, core members of the national hip hop "community" and not just *arrimaos* (interlopers) attempting to "be Black" or do a "Black thing."[13] And since *latinidad* often is viewed as the primary and "natural" focal point of identity for all Latinos, the fact that New York Caribbean Latinos have had a historical presence in hip hop has been automatically extended to encompass Latinos as a whole.

The acknowledgment of hip hop in both the academic and journalistic literature as an urban Black *and* Latino cultural expression has suffered from the perils of pan-ethnic abstraction. In the haste to rescue Latinos from historical invisibility and to acknowledge their current role within hip hop, essentialized connections—often enough based on stereotypes and exotization—are drawn, and crucial differences among groups within the Latino pan-ethnic conglomerate are slighted.[14] The role played by New York Puerto Ricans in hip hop culture has been different from that of other Caribbean Latino groups in New York; the differences are even greater when Puerto Ricans are compared to Chicanos and other Latinos on the West Coast. But these specificities have become obscured by the growing force of *la gran familia latina* (the great Latino family) discourse within hip hop. The historical and current connections between Afro-diasporic Latinos and African Americans in New York are at times muted or even drowned out by the naturalizing call of pan-*latinidad*.

A 1998 feature article in *Industry Insider Magazine* illustrates the case in point. Chang Weisberg, its author, laments that "Latinos in hip hop

have always seemed like second class citizens in an art form they helped create" and sets to find out why.[15]

Throughout the article, Weisberg enthusiastically writes about the "sense of family" manifested among the "Latino brethren" and "Latino hermanos" who are meeting at an *Industry Insider*–sponsored summit of Latino hip hop artists. Brought together under the assumption of a family bond—Weisberg billed the summit as a "family reunion"—many of the artists themselves also celebrate in their statements the ascribed bond of *latinidad.*

According to Jack, from the West Coast group Psycho Realm: "Since we're all Latinos, it's like were [*sic*] all family." Big Punisher also alludes to a *latinidad*-based notion of family: "It's Latino first. That's more important than East/West. That's familia. That's La Raza." Fat Joe elaborates: "Since we're Latino, I feel that we're all spiritual in a way. It doesn't matter if you're Mexican, Puerto Rican, Cuban, Columbian [*sic*], or whatever. We've got something that's real different from many other cultures. No matter what's going down, we always stick together. It's about time we did this. Hopefully, we'll keep gettin' together like this and show everybody love. It doesn't matter if you're from the West Coast or the East Coast. We're Latino. You know what I mean? We cut across all that shit."[16]

Fat Joe, Jack, Punisher and most of the other artists interviewed by Weisberg weave a family-based narrative of unity among Latinos that relies more on future projections than on lived experiences, particularly as it applies to Latinos involved in hip hop culture. Fat Joe's statement that "No matter what's going down, we always stick together" and Pun's statement that "Latinos look out for one another" express what *should be* rather than what actually *is.* The virtual lack of collaboration—particularly cross-coastal—among these artists and their vowing to work in unison *from now on* exposes this celebrated Latino unity as either still forthcoming or wishful thinking.[17] Besides, considering the article's explicit acknowledgment of "misunderstandings" and "differences" that formerly existed among some of the participating artists, the summit can be seen as more of makeup session ("to squash beef," as Frost says) than as yet another manifestation of love and support among the Latino "familia."

Although cloaked in the benevolent, comforting and naturalizing mantle of family, the Latino unity that these artists are advocating is as much a commercial necessity and market strategy as a spiritual, familial or historical imperative. Marginalized within what Fat Joe terms a "Black business," the only option for Latinos, as expressed by most artists at the summit, is to work together and "help their own." Son Doobie, a West Coast–based Puerto Rican and member of the group Funkdoobiest, says: "whether it's black media owned by white folks or black media owned by black folks, I know everybody wants to help their own. Basically, what we've done now is helped ourselves to the table because nobody was going to give it to us. . . . It's time for Latinos to shine because we've been down since day one."[18]

The artists and Weisberg stress throughout the notion that Latinos have been key in hip hop since "day one." Although the Latinos who participated in hip hop's earliest history were specifically Caribbean Latinos and overwhelmingly New York Puerto Ricans, the Latino aggregate as a whole reaps the claim to hip hop historical presence and authenticity. A transcoastal, transnational Latino "us" enables this collectivization of the experience of a sector within the Latino population. The article, by not even nodding in the direction of regional and ethnic—as opposed to pan-ethnic—specificities, makes it seem as if Latino artists in different regions and of different ethnicities have faced the same obstacles and issues.

Weisberg, in his mission to celebrate Latino rap artists and hip hop culture in general, constructs a mythical pan-ethnic bond between Latino artists and portrays hip hop as a democratic, utopian space where the media is the big bad wolf: "If music is truly universal, then hip hop is its purest expression. . . . It doesn't matter if your [*sic*] Black, White, Catholic, or Gay. Hip hop has always been the cultural melting pot of free expression and open dialogue. The watering down and deterioration of hip hop's infrastructure lies in the fact that its education is left in the hands of the media."[19]

Weisberg fails to explore the tensions among Latino groups as well as those existing between African Americans and Latinos—tensions that are as much a part of hip hop history as transethnic solidarities and multiethnic cultural creation. This forced sense of harmony leads him to

ignore gender power dynamics within it and even to make the ludicrous claim that homosexuality is a nonissue in hip hop.

Kevin Baxter, in a 1999 article for *The Source*, suggests that the fact that "Latin culture suddenly bec[a]me so hot" in commercial terms in the late 1990s has to do with "demographics" as well as "the recent political awakening of the Latino community." Baxter mentions several movements and initiatives to illustrate "Latino" political mobilization: the Chicano Moratorium of 1970, the United Farm Workers during the 1960s and 1970s and the more recent mobilizations against California's Proposition 187.[20]

Since Baxter restricts his comments to a few West Coast–based, Chicano-dominated examples, readers unfamiliar with the topic get a myopic introduction to the history of Latino political mobilization. They may think that "Latino" political mobilization has been restricted to the West Coast, or perhaps that the movements mentioned are representative of the interests and efforts of Latinos across the nation. Baxter fails to mention, even peripherally, New York's long history of African American and Puerto Rican joint political struggles—a political history that complements an equally long history of joint cultural production, of which hip hop is a part.

This type of identity-building substitutes an abstract discourse of Latino pan-ethnic solidarity in place of a more regionally based, lived-experience approach where, in the case of New York Caribbean Latinos, urban Afro-diasporic identities dominated. As the mass media visibility and momentum of a largely Hispanocentric, essentialized pan-*latinidad* grows, so do the perceived differences between Caribbean Latinos and African Americans. Caribbean Latinos are assumed to have experiences, histories, identities and solidarities that "naturally" place them within the pan-Latino aggregate. This is not to say that there is no longer within hip hop culture a sense of an "us" between African Americans and Caribbean Latinos in New York, or that Puerto Ricans and other Caribbean Latinos do not also resist the presumption that they share a primary/"blood"-based/ancestral bond with other Latinos and only a secondary or circumstantial one with African Americans. For Puerto Ricans within hip hop, *latinidad* and Afro-diasporic blackness are at times parallel, at times intersecting identity discourses; sometimes they coexist while, at other times, they may compete.

The clashing of Latino and Afro-diasporic identities is not unavoidable, for they are not mutually exclusive identities. The problem is that they are often posed as such, forcing a nonsensical choosing of sides. Ethno-racial rifts between Caribbean Latinos and African Americans within hip hop have been informed to a great extent by a larger social context in which *latinidad* and blackness are often held to be nonintersecting. Hip hop, nevertheless, has been one of the contemporary social realms where Caribbean Latino blackness has been grappled with and celebrated the most.

Whether taken up by elected officials, government bureaucrats, academics, journalists or activists, contemporary discussions of poverty, political and economic empowerment, social marginalization, crime, the prison-industrial complex and police brutality—to mention only a few issues—center around these two groups. So even in the midst of this essentializing of the pan-Latino bond, the notion of shared conditions and the need for a strategic alliance between African Americans and Latinos is not lost. Most often it is not deemed a "natural" or "primary" bond—like those among Latino groups—but one dictated by necessity. As Fat Joe stated in Weisberg's article: "We can't change the world, but we want people to notice the importance of Latinos in hip hop. I want people to notice the power that we have in this industry. I want people to look at the bigger picture and realize that this isn't just about Latinos either. We need Blacks and Latinos to get together to show the strength of this hip hop game, we need to be the majority not the minority. Everybody needs to understand we're on the same fucking page."[21]

The combination of this discourse of Latino pan-ethnicity within hip hop with the sense that Blacks and Latinos are "on the same fucking page" has had the seemingly contradictory effect of extending hip hop authenticity—signified by a ghettocentric "nigganess"—to include all Latinos, but at the same time deepening the rifts between Caribbean Latinos and African Americans. Pan-*latinidad* has, oddly, "niggafied" certain Latino groups, such as Chicanos, through their association with New York Caribbean Latinos. Pan-*latinidad* also has meant, in the case of Puerto Ricans, that a group that was instrumental in hip hop's development and that had been historically associated with African Americans can now be held as nonblack under the assumptions of pan-*latinidad*.

These paradoxes are related to diverging assumptions about who Latinos are and what *latinidad* means. The union of Black and Latino under a hip hop "us" is thrown around more often than it is actually grappled with. Different assumptions can be at play when invoking that "us." Based on the Chicano model, one of these assumptions is that Latinos are "browns" who near Blackness, by virtue of sharing a parallel ghetto experience with African Americans (not necessarily sharing the same ghettos) and by virtue of their multiracial (heavily indigenous) makeup.[22] Another assumption regarding the conceptual underpinnings of *latinidad* is more specifically concerned with Caribbean Latinos in New York, who do share a ghetto experience with African Americans (most often the same ghettos) and an Afro-diasporic culture—thus their being even closer to Blackness.

The increasingly common reference to hip hop as a "Black and Latino" form of cultural expression cannot be understood without dwelling on the ethno-racial categories used to expand inclusiveness beyond African Americans. Puerto Ricans and other "Hispanic" Caribbeans, although Afro-diasporic peoples, are, in general, not considered and do not consider themselves "Black." Black, in its common usage in the United States as an ethno-racial category, is a synonym for African American. Exceptions are made, though, in the case of English-speaking Caribbeans. If the boundaries are stretched even more, even Francophone Caribbeans can be considered Black. But Spanish-speaking Caribbeans are a totally different story, for they are associated with the "Latino" or "Hispanic" categories rather than with Blackness or even the looser Afro-diasporic blackness. Thus, to acknowledge the historical and present role of Puerto Ricans and other Caribbean people, hip hop is explained as "Black and Latino."

HIP HOP AS "BLACK AND LATINO"

Some academic commentators have restricted their discussions of blackness, marginality and ghettocentricity within rap to African Americans[23]; others have included Latinos as coparticipants in rap's discursive and performative constructions.[24] Most frequently, the latter are content

to describe rap as a Black *and* Latino phenomenon but mention nothing about the specificities—or lack thereof—of the "Latino" experience in hip hop. Is there no mention of Latino specificities because these two groups engage—and are engaged by—blackness in the same fashion? Or are Latinos mentioned as coparticipants due to their historical and/or contemporary importance, but the subsequent discussion of blackness applies only to African Americans?

Christopher Holmes Smith describes rap in his article's introductory paragraph as "an expressive outlet for a marginalised and demonised urban social bloc that speaks with heavily black and Latino, predominantly masculine accents within a staunchly white and patriarchal social order."[25] A few pages later he refers to hip hop's "African-American and Afro-Caribbean artisans." Still later he states that although rap is a contemporary expression of an "ancient African oral tradition," it is not the product of a single ethnic culture.

One of Smith's primary focuses is on exploring hip hop performance as it relates to blackness, and he frequently refers to the African American experience. Although Smith introduces rap as an expressive form that is predominantly "black and Latino," he focuses on rap's relationship to a blackness that is discussed solely in terms of African Americans. So where does that leave Latinos with respect to blackness? How do they relate to and/or fit into it? Is this a blackness that includes Latinos? And if that is the case, why does Smith focus only on African Americans?

It is hard to answer these questions without venturing into speculation. Smith never explains why, although he describes Latinos as coformulators, with African Americans, of rap as an "expressive artistic outlet," he never mentions them again. Is it because Latinos are included within the bounds of the blackness being discussed or because they exist/create outside the scope of blackness? Who are these Latinos anyway? Smith does mention another group, aside from African Americans and Latinos, as a key participant within rap when he refers to hip hop's "Afro-Caribbean artisans." Should we then assume the "Latinos" that Smith writes about are Afro-Caribbean Latinos?

Unlike Smith, other authors have made explicit their understanding of rap's internal ethno-racial dynamics when it comes to the relationship between blackness and *latinidad*. Tricia Rose, for example, in her book *Black*

Noise contextualizes hip hop within "Afro-diasporic cultural formations," where "Spanish-speaking Caribbean" youth are explicitly included within the African diaspora.[26] Edward Sunez Rodríguez also avoids discussing an abstract *latinidad*, whose relationship to blackness is unclear or unspoken, by honing in specifically on Afro-diasporic Latinos.[27]

In Smith's case, it is not at all clear if the blackness he talks about includes Latinos (and if it does, how). Peter McLaren, on the other hand, seems to imply that "blackness" and "Latinoness" are distinct but parallel ethno-racial experiences that inform rap music: "Gangsta rap is concerned with the articulation of experiences of oppression that find their essential character among disenfranchised urban *black and Latino* populations. . . . Here, blackness (or *Latino-ness*) marks out a heritage of pain and suffering. . . ."[28] But he never explains why.

Whatever reasons authors may have for not addressing how Latinos relate to rap's ghettocentric blackness, this omission leaves a lamentable gap in the literature. Is "Latino" merely the ethnic label for a group that exists within this ghettocentric blackness? Are Latinos outside the scope of blackness? In Part II, I seek to explain how "sometimes" is the answer to both questions.

Part II

TOPICS AT THE TURN OF THE CENTURY

CHAPTER 6

LATIN@S GET HOT AND GHETTO-TROPICAL

As I explained in the last chapter, the rise of rap's ghettocentricity as a commercial trend in the latter half of the 1990s played a key role in the relegitimation in the public eye of Latinos as core participants of hip hop. This renewed legitimation manifested itself in various ways: the greater media visibility of Latino hip hop artists; the increased use of readily identifiable "Latin music" as well as Spanish words and phrases in rap songs by the most popular rap artists, both African American and Latino; and the frequent references to and images of Latinos in rhymes, videos and articles.

Rigo Morales explains in *Urban Latino Magazine*'s 1998 "hip hop issue" how the romantization of "street life" and the perceived participation of Latinos within it led to rap lyrics populated by Latino characters and references—particularly real-life gangster figures such as Manuel Noriega and Pablo Escobar, and also fictional ones such as Tony Montana, the hero of the movie *Scarface* (1983): "The fact that Latinos play a small part in today's 'game of hustle' has had a big influence on rappers who strive to prove just how 'real' or 'official' they are to the street."[1]

Although rap's trendy ghettocentrism—which has survived the turn of the century and is still going strong today—has been dominated by a celebration of a narrow and stereotyped strip of ghetto life, there exists another approach to ghettocentricity, an approach more concerned with

historicizing ghetto experiences and creativities than with glamorizing the "thug life."[2]

At a February 1999 hip hop conference at New York University, *Blaze* magazine features editor Darrell Dawsey expressed dissatisfaction with the glamorizing of a stereotypical ghetto experience within rap music and called for more rounded and multidimensional accounts of ghetto life: "I came from a so-called bad neighborhood [in Detroit], but the ice cream truck still came down my block. Nobody's mom wanted them b-boying and tagging in her living room. My mom hugged me." He lamented that these experiences typically get left out of rap's popular narratives of ghetto "reality."

KRS-ONE is a popular African American MC who advances the notion of a historicized ghettocentricity: "If rap could be put into a scientific formula the equation would be: Rap = HipHop = Urban = Ghetto = *Reality*."[3] KRS's somewhat puzzling invocation of a "scientific formula" nevertheless articulates the confluence of class, geography, youth culture, ethnicity and race within hip hop culture—particularly since a few pages later he also characterizes hip hop as being created by "inner city African youths." The Rock Steady Crew and the Zulu Nation have been key New York–based hip hop organizations that have long promoted the notion of hip hop's epicenter being U.S. "street" or "ghetto" culture. Their ghettocentric approach, like KRS's, seeks to combat commercial hip hop's tendency toward historical amnesia and does not center around glamorizing the ghetto thug life.

In an interview, B-Unique (Robert Beckett),[4] an African American MC from Williamsburg, Brooklyn, in his early twenties, explained the rise in the use of words and phrases in Spanish by African American MCs as partly informed by a history of joint ghetto experiences between Blacks and Puerto Ricans: "The main reason for that [the use of Spanish in rhymes] is the areas that they [African American MCs] live in. Ghettos are mixed with Puerto Ricans and Blacks. Like me . . . I've grown up around Puerto Ricans and Blacks so we're always together. It's almost like we're the same race. We're always rocking the same styles, the chains and the Timberlands. So when we're writing it's like giving props to my neighborhood and it's also like for all the Puerto Ricans around my neighborhood we gonna throw in a couple of words for them." But, says

B-Unique, commercial considerations have also influenced the recent trend regarding Spanish language use in rap rhymes: "I think at the Puerto Rican Parade is that a lot of rappers realize . . . Hot 97 is like 'oh the Puerto Rican parade.' They realize that like 50 percent of their fans are Puerto Rican. Guys like KRS and Puffy know that."

Rap's ghettocentricity has affected the perception of Latinos within it in various ways. The ghettocentricity trend, largely populated by stereotypical "niggas" and "bitches," "hoes" and "thugs," extends an integral role to Latinos as denizens of a bleak and hyperviolent urban scenario. The more historical ghettocentric approach likewise includes Latinos as central hip hop participants, although for reasons more related to history and lived experience than to stereotypical and violent ghetto fantasies. But, as B-Unique points out, acknowledging Latinos is not merely a disinterested creative move to paint a more complete or vivid picture of ghetto reality. Recognizing Latinos is a way of giving them "props" as much as a way to court them as consumers.

Aside from ghettocentricity, another market trend within which the legitimation of Latinos has taken place is the rediscovery and romantization of "old-school" hip hop. The latter half of the 1990s saw a renewed interest in early hip hop as a site of authenticity. Examples are numerous, so I will mention only a few. After years of virtual absence from the media, breaking was featured in a number of rap and pop videos (the Def Squad's "Rappers Delight," the Fugees' "Staying Alive," Madonna's "Rain"), as well as commercials and ads (Avirex, Gap, Lugz, Sprite, Blockbuster). Sprite promoted its product by appealing to a sense of hip hop nostalgia. One of its TV commercials was built around the infamous rivalries between rappers KRS-ONE and MC Shan. A Sprite magazine ad was based on references from the hip hop movie *Wild Style* (1982). The film itself, after being virtually impossible to find for years, was re-released on video by Rhino Records along with its soundtrack. *The Source* magazine introduced in early 1997 a regular section entitled "Hip Hop 101: Respect the Architects of Your History." A remake of the song that launched rap into the commercial limelight in 1979, "Rappers Delight," was released by Eric Sermon, Keith Murray and Redman in 1998 and enjoyed great commercial success. Its video featured dancing by b-boys and b-girls from the Rock Steady Crew.

The recognition of the key role that Puerto Ricans have played in hip hop's development has endowed them with the mystique of old-school authenticity—an authenticity that has been extended to all Latinos through notions of pan-*latinidad*. Mix that old-school mystique with the ghetto-based legitimacy previously described and, suddenly, Latinos seem to have gained full recognition. By 1998, not only had they been accepted and legitimized within hip hop, but Latino images and artists had become somewhat of a fad.

"Latinos are the move." "Latinos have been making moves." "Latinos are hot." Statements like these were uttered on innumerable occasions by the time 1999 rolled around—particularly in the year-in-review–type specials that radio stations, TV shows and magazines typically do at the end of each year.

Hot 97 (WQHT) was, until recently, New York's only radio station that featured rap and contemporary R&B all day long. Its "Morning Show" hosts on December 28, 1998, Ed and Maia, spent a good part of the show naming everything that was hot and everything that was not in 1998. What was hot? Among other things, metrocards (as opposed to tokens), the record label Def Jam (as opposed to Bad Boy) and Latinos (as opposed to "white people"). Ed and Maia did not bother explaining what was self-evident to most of their listeners. Anyone who had been paying the slightest attention to rap music in 1998 knew what they meant by pronouncing Latinos "hot."

The late Big Punisher's album *Capital Punishment* garnered huge commercial success. Noreaga (Víctor Santiago), a Lefrak City (Queens) native who proudly pronounces himself both African American and Puerto Rican,[5] hit the gold mark with his album *N.O.R.E.* During 1998, these two artists had the most guest appearances on rap and R&B recordings.[6] Roughly around the same time, Hot 97 radio host Angie Martínez, constantly referred to as the Butta Pecan Rican, enjoyed a heightened visibility and popularity through MTV appearances and guest rapping on several popular tracks, among them Grammy-nominated "Ladies' Night" with Missy Elliot, Da Brat and Lil' Kim, and "Heartbeat" with KRS-ONE, as well as in songs with MC Lyte and Beenie Man. Fat Joe's *Don Cartagena* and Cypress Hill's *Cypress Hill IV* went gold.

But Latinos being "hot" did not just point to the commercial success and media visibility of these Latino artists. Many African American rappers—such as Jay-Z, Cam'ron, Puff Daddy, Foxy Brown, Mase, Lil' Kim, Sportythieves, The Lox, Ras Kass, Outkast and Black Star—peppered their rhymes with words in Spanish.

Latinos were mentioned and celebrated in numerous popular rhymes and images. Platinum single "Uptown Baby" by African American artists Lord Tariq and Peter Gunz paid homage to hip hop's Mecca, the South Bronx. The song's catchy chorus proclaimed that, had it not been for the Bronx, rap music would not exist. Not only does it open with a horn sample from a song by Puerto Rican salsa singer Jerry Rivera, but its video includes Big Punisher as an icon of hip hop authenticity. Another South Bronx Puerto Rican hip hop celebrity, b-boy Crazy Legs, was featured in an AVIREX ad and touted as the epitome of hip hop authenticity as evidenced in the ad's caption "Authenticity: 'It's not old skool, it's not new skool, it's about the true skool!'" The video of another platinum seller, Jay-Z's "Hard Knock Life," casually closes with a representative image from Caribbean New York ghetto streets: an old man pushing a *carrito de helado* (sorbet cart) boasting *coco y piña* (coconut and pineapple) painted on the side. Puff Daddy—who now goes by P-Diddy—recorded a version of "PE 2000" that features Puerto Rican rap artist Hurricane Gee and includes footage from the Puerto Rican Day Parade and a mural in El Barrio where the faces of Pedro Albizu Campos and Ché Guevara stand side by side.

It was also during the latter part of the 1990s that Jennifer López, another Bronx Puerto Rican, became Hollywood's highest-paid Latina actress ever and an icon of sexy Latina womanhood. She gained fame through her roles in the movies *Mi Familia, Jack, Money Train, Blood and Wine, Selena, Anaconda, U-Turn* and *Out of Sight*. López's charms also had an impact in the rap music realm. She was featured as the "salsa"-dancing Tunisian princess in the video for Puff Daddy's platinum single "Been Around the World."[7] Articles on her (some focusing solely on her notorious butt) appeared in magazines that feature commercial hip hop culture, such as *Vibe, XXL* and *Ego Trip*. But López was hardly the sole Latina being drooled over. A whole slew of rap artists dedicated lines or

even whole songs to the *mamis*.[8] Latina *mamis* actually became one of the latest faddish hip hop fetishes.

At the turn of the century, Latinos in hip hop have most often been portrayed in commercial rap music as exotic virtual Blacks with the ghetto nigga stamp of approval and, particularly in the case of females, a sexualized flair. The lines uttered by a member of the Lox on Puff Daddy's 1997 hit "It's All About the Benjamins" are a great example of the double-pronged fascination with Latinos manifested in popular rap lyrics and imagery of the late 1990s: on one hand, their participation in ghetto hustles, particularly the drug business, and, on the other, the exoticized sexualization of the *mamis*. Amid the use of words in Spanish like *papi* and *gatos* and references to cocaine, cash and mafiosos, mention is made of a "Latin chick" smuggling drugs in her *chocha*.

The image of this "Latin chick"'s vagina as a vehicle for drug traffic is particularly significant, for it represents the perfect marriage of commercial rap's fixation on sexualized *mamis* and the drug business: The "*chocha*" as the ultimate and disembodied object of male desire is also the vehicle for moneymaking illicit activity. The passing reference to Sosa, the drug-dealing boss in the movie *Scarface*, is also significant as an example of commercial rap's fixation with fictional, as well as real-life, Latino outlaws.[9]

Rap music has undoubtedly been informed by stereotypical mass media Latino images, as its romantization of fictional gangsters and drug dealers illustrates. But this glamorization of and identification with Latino outlaws functions at a somewhat detached and abstract level; it parallels rap's romance with the Italian mafioso figure.[10] Yet there is another level of identification with the Latino outlaw, one rooted in lived experiences and Afro-diasporic identities and reinforced through mass media images, specifically as manifest in the New York context.

New York's Afro-diasporic multiethnic hip hop culture and the integral role of Caribbean Latinos within it has set the tone for commercial Latino hip hop images. But this subtlety remains largely unspoken. The pan-Latino aggregate thus often is awarded a blackness really meant for Caribbean Latinos.

This confusion is exemplified clearly in the "Latin *mami*" fetish that began in the late 1990s. Although most often referred to generically as Latinas, when the *mamis* populating rappers' wet dreams are referred to by their specific national origin, it is almost invariably Boricua—and in-

creasingly, Dominican—females who are invoked. And even when their Puerto Ricanness is not stated explicitly, subtle and not-so-subtle clues reveal these *mamis* as Puerto Ricans.

Puerto Rican women had had a presence in rap lyrics—nearly always as objects of desire—before salivating after *mamis* became a commercial gimmick. A Tribe Called Quest's Phife had said in 1993's song "Electric Relaxation" that his taste in women included brown, yellow, Puerto Rican and Haitian. A member of the Wu-Tang Clan, using the metaphor of ice cream flavors in 1995's "Ice Cream," lusted after Chocolate Deluxes, French Vanillas and Butta Pecans.

The difference between then and now is that a theme that used to be touched on occasionally—namely, the hot *mami*—has since the late 1990s become a market cliché. Another difference is that, as New York becomes more Dominicanized, the local long-standing interchangeability of Spanish/Hispanic/Latino for Puerto Rican has come to be expanded to include Dominicans as well.[11] Puerto Ricans used to be the prototype of the exotic/erotic New York *mami;* now Dominicans also inform that prototype.

The commercial rise of the sexualized *mami* image was not the sole province of the rap industry. The latter half of the 1990s saw an explosion of sexualized images of Latinas and Latinos. Ricky Martin, Antonio Banderas, Jennifer López and Salma Hayek became mainstream sex symbols of the turn of the millennium. Journalist Fab Serignese notes: "While the image of the thieving little Mexican bandit has morphed into a much hipper, cross-cultural urban gangster, the Latin Lover stereotype has simply gained momentum, categorizing both males and females into the insatiable sex machines that sell millions of dollars worth of liquor, clothing and makeup."[12] This renewed hunger for Latin lovers of both genders has developed not in isolation but in the midst of a general media interest in things Latino. As the March 26, 1998, *New York Times* proclaimed from the first page of its Arts Section: "Latino Culture Whirls onto Center Stage."

"SPANISH" GIRLS, *MAMIS* AND *SEÑORITAS*

Puff Daddy released "Señorita" in his platinum-selling 1997 album *No Way Out.* To the sounds of bells ringing lightly and birds tweeting—which, I guess, are supposed to evoke the sweetness of romance—he rhymes about

a woman named Carmen, who lived in Spanish Harlem, and whose father was "Louie the mechanic." A woman's voice sexily vowing eternal love is woven in with the chorus, which employs quite a few Spanish or Spanish-derived words: "*mami,*" "*papi chulo,*" "*conmigo,*" and "steelo" (probably a combination of "style" with "*estilo*"). A sample of New York Puerto Rican salsa artist La India singing a few lines from "O ella o yo" follows the chorus.

Puffy wants to be Carmen's "*papi chulo.*" Carmen is from Spanish Harlem. Her father is a mechanic called Louie. "*Mira*" is a potential way of addressing this woman whom the rapper describes as "my *señorita.*" These clues may escape those not familiar with New York Puerto Ricans. However, though her Puerto Ricanness is never expressly mentioned, there remains little doubt regarding Carmen's ethnicity.

"Señorita" is preceded by a raunchy, sexually explicit interlude where Puffy and a woman described in the song's credits as a "Spanish girl" have and talk about sex. He declares that since it's a turn-on to hear her yell in Spanish, he wants her to teach him Spanish so he can yell back at her. Given her accent, speech patterns and language use, this "Spanish girl" is decidedly Puerto Rican. She purrs about wanting to eat ("*comer*") and lick ("*lamber*") him with an unmistakably Puerto Rican substitution of "l" for "r." But, as in the song, her being Puerto Rican is not mentioned.

Like Puffy, the members of R&B group Dru Hill go weak at the knees when a Puerto Rican woman calls them "*papi.*" Their 1998 hit "How Deep Is Your Love?" features rapper Redman and was played constantly on Hot 97 over the winter of 1998–1999. Contrary to "Señorita," however, her ethnicity is directly stated.

Puff Daddy's "Señorita," Wyclef Jean's "Guantanamera," Mase's "Tell Me What You Want," Puff Daddy and the Lox's "It's All About the Benjamins," Jay-Z's "Lobster & Shrimp," Big Pun's "Still Not a Player," Will Smith's "Miami" and Cam'ron's "Horse and Carriage" and "You Don't Know" were among the rap hits of the late 1990s that made references to Latinas—all of them in terms of desire. Some of these songs make express mention of the *mamis'* ethnicity; others do not. But as we saw with Puffy's "Señorita," even when no direct mention of ethnicity is made, the *mamis* who populate these tracks are almost invariably New York Puerto Ricans.

The commercial hip hop image of the Latin *mami* is most often based on a tropicalized (virtual) blackness. The *mami* typically is taken to be an

exotic (and lighter) variation on black womanhood. I elaborate this point in chapter 7.

Latinas are certainly not the only females to get hypersexualized through rap images and rhymes. Far from it. As Antonette Irving accurately states, the role of African American women in rap has "more often than not, been limited to those voiceless images projected unto the extended wet dream of music videos."[13] Asian women also have had the questionable honor of occasionally populating rap wet dreams. Like Latinas, Asian women are viewed as erotic/exotic creatures. Unlike Latinas, however, their exoticism is not stamped by the U.S. ghetto experience spliced with images of south-of-the-border tropicalism. *Mamis* are inner-city exotics, tropicalized ghetto creatures.

Mamis are typically portrayed as brash, loud, hot, hard, street-savvy and bold—think Rosie Perez's characters in the movies *Do the Right Thing* (1989) and *White Men Can't Jump* (1992), and Rosario Dawson's Lala Bonilla in *He Got Game* (1998). This ghetto tropical spitfire exoticism differs markedly from the common exotization of Asian women based on an imputed silence and subservience.

The Latina spitfire stereotype is by no means a recent phenomenon. It has populated media images in the United States since the early decades of the twentieth century.[14] Lupe Vélez and the Carmelita character she played in various highly successful movies of the 1930s represents an early example. Rita Moreno, tellingly nicknamed "Rita the Cheetah" by the press, had a hard time breaking out of the spitfire mold in the 1950s. These early portrayals of the spitfire, as is the case with today's *mami*, typically were grounded within a gendered lower-class identity.

The next section explores the concept of tropicalizations and how it aids in understanding the racialized erotization of *mamis* as tropicalized (virtually) black women and, more generally, the contemporary position of Puerto Ricans in rap music.

A TROPICALIZED LATINIDAD

African American women have a long history of being perceived as the exotic and hypersexual Other by the white-supremacist U.S. dominant culture.[15] Within rap's heterocentric discourse where African American

male perspectives reign supreme, however, African American women are the norm, part of the ethno-racial collective Self—othered and hypersexualized for gender reasons, but in ethno-racial terms they are the familiar and familial. Puerto Rican women, on the other hand, are familiar yet still exotic. At times they may even be considered part of the family, but always one step removed. African American women are the "sistas." Puerto Rican women are the exotic and tropical "*mamis.*"[16]

The construction within rap of *mamis* as familiar erotic territory for African American men is very much premised on New York Afro-diasporic lived experiences and dynamics. New York has long been an intensely Puerto Rican city where *mamis* abound; Black–Puerto Rican desire is extremely common and fails to raise eyebrows in the way that Black-White or Black-Asian desire does.

Often boxed into the *mami* category myself, a bit of autobiographical information will help illustrate my point. The following chronicles my earliest personal introduction to New York racial/sexual politics, which occurred during a visit to the city close to a decade ago—while I still lived in Puerto Rico—at the Lower East Side apartment of a former boyfriend who was African American.

I met his mom in a casual way, without the least bit of ceremony or fanfare. He had gone out for groceries at the nearby *bodega*. As I sat at the kitchen table, his mom walked in and courteously but a bit too coolly greeted me. Then the dreadlocked matriarch busied herself with some papers in the living room.

The next time we met, however, it was a different story. As soon as I walked in the door his mom flashed a beautiful smile. "Hi! How you doing? You know, the other day I didn't realize you were his friend from Puerto Rico." Her demeanor was totally different. She came through in all her warm, witty and sharp splendor.

I later asked him what the change in attitude was all about. He responded: "She thought you were a white girl when she first met you—probably looking for adventure and some Black dick. But later she realized you were Puerto Rican."

Oh! I thought. So, I "look" white, but I "am" Puerto Rican? So, because I am Puerto Rican, she thinks my intentions have a greater chance of being honorable? I confessed to being totally confused. He explained:

"I'm sure Ma would prefer I was dating a Black woman. But Puerto Rican is at least close enough."

Through this experience and countless others, I began realizing how my Puerto Ricanness "darkened" me and placed me closer to blackness, regardless of what was often initially perceived to be a phenotypic whiteness. My light and freckled skin, straight brown hair and green eyes have led many to guess I am Italian or Jewish. My usual grungy/hippyish attire (old jeans, long skirts, no makeup) adds to my perceived whiteness. But just as many people, usually *after* they know I am Puerto Rican, have told me that my wide nose, fleshy lips, ass and hips are a dead giveaway of my nonwhiteness.

Mine is anything but an unusual story. Innumerable light-skinned Puerto Rican women have lived it, and Magdalena Gómez skillfully shaped it into the poem "To the Latin Lover I Left at the Candy Store." To her suitor she was just another "white girl" until he noticed her accent. That's when he told her he should have guessed she was a "sister" by the ampleness of her hips.

Skin tone, hair texture, facial features, butt shape, hip size, clothes, accent, demeanor, language use and last name are some of the many ethnic markers that identify Puerto Ricans and affect perceptions of their race. These markers may "lighten" or "darken" the person in question. Gómez was a "white girl" until her accent "started to show," thus transforming her in the eyes of her suitor from "white girl" to "sister." Her big hips initially had had no racial connotations. She was just a white girl with big hips. But after her Puerto Ricanness became apparent, her hips were perceived as a hint of blackness—however diluted—and a physical manifestation of her ethno-racial affiliation, thus darkening her.

The reasons why *mamis* are portrayed within rap lyrics and videos as familiar territory for African American males are related directly to African American–Puerto Rican relations in New York City, particularly as these relations express themselves through ethno-racial identity and sexual desire. However, this lived familiarity has given way to a familiarity based more on mass media images.

New York has historically been one of the epicenters of hip hop culture; it is an important source of style, trends and information. Puerto Rican women, as visible participants and objects of desire within New

York hip hop culture, thus became a familiar referent for hip hop enthusiasts across the nation. With the increasing mainstream media exposure of Latinos/Latinas, and by their having become a rap media staple, *mamis* now are imagined as familiar through a combination of the lived, imagined and media-reinforced ties that bind African Americans and Latinos.

Since the latter half of the 1990s, Puerto Ricans have been portrayed and have portrayed themselves within commercial rap music as fullfledged members of an inner-city Afro-diasporic "us." Their "tropicality," however, sets them apart from African Americans.

Frances Aparicio and Susana Chávez-Silverman advance the notion of a "tropicalized" *latinidad*.[17] They explain how *latinidad* is often associated with certain characteristics and images coded as "tropical." Those who are branded as tropical are stereotypically also deemed to be, among other things, exotic, wild and passionate. "Tropicalizations," according to Aparicio and Chávez-Silverman, can be formulated from an "Anglo" or dominant perspective ("hegemonic tropicalizations") or from the point of view of Latinos themselves ("self-tropicalizations"). These authors maintain that tropicalizations privilege culture over geography. Therefore, not only are the literally tropical regions of Latin America "tropicalized," but so is anyplace, anything or anyone else perceived to be in or from Latin America.

According to Aparicio and Chávez-Silverman, while the dominant culture's tropicalizations are rooted in "a mythic idea of *latinidad* based on . . . projections of fear," when Latinos construct themselves as tropical they sometimes subvert the dominant or hegemonic stereotypes. But though these authors hold that Latino-generated tropicalizations may resist and/or transform hegemonic tropicalizations, they emphasize that just because some Latinos choose to celebrate themselves as "tropical" does not mean that the results are necessarily liberatory. Sometimes these "self-tropicalizations" by Latinos reinforce hegemonic tropicalizations and/or are outright "oppressive in their ambiguity."[18]

Aparicio and Chávez-Silverman focus on both "hegemonic tropicalizations" and "self-tropicalizations." The difference between these two types of tropicalizing efforts resides in who is doing the tropicalizing and not necessarily in what is being said. These authors consider hegemonic tropicalizations to be oppressive by definition, whereas self-tropicalizations can be either oppressive or liberatory.

Self-tropicalizations have become more common within rap, particularly since the mid-1990s, when Latinos were legitimized in the mass media as core hip hop participants.[19] Funkdoobiest's 1997 song "Papi Chulo" provides a pertinent illustration through its invocation of the most clichéd symbols of *latinidad:* tropicalizing references to the Latin lover stereotype, mangos,[20] piña coladas, margaritas, señoritas, desperados, piñatas and shaking hips.

Although self-tropicalizations in rap abound, hegemonic tropicalizations are negligible if defined as coming from what Aparicio and Chávez-Silverman call "Anglo (or dominant)" perspectives. The European/white subject position as the voice of hegemonic tropicalization is virtually absent from rap music's discursive and performative terrain.

As a realm commercially dominated by African American subjectivities, rap provides a venue to explore another instance of tropicalization that can be described as neither hegemonic nor self-ascribed. The recent flurry of tropicalized Latino images in rap lyrics and videos has been formulated predominantly by neither whites nor Latinos but by African Americans.

African Americans' tropicalization of Latinos in rap is often indistinguishable in content from "the mythic idea of *latinidad*"[21] in hegemonic tropicalizations; rap's self-tropicalizations, incidentally (and tragically), do not differ much in content from hegemonic tropicalizations either. Sensuality, heat, romance, passion, voluptuousness, vibrant color, frenetic rhythm, sinuous movement and spice are some of the mythical characteristics that define a tropicalized *latinidad*. These ascribed traits are almost invariably present in tropicalizations, whether they are hegemonic, Latino-generated or formulated from an African American perspective. However, whereas hegemonic (white-supremacist) perspectives typically portray tropicality as dangerous and subservient, rap's subaltern-generated tropicalizations (whether formulated from the perspective of African Americans or Caribbean Latinos) do not inscribe "the tropical" with assumptions of inferiority—unless "the tropical" is gendered as feminine.

Tropicalizations within rap privilege and celebrate Afro-diasporic (black) subjectivities, be they African American or Caribbean Latino; rap's black subjects may tropicalize, be tropicalized or self-tropicalize.

Tropicalizations serve to distinguish between two subaltern Afrodiasporic groups. African Americans and Puerto Ricans are the black protagonists of rap's ghettocentric narratives; but only Puerto Ricans—and by extension, other Latinos—are ghetto-tropical.

Puerto Ricans, as Caribbean Latinos, have an ambiguous and shifting relationship to rap's normative blackness. Black, almost black, tepidly black, light black, brown, not quite black . . . their tropicalized *latinidad* distinguishes Puerto Ricans from "regular black folk" (to paraphrase one of the characters in Ntozake Shange's play *For Black Girls Who've Considered Suicide/When the Rainbow Is Enuf*).

Most discussions of *latinidad* focus on its relationship to the dominant U.S. white/Anglo/European culture.[22] These accounts slight another crucial point of reference against which *latinidad* is defined, namely African American culture. This point of reference is particularly relevant in the lived experience of Caribbean Latino groups in New York City.

For Puerto Ricans in New York, *latinidad* has as much to do with not being white as it has to do with not being African American. Piri Thomas's 1967 *Down These Mean Streets* is an epochal[23] example of how a young Puerto Rican's identity and circumstances are shaped by a difference that distinguishes him from whites as well as from African Americans, but where the differences between Puerto Ricans and African Americans are minimized by virtue of a shared history and lived circumstances. But the relationship between these two groups is not always an issue of difference. Puerto Rican identity in New York, although at times defined in contrast to African Americanness, is at other times defined in conjunction with it. Hip hop culture is a venue through which Puerto Rican *latinidad* in the United States can be explored, not by privileging the Anglo/Latino or dominant/subaltern dynamic but by focusing on the interactions of African Americans, Puerto Ricans and other Caribbean populations.

The next chapter explores the way in which a gendered and tropicalized *latinidad*, embodied by the *mami* figure, intersects with blackness in mass-mediated rap discourses.

CHAPTER 7

BUTTA PECAN MAMIS

TROPICALIZED *MAMIS:* "CHOCOLATÉ CALIENTÉ"

An advertisement for the 1998 album *The Rude Awakening* by the Cocoa Brovas, a rap duo of African American MCs, features a cardboard cup—the kind with the blue-and-white "Greek" motifs, common in New York delis and *bodegas*—full of steaming cocoa.[1] Six chocolate-drenched young women are partially immersed in the liquid. On the right-hand side of the cup appear the erroneously accented words "Chocolaté Calienté."

The Spanish words seem to indicate that these women, or at least some of them, swirling in hot chocolate and sexily awaiting ingestion are Latinas. They are all various shades of caramel, unquestionably black by this country's standards but still light-skinned. Their relative lightness, and the fact that all but one have straight or slightly wavy hair, goes along with the butta pecan myth[2]—in other words, the stereotype of Puerto Ricans and other Latinas as golden-skinned (hence the association with butter pecan ice cream) and "good-haired" [*sic!*].[3] But butta pecan is somehow still imagined to be a variation on chocolate. Butta pecans are, after all, a crucial ingredient in the Cocoa Brovas' recipe for chocolaté calienté. The bottom line is that these hot cocoa girls' *latinidad* does not take away from their blackness. What their *latinidad* does do is add an element of exoticism—signified through the ad's use of Spanish—to their blackness.

The accentuation of words that, according to Spanish orthographic rules, should not be accented serves to further intensify a sense of exoticism. Accents are deemed exotic characteristics of an exotic language. Whether this accentuation was a mistake or was done on purpose does not change the fact that the accents in "chocolaté" and "calienté" serve as tropicalizing markers of difference that distinguish *mamis* from other black women.

Let us move on to another example of how Puerto Rican women are portrayed as ghetto-tropical, lighter-skinned variations on black femininity. "Set Trippin," a review of ten popular rap videos in *Blaze* magazine's premier issue, includes Big Punisher's hit song "Still Not a Player." The reviews by Rubin Keyser Carasco consist of short blurbs under specific headings, such as "Plot," "Ghetto Fabulous," "Estimated Budget" and "Black Erotica." Under "Black Erotica," the text reads, regarding "Still Not a Player": "Dozens of scantily clad, lighter-than-a-paper-bag sistas and mamis end up dancing outside. Sounds like a red-light district."

It is significant that the "Black Erotica" category includes mention of both "sistas" and "mamis." While these may be two ethnically distinct female populations, Carasco includes them both in the realm of eroticized blackness. The fact that their light skin tone makes the set seem like "a red-light district" is a commentary on gendered "color-caste hierarchies"[4] that equate "lightness" with sexual desirability as well as an acknowledgment of the prostitute as the embodiment of male sexual fantasy. Considering the common coding of Puerto Ricanness as butta pecanness, it is evident that their attributed phenotypic "lightness" plays a part in the collective erotization of Puerto Rican females.[5]

The text of the song itself poses Puerto Rican and African American women as two distinct groups. Its singsong chorus, which consists of multiple repetitions of "Boricua, Morena," differentiates these two groups of women through the use of New York Puerto Rican ethno-racializing terminology. The video adds a visual dimension to the distinction as the camera alternates between a group of lighter-skinned women when the word "Boricua" is being uttered and a group of comparatively darker-skinned women when the chorus mentions "Morena." The tiny chihuahua that one of the Boricuas is holding serves as yet another mark of

difference. In New York City lore, chihuahuas are a dog breed considered to be popular among Puerto Ricans, and they also invoke the tropicalized pan-*latinidad* of Dinky, the famous chihuahua of the late 1990s' Taco Bell commercial campaign. However, although distinct, these two groups come together by virtue of Pun's sexual desire.

In this song, Pun boasts of not discriminating since he sexually engages "every shade of that ass." But the span of the "shades" that he "regulates" goes from blackberry molasses to butta pecan. Using the language of "gastronomic sexuality"[6] that also informs the Cocoa Brovas ad, Pun focuses his desire on African American and Puerto Rican "ghetto brunette[s]." *Boricuas* and *morenas* may be distinct, but, as Pun constructs them, they are both sweet, thick, pretty, round and various shades of brown. And, evidently, that is how he likes his "hoes."

African American rapper Jay Z., in "Who You Witt II?" defines the ethno-racial span of his sexual desire in a closely related manner when he claims to sexually engage "around the way" women as well as *"miras."* "Mira" is used as a reference to Puerto Ricans—and perhaps, by extension, other Caribbean Latino women. It comes from Puerto Ricans' frequent use of the word *"mira"* ("look") at the beginning of sentences or as a way to get someone's attention.

While not focusing on Puerto Rican women specifically but on Latinas in general, West Coast Puerto Rican artist Son Doobie expresses similar preferences in Funkdoobiest's 1995 "XXX Funk." He boasts that both "black" women and "brown" women "know my name." Whereas Big Punisher makes use of the dichotomy *boricua/morena,* Son relies on a brown/black distinction. Both MCs, however, aim to distinguish Latinas from African Americans and, at the same time, chromatically identify both groups as objects of desire. Son goes one step further than Punisher because he not only celebrates the "black" and "brown" women he likes but explicitly poses thin, "pale bitches" with breast implants—as their opposite.

The Cocoa Brovas ad, Big Pun's "Still Not a Player" video and Son Doobie's and Jay Z's pronouncements are all part of rap's commercially dominant ghetto "nigga" discourse, where African American and Caribbean Latino men construct a landscape of desire in which *sistas* and *mamis* take center stage as "their" women.

Actress Jennifer López's ass is a good example of how Puerto Rican *mamis* have been eroticized within the hip hop zone as tropical Butta Pecan Ricans part of a ghetto black "us." As Frances Negrón-Muntaner has noted, "for any Caribbean interlocutor, references to this part of the human anatomy are often a way to speak of Africa in(side) America."[7] López's status as a turn-of-the-century mainstream sex symbol and the totemization of her buttocks have shaped as well as been informed by popular perceptions of Caribbean Latina womanhood and their racial underpinnings, including those within the hip hop zone.

TROPICALIZED *MAMIS:* JENNIFER'S BUTT

> *Unlike hair and skin, the butt is stubborn, immutable—it can't be hot-combed or straightened or bleached into submission. . . . And the butt's blatantly sexual nature makes it seem that much more belligerent in its refusal to go away, to lie down and play dead.*
> —Erin Aubry, "The Butt: Its Profanity, Its Politics, Its Power"

Welcome to the Realm of the Big Butt Cult. African American rappers Sir Mix-a-Lot and LL Cool J have celebrated strategically placed fatty tissue in their songs "Baby Got Back" and "Big Ol' Butt." Panamanian reggae artist El General has exalted voluminous backsides in "Tu Pum Pum." Island Puerto Rican rapper Vico C has given props to big butts in "Bomba para afincar," and so has Bronx Puerto Rican Fat Joe in "Shorty Gotta Fat Ass."

So central are female *nalgas* (butts) and *caderas* (hips) in the discourse of Afro-diasporic male desire that Frances Aparicio dedicated a chapter entitled "Patriarchal Synecdoques: Of Women's Butts and Feminist Rebuttals" to exploring Latino Caribbean music's (lower) body politics.[8] Negrón-Muntaner also identifies "the butt" as a compelling dimension of Afro-diasporic cultural discourses and practices that deal with sexuality, pleasure, power and the body.[9]

Iris Chacón, a Puerto Rican dancer and singer whose most celebrated asset was most often clad in a g-string, went beyond stardom to acquire mythical status through her immensely popular prime-time Spanish-language TV show of the 1970s and 1980s: *El Show de Iris Chacón.* Negrón-

Muntaner identifies Bronx Puerto Rican actress Jennifer López as a symbolic heiress of Iris Chacón, describing her historical role as that of "the next big bottom in the Puerto Rican cultural imaginary and our great avenger of Anglo analphobia."[10]

López's butt, although initially eyed with worry and deemed in need of camouflage by Hollywood costume designers, has ended up being embraced by the mainstream media. Teresa Wiltz declared in the *Daily News* that López's posterior has "become something of a national obsession." *Entertainment Weekly* pronounced it "an erotic totem up there with Uma Thurman's lips and Pamela Anderson Lee's bust."[11] It has also been written about in *Time* magazine, *Playboy* and *Elle,* among numerous other print media.

A few perceptive observers have noticed how this actress's mainstream acceptance is related to her "embodying ideal 'Latin' beauty . . . neither too dark, nor too light."[12] However, these racial underpinnings of her acceptance have only rarely been discussed.

Jennifer López and her ass also have loomed large in the hip hop collective conscious as the embodiment of Latina desirability. In a *Vibe* article by dream hampton, she was pronounced "the biggest explosion outta the Bronx since the birth of hip hop."[13] Yeah, yeah . . . pretty eyes, flawless (light) skin, flowing (straight) hair, sharp "ghetto" wit. . . . But López might not be the sex icon she has become were it not for her voluminous ass cheeks. As Goldie wrote in the aptly entitled article "Ass Rules Everything Around Us" for hip hop music magazine *XXL: "ButtaPecanRican.* What makes Lopez lovely is not her sexy looks, her unbelievably flawless face or her nut-wrenching aura. It's her ass. It's not a special ass, because most Black women are born with ass like this, but JL makes it work. The half-circle. The sphere."[14]

According to Goldie, López's is a "Black" ass—mystifying to white men and revered by Black and Puerto Rican males. Puerto Ricans thus stand together with African Americans as admirers and/or bearers of voluminous black asses. Implicit in his argument is that Puerto Rican men know how to appreciate this feature of blackness because Puerto Ricans are part of it. Likewise, hampton describes López's butt as a feature of her blackness: "Women like her—namely black women—haven't exactly had issues of shame when it comes to that particular body part. In most sectors of our community, the bigger the better."[15]

Cristina Verán celebrates in *Ego Trip*—another hip hop music-oriented publication—"this pear-shaped Puerto Riqueña" for "single-handedly spearheading a big booty backlash against the supermodel types who espouse Schindler's List chic." Now not only can "los brothas on both sides of the border" feast their eyes on a gluteus after their own heart, but "women of color" can rejoice in a feminine icon that does not conform to "the blonder beauty barometer of Los Blancos." Verán, like Goldie, posits an "us" that includes Puerto Ricans (and other Latinos) and Blacks, and according to which Jennifer López, the Hottentot Venus and Iris Chacón are upheld as "our" images. "From the 19th Century's South African spectacle—unique-physiqued Venus Hottentot's humongous hindquarters—to the Risqué Rican TV variety vixen Iris Chacón and her bombastic Boricua booty, we've got a lengthy legacy of well-endowed icons of our own to look up to."[16]

After a few years of butt-related hype, references to J-Lo's anatomy have even crept into her own repertoire. Her song "Ain't It Funny," featuring African American rapper Ja-Rule and included in her 2002 album *J To Tha L-O!*, has him declaring that it is her fat ass that has made him crazy over her.

López's butt has been celebrated within the commercial hip hop realm as a vindication of "our" Afro-diasporic standards of beauty. In contrast, her ass has been celebrated in the mainstream media as a mark of the dark Other's racial/sexual difference. Dark Others with big asses may come a dime a dozen, but López's "racially nebulous features" or relatively "more Caucasian features" make her a palatable embodiment of racialized/sexualized difference.[17] For the mainstream, she has been the tropical, dark-enough—but not too dark—and big-assed exception to the Eurocentric rule.

While the mainstream celebrates the Other's big ass, "our" ass gets celebrated by African Americans and Latinos within the rap music realm. Both realms coincide in ignoring how approximation to whiteness is privileged even when the object of appreciation is nonwhite. *XXL* columnist Goldie allows that most black women have a butt like López's. The reason why her bottom is famous and other big black bottoms are not is, according to him, that "JL makes it work." Perhaps López does have a certain something that makes her ass seem extra special. But doesn't it

seem too much in accordance with Eurocentric aesthetic hierarchies that a very light-skinned, straight-haired—white, by Latin American standards—woman is the icon celebrated for her so-called black ass?

Eurocentric aesthetic standards have historically informed Afro-diasporic standards of beauty. This is visible in what bell hooks has termed color-caste hierarchies, which, as she explains, are related not only to skin color but also to hair texture and other physical features. These hierarchies are also very gender-specific.

> The exploitative and oppressive nature of color-caste systems in white supremacist society has always had a gendered component. A mixture of racist and sexist thinking informs the way color-caste hierarchies detrimentally affect the lives of black females differently from black males. Light skin and long, straight hair continue to be traits that define female as beautiful and desirable in the racist white imagination and in the colonized black mind set. . . . To this day, the images of black female bitchiness, evil temper and treachery continue to be marked by darker skin. . . . Dark skin is stereotypically coded in the racist, sexist or colonized imagination as masculine. Hence, a male's power is enhanced by dark looks while a female's dark looks diminish her femininity.[18]

Among Afro-diasporic populations, lighter-skinned black women have been thought of as prettier, sexier and more feminine than darker women. Good hair/bad hair (*pelo bueno/pelo malo*) distinctions have been routinely made and are also gender-coded.[19] It is significant, for example, that the *mulata* has been the figure posed in the musical and literary traditions of the Spanish-speaking Caribbean "as the embodiment of rhythm, movement, and erotic pleasure."[20] The lighter beauty of the *mulata* has been privileged over darker female beauty.

Color-caste hierarchies also have been very much a part of hip hop music. On one hand, rap videos present a wider range of Afro-diasporic female beauty than many other contemporary entertainment mediums. According to rap and R&B video actress Anansa Sims: "To me, you'll find the most beautiful Black women in videos because it's where we're allowed to show our natural shapes—the big butts, breasts, and the thick thighs."[21]

Slightly fuller female figures are the norm in rap and R&B videos, although they still are ruled by a cult of thinness. Sims's pronouncement does have a ring of truth to it with regard to body shape; however, the issue of color and other phenotypic characteristics is a whole other story. Rap videos and magazine spreads usually feature light-brown young females with long hair—be it naturally nonnappy, straightened or "weaved"—who are upheld as the epitome of female black beauty but run counter to the blackest, nappiest philosophy championed elsewhere. It seems that while naps and dark skin in men are a proud symbol of blackness, the same physical traits in women are perceived as questionable because they are deemed unattractive, unkempt, unfeminine, menacing, butch.

The Source's Second Annual Swimsuit Issue, published in June 1997, presents an illustration of color-caste hierarchies at work. The problematic character of this pictorial representation was noted by a *Source* reader by the name of Shannon who wrote in a letter to the editors: "Why oh why would you choose six slim, sexy, nearly white models? Are you dissing Black hip-hop culture? Can't you see that your representation of the 'hip-hop woman' is very misguided? A much more balanced and healthy view of hip-hop women is in order."[22]

Jennifer López's quintessential butta pecanness places her high in hip hop color-caste hierarchies. Her lightness combined with her being Puerto Rican, however, may have been a hindrance during rap's Afrocentric stage—before Latinos(as) were reclaimed as bona fide members of a ghettocentric hip hop "us." But as rap has shifted in emphasis from Afrocentricity to ghettocentricity, Puerto Ricanness and blackness have more often come to be seen as overlapping—though not always smoothly, as shown by the controversy among rap enthusiasts over López's use of the word "nigga" in her song "I'm Real." The phenotypic range of black female beauty has been expanded somewhat to accommodate light-skinned Caribbean Latinas. This expansion tends to be celebrated as an acknowledgment of the ethno-racial diversity and complexity of the black experience in the Americas.

But what about the problem of color-caste hierarchies? They are still in effect, of course, perhaps now being even more vicious and still most often going unacknowledged. Within this celebration of a multihued

blackness, proximity to whiteness can be given even more privilege, but cloaked under the guise of Afro-diasporic inclusiveness.

Sadly, this all sounds eerily reminiscent of the Puerto Rican—and more generally, Latin American—tactic of deflecting accusations of racism by raising the banner of miscegenation.[23] *Us? Racists? Gringos are racists, but not us. We can't be racists, because we are all racially mixed here.* Ramón Grosfogel and Frances Negrón-Muntaner explain: "According to this ideology, all Puerto Ricans regardless of 'race' are the mixture of the same ethnic ingredients—Spanish, African, Indian—and therefore equal. This superficially more benign form of racist ideology is often as, *if not more*, effective than more overt racist discourses in preventing racism from being socially and politically challenged in public discourse."[24]

If historian Carl Degler was right in affirming that racial identity and categories in the United States have, since the 1960s, begun converging more with those of Latin America,[25] then hip hop may be a pertinent example. And if that is the case, we are up against some thorny challenges indeed. *Us? Privileging whiteness? Never! We are all black here and just celebrating all dimensions of blackness.*

And thus, Jennifer López, a tropicalized *mami* who practically dangles from the lightest end in the spectrum of blackness, gets celebrated as the totemic bearer of the big black butt.

ENCHILADA RHYMES AND THE "MARK OF THE PLURAL"

In a room dimly lit by candles, a Tunisian princess—played by Jennifer López—displays fiery Eddie Torres–type salsa moves as the hip hop beat in Puff Daddy and Mase's video "Been Around the World" switches to sounds more appropriately "Latin." Ras Kass, a West Coast–based African American MC, passionately describes in his 1998 song "Lapdance" a Guyanese stripper as a "tropical Latin American *mami*" with a "fat derriere" who put her crotch in his face and "worked it with a Latin thing."

Both images are constructed on the basis of a patriarchal desire that eroticizes and exoticizes. The heat and mystery that the images convey is

all that matters. Tunisian princesses are deemed exotic, so they are spliced with exotic lustful *mamis* from the other side of the Atlantic. The tropicalized enchantment of Spanish-speaking *mamis* is extended to other women, thus stretching the *mami* category into oblivion. Who cares if Guyanese are not Spanish-speaking Latin Americans? After all, accuracy and specificity never did much for exoticism.[26]

Rap images, in this sense, are influenced by a larger culture that tends to splice together aspects of interchangeable "exotic" cultures, stamping them with what Albert Memmi terms the "mark of the plural." What is important is not these cultures' specificities but the feeling of desire, mystery, adventure, danger, revulsion and/or pleasure that they evoke. Ella Shohat offers as examples the silent-era films that "included eroticized dances, featuring a rather improbable mélange of Spanish and Indian dances, plus a touch of belly dancing [and the] superimposition in Orientalist paintings of the visual traces of civilizations as diverse as Arab, Persian, Chinese and Indian into a single feature of the exotic Orient."[27]

Ana M. López offers a few examples from 1940s' Hollywood films to illustrate the way in which, from the hegemonic U.S. perspective, inter–Latin American differences are masked behind the sign of *latinidad:* "all Latins and Latin Americans were from South of the Border and *that* border was the only one that mattered as far as Hollywood was concerned. Thus Carmen Miranda is incongruously 'Brazilian' in a studio-produced Argentina (*Down Argentine Way* ... 1940) and Cuba (*Weekend in Havana* ... 1941). ..."[28] Other examples include *Too Many Girls* (1940) with Desi Arnaz as an Argentinian student in a New Mexico college who plays conga drums; *Fiesta* (1947), where Ricardo Montalbán plays a Mexican classical composer who dances Spanish flamenco; and *Anchors Aweigh* (1945), which features Gene Kelly as an Anglo sailor who dances a "Mexican Hat Dance" to the sounds of the Argentinian tango "La cumparsita."[29]

The tropicalized *mamis* of rap's imaginary, as well as the filmic examples of "the mark of the plural," are informed by centuries-old colonialist imaginaries.[30] The classic cinematic "rescue" fantasy where the Western man is both civilizer and savior is present, for example, in Puffy's "Been

Around the World" video. In this case, the U.S. Black male subject is the inheritor of Western (white) imperial discourses where the colonized territory and its inhabitants are constructed through gendered metaphors. The female Other (the "Latin"-dancing Tunisian princess) is the coveted object of desire, while the male Other (in the form of the stereotypical "Arab assassin") is the evil native from whom the Western hero must rescue the exotic damsel in distress. Jennifer López, as the video's Tunisian princess, bears "the mark of the plural" and is portrayed as an exotic blend of Arab royalty and tropicalized *mami* heat.

The ubiquitousness of the eroticized *mami* in rap videos and rhymes has been accompanied by a canned, stale and tropicalized injection of Spanish words and phrases into mostly English rhymes. Mase and Total's hit "Tell Me What You Want" provides what is perhaps the best (and corniest) example. In the song, Mase beckons a certain "mama" to come to "papa"; he gives her the phone number to his "casa" and asks her to call him "*mañana.*"

One of the most pleasurable aspects of the art of MCing is its mastery, manipulations and innovations based on urban vernacular language—particularly the so-called nonstandard or broken kinds.[31] Behold the simplicity and evocativeness of Guru passing the *bodega* and saying "*suave,*" Hurricane Gee dissing the "*pollos* in snakeskin stilettos," Jeru referring to cocaine as "*perico,*" Tony Touch rhyming "*títeres*" with "freakin' it," and Cam'ron's line about "Jimmy Jones frontin' in the *chancletas.*" Now compare their witty references and wordplay to Mase insipidly rhyming "mama" with "papa," "fatha" with "*casa,*" and "*mañana*" with "*enchilada.*" The clincher is his use of the quintessential cliché "the whole enchilada," particularly given its stereotypical evocation of Mexican food as if it had anything to do with the *mami* he courts. This is not an argument for Mase's language "inauthenticity." But it is important to distinguish rhymes that make skilled use of urban street vernacular(s) from those that pretend to but do not.

Ethnicity is certainly not the factor that determines whether an artist's infusion of Spanish into his or her lyrics is creative or clichéd. Of the MCs whose rhymes I praised before, two are Puerto Rican—Hurricane Gee and Tony Touch—and the other three are African American. By the

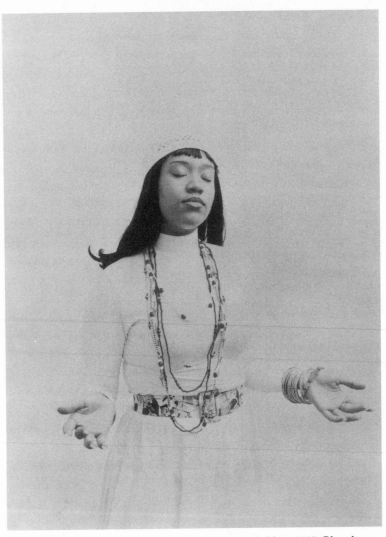

Hurricane G during her one-year yaboraje *as a santería initiate, 1997. Photo by Erin Patrice O'Brien.*

same token, Mase may be African American, but Puerto Rican rappers often resort to similarly stereotypical language practices.

This tropicalized and trite use of Spanish is addressed in Danny Hoch's theater piece *Jails, Hospitals & Hip-Hop*. His character Emcee Enuff offers the audience a rhyme from his new album:

> Mister Big Poppa, flashin' a hun'ed dolla
> Poppin' Cristal at the club, doin' the *cha-cha*
> Actin' drunk, talkin' to *mama*, sayin' *la la*
> Where is the joy? That shit is *caca, da-da*[32]

Hoch parodies here not only the simplistic and contrived use of Spanish or Spanish-sounding words, but also commercial rap's fascination with the high life and all its trappings, which includes money, champagne—Cristal—and a surplus of *mamis*.

The Atlanta-based African American rap duo Outkast likewise pokes fun at rap's gimmicky use of Spanish words and *mami* fetishism.[33] In a song entitled "Mamacita," references to rice and beans are intertwined with a description of a woman lusting after her girlfriend as a "pit mixed with a chihuahua"—rice, beans and chihuahuas being markings of *latinidad*. The next verse has guest artist Witchdoctor rhyming about a "Miss Bilingual" whom he's trying to get horny by serving her Moët champagne. The irony in this song is subtle. One can almost miss its tongue-in-cheek reproduction of rap's clichéd references to the *mamis*. But clues like Witchdoctor saying that the *mami*'s speaking Spanish "got me feeling mannish" reveal that Outkast is making fun of rappers who brandish *mamis* as exotic trophies of their manliness.

The Source magazine editor-in-chief Carlito Rodríguez[34] lamented in an interview that the *mami* gimmick was still going strong in 2001: "Everyone wants a Spanish mami in their video. I think you need balance. Don't get me wrong, I'm full-blooded Latino; I love that too but sometimes, coño, alright, I've seen cuter girls before. You get tired of it. There's more to Latinas than that."[35] Despite these internal rumbles of discontent regarding the *mami*-related clichés, rap's obsessing over

Latinas may not have yet reached saturation levels as a commercial trend. So brace yourself: We may yet be in for quite a few more *mami*-focused "enchilada rhymes."

The "mark of the plural" poses diverse "exotic" cultural signifiers as equivalent; thus, enchiladas, mangos, rice and beans, tango, salsa and flamenco can all be tropicalizing symbols of pan-*latinidad*. Furthermore, according to the logic of the "mark of the plural," women of diverse cultural backgrounds are interchangeable. *Puerto Rican, Dominican, Chicana, Argentinian, Guyanese . . . What's the difference? Who cares? They are all hot Latin* mamis, *aren't they?*

The "mark of the plural," as a trope of Eurocentric colonialist thought, though affecting the males differently from females, still encompasses both genders. But there is another such "mark" that is made to apply to women specifically—all women, not just those defined as subaltern in the colonialist discourse. Frances Aparicio writes of a "pluralizing of Woman (Woman as multiplicity)" that "not only maps the geography of a Latin male gaze and desire, but most centrally, it delineates a Don Juan subjectivity whose desire and libidinal economy are never static nor totally satisfied."[36] Although concentrating her discussion on representations of women in Latin American music, Aparicio acknowledges the transcultural character of this phenomenon. Unsurprisingly, rap is also ruled by an I-want-them-all mentality, where women—whether *sistas* or *mamis*—are not real subjects, complex and distinct, but interchangeable sources of masculine pleasure or pain. Funkdoobiest expresses this sentiment in particularly raw terms in their 1995 song "Pussy Ain't Shit," where they say "fuck the pussy" and then discard it; though "bitches" act like that part of their bodies is precious, to them, one pussy is the same as the next. Or as Noreaga says in 1998's "N.O.R.E.": He "fucks" the same woman twice only if she kneels and begs.

MAMIS SPEAK

Yo estoy cansá de la mielda que yo oigo en el radio y que veo en MTV, porque cuando yo veo a esas mujeres bellas, lindas, en little bikinis shaking their ass like that's all they're good for, eso me dice a mi, coño, they don't

*have no kind of hope. No tienen esa fé de que podemos cambiar este
mundo, que algo viene, algo bueno nos espera. Eso me rompe el alma.*[37]

—La Bruja

African American female rap artists, although radically fewer in number
than their male counterparts, and although severely constrained by patri-
archal notions of appropriate/desirable/profitable female images and cre-
ativity, have managed to make inroads in this male-dominated realm.
Lauryn Hill, Missy "Misdemeanor" Elliott, Foxy Brown, Lil' Kim, Mia
X, Eve, Da Brat, MC Lyte, Heather B, Bahamadia and Queen Latifah
are some of the better-known African American female rap artists. With-
out their diverse creative voices, Black female subjectivity within rap
would be limited to male representations of female subjectivity and would
be overwhelmingly one-dimensional.

The case of Latinas, however, is another story. The only Latinas to
have garnered considerable media visibility as solo artists in the "core" hip
hop music market—as opposed to the *rap en español* niche—have been
two New York Puerto Ricans. First, there was the Real Roxanne (Joanne
Martínez) who appeared in the rap scene in 1984, right in the middle of
the flurry of "Roxanne" response records spurred by UTFO's hit single
"Roxanne, Roxanne." Since the Real Roxanne's heyday, there was no
other Latina of comparable visibility until New York radio jock Angie
Martínez began making inroads in the rap scene during the late 1990s
through brief guest appearances on other artists' recordings. Within a few
years, she landed a deal with Elektra and released her debut album *Up
Close and Personal* in the spring of 2001.

The only other Latina MC to have garnered some media recognition
is Hurricane G (Gloria Rodríguez), a seasoned artist who has collabo-
rated with Redman, Eric Sermon, Keith Murray, Busta Rhymes, Xzibit,
Cocoa Brovas, Puff Daddy and Funkdoobiest. G, also a New York Puerto
Rican, released her first and only solo album in 1997, titled *All Woman*. It
is significant that although *mamis* have been high on many a rapper's sex-
ual agenda, Hurricane G has not reaped commercial rewards from rap's
mami fetish. All this obsessing over *mamis* and the better-known Latina
MC with solid lyrical skills and underground credentials—although not
large-scale commercial success—hardly gets any play?

Angie Martínez's media visibility, contrary to Hurricane G's, seems to have benefited considerably from hip hop's newfound appreciation for the *mamis*. Though G is the stronger and more seasoned MC of the two, it is Martínez who has gotten the most commercially visible rhyming gigs. Could it be that Martínez's image is deemed more marketable than Hurricane G's? Could it have to do with the fact that, while Martínez's looks are quintessential "butta pecan," G is straight-up black?

Hurricane G's complex and strong subjectivity indisputably clashes with the hot-and-compliant mythical *mami* subjectivities being celebrated. When I asked a young Puerto Rican MC/producer what he thought of Hurricane G as an artist, his lack of enthusiasm for her work centered on her not being "ladylike." As he said, "women rappers have to be ladies to get treated as ladies." Such notions regarding appropriate female images are not *mami*-specific. Both African American and Latina MCs are affected by these types of gender-based limitations and expectations.

According to Jeff Fenster, then vice president of A&R at the record label Jive, "males just don't want to hear hard things from women." That, combined with comparatively less label support for women, is the reason Fenster gives as to why African American female rap artists Boss, Yo-Yo and Queen Latifah did not fare well in terms of sales.[38] Un Rivera, rap producer, video director and president of the labels Undeas Records and Untertainment, gives credence to Fenster's pronouncements in his account of shaping Lil' Kim's image: "I used to buy Kim her clothes . . . Me and Big used to go back and forth with ideas trying to figure what is it that niggas wanted to see. *Maybe,* they want to hear about Kim fuckin'. So, we started makin' records like that."[39]

Hurricane G is neither focused on exploiting her sexual appeal, as Kim is, nor is she a quintessential butta pecan *mami* like Martínez. She is a powerful and skilled Puerto Rican black woman MC who projects herself multidimensionally as loving, faithful, dedicated, horny, aggressive, demanding, vulnerable and spiteful, depending on the situation. The wounded lover who struggles to maintain her self-respect in "Somebody Else" gives way to the hard-rock MC from "Underground Lockdown." She goes from thankful and dutiful daughter in "Mamá" to lustful and eager to please lover in "Boricua Mami." She is also the mother who bit-

terly pokes fun at her lying and irresponsible baby's father as she kicks him out of her life. Whereas Hurricane G is, as her 1997 album title proclaims, *All Woman,* complex and ever-evolving, the mythical *mamis* of rap songs are simple and cartoonish. When their voices are heard, they are almost invariably sensuous creatures whose only interests are material goods and sexual pleasure.

We hear Puff Daddy's "Spanish girl" in the interlude right before the song "Señorita" slurping as she performs oral sex, moaning and teaching him a couple of phrases for hot pillow talk. All the while, as if to create a properly tropical ambiance, Cachao's "Descarga cubana" is playing in the background. During "Señorita" itself, two female voices are heard. One, presumably the song's subject, vows that she will be his forever. The second comes from a sample of a song by salsa singer La India where she accuses her lover of lying to her.

The "mamacita" of Cam'ron's "Horse and Carriage" video speaks once, exclaiming delightedly: "Oh, you're going to buy me diamonds!" Like Cam'ron's gold-digging *mami,* Puffy raps in "Señorita" about a woman who, presumably, shares his luxury-obsessed mentality. He attempts to charm her by promising to keep her laden with jewelry and thousand-dollar shoes, and detailing all the other material goods he is able to offer her.

In a notorious interlude, entitled "Taster's Choice," in Big Punisher's debut album, two Puerto Rican *mamis* get it on with the rapper. Their exchange takes place mostly in English but is peppered by words and phrases like "*ay, que grande,*" "*mámame la chocha*" and "*castígame*" ("oh, how big," "lick my pussy" and "punish me"). Amid slurping sounds, moans and a creaking bed, a fight breaks out between "Joanne" and "Lissette" as they both compete to be penetrated by Pun's "dick."

The Puerto Rican *mami* of R&B crooners Dru Hill's "How Deep Is Your Love?" (featuring rapper Redman) coos how much she misses her "*papi morenito*" and begs him to "*dámelo duro*" ("give it to me hard"). DJ Enuff, a Puerto Rican DJ who is part of radio station Hot 97's "Morning Show," has occasionally slipped in between songs a sample of a woman moaning: "*Ay, papi.*"

Black Star, an African American duo from New York, offers one of the welcome exceptions to this legion of sexually explicit caricatures of Latinas. In a beautifully crafted 1998 song entitled "Respiration" that plays

with the notion of the city as a breathing organism, a woman's voice opens the track: "*Escúchala, la ciudad respirando*" ("Listen to the city breathing"). Her words are immediately followed by the guitar chords that establish from the beginning the reflexive, bordering on melancholic, mood of the song. The chorus offers a good example of how Mos Def, Talib Kweli and guest artist Common skillfully weave together images and feelings based on their home cities—New York for Black Star, Chicago for Common. Right after the chorus, the same soulful female voice comes in again asking the listeners in Spanish to notice the way in which the city, fearful and sorrowful, breathes like her.

The city is both feminized and Latinized through its association with the words and experience of this female subject. In contrast to most Latina voices heard in contemporary rap recordings, Black Star and Common incorporate a Latina voice into their music to weave a poetic narrative whose last concern is the usual Don Juan economics of sex. Lamentably, this trio of artists is an exception to the rule.

Foxy Brown's 1996 debut platinum-selling album, *Ill Nana*, incorporated a woman's voice with a distinct Puerto Rican accent as a marginal commentator in the opening track "Intro . . . Chicken Coop." The "Intro" is partly a commercial for upcoming artists—some of them Latino—the Cru and Cormega. The latter was then the most recent member of The Firm, a crew made up of popular rap artists Foxy Brown, Nas and AZ. In an aggressive and exasperated tone, an unidentified female voice inquires in Spanish: Who is this "*maricón*" ("faggot") and "*mamao*" ("cocksucker")[40] Cormega? Although this woman's interjection is a marginal aside to add flavor and humor to the "Intro," it is also one of the few examples of Latina female voices in rap recordings that do something different than moan in ecstasy.

The problem with the prevalent representations of Latinas does not reside in the sexually explicit images. Explicit sex should not be confused with sexism. An image does not get more sexist as it gets more "hard core." Big Punisher's "Taster's Choice" interlude would be just as sexist if its protagonists were kissing instead of having sex. The problem with these representations is that the *mamis* are thought of only in terms of sexual desire. *Mamis* are not sisters, friends or mothers. Their only conceivable role is that of lovers. To compound the matter, the terms of these

sexual representations are tragically misogynist and operate under a patriarchal logic. The *mamis* are frivolous, gold-digging and infinitely substitutable beings.

Big Pun's "Taster's Choice" again provides a telling example. Lissette and Joanne are portrayed as petty and egotistical, quick to jump at each other's throats in their competition for Punisher's "dick." They are, of course, desperate for the ultimate phallocentric prize. Pun, on the contrary, is way above their silliness. He demeans them by muttering under his breath "stupid bitches" and proceeds to mediate their spat. Of course, their being "stupid bitches" does not make them any less desirable for him. Dealing with female frivolity is just the heterosexual man's burden. Poor guys, that is what they have to put up with if they want to get laid.

Furthermore, lesbian pleasure is celebrated in "Taster's Choice," but only because it is for male consumption. Lesbian desire is redeemed only by male participation. Had Pun not been there, or had these women not conformed to stereotypically "feminine" standards of beauty, then Lissette and Joanne's desire for each other would be repulsive and a threat.

Lesbianism is acceptable only given a phallocentric logic, according to which, without a penis, there is no "real" sex. By the same phallocentric token, gay male desire is perceived as way too real, and thus under no circumstances is it deemed hot, cute or even remotely acceptable.[41]

"Lesbian chic" surfaces not only in rap but in popular culture in general, being a common male erotic fantasy. When asked about the commercial viability of an openly lesbian rapper, Lenny Santiago, an A&R at Roc-A-Fella Records, responded: "It's such a turn-on for guys, I think it would be marketable. It's every man's fantasy to sleep with two women. If she were *ghetto-sexy* and had skills, I could see that."[42] A clueless male reader asks Lana Sands, *XXL*'s sex columnist: "How do I get with a lesbian?" She responds: "I think you might be looking for a girl who is bisexual or maybe bi-curious as opposed to a full blown lesbian, 'cause you might not find what you're looking for by *Chasing Amy*."[43] The assumption that a lesbian woman would necessarily want to engage males sexually reveals an extremely heterocentric perspective and a lack of imagination. Lesbian fetishism is evidently not about actual female-to-female desire but about a cute show for male consumption.

In a conversation I had with two Puerto Rican teenage rap artists who expressed great admiration for Big Punisher, the "Taster's Choice" interlude came up. I asked what they thought about it. One of them dutifully informed me that "it was degrading to women." The following exchange ensued:

> *Raquel:* Why do you say it's degrading to women?
> *Jay:* Because it makes them seem like two freaks.
> *Raquel:* But isn't he a freak too, then?
> *Jay:* Yeah, he's a freak too. See, it's that double standard. If guys do it, it's all right, but if girls do it they're hoes or freaks.
> *Tony:* They probably got some hoodrats to do that! [laughter]

The assumption that the women who played Lissette and Joanne's roles were "hoodrats" struck me, particularly since Tony's statement followed Jay's acknowledgment that branding this kind of raw female sexual behavior as "freakish" is a sexist double standard. So not only does raw sexual behavior in real life make a woman a freak, but it also makes freakish (dirty, worthless "hoodrats") the actresses or models who enact such behavior. Reality and fantasy collide at a fascinating angle when playing a role in a staged sexual encounter, for commercial consumption, has bearing on the assumptions—coded as negative—about the real lives of this encounter's female participants.

The sexualized actresses and models of rap songs and videos, although indispensable in rap's landscape of male pleasure, are routinely debased. *Blaze* magazine's rap video reviewer Rubin Keyser Carasco quips that the estimated budget for Punisher's "Still Not a Player" consisted of "a three-piece meal at KFC for each girl," referring to the low compensation for their services the women most likely settled for.[44] If women selling sex for high prices is viewed as morally reprehensible,[45] selling sex cheap is viewed as even worse. And that is why the actresses who played Joanne and Lissette are assumed to be "hoodrats."

Seeking to challenge the dismissal of these actresses and models as "video hoes," Mimi Valdés reminds her *Source* readers that the success of a rap song is directly related to the beauty of the women in the video: "Ironically, no one knows much about these females; yet, *everyone* has

something to say about them. Now don't go there and dismiss these ladies as 'video hoes.' Do you call actresses who star in dozens of movies 'movie hoes'? Don't hate these women because they're beautiful."[46]

Valdés makes a good point by highlighting the hypocrisy of singling out video actresses for negative judgments, while movie actresses are not judged as harshly. But to validate these women as respectable professionals, Valdés draws a clear separation between the "freaky" roles they portray and their real lives. She stresses that their video images are "just an act" and do not reflect their "morals and goals."

And what if it wasn't an act? What if these women were sexually aggressive and/or promiscuous in real life? Would that invalidate their also being respectable professionals? Unfortunately, the answer is yes. Female "freaks" are assumed to be ditzy, sleazy and unprofessional. The same judgment is not applied to males, due of course to the patriarchal sexual double standard.

Valdés also relies on denying the central role of sex as a commodity in these actresses' careers in order to validate them. She claims they are not selling sex but interpreting a character. There is no contradiction in selling sex through role-playing as a professional occupation, yet Valdés poses it as such. The so-called video hoes she aims to vindicate as "video queens" have to navigate between economic necessity (earning a living, building a career) and notions of female dignity (according to which selling sex is dishonorable).

Women within the rap music industry are overwhelmingly relegated to secondary roles. They are most highly visible as the models and actresses in magazines and videos. Indispensable as members of the collective at the core of male pleasure—females, honeys, hotties, bitches, hoes, freaks, chickenheads, pigeons, chicks—they are branded by the "mark of the plural" that makes them expendable and easily substitutable as individuals. Women are coveted and necessary but also debased and disrespected.

The ubiquitous tropicalized representations of Caribbean Latinas in rap music since the late 1990s present a striking and ethno-racially specific example of how women bear the "mark of the plural" that hypersexualizes and demeans them. These representations also illustrate, in a gender-specific fashion, the way in which Puerto Ricanness is constructed through navigations between a tropicalized *latinidad* and a

ghettocentric blackness. Puerto Rican *mamis* are portrayed most commonly within the hip hop music realm as a tropical, exotic and racially "lighter" variation on ghetto blackness, and that is precisely why they are so coveted.

"TROPICAL" BLACKNESS

Rap music's turn-of-the-millennium commercial ghettocentricity, old-school nostalgia and butta pecan *mami* fetish have all helped legitimize and even trendify Puerto Ricans—and by extension, Latinos as a whole. This renewed embracing of Puerto Ricans as entitled hip hop participants invested with cultural "authenticity" is also connected to the wider social context of the United States, where the rising population numbers, political clout and media visibility of Latinos highlight their desirability as consumers and/or objects of mass-mediated exotization.

Hip hop's "Latino Renaissance"—as Rigo Morales's 1996 article dubs it—of the latter half of the 1990s, on one hand signaled an era of greater legitimacy and visibility for Puerto Rican (and other Latino) participants and expanded their opportunities for participation and expression. At the same time, the constraints placed on artists through flavor-of-the-month commercial packaging has inhibited the potential for a wider range of creative expression. The market shuns those who dare to deviate from the profitable ghetto-tropical formula.

This redrawing of hip hop's realm of creative expression is reminiscent of freestyle music in the late 1980s, which pushed the bounds of New York Puerto Rican creativity through the inclusion of second- and third-generation perspectives but reproduced certain myths and stereotypes regarding Latino cultural production. As I explained in chapter 4, one of freestyle's central myths was the construction of a Latino aesthetic that was imagined as disengaged from the Afro-diasporic history and context of Caribbean Latino cultural expression in New York.

Despite the similarities—in terms of perpetuating a stereotypical *latinidad*—between freestyle and "Latin rap" in the late 1980s/early 1990s and Latino hip hop participation at the turn of the century, a crucial distinction must be made. While freestyle and "Latin rap" were defined as

Latino expressions, "core" hip hop is perceived to be an Afro-diasporic cultural sphere shared by African American and Latino youth. Caribbean Latinos may tropicalize themselves and be tropicalized by others, thus being readily distinguishable from African Americans. However, their participation in hip hop is still grounded in and celebrated as part of an Afro-diasporic cultural realm.

NAVIGATING BLACKNESS AND *LATINIDAD* THROUGH LANGUAGE

Niuyorricans do not realize that their language is English and the language of Puerto Ricans is Spanish.
—*Eduardo Seda Bonilla, "El problema de la identidad de los Niuyorricans"[1]*

Look, if I don't speak Spanish well it's because I wasn't born in Spain; if I don't speak English well it's because I'm not a son of a bitch.
—*Pedro Pietri,* Puerto Rican Voices in English[2]

The creative output of New York Puerto Ricans involved in hip hop's musical element varies widely. General aesthetics, themes, lyrical styles, choice of poetic language, verbal delivery techniques, musical sources as well as styles and modes of musical production (live instrumentation, samples, DJing) vary tremendously from artist to artist—as they also vary among African American artists. I mention this wide range of creative output because Puerto Ricans, and Latinos in general, often have been expected to reduce that range to fit into acceptable and/or recognizable parameters of *latinidad*. The assumption, most frequently made by people outside of hip hop's bounds, is that these artists must "Latinize" hip hop to make it truly "theirs." Otherwise they are

perceived to be imitating or adopting African American cultural expressions. And if Latino artists make no effort to "Latinize" their artistic expression, it is because they have lost "their" culture and "assimilated."

Within the "core" hip hop expressive realm there has existed a strong resistance against pressure for Latino artists to "Latinize" their creative output, particularly before the late 1990s, when it became trendy to incorporate Latino themes into rap music. If anything, the flip side of the pressure to "Latinize" has often been evident. Certain artists, such as Latin Empire, Kid Frost and Mellow Man Ace, who worked during the late 1980s and early 1990s with explicitly Latino themes, language and/or sources in their music, often were shunned—by African Americans and Latinos alike—for stepping out of the hip hop norm. While brief or peripheral Latino references and influences generally have been deemed acceptable, it seems as if there has been an "insider" cutoff point on acceptability—shifting and highly subjective, but nonetheless real.

In a 1995 conversation I had with a then well-known "underground" Puerto Rican MC raised in the Lower East Side, he said: "If you want to say something about being Latino, make a short statement and that's enough." Once artists step beyond the cutoff point, they can be perceived to be, as he told me, "try[ing] too hard to bring in their ethnic background"; or, as Q-Unique once described it to me, "impos[ing] Puerto Rican culture on hip hop." They also may be accused of trying to use their Puerto Ricanness or Latinoness as a commercial hook.[3] Rapper Main One,[4] probably suspecting that stressing his Puerto Ricanness could tarnish his hip hop legitimacy—coded as "rawness" and "realness"—felt compelled to promise that his heritage would not inject softness or fakeness into his upcoming music projects: "My next album is gonna be straight-up raw. . . . I'm still going to put my heritage in it, but I ain't no Rico Suave. I'm real."[5]

As one of the first New York Puerto Rican rap artists to make their Puerto Ricanness one of the central components of their musical production, the duo Latin Empire frequently has evoked criticism. Explaining their lukewarm acceptance in hip hop "core" circles, a well-respected New York Puerto Rican MC—who shall remain nameless—said in 1995: "They impose Puerto Rican culture on hip hop. Hip hop doesn't need to be infused with anything in order to be complete. That's why they don't get much acceptance." Alano Báez, lead singer of the band Ricanstruc-

tion, once explained to me: "When Latin Empire came out they were seen as more of a novelty act and never really accepted as hip hop. The reaction to them was 'Oh, Latinos doing hip hop'—as if Latinos hadn't long before been doing hip hop."

In an interview held in 1995 at Rappers Discotheque in Puerto Rico, Panamasta (an MC from the Lower East Side of Manhattan) and D-Stroy (an MC from Bushwick, Brooklyn, and then member of the duo Touch and D-Stroy) faulted some New York Puerto Rican artists for stressing their ethno-racial affiliation too much and thus being responsible for their own lack of success. A Puerto Rican MC "gotta represent as a rapper first and then as a Puerto Rican." Panamasta and D-Stroy believe that MCs have to prove themselves in hip hop's African American–identified core realm first, in order to later be able to stress their ethno-racial background. According to both MCs, this avowed need to "represent as a rapper first" was applicable not only to Puerto Ricans or even Latinos in general but to MCs of other non–African American ethnicities as well:

Panamasta: Check it out, in New York, Puerto Ricans right now are having a hard time 'cause they ain't getting too much light. First you gotta represent as a rapper. Then when you get up there and shit . . . [The music industry decision makers won't say] he's a Puerto Rican rapper, lets give him a break, he speaks Spanish. No. He's gotta represent as a rapper first and then as a Puerto Rican. He's a Puerto Rican in deep anyway. But they need to represent as an artist, as an MC. That's why people like Fat Joe and Funkdoobiest and Kurious they haven't been coming out "yo, I'm Puerto Rican, I'm Puerto Rican," but you can feel their vibe. But they gotta represent as MCs.

D-Stroy: For example, with House of Pain. They Irish, but you can't say, "yo, he's good for a white MC." It ain't really that 'cause you gotta be nice as an MC. When you start dividing, it hurts. You gotta start like that but when you get there and people respect you as an MC then you can go and do it. Although, no matter how it goes I'm still Puerto Rican.

DJ Muggs, Cypress Hill's Italian American DJ, makes a similar distinction between "representing as an MC" and "representing as a Latino MC":

I'm gonna come right out and tell you that the problem with Latino rap-
pers is they come out representing that they're a Latino rapper instead of
coming out just as an mc. They pigeon-hole themselves, ya see? Black peo-
ple down south don't give a fuck if you're Latino. White people who love
hip hop don't give a fuck if you're Latino. You have to come out and let the
music speak for itself so that people will check you with an open mind. You
just gotta come out and do your shit. Don't rely on being Latino as your
gimmick. Latinos are a minority and if those are the only people buy-
ing your shit. . . . You have no one to blame for not succeeding.[6]

Ju-Ju, the Dominican half of the Beatnuts, said in the NPR docu-
mentary "Latino Rappers and Hip Hop: Que Pasa" that although he in-
cludes some Spanish in his rhymes, "I ain't trying to stress that shit. I
want to be respected as a talented hip hop artist, not as a talented *Latino*
hip hop artist."[7] Or as Angie Martínez told me in a telephone interview
shortly after the release of her 2001 debut album: "Why can't I be just a
strong woman who is Latina, who is doing her thing, as opposed to 'the
Latina rapper'? I'm proud of where I come from, but I also don't wanna
use it as some kind of marketing tool." Big Punisher addressed the same
concern when he described himself and other artists who took a similar
approach in the following manner: "What makes us special is that we're
Latino, not Latino rappers. We mastered Black music—Hip Hop—not
the Latino style of hip hop."[8]

According to these commentators, rap music's authenticity is violated
when certain expressions of *latinidad* are placed too close to the axis of artis-
tic creation. Although this authenticity is certainly not restricted to African
American artists, it allows only for Latinos whose creative expression is in-
telligible to and/or deemed desirable by African Americans. *Latinidad* is un-
stable and potentially hazardous, particularly in commercial terms, because
Blackness (African Americanness) is rap's reigning commercial hook.

Language is one of the central signifiers of *latinidad* that has the
potential to evoke perceptions of disruption and deviation from the
African American matrix upon which rap authenticity rests. The sparse
use of Spanish or "Spanglish,"[9] may be perfectly all right; their
"overuse" is another story. Journalist Rigo "Riggs" Morales describes
Mellow Man Ace, Messengers of Funk and Little Indian as artists who

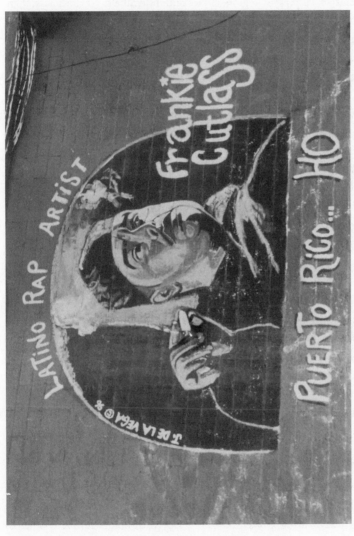

El Barrio artist James de la Vega includes Frankie Cutlass's portrait among his Latino musicians' street hall of fame, 104th Street and Third Avenue 1998. Photo by Anabellie Rivera Santiago.

"have gone on to become statistics in the rap game, mostly due to their overuse of 'Spanglish.'"[10]

The boundaries between "use" and "overuse" have always been subtle and elusive, varying by region, circles and individuals. Nevertheless, there has been a noticeable expansion in the acceptability of Spanish, Spanglish and code-switching in rhymes during the latter half of the 1990s. The members of Cypress Hill, who in the early 1990s abrasively criticized Kid Frost for focusing too much on a Latino-oriented aesthetic,[11] a few years later released their first Spanish EP. Funkdoobiest, whose 1995 album *Brothas Doobie* included only sparse sprinklings of Spanish and a few fleeting mentions of its members' ethno-racial affiliations, came back in 1997's *The Troubleshooters* with lyrics heavily infused with Spanish and ethno-racial references. A New York Puerto Rican MC I interviewed a few years ago, who at the time disdained Latino rappers who put "too much" emphasis on their ethnicities, is today rhyming in Spanish and has garnered more media visibility than ever. Times have changed, and as *latinidad* has acquired greater legitimacy as a component of hip hop's core, the scope of acceptable "Latinized" deviations from hip hop's African American matrix has expanded accordingly.

The role of commercially successful African American artists in the increased acceptability of *latinidad*-infused hip hop cannot be underestimated. Fat Joe, making reference to hit rap songs such as Wyclef Jean's "Guantanamera" and Puff Daddy's "Señorita," explains that because these rappers are showing respect for Latinos, their fans are also becoming more prone to do so.[12]

Due in no small part to the legitimation of Latino themes by African American artists, what in the earlier half of the 1990s may have been perceived as Latino sectarianism is today a sign of hip hop ghetto authenticity. For example, consider a 1998 interview that New York radio personality and rapper Angie Martínez did with Cypress Hill's Sen Dogg and B-Real for MTV's August 1, 1998, show "Smoking Grooves." Sen Dogg was wearing a black baseball jersey with bold white letters across the chest that read LATIN THUG. In the course of the conversation, the MCs revealed that they were working on an EP in Spanish. After a brief exchange, Sen introduced in Spanish a Tupac video, as English subtitles appeared at the bottom of the screen. Remember, these are the same

artists who years before had criticized Kid Frost for overemphasizing his *latinidad* and catering only to Latinos. The big difference is that what constituted catering to a Latino audience in previous years today has widespread appeal.

The increased acceptance and marketability of Spanish-infused rhymes has led some Puerto Rican artists, but not all, to incorporate more Spanish into their rhymes. Fat Joe's sparse use of Spanish within rhymes has remained constant over the course of his four albums. I asked him during a telephone interview in 2001 if he had felt pressured to employ more Spanish in his rhymes; he answered with a resolute no: "I was content being Puerto Rican and everybody knows that I'm Latino and I'm representing my culture to the fullest. But I never felt like I had to rhyme in Spanish, none of that. Up to this day, I don't compromise. I don't come running out with a big flag. Everybody knows we're representing the Boricuas, the Latinos. But I'm just making great music. The fact that we're Latino is obvious. I don't have to put that in every song."

While the use of Spanish in rhymes enjoys greater acceptance now, it has not become a necessary identity marker either. For the New York Puerto Rican second and third generations, ethno-racial identity often has more to do with the way English is spoken than with the use of Spanish in rhymes.

"BORIQUAS ON THE SET"

Frankie Cutlass's "Boriquas on the Set," featuring Doo Wop, Fat Joe, Ray Boogie and True God, is an early 1990s' self-affirming ode to New York Puerto Ricans. Nuyoricanness is praised and defined from a working-class, youth and male perspective. Class identity, ethno-racial affiliation and ethno-racial solidarities are constructed with respect to each other, as evidenced by Fat Joe and Ray Boogie offsetting their respective identities against "downtown white boys" and "Caucasian[s]" and by Ray Boogie praising the "street" and the "ghetto" while he draws connections between himself and African American ("Blacks"), Puerto Rican ("Arawaks") and Chicano ("Aztec") ghetto dwellers.

Ray Boogie uses the term "Arawaks" for Puerto Ricans (and maybe even other Caribbean Latinos); this is a popular strategy—which extends way beyond hip hop—of defining Puerto Rican cultural history in terms of Native American ancestry, particularly to distinguish Puerto Ricanness from the U.S. African American experience.[13] Puerto Ricans and Chicanos, the two Latino groups invoked by Ray Boogie, thus are linked by an appeal to a shared indigenous American connection, adding yet another bond to the "ghetto" connection they share with each other and with African Americans.

"Boricuas on the Set" is an exemplary manifestation of Puerto Rican second- and third-generation cultural practices. These MCs are English-dominant, New York Puerto Rican style—their approach to language is much indebted to the New York African American vernacular of their peers as well as to the Puerto Rican Spanish of their parents.[14] In this particular song, language is an identity badge, but it has more to do with the way English is used and less with the faint sprinklings of Spanish through the rhymes. Spanish usage is practically limited to Doo Wop's mention of "eat[ing] *cuchifrito*," Fat Joe's taunting an opponent to "*mámame el bicho*" and a sample from African American rapper Method Man in which he mentions the words "*mi casa.*"

This celebratory classic honoring hip hop's Boricua presence employs minimal Spanish and no musical sources commonly identified as Latino. The Boricua experience is celebrated through English-dominant rhyme skills, the flaunting of male sexual prowess and ghetto street knowledge—described in the song as the "nigga" experience.

Nigganess, as evidenced in Fat Joe's rhyme, defines the self as well as those around him whose respect he commands. Aside from the appeals to a Boricua Arawak past, the Boricua New York inner-city experience is coded as a "nigga" present. Hip Hop editorialist Edward Sunez Rodríguez explains the use of the word "nigga": "The word 'nigga' was the the only word Blacks and Latinos could easily use to relate to each other. With a negative, oppressive reality experienced, only a negative word could immediately be used to represent their reality. . . . So 'nigga,' as it was for me, was a way of saying, 'I am Black.'"[15]

In a 1996 article, Rodríguez described "nigga" as one of several "unifying terms" that he had personally chosen to employ "so I wouldn't forget

my ancestry and history of domination."[16] But much has changed in the rap industry and also in Rodríguez's worldview since that article was written. In a 2002 article he explains:

> Now the nigga word can be used by whites and that is neither creative nor original if the word can be used by them having no other significance [than] everyone else around them is making or enjoying rap music. Now there is no solidarity expressed between Black peoples of different cultures, ethnicities and shades of Black when the "nigga" word is used. It truly has [none of the] power or bite that it was once supposed to have. This is purely for commercial benefit as there is an allowance of cultural expressions to be abused for the mainstream audience to feel a rightful ownership and relation to it. In hip hop, whites feel they now have a dual ownership as we are its creators and they are its sustainers and purveyors. "Nigga" and other aspects of hip hop were easy to take because we never explained it and thus never really could enforce its usage for long. If we explained it though, we probably would realize it shouldn't be used anyway.[17]

"NIGGAS" IN THE "AGE OF THE EBONIC PLAGUE"

Language plays no small role in the construction of a "niggafied" Puerto Rican experience. "Niggas know who niggas are,"[18] partly through language use, particularly within the hip hop realm. "Ebonics slingin'"[19] is a primary communicative "nigga" practice, with MCing being one of its principal poetic methods.

Old-school legend Rubie Dee warned in an early 1980s song that, although Puerto Rican, his speech patterns might lead audiences to think he is African American.[20] Hurricane G boasted in a rhyme nearly two decades later, in the late 1990s, that her "verbal Ebonics" would get her listeners higher than a certain potent type of marijuana. Around the same time, the Cru released a track titled "The Ebonic Plague," featuring Ras Kass, which proposes language as a realm where community consciousness is built as well as manifested. No ethno-racial distinctions are made between the African American and Puerto Rican artists who contributed to this song; they are all part of the "we" building and living the "Age of the Ebonic Plague." Linguistic manifestations of New York Caribbean

latinidad are incorporated into the "Ebonic" community realm: the trilling "r" of the word "three" in a phrase that is looped throughout the song—a linguistic debt to New York Puerto Rican English—and the effortless integration of "México," pronounced in Spanish, into an otherwise all-English rhyme.

The way in which this track is imprinted by New York Caribbean *latinidad* may be lost to casual observers not familiar with urban Afro-diasporic youth culture. The linguistic and other markings that signify *latinidad* for the second and third Caribbean Latino generations and for their African American peers are very specific to the urban youth culture they share.

"NIGGAS KNOW WHO NIGGAS ARE"

The Latino community needs to get up in this piece. 'Cause you know y'all just got dropped off at a different port than nigga niggas.
—organizer, Black August Collective

The paced and somber piano chords of "Return of the Crooklyn Dodgers," laced with gloomy horn riffs, provide a contrast with the high-pitched bells pealing throughout, the energetic boom-bap of the drums and the rhymers' forceful and lyrically packed deliveries. African American MCs Chubb Rock, OC and Jeru the Damaja teamed up for this song, which was included in the soundtrack for the movie *Clockers* (1995), directed by Spike Lee. An elegy as well as a celebration of Brooklyn and Brooklynites, "Return of the Crooklyn Dodgers" is also an indictment of the racialization of crime. Chubb Rock is the first to step to the microphone, countering the myth that black people are at the center of the drug trade and explaining the role of whites in this lucrative business. While "niggas" get blamed, he raps, it is actually "whitey" who profits.

Not content to speak in the abstract, these MCs situate themselves within specific "Crooklyn" neighborhoods: Bushwick, Flatbush, Bed-Stuy, Fort Greene and East New York. Bushwick, the first of the neighborhoods mentioned, is a heavily Puerto Rican neighborhood in north-central Brooklyn and one of the borough's most depressed areas.[21] Its inclusion as one of the neighborhoods where "whitey" profits as "nig-

gas" die is an illustration of how New York Puerto Ricans are branded by "nigganess." It also serves as an example of Puerto Ricans being recognized and "shouted out" by African Americans within rap in ways that are not readily apparent to listeners unfamiliar with New York City and its youth culture. Indeed, "niggas know who niggas are."

THE "MASTER'S LANGUAGE"

Edward Sunez Rodríguez describes MCs in his hip hop editorial for Baruch College's *The Ticker* as "ghetto poets" who "have mastered their oppressor's language better than their masters." His comments have certain parallels to Frances Aparicio's characterization of the literature written entirely or almost entirely in English by Latinos as "writing the self using the tools of the Master and, in the process, infusing those signifiers with the cultural meanings, values and ideologies of the subaltern sector."[22]

But Aparicio, unlike Rodríguez, focuses on these literary practices through a Latin Americanist/tropicalist perspective that neglects the urban Afro-diasporic context which is crucial in the reappropriation of the "tools of the master" for many Latino writers, particularly those from New York. For hip hop lyricists as well as for other writers, the subversion of the language of the "master" in the New York context owes as much to "linguistic tropicalization"[23] as it does to linguistic Afro-diasporization.

In terms of Afro-diasporic sources and approaches to creative expression, the practice of writing rap rhymes and MCing by Puerto Ricans has much in common with the school of Nuyorican poetry, which includes poets such as Sandra María Esteves, Tato Laviera, Jesús "Papoleto" Meléndez and Pedro Pietri—and their twenty-something and thirty-something heirs like María "Mariposa" Fernández, the Welfare Poets, Sandra García Rivera, Flaco Navaja and Caridad "La Bruja" de la Luz. In the words of Louis Reyes Rivera, another Nuyorican poet: "what is referred to as Nuyorican poetry is as much rooted in African-U.S. urban poetry as it is an attempt to redefine or reclaim the Puerto Rican culture."[24] This rootedness of Nuyorican artistic expression within an urban

Afro-diasporic context, however, frequently goes unacknowledged. Anglo/Latino and master/subaltern dichotomies are most frequently privileged in discussions of U.S.-based Puerto Rican creative expression, thus neglecting the tensions and connections between African Americans and Puerto Ricans. Aparicio's arguments regarding "linguistic tropicalization" are a case in point. Javier Santiago presents another example, through his erroneous description of *bugalú* as a mix of Afro-Antillean and Anglo-Saxon musical traditions, when in fact this genre blends Afro-Antillean and African American musical sources.[25] Criticisms of Puerto Rican and other Latino rappers' heavy use of English in their rhymes as being indicative of "Anglocentrism" make similar assumptions.

If Latino rappers use English in their rhymes, it is because rap is an Afro-diasporic oral/musical form of expression that originated in the United States among English-dominant Afro-diasporic youth—a population that includes Caribbean Latinos. The assumption that the use of English by Latino rappers equals Anglocentrism whereas the use of Spanish signals some kind of adherence to *latinidad* points to severe conceptual problems. Equating the use of English with Anglocentrism negates the appropriation and transformation of the colonizers' language by Afro-diasporic people. Furthermore, not only are Latinos following rap's Afro-diasporic English-based orality, but their use of English also derives from their most immediate communicative experience as young people raised in the United States.

Another problem with these charges of Anglocentrism is that they assume that *a* language equals *a* culture. Authors Juan Flores, John Attinasi and Pedro Pedraza and Bonnie Urciuoli all challenge the notion that the use of English or Spanish indicates how much "assimilation" there is.[26] Puerto Ricans and other Latinos often assert their cultural identity through their particular way of speaking English.

Language choices by New York Puerto Rican MCs run the spectrum of linguistic codes that include multiple variants of English and Spanish. Linguist Ana Celia Zentella has identified some of these variants—which, she says, tend to overlap—as Popular Puerto Rican Spanish, Standard Puerto Rican Spanish, English-dominant Spanish, Puerto Rican English, African American Vernacular English, Hispanized English and Standard New York City English.[27] Within the hip hop zone, the lack of

Spanish usage is not taken to be necessarily related to ethno-cultural identity. Thirstin' Howl III's all-English rhymes in the 1998 compilation album *Lyricist Lounge* have no bearing on his Puerto Ricanness; Hurricane G is not considered any more in touch with her Puerto Ricanness than he because she skillfully switches back and forth between English and Spanish in her 1997 solo album *All Woman.*

Hip hop is a cultural realm where the blackness (Afro-diasporicity) of second- and third-generation Caribbean Latinos is affirmed and celebrated, partly through the linguistic practices they share with African Americans. These linguistic practices are largely English-based and at times include the use of certain Spanish terms and phrases as common territory. However, the Caribbean *latinidad* of New York Puerto Ricans involved in hip hop culture is not necessarily defined through the use of Spanish.

CHAPTER 9

REMEMBERING BIG PUN

Big Punisher's unexpected death on February 7, 2000, was a painful blow for rap fans across the globe. Those who loved and admired Christopher Ríos had feared the fatal effects obesity could have on his health. But no one was truly ready to lose so soon rap's most popular Boricua, who was twenty-eight years old when his overburdened heart gave out.

Although Big Pun may no longer inhabit Christopher Ríos's body, he is bound for enduring materiality through his musical legacy. This son of the South Bronx was one of the most influential rappers of the latter half of the 1990s and the first Latino rap soloist to reach platinum sales. He has been praised by rap critics as: "one of the Boogie Down Bronx's favorite superlyrical sons"; "king of verbs, killer of words"; "a rapper's rapper armed with chilling, detailed stories that are backed by a non-stop, attack-the-track flow"; "master of his craft"; and "street-wise, intellectually sharp, sex-crazed—and funny as all hell."[1]

Fans praise his peculiar lyrical cadences, aggressive verbal projection and rhymes heavy with rich images, razor-sharp wit and unexpected combinations of sound and meaning. As a songwriter and performer, he managed to make his verses pulsate with the everyday, the fantasies and the neuroses of his generation.

Big Pun is a hip hop icon, a chart-topper who nevertheless managed to execute the tricky balancing act of holding on to ghetto credibility and community respect. His image and musical aesthetics have been central

factors in his sustained credibility. He was unlike the rap artists who seem to think creative development means spending hours practicing their commercially seductive scowls and barking "What?" at the mirror while forgetting to challenge themselves beyond mediocre refried rhymes. Pun had a sharp lyrical edge and a ghetto-typical hardness that seemed to flow naturally—so much so that he could afford exploring pop-friendly and even Boricua-centric themes without them being held against his "hardcore" credentials.

Given his lyrical skills and the delicate balance he achieved between commercial and so-called underground appeal, comparisons to the late Notorious B.I.G. and Tupac Shakur—hip hop's other platinum fallen heroes—have become commonplace. All three were talented, accomplished, promising to shine even brighter but dead before reaching their third decade. Clyde Valentín pronounces Pun as standing "in the upper echelon of Hip Hop next to Biggie and Tupac"[2]; while Riggs Morales likens Biggie and Pun, describing them as "lyrical giants, who, after sessions of rewinding, still leave listeners in awe."[3]

Compelling listeners to rewind over and over is perhaps the surest proof that an MC's rhymes are deemed hot. And Pun delivered some of the most rewound lines at the turn of the century, like the tongue-twister referencing Little Italy featured in "Twinz (Deep Cover 98)" from his debut album *Capital Punishment* and his ingenious stuttering punch line in Fat Joe's "John Blaze" (1998).

Mentor and music partner Fat Joe recalls the rush he felt the first time he heard Big Pun rhyme. As he was leaving a store on 166th Street and Tinton Avenue in the Bronx, he noticed Pun among a group of guys rapping on the sidewalk: "he said a rhyme that just blew my mind. He rhymed so rapidly, so many words in one sentence, and he would spit them out with no problem, with all breath control. The next day I took him to the studio and put him on my album."[4]

Before he linked up with Fat Joe, Pun had been known as Big Moon Dog and was part of the group Full a Clips, which included Triple Seis, Cuban Link and Prospect. Later, all of them became key players in Fat Joe's Terror Squad.

After being featured in Fat Joe's 1995 song "Watch Out" and a year later in "Firewater," Pun's "You Ain't a Killer" was included in the soundtrack for

From left to right: BG 183 (TATS Cru), Big Punisher, SEN2 (TATS), NICER (TATS), Fat Joe. Front: BIO (TATS). Hunts Point, The Bronx, 1997. Photo by W. D. Allah.

the 1997 movie *Soul in the Hole*. He contributed two tracks to Funk Master Flex's 1998 *Mix Tape Volume III* and was featured in The Beatnuts' hit "Off tha Books." His commercial acclaim kept rising; in 1998 he was celebrated by *The Source* magazine as one of the two rappers with most guest appearances on other artists' releases. To the surprise of many in the music industry, his solo album *Capital Punishment* debuted at number 1 on *Billboard's* R&B and rap charts and at number 5 on its pop charts and was greeted by rave reviews and heavy rotation on radio and video channels. The album eventually reached double platinum sales.

LADY LUCK SWEATS PUERTO ROCK STYLE

Aside from the appeal of his image and music, there was yet another factor bearing on Big Punisher's popularity on both the grassroots and commercial fronts. His legitimacy as street cultural icon and status as hot commodity, although not predetermined by his being Puerto Rican, were undoubtedly influenced by it.

Big Punisher's debut album came out during a time in commercial hip hop history when the constant redefinition of cultural "legitimacy" had resulted in the reclaiming and celebration of hip hop's precommercial Bronx 1970s' origins. Artists, elements of knowledge and styles that a few years earlier may have been considered played out or at least irrelevant became invested with renewed significance during the last half of the 1990s, as I explained in chapter 6. The key role played by Puerto Ricans during all of hip hop culture's history was one of those unearthed elements of knowledge that was dusted off and proudly displayed as a way to distinguish those considered authentic—or, at least, those who *know* who is authentic—from those who are not. And, to Pun's benefit, he was not just Puerto Rican; he was a South Bronx Puerto Rican. How much more authentic can you get?

Hip hop's boundaries of cultural legitimacy are most often defined through collective identities linked to ghetto/street culture and ethnoracial affiliations. Inner-city African American and Latino hip hop participants currently bask in the glow of cultural authority. An overwhelming majority of commercial rap acts are African American. But

commercial rap's consumer base is multiracial and anything but exclusively ghetto based. Legitimacy sells and is used as a marketing tool: *Buy this! It's raw, authentic, hard core, truly ghetto!*

Although some may argue that Big Punisher rose to the top of the music charts in spite of his cultural heritage and ethno-racial background, I would argue the contrary. His commercial acceptance was in great part brokered by hip hop's renewed interest in roots and history as well as by a mainstream fascination for things Latino: from Jennifer López's and Ricky Martin's respective cute faces and butts, to Marc Anthony's voice, to Latino novelists like Junot Díaz and Julia Alvarez, to the Buena Vista Social Club. The "Latin Explosion" has made a mark on the hip hop zone as well.

Big Pun's image, creative style and the marketing strategies of his production team were central reasons for his success, but timing holds equal importance. The market was ripe for a Puerto Rican MC of his caliber. His commercial debut took place at a time when things Latino were in style. The commercial trend within rap was for African American artists to include Spanish phrases and references to Latinos—particularly Latinas—in their lyrics and to sample Caribbean Latino music. Had Pun come out in the early 1990s, it is doubtful he would have met a similar level of success. Most probably he would have been accused, as were other Latino artists at that time, of stressing his *latinidad* too much. But in these Latino-friendly times, Pun's Puerto Ricanness actually worked in his favor.

Music industry decision makers initially may have been skeptical of this light-skinned Puerto Rican's commercial viability. Hip hop journalist Riggs Morales reports being at a music industry party in March 1998 where an A&R shared with colleagues his skepticism regarding Pun's potential: "Big Pun is just another Spanish rapper. He's only gonna sell a few records."[5] But Pun's massive success put a quick end to skeptics' reservations.

It is important to note that Pun's commercial acclaim was not the catalyst for the cultural legitimation of Latino rappers but that it informed the industry of a phenomenon that had been long in the making—the growing grassroots recognition of Puerto Rican participation in hip hop and of the similarity in living conditions and cultural practices between

African Americans and Latinos in large U.S. urban centers. Big Pun, as a Puerto Rican artist of precious lyrical skills, had cultural legitimacy way before he was validated commercially.

Some music critics covering the heightened mass media visibility of Latino artists in the hip hop realm have mistakenly equated their commercial legitimation with cultural legitimation. In an article in *Urban Latino Magazine,* James Lynch writes: "With the success of such artists as Fat Joe and Big Punisher, Latinos are no longer being shunned by hip-hop culturists."[6] Lynch's statement makes it seem as if Latinos were granted authenticity by "hip-hop culturists" only *after* the commercial success of those two Puerto Rican artists. The truth, however, is that a few years before the mass media "discovered" that Latinos were widely considered bona fide members of the hip hop core (and that huge amounts of money could be made by marketing Latinos through flaunting that legitimacy), it was a fact of hip hop vernacular or underground knowledge—granted in some cities (New York, Los Angeles) more than others (Atlanta, Detroit). Big Pun's success did serve to legitimize the Latino MC concept, not in the vernacular realm where it was already a fact, but for the mainstream market. In an article for *XXL* magazine Edward Sunez Rodríguez explains it well: "Certainly Fat Joe defeated many stereotypes scarring the Boricua's place in hip hop, and it's patently obvious that the fact benefited Big Pun on his debut album, *Capital Punishment.* This album unquestionably validates the Latino MC concept to a mass market."[7]

Carlito Rodríguez, then an editor at *The Source,* put the situation in proper perspective during an interview for a TV special entitled *Viva! The Hip Hop Nation,* which aired in September 1999 on New York WB Channel 11. Instead of making the common mistake of equating cultural legitimacy with commercial legitimacy, he differentiated between a recognition afforded by "those who really understand the history" and the validation granted by the "corporate machine."

A&Rs, publicists, chief executives and image consultants may have fretted over how to market a Puerto Rican MC in an artistic zone dominated by African Americans. But Big Pun's success demonstrated that it wasn't necessarily that complicated, considering this Puerto Rican's degree of immersion in a local culture where African Americans and Puerto Ricans—

though not without frictions—see eye to eye. He had little to prove, this South Bronx–raised Puerto Rican. In fact, to the contrary: His image and artistic contributions became a badge of legitimacy of sorts for others.

Big Pun's cameo appearance in the video for Lord Tariq and Peter Gunz's 1998 hit "Uptown Baby (Deja Vu)" was anything but circumstantial. Considering the reigning definitions of hip hop legitimacy during the time when the song was released, omitting recognition of Puerto Ricans in this ode to the Bronx that proclaims it the cradle of rap music would have been considered not only a slap in the face for a group deemed instrumental to the development of hip hop artistic expressions but also a crass display of cultural ignorance. And what better prototype of hip hop legitimacy with a Puerto Rican face than Big Pun? Lord Tariq and Peter Gunz may have been acknowledging the far-reaching contributions of Bronx Puerto Ricans in a realm where Pun was only the freshest face, but Pun is the artist who marks this period of renewed recognition. The truth is that TV viewers would not have recognized most Puerto Rican hip hop pioneers, whereas Pun's image had by then become a staple of commercial popular culture.

AN MC FIRST

A popular figure for the wider multiethnic rap audience, Big Punisher holds particular significance for Latinos in general and Puerto Ricans most specifically. He was proof that Puerto Ricans can do hard-core, "real" hip hop and make some money while they're at it. As Clyde Valentín wrote in *Stress* magazine: "Big Pun was our shining son. When I say 'our,' narrowly I mean Puerto Ricans from New York who grew up on Hip Hop like kids grow up on Similac. In the broadest sense I mean Latinos in the United States who represent for Hip Hop and Rap Music. Yes, cultural pride is an essential part of Pun's legacy and there shouldn't be anything wrong with that."[8]

Big Pun was not marginalized like earlier Latino rap artists, such as Kid Frost, Mellow Man Ace and Latin Empire, who were largely perceived as novelties with average artistic skills who catered almost exclusively to Latino audiences. He managed the tricky balancing act of

infusing his music with Puerto Rican culturally specific elements while still being perceived as having excellent and innovative artistic skills, holding on to hip hop authenticity and having wide commercial appeal. His Puerto Ricanness was perceived to be within the hip hop realm, not marginal to it, but part of a cultural force that has been enriching hip hop since its earliest times.

The delicate balance that Pun achieved among street authencity, cultural specificity and commercial success often has been explained as his having been, first and foremost, an MC and, second, an MC who happened to be Latino. Cypress Hill's B-Real praised him for this: "he left a good impression on people, because he didn't capitalize on the fact that he was Latin and capitalize on that market. He was just an overall hip-hop head who happened to be Latin."[9] Above all, Pun remained loyal to a cultural realm where the rules of legitimacy are set by a collective that includes Puerto Ricans and Latinos but transcends them. His primary creative sources and references arose from an urban youth culture that has been fundamentally informed by both Latino and African American practices but whose commercial dimension has been dominated by and, thus, identified with African Americans. Pun has been lauded within hip hop for being true to himself and his Puerto Rican roots, but this celebration could have taken place only because his primary loyalty was perceived to have been directed toward African American–matrixed hip hop aesthetics. For the most part, he worked with manifestations of his Puerto Ricanness that the African American contingent of his core audience would find familiar and in certain cases maybe even intriguing or challenging—but never so challenging that they could feel excluded. The key was his maintaining a foothold on the common cultural ground, in other words, in the vernacular culture shared by young African Americans and Latinos in U.S. urban centers upon which hip hop art forms have drawn their most basic drive.

Beware of branding him a "Latin hip hop" artist. In terms of his music, Big Pun considered himself an MC first . . . and then came that Puerto Rican twist. That is why in his 2000 hit "100%" he describes himself as a combination of African American rappers Kool G Rap, Master P and Tupac Shakur "with a twist of" New York Puerto Rican singer Marc Anthony. That is also why the hip hop beats driving this song also include

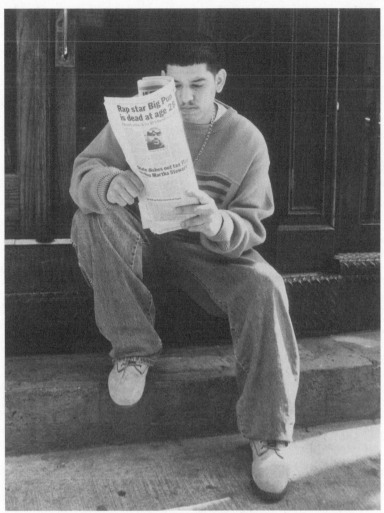

"Death of Big Pun," SoHo, Manhattan, 2000, by Jamel Shabazz.

musical allusions to Pun's Puerto Ricanness: Tony Sunshine singing a few lines from the Puerto Rican national anthem "La Borinqueña" as well as a modified snippet of Willie Colón and Héctor Lavoe's 1973 *salsa* hit "El día de mi suerte."

NADIE SE ATREVA A LLORAR

Between 40,000 and 60,000 people were estimated to have gathered outside the Ortiz Funeral Home on Westchester Avenue in the Bronx to pay their respects to Christopher Ríos. Among those attending were rap artists Fat Joe, LL Cool J, Lil' Kim, Puff Daddy, Xzibit, Mack 10 and members of MOP. Right in the midst of tears and pain, mourners still found reasons to celebrate. An impromptu memorial party erupted outside the funeral home, with hundreds of people dancing and singing to Pun's music blaring from a car.[10]

Big Pun's death made the *New York Post*'s first page. It was also covered by the *Daily News* and *El Diario/La Prensa*. The latter, which had not directed a single glance toward Pun prior to his death, ran a series of articles posthumously explaining his impact and achievements (one of which I wrote). He was featured on the cover of *The Source* and *Industry Insider*, and articles on his life and death were published in other hip hop–oriented magazines. The *New York Times Magazine* included him in the 2001 issue of "The Lives They Lived," an annual tribute dedicated to "remarkable lives that ended over the course of the previous 12 months." Even Congressman José E. Serrano (D-NY) made an official pronouncement of sympathy to Big Punisher's family and friends: "I am deeply saddened by his death. He was one of the many success stories that came out of the South Bronx. And his music was an example of the influence of Latino artists in this country."[11]

The communal grief over Big Pun's death had as much to do with the artist as with the man. In life as in death he was widely praised as a generous, unassuming and sensitive human being. The talented artist who passed away just as he was starting to reap the fruits of his labor was also a man of humble origins who defied the odds of the concrete jungle.

Pun grew up in the Soundview section of the South Bronx. The youngest of six siblings, he was a survivor: hustling, working as a door-

man, loading boxes at a truck stop in Hunts Point and living through a stint of homelessness.[12]

Big Punisher is the embodiment of the exceptional ghetto success story, holding particular significance for young Latinos who barely have any successful role models whose experiences closely mirror their own. Teenage journalists Akeenah Thomas and Jennifer Quiñones expressed from the pages of *Hunts Point Alive!*, the newspaper of community organization the Point: "Many people found Big Pun to be inspirational because he was proud to be Puerto Rican from the Bronx and because he overcame many obstacles in order to be successful."[13]

Pun and his family—Liza, his wife for thirteen years, and his children Amanda, Vannesa, and Christopher, who at the time of his death were nine, seven and six years old, respectively—continued to live in the South Bronx, even after his meteoric rise to fame. This fact made him even more dearly appreciated by his fans. South Bronx resident Jessica Roma expressed at Pun's funeral: "He didn't forget where he came from. He lived here with us right where he grew up."[14]

Spray-can artist Nicer (Héctor Nazario) is a member of TATS Cru, the well-known Hunts Point–based graffiti crew who sprang into action as soon as they heard the news of Pun's death and painted an impressive memorial mural in the South Bronx. One day when I visited TATS' headquarters at the Point, Nicer told me, regarding Pun's significance: "He was a great example. He made millions with this music and he could have moved anywhere, but he decided to stay in his community." Visibly moved, he added that the artist also "did a lot for the community" by opening up a youth center, a barber shop and a pool hall.

The significance of Big Pun's life and the impact of his death extend way beyond his immediate community. He is a cultural icon and role model for young Latinos and African Americans across the nation; rap audiences in general mourn the loss of a talented artist in his prime.

A key part of Big Punisher's legacy resides in his celebration and vindication of the creativity of young New York Puerto Ricans who have most often felt squeezed between, on one hand, a stifling traditional definition of Puerto Ricanness—and *latinidad*—that doesn't adequately take them into account and, on the other hand, perceptions of hip hop culture as an exclusively African American domain. New York Puerto Ricans often have been made to feel that they are not Puerto Rican enough

and that they are not wholly welcome either in the hip hop zone. But Big
Punisher without apology claimed territory in both the Puerto Rican and
the hip hop realm. And he refused to be content with marginal status in
either. There was no half this and half that with him. He was 100%
Boricua, 100% hip hop.

He proudly called himself a "Porto Rock," thus stripping of its nega-
tive charge this pejorative term formerly used by African Americans to
mock and question the authenticity of Puerto Ricans who participate in
the rap scene. A big part of his mission was to struggle against the his-
torical amnesia that leads many to ignore the fact that Puerto Ricans did
not belatedly "adopt" rap and the hip hop culture of which it is part but
played an integral role in their development.

Big Punisher is up there among the other luminous musical heroes of
the Puerto Rican diaspora who have passed away: Ismael Rivera, Héctor
Lavoe, Frankie Ruiz and Tito Puente. "Nooooo!" will scream those who
insist that Big Pun should not be counted among the other great ones,
because he defected into the "*moreno* music" camp or because his lyrics
were "offensive." But whether his critics accept it or not, Big Pun earned
a privileged place in the popular hall of fame.

The faces of recently deceased Tito Puente and Big Punisher side by
side on a T-shirt worn by scores of revelers during the 2000 Puerto Rican
Day Parade festivities is only one among many examples of feelings long
in the air. Then there was also the proudly displayed flag with its layer
upon layer of meaning: Splayed across the hood of a beat-up Toyota
parked in front of Jefferson projects in El Barrio was a Puerto Rican flag
flaunting a superimposed illustration of prizefighting roosters facing each
other, each armed with boxing gloves. Handwritten in black ink across
the flag's white stripes was a roll call of late musicians that completed the
layered symbols of Puerto Ricanness: Ismael Rivera, Héctor Lavoe,
Frankie Ruiz, Tito Puente, Big Pun.

MUSIC, SPIRIT AND REMEMBRANCE

I was not at Big Punisher's album release party at Jimmy's Bronx Café
two months after his death, in April of 2000. But Jorge "Georgie"

Vázquez was, and he described the event with such detail and emotion that I couldn't escape the impact of the sounds and images in his story, nor the significance that he attached to them.

Vázquez is a percussionist who has played everything from heavy metal, to reggae, to *plena* and *bomba*, and is currently a member of the bands Welfare Poets and YerbaBuena.[15] A twenty-seven-year-old "kid" to the old-school *pleneros* and *bomberos* who have embraced him, he is not precisely young in the hip hop realm. And like many Boricuas now living that eventful decade between twenty and thirty, he has the same love of hip hop that he has for salsa. A compelling sense of collective cultural identity and connectedness draw him to both. He cherishes his Bronx stomping grounds as much for being the cradle of hip hop as for being *el condado de la salsa.*

Arms and shoulders expressively punctuating his words, Vázquez told me of the album release party. Pun's widow and sister were there as were fellow artists Funkmaster Flex, Red Alert, Tony Touch, Darnell Jones, Fat Joe and other Terror Squad members. For Vázquez, it was a very emotional event bordering on magical: the celebration of a great accomplishment, a promising sophomore album from a platinum artist; but the central figure in the effort was missing, dead at twenty-eight. His friends, collaborators, family and supporters were determined to emphasize the joy of dreams fulfilled and not the pain of a life cut short.

A brief sequence of events struck Vázquez as illustrating that celebration's significance. DJ Tony Touch was on the turntables and let the needle loose on a song from his own album *The Piece Maker*. The crowd reacted enthusiastically and a flurry of breakers descended on the dance floor. What better way to pay tribute to the recently departed South Bronx son than with the quintessential Boogie Down Bronx dance form so devotedly cultivated by his fellow Porto Rocks?

After letting his own album's hip hop music and rhymes play for a while, DJ Tony Touch scratched his way into the disco-like introduction of Rubén Blades and Willie Colón's 1978 *salsa* hit "Plástico." As the song progressed, the room was filled by the rich rhythms that—though back then largely shunned by the hip hop generation—were as much a staple of New York life during the late 1970s as rap rhyming and breakbeats. What better way to celebrate the environment that nourished the late Big

Pun's vibrantly creative spirit than by laying down the musical testimony of the intergenerational New York Rican experience?

Tony Touch's choice of grooves that night tapped right into the intangible spot where history, philosophy and spirituality intersect. His seamless shifts in musical styles may have seemed incongruous to the uninitiated, but for Vázquez, they only responded to the logic, experience and hybrid pleasures of a collective of which Big Pun was part. The individual breakers who had first flocked to the dance floor to the sounds of hip hop gave way to dancing couples once Blades and Colón's song took over. It was a fluid and effortless movement in terms of music, dancing and history.

This party seeking to honor Pun's memory was brimming with cultural significance as much for the man being honored as for the shaman—or more appropriately *bohique*, in the Taíno tradition Touch claims as a source of identity and strength—on the turntables. Tony Touch, a.k.a. Tony Toca, a.k.a. The Taíno Turntable Terrorist, is a well-respected DJ who also rhymes and who started out as a b-boy—an impressive range of skills, for not many can claim mastering one hip hop art form, let alone three. Like Big Pun, Touch is a New York Puerto Rican who weaves the images and sounds of those he considers his people into his hip hop craft. And he was the DJ who doubled as *presidente de mesa*—or spiritual guide—leading an event that was a cross between a record release party and a healing session for a crowd perplexed by the transformation of a massive man into spirit and remembrance.

BIG PUN PLACE: *DIMES Y DIRETES*

The running controversy over the artistic merit of rap music's "explicit" lyrics, their influence on youth and their relationship to Puerto Rican culture flared up yet again in May 2001. This time it was the late Big Punisher who stood right in the middle of it.

Should Rogers Place between 163rd Street and Westchester Avenue be renamed Big Pun Place? Does the rapper deserve to have a street in his native South Bronx named after him? For Big Pun's admirers the answer is a resounding yes. Seven thousand area residents signed a petition

requesting the change. Local Community Board #2 approved a motion to the same effect. Councilman Pedro G. Espada sponsored an enabling bill. The proposal, however, did not go over well in the New York City Council.

The day after the council's Parks Committee was supposed to vote on the bill, the *Daily News* reported the bill was squelched because several members complained about Big Pun's "misogynistic" and "obscene" lyrics and his "use of words that some consider racially offensive."[16] Councilman Espada was quoted expressing his dissatisfaction with the decision but optimism that the bill would be allowed to go to vote at some later point.

"This is a jurisdictional issue; this is what the community wants," Espada told me in an interview shortly after the *Daily News* article was published. "This is not a street that anyone has to live with besides those people that signed the petition and live in that community," he added. For Espada, those who oppose the bill do not understand Big Pun's music, legacy and significance for South Bronx residents.

Dahu Bryson, the owner of a small record store in the South Bronx who led the petition drive, explained in an interview in May 2001 that the shock waves rippling through the neighborhood after Big Pun's death compelled him to take action: "Seeing everybody so sad, and seeing the big mural being painted and everybody leaving the candles and people having an all night vigil, sleeping at the mural. I just wanted to do something." Since Big Pun's body was cremated, the mural on Rogers Place is "his resting place as far as people in the block is concerned; that's the final place where they can mourn and leave flowers and leave candles." In Bryson's eyes, having that block renamed Big Pun Place would make official what has already become a memorial site in the artist's honor.

Elementary and high school students were the most fervent participants of the petition drive. Bryson says their efforts were warmly received by area residents: "We started with just one petition with twenty slots for twenty signatures and filled it instantaneously, so we made more pages." Young people's dedication and passion for this cause was a decisive factor in the local community board's unanimous vote in favor of renaming the street in the rapper's honor. Board member Sister Thomas told me in May 2001 she was extremely moved by the "impassioned,

emotional presentation by teenagers and young preteens" made before the board. Andrea Eisner, the board's assistant district manager, explained to me:

> You had to see these kids that made the presentation. They were terrific. Even one talked about that he was fat and that Big Pun was fat and he made him feel that he didn't have to be ashamed of himself. They did really thorough petitioning. We were really taken by them. We were so thrilled to have young people so involved in a civic issue like this. And their presentation was just so touching. . . . [They said] that he was a role model; that he was from this neighborhood; that he stayed in the community and that he put money back into the community and that he didn't desert once he got to be Big Pun.

Dahu Bryson, Councilman Espada and scores of others who support the street renaming argue that Big Pun was not only a virtuoso rapper but also a great role model for young people. According to Bryson, who also grew up in the South Bronx: "He deserves a street because he was a caring individual that cared about his community. He opened up a recreation center on Westchester as an example. He used his own money to have a place where young people from that neighborhood could come and play. And he was there himself, so they could come and talk to a star. And they could see that the only alternatives in the ghetto are not going to jail and a life of crime. You can be somebody, you can be a father, you can turn your life around."

But what about Big Pun's lyrics? Were they offensive? Were they sexist? Were they violent? Do they set a bad example for young people? Would it be an error to honor the rapper by making Big Pun Place a reality?

Sister Thomas says she voted in favor of the motion to support the creation of Big Pun Place, even though she was not personally familiar with the artist's music. Unlike other rappers widely recognized for their lyrical crudeness, Sister Thomas declares she "never heard anything negative or anything to oppose him." On the contrary, "everyone was assuring me that he was a very positive, generous and community-minded person."

But once those several New York council members condemned Big Pun's lyrics for being sexist and obscene, Sister Thomas began to think

that the community board should reconsider its decision. "If I knew that this is the kind of language [in his songs], I would have voted no," she says. If it were in fact true that "this man is a proponent of violence and women bashing," Sister Thomas states she would change her original position on renaming the street.

Orlando Marín, who is also a member of Bronx Community Board #2, does not share his colleague's position. Marín was familiar with Big Pun's lyrics and knew for a fact they were at times crude and sexist. This, however, does not mean for him that the artist does not deserve the honor. He told me: "Do I think Pun stood up for everything that a citizen should stand up for? No, because I'm not fond of cursing and belittling women. Do I think that he's a prominent Latino figure that kids could say 'that's one Latino that I can look at'? Yes, I do." Even though Big Pun had his shortcomings, Marín believes it is important to recognize him "because he's Latino, he's from the Bronx and because this shows that we are building ourselves back up as a community." Marín, who was a teenager at the time of rap's commercial debut in 1979, emphasizes Pun's importance as a role model "because when I was growing up I had no Latino role models or mentors."

"I think [judging] any individual's lyrics or any individual's character is a generational issue," Councilman Pedro G. Espada, who is twenty-nine years old, told me during an interview. "When Elvis was seen as the anti-Christ, many of my colleagues were listening to his music and were excited by that; and today Elvis can be placed on stamps," he adds. Espada is sure that in thirty years the predominant perspective in the council will be very different. Rappers will not be viewed with so much suspicion, "when there's a council member in their seat that sees things from the perspective of the hip hop community and the rap phenomenon."

Big Pun's friend and mentor, Fat Joe, also believes the controversy over the street renaming is the product of the existing generation gap. He told me during an interview: "Espada is a younger councilman who understands the Latino youth that Big Pun has touched their hearts, all the Blacks, everybody who loves hip hop music, all the kids that Big Pun represented coming out of the South Bronx. Us hip hop artists mean a lot to these kids and the problem is these old people, they usually don't go

nowhere, they don't know how to relate to what we do, so they immediately think of us as bad people 'cause we say bad lyrics."

Dahu Bryson accuses the council of stereotyping Big Pun "based on their impression of what hip hop is about." "They've heard on the news about Puff Daddy's trial and these other rappers, and the violence and the drugs that can be associated with this, and they're grouping Big Pun in that same category 'cause he happened to be a rapper also."

Many rap artists and fans are incensed by what they describe as prejudice against them. Fat Joe notes that this bias came out full force during the aftermath of the Central Park sexual attacks perpetrated a few hours after the Puerto Rican Day Parade 2000. "Something happens in the Puerto Rican Parade and they blame hip hop music," he says, referring to statements made by Federico Pérez, spokesman for the parade's board, who announced that the organization was contemplating banning certain rap artists from participating. "If we can prevent music that is conducive to these acts that are outside the norm, well, we'll have to do that," Pérez said in an interview with the *New York Times*.[17]

Vee Bravo, then editor of *Stress* magazine, denounced in a televised debate with Pérez on ABC's (NY Channel 7) weekend morning show called *Tiempo* that hip hop music became a convenient "scapegoat" for the parade organizers.[18] Through their finger-pointing, the parade organizers attempted to excise the alleged culprits (rappers) from "us" (true and decent Puerto Ricans) and deflect "our" collective responsibility. However, the painful truth, in Bravo's words, is that "the incident had more to do with how we view women in Latino culture than with hip hop floats." Chilean-born and New York–raised Bravo acknowledges "hip hop lyrics have contributed to violence against women." But he emphasizes that it is important to note that this musical genre is not the exception but the rule within the sexist society we live in.

Fat Joe declares it is hypocritical to accuse rappers of having certain attitudes when such attitudes also prevail among *salsa* and *merengue* musicians. "Hector Lavoe talked about drugs, money and sex all day," says Joe. "And what about the merengue 'ponte en cuatro' this and that?" he asks. "If you wanna take that as offensive towards women, you can," Joe says, even though he himself does not deem those lyrics derogatory. "They blamed hip hop because they're all old fashioned and do not un-

derstand the music," according to Joe, who believes a false connection has been drawn between the sexual attacks and rap music. The parade organizers decided to lay the blame on rap because "when they seen most of the people doing it was the youth, they said let's blame it on hip hop music."

New York radio disc jockey and rap artist Angie Martínez told me during a May 2001 interview she was very angry that rap artists were singled out as contributors to the sexual violence that tarnished the 2000 parade. "It's youth that likes hip hop, so when you turn your back on hip hop, you're turning your back on Latino youth. So what, we can't be there? We can't listen to the music that we like? When you categorize all hip hop people to be this, when you categorize all Dominicans or all Puerto Ricans to be this. . . . That to me is dangerous. I never like to do that, personally, and it irritates me when other people do it. 'Cause everybody has a different experience, everybody is a different person. Sure, there's people in hip hop that are troublemakers and there's people that are into hip hop and that love hip hop that are not. Same thing with everything else. It's ignorant to group anybody and put a negative thing on any group of people."

Monse Torres, a rapper and poet who works as Martínez's assistant at Hot 97 FM, told me that it is not fair or wise to blame rap artists for the sexism and violence that thrive throughout society as a whole. "Women have always played a certain role to the man in this society; and music, including hip hop, is an expression of that negative aspect," says Torres, an avid hip hop music fan. He recalls his angry reaction upon reading the *New York Times* article whose headline proclaimed "Puerto Rican Parade May Ban Some Rap." Torres was alarmed that rappers were blamed for the sexual attacks and by the suggestion that rap is outside the scope of Puerto Rican culture: "I was offended [by the statements in the article]. They were trying to separate hip hop from Puerto Rican culture. The article basically said that [the organizers] were going to exclude anything that was not a representation of the Puerto Rican culture. And that's saying that hip hop is not a representation of the Puerto Rican culture. Then they can say 'well, it's not just hip hop; it's certain acts in hip hop that aren't a representation of Puerto Rican culture.' But how can you really draw that line?"

If rap music with "negative connotations" is not "representative of us . . . of the Hispanic," as parade board spokesman Pérez said in the article, then a whole slew of other cultural expressions with similar "negative connotations" should not be considered "representative of us" either. However, the parade organizers decided to go for the contemporary musical scapegoat of choice, the one mistakenly thought to be a *moreno* music that has lured Puerto Rican youth away from their cultural roots, in short, the proverbial *mangó bajito:* rap.

Perez's statements for the *New York Times* were contested in the same article by Assemblyman Rubén Díaz of the Bronx who, like Councilman Espada, is also in his late twenties: "I love rap music and I didn't grow up hassling women. Someone who says rap music or hip-hop is not a part of Puerto Rican culture would be sadly mistaken."[19] Vee Bravo, who was also quoted, likewise countered Perez's pronouncements: "As far as saying hip-hop artists are not part of the Puerto Rican tradition, they're crazy."

Dahu Bryson holds that the same misguided assumptions used to tie rappers with the Central Park attacks and to justify excluding them from the Puerto Rican Parade are at work when council members argue that Big Pun does not deserve a street in his name. Behind these actions lies the existing prejudice against contemporary youth culture. "We're not saying [Big Pun] was perfect," says Bryson, but "many people have streets named after them and they're not perfect either, even the reverends and the priests."

"If seven thousand people signed the petition in the South Bronx to get an avenue named after Big Pun, why has that gone unnoticed?" asks Fat Joe who, like Pun, is a South Bronx native son. "Probably [more people] voted for Big Pun Avenue than they voted for borough president, councilman or assemblyman," he adds. But despite the controversy over Big Pun's lyrics, Joe says, he has not lost faith that Big Pun Place will one day become a reality: "They have to recognize us sooner or later."

CHAPTER 10

BETWEEN BLACKNESS AND *LATINIDAD*

A Brief Historical Overview

New York Puerto Ricans have negotiated their spaces and identities within hip hop through various creative approaches, most of which evidence an effort to balance two identity categories—blackness and *latinidad*—that are frequently imagined to be mutually exclusive. Their strategies of negotiation have shifted during the course of hip hop's three-decade history in response to the predominant understandings regarding cultural "entitlement" and "authenticity."

Hip hop's dominant discourses of the 1970s were locally based and posed this culture as an Afro-diasporic ghetto-based zone inclusive of Puerto Ricans. During the 1980s and 1990s, as rap music went national and international, hip hop's scope of "entitlement" was significantly reduced, so that most often it accommodated only the African American experience. In the latter part of the 1990s, hip hop discourses evidenced a renewed inclusiveness directed toward Puerto Ricans and other Latinos. Although highlighting Latino difference through tropicalizations, these discourses also have emphasized the existence of shared class-based ethno-racialized identities that are not circumscribed by the boundaries of either *latinidad* or African Americanness.

New York Puerto Ricans tended to step lightly through the identity minefield, though with a sense of ghetto-based Afro-diasporic entitlement, during hip hop's earliest times. As their participation and entitlement were strongly questioned in the 1980s and early 1990s, two divergent negotiation approaches developed: Some Puerto Ricans began emphasizing their *latinidad* as expressed through "Latin hip hop," thus excising themselves from the hip hop "core"; others took the opposite approach, muting displays of ethno-racialized difference from African Americans and insisting on their claim to creation and participation within hip hop's Afro-diasporic realm. During the late 1990s, the relegitimation of Puerto Rican participation in hip hop music has afforded Puerto Ricans the opportunity to explore—without alienating themselves from that hip hop "core"—forms of creative expression that during the 1980s would have been perceived as critical violations of the music's scope of authenticity.

New York Puerto Ricans have been key participants in the cultural zone that is hip hop, a realm that has been profoundly informed by their creativity, identities and sociocultural history. Hip hop, since its very beginnings, has been about cultural convergence among African Americans, Puerto Ricans and other Caribbean people. However, often these groups' shared cultural ground is associated exclusively with African Americans. Even among participants themselves, hip hop has been largely perceived to be an African American–matrixed cultural zone where "too much" Puerto Ricanness presents a disruption.

Does this mean that Puerto Rican participation in hip hop takes place within a context of "assimilation" into African Americanness? Not quite, as manifested by the participants themselves. Hip hop cultural production is not overlapping with African American ethno-racial identity. Puerto Rican legitimation as entitled participants has not been contingent on their subsumption under African Americanness. On the contrary, Puerto Ricans have been legitimated through the invocation of an urban, class-based, and Afro-diasporic shared identity that serves as the base from which to name hip hop "Black and Puerto Rican," "Black and Latino," an expression of ghetto-based "people of color" and/or "niggas."

Hip hop's Afro-diasporic practice destabilizes the dominant understandings of identity and cultural expression that envision African Amer-

icanness and Puerto Ricanness as nonintersecting. But this does not negate the fact that these exclusionary notions have impacted the hip hop zone, thus creating tensions and affecting relations among participants as well as their creative expression.

Since the late 1990s, we have witnessed how pan-Latino social solidarity and markets are being constructed and how those constructions are manifested in cultural expression. We stand at a crucial moment in terms of Puerto Rican hip hop enthusiasts, because despite the growing trends and pressures toward pan-ethnic identification, they still exhibit a strong resistance to being lumped under the Latino banner. Puerto Rican hip hop participants are part of a cultural zone, where even though a crack has been opened for Latino entitlement, emphasizing Puerto Ricanness (or *latinidad*) in certain ways may push one toward the sidelines.

Second- and third-generation New York Puerto Ricans often have either excluded themselves or found themselves excluded from the generally accepted bounds of *latinidad*, given the fundamental urban Afro-diasporicity of their cultural practices. Puerto Ricans who participate in hip hop culture have sought to acknowledge their Afro-diasporic Caribbeanness without wholly submerging themselves under the reigning Hispanocentric definition of *latinidad* as nonblack, or under a blackness that takes only African Americans into account.

EPILOGUE

"If they play music, they can play something in rap," said Madelyn Lugo, National Puerto Rican Day Parade board member, referring to rap artists who seek to participate in the event. "But they should identity [*sic*] at least with the Puerto Rican culture," she concluded.[1]

Her comments, published by the *New York Times*, are yet another example of the widespread assumption that hip hop art forms are foreign to Puerto Rican culture. For rap artists to deserve inclusion in the parade, their musical output needs to bear the cultural signs of "true" Puerto Ricanness, a narrow category that fails to recognize many elements of Nuyorican cultural expression.

New York Puerto Rican MCs, DJs and producers often put out music that cannot be readily distinguishable from that of African American artists. Although for many that fact proves the weakening of Puerto Rican culture and identity in New York City, it is merely a testament of the Nuyorican hip hop generations' conception of being Puerto Rican. Their ethnic identity is heir to their parents' and grandparents' culture, but it also draws heavily from the culture of their most immediate partners/rivals/neighbors, namely African Americans. But the impact does not run in only one direction. The way in which African Americans express themselves through rap music has been fundamentally shaped by Puerto Ricans and their particular forms of cultural expression.

It is also important to stress the common African roots of the cultural traditions of those African Americans and Puerto Ricans who met in New York City, learning and borrowing from each other and producing new forms of expression. Even if Puerto Rican rap artists never included one lick of Spanish in their rhymes or incorporated *salsa* or *bomba* rhythms into their songs, how much would they really be deviating from

the Afro-Caribbean culture of their ancestors? Not as much as people have been prone to assume.

Rap music is a contemporary manifestation of cultural traditions that can be traced all the way back to Africa. Storytelling, lyrical competition and boasting, improvising rhymes over a repetitive rhythmic or melodic structure, call-and-response patterns, tonal semantics (vocal rhythm and inflections, or "flow"), rhythmic complexity and rupture . . . These are all elements present not only in rap music and the African American tradition but in the music of Puerto Rico and all other Afro-diasporic regions of the Americas. Thus, when Puerto Ricans, Jamaicans and other Caribbeans joined African Americans in the early development of hip hop culture during the 1970s, they were not straying too far from their particular ethnic traditions.

But let us not be deluded. Puerto Ricans and other Caribbeans may not have moved that far away from their parents' and grandparents' traditions, but aspects of those traditions were viewed with suspicion and were even outright unwelcome within the hip hop zone. Back in the early 1970s, Jamaican-born Kool DJ Herc gave up trying to spin reggae at parties and instead concentrated on the funk music his peers reacted best to. Both Afrika Bambaataa and DJ Charlie Chase recall that in those years, "Spanish" music was largely looked down upon by their youthful audiences, including Puerto Ricans themselves. Neither reggae nor Caribbean Latino music was deemed "cool" by youngsters during that era.

Caribbean young people—especially those from Spanish-speaking countries—although key participants in hip hop music, had to step lightly on this contested cultural ground, lest their entitlement be questioned and their immigrant background thrown in their face. They strove to "fit in" and "belong," shedding the aspects of their parents' culture deemed backward, hickish, unpolished, uncool.

Much has changed in rap music in the nearly thirty years that have gone by. Since the latter half of the 1990s, it has become extremely common among even the most popular artists, both African American and Latino, to incorporate Spanish phrases into English rhymes and to sample or re-create music deemed to have a "Latino flavor." But the apparent victory is tainted by both its conditions and its costs. The Spanish words and "Latino" beats employed are often unimaginative and stereotypical: a

dash of exotic tropical spice. Images of Butta Pecan Rican *mamis* are all over the place, in all their silent and contrived sexual splendor. And, ironically, Latino artists still run the risk of having their hip hop authenticity questioned by bringing in "too much" of their ethnic backgrounds, while African American artists can throw around that "Latino flavor" without fearing any repercussion.

"It wasn't until they [African Americans] got with our stuff that we [Puerto Ricans] were able to get with our stuff," Bronx rapper and singer La Bruja (Caridad de la Luz) told me in a 2001 interview. Until fairly recently, Puerto Rican and other Latino rap artists had to be careful about the amount of Spanish words and Caribbean rhythms they used in their music, since they could be accused of corrupting the hip hop musical aesthetic and defecting to the "Latin hip hop" artistic ghetto. But once African American rap artists incorporated Spanish phrases and Caribbean Latino rhythms into their music during the latter half of the 1990s, the use of such by Latino artists became much more palatable within the mainstream rap market.

In fact, injecting a certain "Latino flavor" into rap rhymes has become such a gimmick that commercially successful New York Puerto Rican rap artists such as Angie Martínez and Fat Joe actually complained, in separate interviews with me in 2001, of feeling a pressure to "Latinize" their sound in ways they do not wish to. In an interview with journalist Carol Cooper, Martínez said: "When I first started doing this record everybody was giving me Spanish beats! I was like, come on, y'all know me, I'm hip-hop! Why do you think that I'm suddenly going to be like Miss Cha Cha? I mean, I am Latin and that's cool, but I'm not trying to use my Latinness to sell records."[2] Cooper herself seems taken aback by the low degree of Latino "flavor" in Martinez's 2001 debut solo album titled *Up Close and Personal:* "What *is* perhaps surprising, given Martínez's background and the ongoing popularity of Latin music, is that there are only two salsa-flavored tracks on the album."

Martínez's guarded flirtation with *merengue* and *salsa* beats in two of the songs and her sparse use of Spanish lyrics—limited to a few phrases here and there—should surprise no one. Neither should her insistence on being identified as a hip hop artist, first and foremost, rather than championed as a Latina hip hop artist. As Martínez explains it, she is an

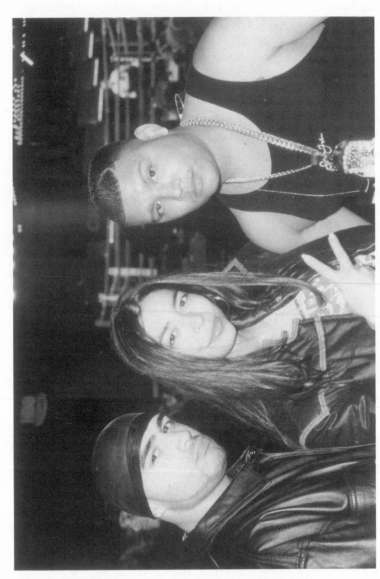

Left to right: Tony Sunshine, La Bruja and Cuban Link. Photo by G–Bo the Pro.

English-dominant Puerto Rican who feels most comfortable navigating the traditional hip hop musical aesthetic. But even if she had wanted to fuse more Caribbean rhythms into her music and Spanish words into her lyrics, would she have done so, considering that her hip hop authenticity could have come into question?

As La Bruja explained to me, it is easier for an African American rapper to use cultural elements readily identifiable with Latinos than it is for Latinos themselves to do so: "Lil' Kim can say something in Spanish and everyone thinks it's crazy cool; but a Latino that tries to use his or her culture and mix it in. . . ." That hypothetical Latino runs the risk of being accused of overemphasizing and pimping his or her ethnicity and shunned for turning his or her back on "true" hip hop. The risk is particularly high if that artist wants to explore themes and musical sources that do not fall within the narrow strip of *latinidad* that is now deemed cool—referencing *merengue* and *salsa* hits and invoking tough-guy *papi chulos*, beautiful hot *mamis* and assorted ghetto-fabulous images.

La Bruja knows that singing *orisha*[3]-inspired tunes backed up by the *cuatros* and *bomba* rhythms of the band YerbaBuena, indicting our materialistic culture in her rap songs and refusing to play the butta pecan "hoochie mamma" role has not helped her get media visibility. As she told me during a conversation at a Bronx park, as her two beautiful small children played nearby: "Being Latina, not trying to sell your body, speaking of our roots, our power, our *ashé*. . . . Imagine, I don't have a record deal. But I do my thing and whoever is supposed to hear it will hear it."[4]

La Bruja has decided to do "her thing"—which has meant mixing art, political activism and her spiritual beliefs as well as incorporating *bomba* and *jíbaro* music into her repertoire—regardless of its commercial implications. Other artists have been moving in a similar direction. Fat Joe, Tony Touch, Rock Steady Crew, G-Bo the Pro, Bobbito García and other well-known Puerto Rican hip hop artists have become involved in the movement to get the U.S. Navy out of Vieques, Puerto Rico. Hurricane G was featured in the *No More Prisons* CD as part of a campaign to dismantle the U.S. prison-industrial complex. The Welfare Poets—whose members are noted Puerto Rican and African American political activists—have for many years integrated poetry, rap and varied musical genres into their repertoire[5]; but it has been in the last few years that the

group has aggressively explored *plena* and *bomba*. Freddy Skitz (Iván Ferrer), formerly of Puerto Rico–based hip hop group Boricua Bomb Squad, now lives in New York, where he has begun collaborating with music groups that play *bomba* and Dominican *palos*. A studio recording that will soon be released, it is hoped, under Kahlil Jacobs-Fantauzzi's Borinquen Libre Productions features a lively session with DJ Tony Touch on the turntables, *bomba* drummers (among them *el maestro* Micky Sierra) and local rappers and poets.

Cultural, spiritual and political symbolism that a decade ago might have been inconceivable within rap music has proliferated. A very early example is Fat Joe's 1995 album *Jealous One's Envy*, which featured a captivating image of a cockfight on the cover. Hurricane G went through a very public year as a *yabó* (*santería* initiate) in 1997 and appeared in Cocoa Brova's 1998 video for the song "Spanish Harlem" dressed all in white as she gave praises in her rhymes to the *santeras* and *espiritistas* who share her faith. Tony Touch included Puerto Rican nationalist leader Pedro Albizu Campos's fiery voice booming over thick hip hop beats in the "Intro" of his 2000 album *The Piece Maker*. Big Punisher's "100%," also released in 2000, includes four lines from Puerto Rican national anthem "La Borinqueña" as well as a few verses derived from the 1970s' *salsa* classic "El día de mi suerte."

Dancer Jorge "PopMaster Fabel" Pabón is currently working on a documentary devoted to the history of Puerto Ricans in hip hop culture. In a recent conversation we had, he explained that one of his aims is to explore the uniqueness of the Puerto Rican hip hop experience and its connections to previous Boricua generations, but without severing the cultural links than bind Puerto Ricans and other Afro-diasporic groups in New York City: "The purpose is to reveal the long unbroken chain of cultural identity among Puerto Ricans of different generations—an identity inclusive of many different ingredients—and to illustrate through documentation this struggle of trying to define our identity. Each cultural group has its own experiences. There is not just one black reality. Depending on how you grew up culturally, you'll gravitate towards that— and it just doesn't depend on color."

I mention all these examples because they are to me hope-bearing signs of a Puerto Rican generation reveling in the particularity (and diversity!)

of its cultural heritage and reality and also signs that cultural symbols and group identity can be made to serve worthy political purposes.

But mass-mediated taste is a fickle thing. For all we know, references to *bomba* music, *santería* and political activism around Vieques, police brutality and the prison-industrial complex may become rap music commercial fads. La Bruja can become a media darling tomorrow, and the new rap market gimmick will be the "spiritual yet sexy Puerto Rican goddess." But even that will not necessarily mean anything as long as our perception of pleasure and artistic worth is dictated by the entertainment industry. What good would it be to have our cultural traditions and political struggles celebrated as the flavor-of-the-month moneymaker? What purpose does it serve to keep paying more attention to form than substance, words than deeds, image than feeling, ego than spirit?

As La Bruja herself said during an showcase/forum held in November 2001 called "Lenguas Libres"[6] (Liberated Tongues): "What is our priority? Is it the bling, bling [jewelry and money]? Is it the celli [cellular telephone]? What will we eat when there is not one more tree to bear fruit? Are you going to be able to eat that celli? . . . *Seguimos y estamos en guerra. Esto es nuestro pra-ca-ca-cá para pelear: nuestras palabras, nuestros pensamientos, nuestros seres.*"[7]

NOTES

CHAPTER 1—INTRODUCTION

1. See Juan Flores, "Rappin', Writin' & Breakin,'" *Centro*, no. 3 (1988): 34–41; Nelson George, *Hip Hop America* (New York: Viking, 1998); Steve Hager, *Hip Hop: The Illustrated History of Breakdancing, Rapping and Graffiti* (New York: St. Martin's Press, 1984); Tricia Rose, *Black Noise: Rap Music and Black Culture in Contemporary America* (Hanover, NH: Wesleyan University Press, 1994); David Toop, *The Rap Attack 2: African Rap to Global Hip Hop* (London: Serpent's Tail, 1991).
2. Edward Rodríguez, "Sunset Style," *The Ticker*, March 6, 1996.
3. Carlito Rodríguez, "The Young Guns of Hip-Hop," *The Source* 105 (June 1998): 146–149.
4. Clyde Valentín, "Big Pun: Puerto Rock Style with a Twist of Black and I'm Proud," *Stress*, issue 23 (2000): 48.
5. See Juan Flores, *Divided Borders: Essays on Puerto Rican Identity* (Houston: Arte Público Press, 1993); Bonnie Urciuoli, *Exposing Prejudice: Puerto Rican Experiences of Language, Race and Class* (Boulder, CO: Westview Press, 1996).
6. See Manuel Alvarez Nazario, *El elemento afronegroide en el español de Puerto Rico* (San Juan: Instituto de Cultura Puertorriqueña,1974); Paul Gilroy, *The Black Atlantic: Modernity and Double Consciousness* (Cambridge, MA: Harvard University Press, 1993); Marshall Stearns, *The Story of Jazz* (Oxford: Oxford University Press, 1958); Robert Farris Thompson, "Hip Hop 101," in William Eric Perkins, ed., *Droppin' Science: Critical Essays on Rap Music and Hip Hop Culture* (Philadelphia: Temple University Press, 1996), pp. 211–219; Carlos "Tato" Torres and Ti-Jan Francisco Mbumba Loango, "Cuando la bomba ñama . . . !: Religious Elements of Afro-Puerto Rican Music," manuscript 2001.
7. Torres and Mbumba Loango, "Cuando la bomba ñama . . . !"
8. Thompson, "Hip Hop 101." See also Robert Farris Thompson, *Dancing Between Two Worlds: Kongo-Angola Culture and the Americas* (New York: Caribbean Cultural Center, 1991).
9. The artists who rhyme over hip hop beats were originally known as MCs. With hip hop's commercialization, the term "rapper" gained favor.

However, many hip hop enthusiasts—among them Q-Unique—still prefer to use the term "MC." B-boys and b-girls, also known as breakers, specialize in the hip hop dance form known as breaking.

10. D-Stroy, a solo hip hop lyricist, is a Brooklyn-raised Puerto Rican and former member of the Arsonists.

11. For explorations of *latinidad* as a pan-ethnic category, see Juan Flores, "Pan-Latino/Trans-Latino: Puerto Ricans in the 'New Nueva York,'" *Centro* 8, nos. 1 and 2 (1996): 171–186; Michael Jones-Correa and David Leal, "Becoming 'Hispanic': Secondary Pan-Ethnic Identification Among Latin American–Origin Populations in the United States," *Hispanic Journal of Behavioral Sciences* 18, no. 2 (1996): 214–254; Suzanne Oboler, *Ethnic Labels, Latino Lives: Identity and the Politics of (Re)Presentation in the United States* (Minneapolis: University of Minnesota Press, 1995).

12. Rodríguez was for several years a regular contributor to the Baruch College newspaper *The Ticker*. His often-controversial column, "Sunset Style" (now published on the web at ourswords.com), is a "hip hop editorial" named after Rodríguez's working-class and heavily Puerto Rican Brooklyn neighborhood.

13. The advantage of using a rather cumbersome term like "ethno-racial" (rather than "ethnic" and/or "racial") is that it acknowledges the racial dimension of ethnic categories as well as the social constructedness of racial classifications. See David Hollinger, *Post-Ethnic America: Beyond Multiculturalism* (New York: Basic Books, 1995); Michael Omi and Howard Winant, *Racial Formation in the United States* (New York: Routledge, 1994).

14. See Edward Rodríguez, "Sunset Style," *The Ticker*, May 8, 1996, p. 26. Emphasis added.

15. See Edward Rodríguez, "Hip Hop Culture: The Myths and Misconceptions of This Urban Counterculture," manuscript 1995.

16. See Linda Chávez, *Out of the Barrio: Towards a New Politics of Hispanic Assimilation* (New York: Basic Books, 1991); Flores, "Pan-Latino/Trans-Latino"; Robert Smith, "'Doubly Bounded' Solidarity: Race and Social Location in the Incorporation of Mexicans into New York City," paper presented at the Conference of Fellows: Program of Research on the Urban Underclass, Social Science Research Council, University of Michigan, June 1994.

17. See Nazario, *El elemento afronegroide en el español de Puerto Rico;* Juan Giusti Cordero, "AfroPuerto Rican Cultural Studies: Beyond Cultural *negroide* and *antillanismo,*" *Centro* 8, no. 1 and 2 (1996): 57–77; José Luis González, *El país de los cuatro pisos y otros ensayos* (Rio Piedras: Ediciones Huracán, 1989); Isabelo Zenón Cruz, *Narciso descrubre su trasero* (Humacao: Furidi, 1975).

18. See Coco Fusco, *English Is Broken Here: Notes on Cultural Fusion in the Americas* (New York: The New Press, 1995); Gilroy, *Black Atlantic*.

19. See Flores, "Rappin', Writin' & Breakin'"; Rose, *Black Noise;* Thompson, "Hip Hop 101."

20. See Frances Aparicio and Susana Chávez-Silverman, "Introduction," in Frances Aparicio and Susana Chávez-Silverman, eds., *Tropicalizations: Transcultural Representations of Latinidad* (Hanover, NH: University of New England, 1997).

21. Although it is most common for hip hop culture to be defined in terms of these art forms, many participants also include the dances known as *popping, locking* and *uprocking*. Others argue that there are also hip hop–specific takes on fashion, poetry/spoken word, fiction, journalism, theater, video/filmmaking and language.

22. See Dawn Norfleet, *"Hip Hop Culture" in New York City: The Role of Verbal Musical Performance in Defining a Community*, Ph.D. diss., Columbia University, New York, 1997.

23. See Peter McLaren, "Gangsta Pedagogy and Ghettoethnicity: The Hip Hop Nation as Counterpublic Sphere," *Suitcase* 1, nos. 1 and 2 (1995): 74–87; Rose, *Black Noise*.

24. See Andre Craddock-Willis, "Rap Music and the Black Musical Tradition," *Radical America* 23, no. 4 (1989): 29–39; Toop, *The Rap Attack*.

25. See Dick Hebdige, *Cut 'N' Mix: Culture, Identity and Caribbean Music* (New York: Methuen & Co., 1987); Flores, "Rappin', Writin' & Breakin'"; Rose, *Black Noise*.

26. Ibid. See also Daisann McLane, "The Forgotten Caribbean Connection," *New York Times*, August 23, 1992, p. 22; Thompson, "Hip Hop 101"; Torres and Mbumba Loango, "Cuando la bomba ñama."

27. Cyphers are spontaneous and informal gatherings where participants arrange themselves in a loose circle to rhyme or dance and where improvisational skills have a primary role. See Tony Bones, Queen Heroine and MFW, "The Cypher: Add Water and Stir," *Stress*, issue 10 (December 1997): 44, for an assessment of the cypher's importance in hip hop: "It goes beyond rhyming, conversation and other means of communication. It's the ultimate brainstorming session. Everything from playing congos to African spiritual dances to after school fights to group therapy to ring around the rosie to the Nation of the Gods and Earths all get down in ciphers." See also Norfleet, *"Hip Hop Culture" in New York City*, for a reflection on cyphers as performance.

28. See Oscar Handlin, "Comments on Mass and Popular Culture," in Norman Jacobs, ed., *Culture for the Millions?: Mass Media in Modern Society* (Boston: Beacon Press, 1968); Andrew Ross, *No Respect: Intellectuals and Popular Culture* (New York: Routledge, 1989).

29. See Juan Flores, "Puerto Rican and Proud, Boyee!: Rap, Roots and Amnesia," *Centro* 5, no. 1 (1992–93): 22–32; Norfleet, *"Hip Hop Culture" in New York City*.

30. Island-based underground music is different from the New York–based "underground" rap scene. The latter, a realm whose borders are in contention within hip hop insider discourses, can be loosely described as the gatherings, performances, practices and recordings that tend to be

organized and produced by independent parties with minimal or no connection to the most dominant and profitable sectors of the rap music industry.

31. See Cristina Verán, "Knowledge Droplets from a B-Boy Rainstorm," *Rap Pages* 5, no. 8 (September 1996): 42.

32. See Norfleet, *"Hip Hop Culture" in New York City*.

33. New York has been regarded as a hip hop hot spot, not only because of its place in hip hop history but also because of its continuous creative contributions to hip hop's development.

34. Bobbito García has been a key figure in New York hip hop culture for many reasons. Not only has he, for years, hosted some of the most important radio shows and "open-mic" events in the city, he also has been a regular contributor to various hip hop–oriented magazines, has served as a panelist in many hip hop conferences and has been the founder and owner of two small but influential independent record labels, Fondle 'Em Records and Fruitmeat Records.

CHAPTER 2—ENTER THE NEW YORK RICANS

1. See Juan Flores, "Pan-Latino/Trans-Latino: Puerto Ricans in the 'New Nueva York,'" *Centro* 8, nos. 1 and 2 (1996): 171–186.

2. See Angelo Falcón, Minerva Delgado and Gerson Borrero, *Toward a Puerto Rican/Latino Agenda for New York City* (New York: Institute for Puerto Rican Policy, 1989).

3. Figures provided by the Lewis Mumford Center for Urban and Regional Research at the State University of New York-Albany.

4. Puerto Ricans are not only the largest Latino group but also one of the largest ethnic groups in New York City.

5. See Linda Chávez, *Out of the Barrio: Towards a New Politics of Hispanic Assimilation* (New York: Basic Books, 1991); Douglas Massey and Nancy Denton, "Trends in the Residential Segregation of Blacks, Hispanic and Asians," in Norman R. Yetman, ed., *Majority and Minority: The Dynamics of Race and Ethnicity in American Life* (Boston: Allyn and Bacon, 1991); Robert Smith, "'Doubly Bounded' Solidarity: Race and Social Location in the Incorporation of Mexicans into New York City," paper presented at the Conference of Fellows: Program of Research on the Urban Underclass, Social Science Research Council, University of Michigan, June 1994.

6. See James Dietz, *Economic History of Puerto Rico: Institutional Change and Capitalist Development* (Princeton, NJ: Princeton University Press, 1991); Centro de Estudios Puertorriqueños, History Task Force, *Labor Migration Under Capitalism: The Puerto Rican Experience* (New York: Monthly Review Press, 1979).

7. Joseph P. Fitzpatrick, *Puerto Rican Americans: The Meaning of Migration to the Mainland* (Englewood Cliffs, NJ: Prentice Hall, 1987); Vicky Muñiz, *Resisting Gentrification and Displacement: Voices of Puerto Rican Women of the Barrio* (New York: Garland Publishing, 1998).

8. Nathan Kantrowitz, *Ethnic and Racial Segregation in the New York Metropolis* (New York: Praeger Publishers, 1973), p. 23; Dennis Conway and Ualthan Bigby, "Where Caribbean People Live in the City," in Constance R. Sutton and Elsa M. Chaney, eds., *Caribbean Life in New York City: Sociocultural Dimensions* (New York: Center for Migration Studies of New York,1985), p. 81.

9. See Ramón Grosfoguel and Chloé Georas, "The Racialization of Latino Caribbean Immigrants in the New York Metropolitan Area," *Centro* 8, nos. 1 and 2 (1996): 190–201; Roberto Rodríguez-Morazzani, "Beyond the Rainbow: Mapping the Discourse on Puerto Ricans and 'Race,'" *Centro* 8, nos. 1 and 2 (1996): 150–169; Andrés Torres, *Between Melting Pot and Mosaic: African Americans and Puerto Ricans in the New York Political Economy* (Philadelphia: Temple University Press, 1995).

10. See John U. Ogbu, *Minority Education and Caste: The American System in Cross-Cultural Perspective* (New York: Academic Press, 1978); Douglas S. Massey and Brooks Bitterman, "Explaining the Paradox of Puerto Rican Segregation," *Social Forces* 64, no. 2 (1985): 306–330; Herbert Gans, "Second-Generation Decline: Scenarios for the Economic and Ethnic Futures of the Post-1965 Immigrant," *Ethnic and Racial Studies* 15, no. 2 (1992): 173–192; Alejandro Portes and Min Zhou, "The New Second Generation: Segmented Asimilation and Its Variants," *Annals of the American Academy of Political and Social Sciences* 530 (November 1993): 74–96.

11. See Flores, "Pan-Latino/Trans-Latino"; Torres, *Between Melting Pot and Mosaic;* Bonnie Urciuoli, *Exposing Prejudice: Puerto Rican Experiences of Language, Race and Class* (Boulder, CO: Westview Press, 1996).

12. See James Early, "An African American-Puerto Rican Connection: An Auto-Bio-Memory Sketch of Political Development and Activism," in Andrés Torres and José E. Velázquez, eds., *The Puerto Rican Movement: Views from the Diaspora* (Philadelphia: Temple University Press, 1998); Roberto Rodríguez-Morazzani, "Puerto Rican Political Generations in New York: Pioneros, Young Turks and Radicals," *Centro* 4, no. 1 (1991–92): 96–116; Torres, *Between Melting Pot and Mosaic;* Michael Abramson and Young Lords Party, *Palante: Young Lords Party* (New York: Pantheon, 1971).

13. See Philip Kasinitz, *Caribbean New York: Black Immigrants and the Politics of Race* (Ithaca, NY: Cornell University Press, 1992); Smith, "'Doubly Bounded' Solidarity"; Mary Waters, "Ethnic and Racial Identities of Second-Generation Black Immigrants in New York City," in Alejandro Portes, ed., *The New Second Generation* (New York: Russell Sage Foundation, 1996), pp. 171–196.

14. See Grosfoguel and Georas, "The Racialization of Latino Caribbean Immigrants in the New York Metropolitan Area." They assert that the marginalization of New York Puerto Ricans has set the stage for the incorporation of Dominicans as yet another stigmatized and racialized "minority" group into New York socioeconomic hierarchies.

15. William Kornblum, "Who Is the Underclass: Contrasting Approaches, a Grave Problem," *Dissent* 38 (Spring 1991): 202–211; Nicholas Lemann, "The Other Underclass," *The Atlantic Monthly* (December 1991): 96–110; Richie Pérez, "From Assimilation to Annihilation: Puerto Rican Images in U.S. Films," *Centro* 2, no. 8 (Spring 1990): 8–27.

16. See Smith, "'Doubly Bounded' Solidarity," p. 26.

17. New York City Department of City Planning, *Puerto Rican New Yorkers in 1990* (New York: Department of City Planning, 1994).

18. See, for example, Philipe Bourgois, *In Search of Respect: Selling Crack in El Barrio* (Cambridge: Cambridge University Press, 1995), pp. 79–80.

19. See Urciuoli, *Exposing Prejudice,* p. 65.

20. See Nancy Guevara, "Women Writin', Rappin', Breakin'," in Mike Davis, ed., *The Year Left* (London: Verso Books, 1987), pp. 160–175; Tricia Rose, *Black Noise: Rap Music and Black Culture in Contemporary America* (Hanover, NH: Wesleyan University Press, 1994).

21. See Juan Flores, "Writin', Rappin' & Breakin'," *Centro,* no. 3 (1988): 34–41; Juan Flores, *From Bomba to Hip-Hop* (New York: Columbia University Press, 1999); Steve Hager, *Hip Hop: The Illustrated History of Breakdancing, Rapping and Graffiti* (New York: St. Martin's Press, 1984); Max Salazar, "Afro-American Latinized Rhythms," in Vernon Boggs, ed., *Salsiology: Afro-Cuban Music and the Evolution of Salsa in New York City* (New York: Greenwood Press, 1992).

22. Carmen Dolores Hernández, *Puerto Rican Voices in English: Interviews with Writers* (Westport, CT: Praeger, 1997), p. 129.

23. See Jack Miles, "Blacks vs. Browns: The Struggle for the Bottom Rung," *The Atlantic Monthly* 270, no. 4 (1992): 41–68; Torres, *Between Melting Pot and Mosaic.*

24. Juan Flores, "Puerto Rican and Proud, Boyee!: Rap, Roots and Amnesia," *Centro* 5, no. 1 (1992–93): 28.

25. See Flores "Pan-Latino/Trans-Latino"; Geoffrey Fox, *Hispanic Nation: Culture, Politics and the Construction of Identity* (Tucson: University of Arizona Press, 1996); Carlos Pabón, "De Albizu a Madonna: Para armar y desarmar la nacionalidad," *bordes* 2 (1995): 22–40.

26. See Clara Rodríguez, *Puerto Ricans: Born in the U.S.A.* (Boulder, CO: Westview Press, 1991); Víctor Rodríguez, "The Racialization of Puerto Rican Ethnicity in the United States," in Juan Manuel Carrión, ed., *Ethnicity, Race and Nationality in the Caribbean* (Rio Piedras: Institute of Caribbean Studies, University of Puerto Rico, 1997).

27. See Roberto Rodríguez-Morazzani, "Beyond the Rainbow."

28. See George Fredrickson, *White Supremacy: A Comparative Study in American and South African History* (New York: Oxford University Press,1981); Michael Omi and Howard Winant, *Racial Formation in the United States* (New York: Routledge, 1994).

29. See Carl N. Degler, *Neither Black Nor White: Slavery and Race Relations in Brazil and the United States* (Madison: University of Wisconsin Press, 1971); Harmannus Hoetink, "'Race' and Color in the Caribbean," in Sidney W. Mint and Sally Price, eds., *Caribbean Contours* (Baltimore: John Hopkins University, 1985); Eduardo Seda Bonilla, "Dos modelos de relaciones raciales: Estados Unidos y América Latina," *Revista de Ciencia Sociales* 12, no. 4 (1968): 569–597.

30. See Tomás Blanco, *El prejuicio racial en Puerto Rico* (Rio Piedras: Ediciones Huracán, 1985); Arlene Dávila, *Sponsored Identities: Cultural Politics in Puerto Rico* (Philadelphia: Temple University Press, 1997); José Luis González, *El país de cuatro pisos y otros ensayos* (Rio Piedras: Ediciones Huracán, 1980); Antonio S. Pedreira, *Insularismo* (Rio Piedras: Edil, 1992).

31. See Isabelo Zenón Cruz, *Narciso descubre su trasero* (Humacao: Furidi, 1975); Arcadio Díaz Quiñones, "Tomás Blanco; racismo, historia y esclavitud," in Tomás Blanco, *El prejuicio racial en Puerto Rico* (Rio Piedras: Ediciones Huracán, 1985), pp. 15–91; Angela Jorge, "The Black Puerto Rican Woman in Contemporary Society," in Edna Acosta-Belén, ed., *The Puerto Rican Woman: Perspectives on Culture, History and Society* (New York: Praeger, 1986); González, *El país de los cuatro pisos;* Luis Rafael Sánchez, "La gente de color," in *No llores por nosotros Puerto Rico* (Hanover, NH: Ediciones del Norte, 1998).

32. See Vernon Boggs, *Salsiology: Afro-Cuban Music and the Evolution of Salsa in New York City* (New York: Greenwood Press, 1992); Flores, *From Bomba to Hip-Hop;* John Storm Roberts, *The Latin Tinge: The Impact of Latin American Music on the United States* (Oxford: Oxford University Press, 1979).

33. Roberts, *The Latin Tinge,* p. 167.

34. See Flores, *From Bomba to Hip Hop,* p. 106.

35. Rocking was a competitive youth dance form developed in the late 1960s that attained great popularity, primarily among Puerto Ricans, in the 1970s. The north-central Brooklyn neighborhood known as Bushwick seems to have been at the epicenter of rocking's development. Other neighborhoods known as rocking hot spots included East New York, Bay Ridge and Williamsburg. Rocking eventually became known as Brooklyn rock or uprocking outside of the borough where it was first developed. See the Appendix, "Dynasty Rockers' Diana."

36. See Lola Aponte, "Para inventarse el Caribe: la construcción fenotípica de las antillas hispanófonas," *bordes,* no. 2 (1995): 5–14; Coco Fusco, *English Is Broken Here: Notes on Cultural Fusion in the Americas* (New York:

The New Press, 1995); Paul Gilroy, *The Black Atlantic: Modernity and Double Consciousness* (Cambridge, MA: Harvard University Press, 1993).

37. Rodríguez-Morazzani, "Beyond the Rainbow," p. 153.

38. See Cheryl Keyes, "At the Crossroads: Rap Music and Its African Nexus," *Ethnomusicology* 40, no. 2 (Spring/Summer 1996): 223–247.

39. See Manuel Alvarez Nazario, *El elemento afronegroide en el español de Puerto Rico* (San Juan: Instituto de Cultura Puertorriqueña, 1974); Russell Potter, "Calypso: Roots of the Roots," *www.ric.edu/rpotter/calypso. html;* Marshall Stearns, *The Story of Jazz* (Oxford: Oxford University Press, 1958); Carlos "Tato" Torres and Ti-Jan Francisco Mbumba Loango, "Cuando la bomba ñama . . . !: Religious Elements of Afro-Puerto Rican Music," manuscript 2001; Carlos "Tato" Torres, "'Cocobalé': African Martial Arts in Bomba," *Güiro y Maraca* 5, no. 1 (Winter 2001): 9–12; Francisco Valcárcel, "An Introduction to Afro-Caribbean Martial Arts," *Güiro y Maraca* 5, no. 1 (Winter 2001): 4–6.

40. Ibid.

41. Robert Farris Thompson traces uprocking back to various challenge dances in Kongo, such as *nsunsa*. See Robert Farris Thompson, *Dancing Between Two Worlds: Kongo-Angola Culture and the Americas* (New York: Caribbean Cultural Center, 1991).

42. David Toop, *Rap Attack 2: African Rap to Global Hip Hop* (London: Serpent's Tail, 1991), p. 19.

43. See Anthony Lauria, "'Respeto,' 'Relajo' and Inter-personal Relations in Puerto Rico," *Anthropological Quarterly* 37, no. 2 (1964): 62.

44. Currently in his late twenties, José Raúl "Gallego" González is part of the "new" generation of poets in Puerto Rico and author of *Barrunto*. Some of his poems are well known among fans of rap in Spanish and *reggaetón,* given his collaboration in recent popular recordings.

45. Ricardo Alegría, "Puerto Rico y su cultura nacional," speech presented in Ponce, Puerto Rico, May 23, 1971; Eugenio Fernández Méndez, *La identidad y la cultura* (Rio Piedras: Edil, 1970).

46. Pabón, "De Albizu a Madonna," p. 22. The translation is mine.

47. See Arcadio Díaz Quiñones, *La memoria rota* (Rio Piedras: Ediciones Huracán, 1993); González, *El país de cuatro pisos;* Lydia Milagros González, ed., *La tercera raíz: Presencia africana en Puerto Rico* (San Juan: Centro de Estudios de la Realidad Puertorriqueña and Instituto de Cultura Puertorriqueña, 1992); Mayra Santos, "Puerto Rican Underground," *Centro* 8, nos. 1 and 2 (1996): 219–231; Zenón Cruz, *Narciso descubre su trasero.*

48. See Jorge Duany, "Nation on the Move: The Construction of Identities in Puerto Rico and the Diaspora," *American Ethnologist* 27, no. 1 (February 2000): 5–30; Dávila, *Sponsored Identities.*

49. See Luis Manuel Alvarez, "La presencia negra en la música puertorriqueña," in Lydia Milagros González, ed., *La tercera raíz: Presencia africana en Puerto Rico* (San Juan: Centro de Estudios de la Realidad

Puertorriqueña and Instituto de Cultura Puertorriqueña, 1992), pp. 30–41; Manuel Alvarez Nazario, *El elemento afronegroide en el español de Puerto Rico* (San Juan: Instituto de Cultura Puertorriqueña, 1974); J. Emanuel Dufrasne, *Puerto Rico también tiene . . . ¡tambó!: recopilación de artículos sobre la plena y la bomba* (Rio Grande: Paracumbé, 1994); Angel Quintero Rivera, *Salsa, sabor y control: Sociología de la música tropical* (Ciudad de México: Siglo XXI Editores, 1999).

50. Rap's musical and oral sources challenge the dominant narrow territorial conception of nationhood. See Fernández Méndez, *La identidad y la cultura*, p. 8. He offers an example of this territorial approach in the form of his statement that Puerto Rican culture "is nothing else but a concrete historical reality: that which takes place in a territory called Puerto Rico."

51. See Toop, *Rap Attack 2*.

52. See Dick Hebdige, *Cut 'N' Mix: Culture, Identity and Caribbean Music* (New York: Methuen & Co., 1987); Daisann McLane, "The Forgotten Caribbean Connection," *New York Times*, August 23, 1992, p. 22 (Arts and Leisure).

53. See Juan Cartagena, "Raíces: The Film Special by Banco Popular," *Güiro y Maraca* 5, no. 4 (Winter 2001): 8.

54. See Raquel Ortiz, "El especial del Banco Popular," *El Nuevo Día*, December 4, 2001, p. 91.

55. See Angel Quintero Rivera, "Salsa: ¿Desterritorialización?, nacionalidad e identidades," *Revista de Ciencias Sociales*, no. 4 (January 1998): 105–120.

56. Néstor García Canclini, "Cultural Reconversion," in George Yúdice, Jean Franco and Juan Flores, eds., *On Edge: The Crisis of Contemporary Latin American Culture* (Minneapolis: University of Minnesota Press, 1992), pp. 29–43; Juan Flores, *Divided Borders: Essays on Puerto Rican Identity* (Houston: Arte Público Press, 1993); Stuart Hall, *Identity: Community, Culture, Difference* (London: Lawrence & Wishart, 1990); Peter Manuel, *Caribbean Currents: Caribbean Music from Rumba to Reggae* (Philadelphia: Temple University Press, 1995).

57. Manuel, *Caribbean Currents*, p. 92. Emphasis added.

58. George Lipsitz, *Dangerous Crossroads: Popular Music, Postmodernism and the Poetics of Place* (New York: Verso, 1997), p. 71.

59. Rodrigo Salazar, "Afro-Cuban Music 101," *Urban Latino Magazine* 4 (Fall 1995): 21.

60. Jorge Cano-Moreno, "La nueva visión/The New Vision," *Urban Latino Magazine* 4 (Fall 1995): 8–9.

CHAPTER 3—"IT'S JUST BEGUN"

1. See Nicholas Lemann "The Other Underclass," *The Atlantic Monthly* (December 1991): 96–110; Clara E. Rodríguez, *Puerto Ricans: Born in the*

U.S.A (Boulder, CO: Westview Press), p. 109; Edgardo Rodríguez Juliá, *El entierro de Cortijo* (Rio Piedras: Ediciones Huracán, 1988), p. 29.

2. See Marshall Berman, *All That Is Solid Melts into Air: The Experience of Modernity* (New York: Methuen Books, 1988); Deborah Wallace and Rodrick Wallace, *A Plague on Your Houses: How New York Was Burned Down and National Public Health Crumbled* (New York: Verso, 1998).

3. Steve Hager, *Hip Hop: The Illustrated History of Breakdancing, Rap Music and Graffiti* (New York: St. Martin's Press, 1984).

4. Juice (TC-5) Lascaibar, "Hip Hop 101: Respect the Architects of Your History," *The Source*, no. 95 (August 1997): 47–48.

5. See Rodríguez, *Puerto Ricans*, p. 109.

6. Blanca Vázquez, Juan Flores and Juan Figueroa, "KMX-Assault: The Puerto Rican Roots of Rap," *Centro* 5, no. 1 (Winter 1992–93): 41.

7. The disproportionate negative impact of "urban renewal" projects on poor African Americans and Puerto Ricans was not only felt in the South Bronx, but in many other areas of the city. Critics of the city government's approach to "urban renewal" dubbed it "urban removal" and—more explicitly indicative of the racial underpinnings of the policies—as "Negro removal." See Berman, *All That Is Solid Melts into Air;* Fredrick M. Binder and David M. Reimers, *All Nations Under Heaven: An Ethnic and Racial History of New York City* (New York: Columbia University Press, 1995); Vicky Muñiz, *Resisting Gentrification and Displacement: Voices of Puerto Rican Women of the Barrio* (New York: Garland Publishing, 1998).

8. See Wallace and Wallace, *A Plague on Your Houses.*

9. See Rodríguez, *Puerto Ricans*, p. 109.

10. See Andrés Torres, *Between Melting Pot and Mosaic: African Americans and Puerto Ricans in the New York Political Economy* (Philadelphia: Temple University Press, 1995); William J. Wilson, *The Truly Disadvantaged: The Inner-City, the Underclass, and Public Policy* (Chicago: University of Chicago Press, 1987).

11. See Torres, *Between Melting Pot and Mosaic*, pp. 44–45.

12. See Tricia Rose, *Black Noise: Rap Music and Black Culture in Contemporary America* (Hanover, NH: Wesleyan University Press, 1994), p. 28.

13. See Nelson George, *Hip Hop America* (New York: Viking, 1998); Hager, *Hip Hop;* Rose, *Black Noise*, p. 34.

14. Marshall Berman, "Views from the Burning Bridge," *Dissent* (Summer1999): 79.

15. Juan Flores, "Wild Style and Filming Hip Hop," *Areito* 10, no. 37 (1984): 36–39.

16. PopMaster Fabel, who grew up in East Harlem and began dancing in the 1970s, was a firsthand witness and participant in the early development of hip hop.

17. Hager, *Hip Hop*, p. 33.

18. See Cheryl Keyes, "At the Crossroads: Rap Music and Its African Nexus," *Ethnomusicology* 40, no. 2 (Spring/Summer): 227; Rose, *Black*

Noise, p. 47; David Toop, *Rap Attack 2: African Rap to Global Hip Hop* (London: Serpent's Tail, 1991), p. 60.

19. Toop, *Rap Attack*, p. 60.
20. Ibid., p. 66.
21. Juan Flores, "It's a Street Thing!," *Callaloo* 15, no. 4 (1992): 999–1021.
22. Toop, *Rap Attack 2*, p. 104.
23. "Moreno" is a Spanish word that describes someone with dark skin. While in Puerto Rico "moreno" can apply to anyone—whether Puerto Rican or not—with dark skin, Puerto Ricans in New York use the term most often to refer to African Americans.
24. "Porto Rock" is a mocking term first used by African Americans to describe Puerto Rican hip hop enthusiasts. Puerto Ricans then reappropriated the term as a way to assert their entitlement to hip hop. I know of at least two MCs who have taken the term as their artistic name: Puerto Rock of Latin Empire and Puerto Rock, the East Harlem rapper who released the single "Bang Out!!!" (2000). Fat Joe and Big Pun, among many others, also proudly describe themselves as Porto Rocks in some of their rhymes.
25. See Davey D, "Why Is Cleopatra White?" *The FNV Newsletter* (May 21, 1999), www.daveyd.com/fnvmay21.html.
26. Sekou Sundiata, "The Latin Connection," essay in playbill for the Black Rock Coalition's music performance *The Latin Connection*, BAM Majestic Theater, Brooklyn, June 27, 1998.
27. Ana Celia Zentella, *Growing Up Bilingual: Puerto Rican Children in New York* (Malden, MA: Blackwell Publishers, 1997).
28. See Juan Flores, "Writin', Rappin' & Breakin'," *Centro* 2, no. 3 (1988): 39.
29. See Nancy Foner, *New Immigrants in New York* (New York: Columbia University Press, 1987), p. 248. She argues the existence of a difference between the experience of black Puerto Ricans who tend to identify in terms of their national origins group and not racially versus recent West Indian immigrants who develop a consciousness of themselves as black and of their placement as black people within the racial hierarchies of U.S. society.
30. See Foner, *New Immigrants in New York;* Phillip Kasinitz, *Caribbean New York: Black Immigrants and the Politics of Race* (Ithaca, NY: Cornell University Press, 1992); Mary Waters, "Ethnic and Racial Identities of Second Generation Black Immigrants in New York City," in *The New Second Generation*, ed. Alejandro Portes (New York: Russell Sage Foundation, 1996), pp. 171–196.
31. Hager, *Hip Hop*, p. 31.
32. See Flores, "It's a Street Thing!"
33. George Lipsitz, *Dangerous Crossroads: Popular Music, Postmodernism and the Poetics of Place* (New York: Verso, 1997).
34. Juan Flores, *Divided Borders: Essays on Puerto Rican Identity* (Houston: Arte Público Press, 1993), p. 192.

35. See George, *Hip Hop America*, p. 16. George argues that Latino youth played a key role in shaping hip hop's musical development through their participation as b-boys and b-girls. "It was their taste, their affirmation of certain tracks as good for breaking, and their demand to hear them at parties that influenced the DJs and MCs who pioneered hip hop's early sound."

36. The concept of having a claim on a certain cultural expression is one that comes up constantly in the cultural arena. Arguably a step more inclusive than the concept of "cultural property," it usually draws on history, traditions, origins and participation to separate insiders from outsiders. See Edward Rodríguez's comments regarding the Latino "claim" to hip hop, early in chapter 1.

37. See Toop, *Rap Attack 2*, p. 81.

38. Ibid., p. 76.

39. Both Grandmaster Caz and Waterbed Kev made these comments during a panel discussion at the conference The Rap Session held at Barnard College in New York in 1998.

40. The Fearless Four was the first rap group, after Kurtis Blow, signed to a major label. Nelson and Gonzales dub the Fearless Four, along with the Furious Five and Soul Sonic Force, as the groups at the "cutting edge of this new Black Noize" in 1983 and 1984. I wonder how Puerto Ricanness and Blackness relate to each other in Nelson and Gonzales's eyes considering the contribution of Puerto Rican artists to "this new Black Noize." See Havelock Nelson and Michael A. Gonzales, *Bring the Noise: A Guide to Rap Music and Hip Hop Culture* (New York: Harmony Books, 1991), p. 206.

41. See Bryan Cross, *It's Not about a Salary: Rap, Race and Resistance in Los Angeles* (New York: Verso Books, 1993), p. 69; Mandalit del Barco, "Rap's Latino Sabor," in William Eric Perkins, *Droppin' Science: Critical Essays on Rap Music and Hip Hop Culture* (Philadelphia: Temple University Press, 1996), p. 66; Toop, *Rap Attack 2*, p. 122.

42. Nelson and Gonzales, *Bring the Noise*, p. 206.

43. Sally Banes, "Physical Graffiti: Breaking Is Hard to Do," *Village Voice*, April 22, 1981, p. 31.

44. Phase 2, "The Realness: Too Hip to Party," *Stress*, issue 2 (Spring 1996): p. 54.

45. Ibid.

46. See Peter Rosenwald, "Breaking Away 80's Style," *Dance Magazine* 58, no. 4 (April 1984): p. 74; Robin D. G. Kelley, *Yo Mama's Disfunktional: Fighting the Culture Wars in Urban America* (Boston: Beacon Press,1997), p. 68.

47. Video Channel VH1 introduced its August 2, 1998, showing of *Breakin'* by pronouncing it "the movie that started it all." Considering that this movie was made in 1984, more than a full decade after breaking's public—although ghettoized—recognition as a dance form, the "all" that this

movie is being purported to have started refers only to breaking's phase as mainstream fad. This is only one example among countless others of the way in which the mainstream media severs history and social context from cultural expression.

48. See Richie Pérez, "From Assimilation to Annihilation: Puerto Rican Images in U.S. Films," *Centro* 2, no. 8 (Spring): 8–27. He has dubbed the products of this approach to movie-making "missionary films." He points to the 1960s reigning "liberal perspective" as the key moment in the production of such films among which are *Up the Down Staircase* (1967), *Change of Habit* (1969) and *The Possession of Joel Delaney* (1972). Countless prior and later films like *The Young Savages* (1961), *Fort Apache* (1981) and *Dangerous Minds* (1995) exhibit the same "missionary" approach.

49. See Kevin Grubb, "'Hip-hoppin' in the South Bronx: Lester Wilson's Beat Street," *Dance Magazine* 58, no. 4 (April 1984): 75–78; Margaret Pierpont, "Breaking in the Studio," *Dance Magazine* 58, no. 4 (April 1984): 82; Peter J. Rosenwald, "Breaking Away 80's Style," *Dance Magazine* 58, no. 4 (April 1984): 70–74.

50. See Nancy Guevara, "Women Rappin', Writin', Breakin'," in *The Year Left*, ed. Mike Davis (London: Verso Books, 1987), pp. 160–175; Rose, *Black Noise*.

51. See Juan Flores, "Wild Style and Filming Hip Hop," *Areito* 10, no. 37 (1984): 36–39; Guevara, "Rappin', Writin', Breakin'."

52. Guillermo Gómez-Peña, *Warrior for Gringostroika: Essays, Performance Texts and Poetry* (St. Paul, MN: Graywolf Press, 1993), p. 51.

53. See Flores "Writin', Rappin', Breakin'"; Katrina Hazzard-Donald, "Dance in Hip Hop Culture" in *Droppin' Science: Critical Essays on Rap Music and Hip Hop Culture*, ed. William Eric Perkins (Philadelphia: Temple University Press, 1996); Rose, *Black Noise*.

54. Rose, *Black Noise*.

55. Cristina Verán, "That's the Breaks," *Rap Pages* 5, no. 8 (September 1996): 6.

56. See Lola Ogunnaike, "Breakdancing Regains Its Footing," *New York Times*, June 7, 1998, p. 1 (Section 9); Frank Owen, "Breaking's New Ground: Generation Next Spins on Its Head," *Village Voice*, May 20, 1998, pp. 61–62.

57. See Guevara, "Women Writin', Rappin', Breakin'."

CHAPTER 4—WHOSE HIP HOP?

1. Samples are segments of previously recorded material (including music, speeches and movies) that are incorporated into a rap song.

2. See Errol Henderson, "Black Nationalism and Rap Music," *Journal of Black Studies* 26, no. 3 (January 1996): 308–339; Edward Sunez Rodríguez, "Sunset Style," *The Ticker*, March 6, 1996.

3. Run DMC's *Raising Hell* was the first rap album to go triple platinum with 3 million copies sold. This group had previously released the first rap album to go gold (500,000 sold) and the first rap song to be featured on MTV. See Michael Eric Dyson, *Reflecting Black: African American Cultural Criticism* (Minneapolis: University of Minnesota Press, 1995), p. 5.

4. See Ernest Allen, Jr., "Making the Strong Survive: The Contours and Contradictions of Message Rap," in *Droppin' Science: Critical Essays on Rap Music and Hip Hop Culture,* ed. William Eric Perkins (Philadelphia: Temple University Press, 1996), pp. 159–191.

5. Afrocentricity was, in some senses, a commercial phase that rap went through. The movie *CB-4* (1993), starring comedian Chris Rock, portrays it as one of numerous fads in the history of rap. The movie includes a scene in which one of the protagonists—dressed in heavily layered, stereotypically "Afrocentric" attire—raps something to the effect of: "because I'm black, I'm black, I'm blickety, blickety, black, black, I'm black." His intense, self-righteous, blacker-than-thou pose is played off as ridiculous given the inane lyrics and the fact that the audience has seen him adopt a whole slew of rapping personae in an attempt to boost record sales. His Black nationalist image thus represents just one more gimmick.

6. Louis made these statements during a meeting of the Latino Leadership Opportunity Program of the Center for Puerto Rican Studies at Hunter College in New York City, where I had been invited to discuss my work with the student program participants.

7. See E. Allinson, "It's a Black Thing: Hearing How Whites Can't," *Cultural Studies* 8, no. 3 (1994): 438–456; Andrew Ross, *No Respect: Intellectuals and Popular Culture* (New York: Routledge, 1989).

8. See Allinson, "It's a Black Thing"; Rodríguez, "Sunset Style"; Tricia Rose, *Black Noise: Rap Music and Black Culture in Contemporary America* (Hanover, NH: Wesleyan University Press, 1994); David Samuels, "The Rap on Rap: The 'Black Music That Isn't Either," in *Rap on Rap: Straight-up Talk on Hip Hop Culture,* ed. Adam Sexton (New York: Dell Publishing, 1991), pp. 241–252.

9. Allinson, "It's a Black Thing," p. 449.

10. See James Bernard, "Man of the People," *XXL* 1, no. 2 (1998): 68–72.

11. Cristina Verán, "(Puerto) Rock of Ages," *Rap Pages* 5, no. 8 (1996): 42.

12. John Storm Roberts, *The Latin Tinge: The Impact of Latin American Music on the United States* (Oxford: Oxford University Press, 1979).

13. Sekou Sundiata, "The Latin Connection," essay in playbill for the Black Rock Coalition's music performance *The Latin Connection,* BAM Majestic Theater, Brooklyn, New York, June 27, 1998.

14. Cristina Verán, "What's Up Doc?: A Decade of Getting Jerked in the Game as Told by Engineer Extraordinaire Ivan 'Doc' Rodriguez," *Ego Trip* 3, no. 3 (1997): 34.

15. Clyde Valentín, "Bringing Dead Records Back to Life: Ivan 'Doc' Rodriguez," *Stress* 10 (December, 1997): 47.

16. Ibid.

17. David Toop, *Rap Attack 2: African Rap to Global Hip Hop* (London: Serpent's Tail, 1991).

18. Mandalit del Barco, "Rap's Latino Sabor," in *Droppin' Science: Critical Essays on Rap Music and Hip Hop Culture*, ed. William Eric Perkins (Philadelphia: Temple University Press, 1996), pp. 63–84; Ed Morales, "How Ya Like Nosotros Now?" *Village Voice*, November 26, 1991: pp. 26, 91.

19. LaMond, like many other artists who began their careers as freestyle singers such as Marc Anthony, La India, Brenda K. Starr and Lissette Meléndez, in the 1990s redirected his musical pursuits toward salsa.

20. Jennifer Parris, "Freestyle Forum," *Urban Latino Magazine* 2, no. 1 (1996): 30.

21. See Roberts, *The Latin Tinge*.

22. See Robert Orsi, "The Religious Boundaries of an Inbetween People: Street *Feste* and the Problem of the Dark Skinned Other in Italian Harlem, 1920–1990," *American Quarterly* 44, no. 3, 1992: 313–347.

23. Parris, "Freestyle Forum," p. 30–31.

24. Edward Sunez Rodríguez, "Hip Hop Culture: The Myths and Misconceptions of This Urban Counterculture." Ms. 1995, p. 7.

25. Del Barco, "Rap's Latino Sabor"; Morales, "How Ya Like Nosotros Now?" p. 91; Cindy Rodríguez, "Go Loco!," *Village Voice*, August 9, 1988: pp. 24–25.

26. Rodríguez, "Hip Hop Culture"; Rodríguez, "Sunset Style."

27. For hip hop enthusiasts' critiques of Gerardo, see Raquel Z. Rivera, "Boricuas from the Hip Hop Zone," *Centro* 8, nos. 1 and 2 (1996): 202–215.

28. See Peter Manuel, *Caribbean Currents: Caribbean Music from Rumba to Reggae* (Philadelphia: Temple University Press, 1995).

29. Ed Morales disputes this charge. See Morales, "How Ya Like Nosotros Now?"

30. Brian Cross, *It's Not About a Salary: Rap, Race and Resistance in Los Angeles* (New York: Verso Books, 1993), p. 238.

31. See Morales, "How Ya Like Nosotros Now?"

32. Mandalit del Barco, "Latino Rappers and Hip Hop: Que Pasa," National Public Radio documentary aired September 10, 1991.

CHAPTER 5—GHETTOCENTRICITY, BLACKNESS AND *LATINIDAD*

1. Kevin Powell, "The Ghetto," *Vibe* 3, no. 10 (December/January 1995): 49.

2. See Robin D. G. Kelley, "Kickin' Reality, Kickin' Ballistics: Gangsta Rap and Postindustrial Los Angeles," in *Droppin' Science: Critical Essays on*

Rap Music and Hip Hop Culture, ed. William Eric Perkins (Philadelphia: Temple University Press, 1996), pp. 117–158; Peter McLaren, "Gangsta Pedagogy and Ghettoethnicity: The Hip Hop Nation as Counterpublic Sphere," *Socialist Review* 25, no. 2 (1995): 9–55; David Samuels, "The Rap on Rap: The 'Black Music' That Isn't Either," in *Rap on Rap: Straight-up Talk on Hip Hop Culture,* ed. Adam Sexton (New York: Dell Publishing, 1991), pp. 241–252.

3. See Todd Boyd, *Am I Black Enough For You?: Popular Culture from the 'Hood and Beyond* (Bloomington: Indiana University Press, 1997); Christopher Holmes Smith, "Method in the Madness: Exploring the Boundaries of Identity in Hip Hop Performativity," *Social Identities* 3, no. 3 (1997): 345–374.

4. Smith, "Method in the Madness," p. 346.

5. Kelley, "Kickin' Reality, Kickin' Ballistics," p. 137.

6. See Reginald Dennis, liner notes for *Street Jams: Hip Hop from the Top Part 2,* Rhino R470578, 1992; Roberto "Cuba" Jiménez, "Vanishing Latino Acts," *The Source,* no. 95 (August 1997): 22; Juice (TC-5) Lascaibar, "Hip Hop 101: Respect the Architects of Your History," *The Source,* no. 95 (August 1997): 47–48; McLaren, "Gangsta Pedagogy and Ghettoethnicity"; Smith, "Method in the Madness."

7. Joel Antonio Sosa, "Station Zero: Animation for the Hip Hop Nation," *Urban Latino Magazine* 4, no. 2 (1999): 50–51.

8. However, the fact that there is only one Latino artist among Flip's rap dream team does point to the low numbers of commercial Latino rappers in a music realm overwhelmingly populated by African Americans.

9. Mandalit del Barco, "Latino Rappers and Hip Hop: Que Pasa," National Public Radio documentary aired September 10, 1991. Emphasis added.

10. *Jam on the Groove* ran during 1995 at PS 122 in the East Village and the Minnetta Lane Theater in the West Village. The company also did an international tour. See Gabriela Bousaada, "Breaking In," *Village Voice,* August 22, 1995, p. 75; Jon Pareles, "Review of *Jam on the Groove* by Ghettoriginal," *New York Times,* November 18, 1995, p. 19.

11. Miguel Burke, "Puerto Rico . . . Ho!!!: Frankie Cutlass," *The Source,* no. 90 (March 1997): 132.

12. James "Chase" Lynch, "Holdin' It Down," *Urban Latino Magazine* 3, no. 2 (1998): 34.

13. This reassessment of Latino participation did not spring up out of nowhere. Even before it became common to speak of hip hop as "Black and Latino," certain sectors held a vision of hip hop history that ran counter to the then-dominant construction of hip hop as exclusively African American.

14. For example, in the August 1999 *Source* magazine cover, an article on the duo Beatnuts was subtitled "Dos Vatos Locos," thus assuming that West Coast Chicano self-referential terminology can be automatically made to apply to these New Yorkers of Dominican and Colombian background.

15. Chang Weisberg, "Hip Hop's Minority?: Latino Artists Unite and Speak Out," *Industry Insider Magazine* 15 (1998): 50–51.

16. Ibid., p. 55.

17. Further illustrating that this trumpeting of a Latino unity that has yet to materialize, Weisberg wonders "why haven't Latino artists worked on more projects together?" His assumption is that Latino artists *should* want to work together, and since there have been very few projects of such kind, it must be due to obstacles that should be overcome.

18. Weisberg, "Hip Hop's Minority?," p. 54.

19. Ibid., p. 51.

20. See Kevin Baxter, "Spanish Fly: Latinos Take Over," *The Source*, no. 113 (February 1999): 136–141.

21. Weisberg, "Hip Hop's Minority?" p. 55.

22. See Boyd, *Am I Black Enough for You?*; Jiménez, "Vanishing Latino Acts"; William Eric Perkins, "Youth Global Village: An Epilogue," in *Droppin' Science: Critical Essays on Rap Music and Hip Hop Culture,* ed. William Eric Perkins (Philadelphia: Temple University Press, 1996), p. 263.

23. Nick De Genova, "Gangsta Rap and Nihilism in Black America: Some Questions of Life and Death," *Social Text* 13, no. 2 (1995); Errol Henderson, "Black Nationalism and Rap Music," *Journal of Black Studies* 26, no. 3 (January 1996): 308–339; Kelley, "Kickin' Reality, Kickin' Ballistics."

24. See Smith, "Method in the Madness"; McLaren, "Gangsta Pedagogy and Ghettoethnicity."

25. Smith, "Method in the Madness," p. 345.

26. Tricia Rose, *Black Noise: Rap Music and Black Culture in Contemporary America* (Hanover, NH: Wesleyan University Press, 1994), p. 189.

27. Edward Rodríguez, "Hip Hop Culture."

28. McLaren, "Gangsta Pedagogy and Ghettoethnicity," pp. 33–34. Emphasis mine.

CHAPTER 6—LATIN@S GET HOT AND GHETTO-TROPICAL

1. Rigo "Riggs" Morales, "Renaissance Revisited," *Urban Latino Magazine* 3, no. 2 (1998): 33.

2. These approaches to ghettocentricity, however, are not necessarily mutually exclusive; the difference, most frequently, is a matter of emphasis.

3. KRS-ONE, *The Science of Rap* (New York: privately printed, 1995).

4. As part of the duo Brooklyn Bandits, B-Unique rhymed on "Venganza" (DJ Adams 1998) and "Bandido Style" (Coo-Kee 1998). His music partner is Don Gato, a Puerto Rican MC who has grown up partly in Williamsburg, Brooklyn, and partly in Guaynabo, Puerto Rico.

5. In Noreaga's words: "When I was growing up, people around my neighborhood used to call me a nigger-rican. It meant something to me. It's a

representation of who I am. . . . I'm half Latino and half African-American. I gotta claim both." See Kevin Baxter, "Spanish Fly: Latinos Take Over," *The Source*, no. 113 (February 1999): 138.

6. See "The Source '98 Yearbook," *The Source*, no. 113 (February 1999): 67–111.

7. See Chapter 7 for more about this video.

8. "Mami," diminutive of "mother" in Spanish and commonly loaded with affection or sexual interest, has long been used as a synonym for "woman" among Puerto Ricans and other Latinos.

9. For more on the movie *Scarface* as a seminal (pun intended) source of reference for contemporary youth culture, see Ed Morales, "The Scarface Myth and the Urban Agenda," *Urban Latino Magazine* 2, no. 3 (1997): 34–35.

10. Listen to De La Soul's "Itzoweezee" for a fierce indictment of rap's glamorization of Latino drug dealers and Italian mafiosos.

11. See Juan Flores, "Pan-Latino/Trans-Latino: Puerto Ricans in the 'New Nueva York,'" *Centro* 8, nos. 1 and 2 (1996): 171–186. On the "Puerto Ricanization" of Dominicans in New York, see Ramón Grosfoguel and Chloé Georas, "The Racialization of Caribbean Latino Immigrants in the New York Metropolitan Area," *Centro* 8, nos. 1 and 2 (1996): 190–201.

12. Fab Serignese, "Your Ass Here: The Sexploitation of the Latino Market," *Mía* (Summer 1998).

13. Antonette K. Irving, "Pussy Power: The Onerous Road to Sexual Liberation in Hip-Hop," *The Source*, no. 101 (February 1998): 34. See also Joan Morgan, "Fly-Girls, Bitches and Hoes: Notes of a Hip Hop Feminist," *Elementary* 1 (Summer 1996): 16–20; Tricia Rose, *Black Noise: Rap Music and Black Culture in Contemporary America* (Hanover, NH: Wesleyan University Press, 1994).

14. See Clara Rodríguez, *Latin Looks: Images of Latinas and Latinos in the U.S. Media* (Boulder, CO: Westview Press, 1997).

15. See Leith Mullings, "Images, Ideology and Women of Color," in *Women of Color in U.S. Society*, ed. Maxine Bacca Zinn and Bonnie Thornton Dill (Philadelphia: Temple University Press, 1994); Ella Shohat, "Gender and Culture of Empire: Toward a Feminist Ethnography of Cinema," in *Orientalism in Film*, ed. Mathew Bernstein and Gaylyn Studlar (New Brunswick, NJ: Rutgers University Press, 1997).

16. Rap's Puerto Rican (as well as other Latino) male subjects also eroticize *mamis*. The difference is that in these cases, *mamis* are eroticized not as a tropical (ethno-racial) Other but as part of a tropical collective Self.

17. See Frances R. Aparicio and Susana Chávez-Silverman, "Introduction," in *Tropicalizations: Transcultural Representations of Latinidad*, ed. Frances Aparicio and Susana Chávez-Silverman (Hanover, NH: Dartmouth College, University Press of New England, 1997), pp. 1–17.

18. Frances R. Aparicio, "On Sub-Versive Signifiers: Tropicalizing Language in the United States," in ibid., p. 195.

19. Before the mid-1990s, the less Latino rap enthusiasts distinguished themselves from African Americans, the less their entitlement to this cultural form was likely to be questioned.

20. See Aparicio, "On Sub-Versive Signifiers," p. 206, where she writes about mangos as "tropicalizing cultural signifiers."

21. Aparicio and Chávez-Silverman, "Introduction" in *Tropicalizations.*

22. See Frances Aparicio, *Listening to Salsa: Gender, Latin Popular Music, and Puerto Rican Cultures* (Hanover, NH: Wesleyan University Press, 1998); Aparicio and Chávez-Silverman, "Introduction," in *Tropicalizations;* Geoffrey Fox, *Hispanic Nation: Culture, Politics, and the Constructing of Identity* (Tucson: University of Arizona Press, 1996); Javier Santiago, *Nueva Ola Puertoricensis: La revolución musical que vivió Puerto Rico en la década del 60* (San Juan: Publicaciones del Patio, 1994).

23. As Roberto Rodríguez-Morazzani has noted, ethno-racial identities, perceptions and interactions vary from one generation to the next. Therefore, Thomas's experiences as a black Puerto Rican growing up in the 1950s differ from those of Arturo Alfonso Schomburg and Jesús Colón during the earlier part of the twentieth century, and from those of Pablo "Yoruba" Guzmán and other Young Lords in the late 1960s. The civil rights movement and the Black Power struggles, among many other factors, contributed to cementing the notion, particularly among the younger generations of the time, that Black and Puerto Rican identities and circumstances shared many things in common. See Roberto Rodríguez-Morazzani, "Puerto Rican Political Generations in New York: Pioneros, Young Turks and Radicals," *Centro* 4, no. 1 (1991–92): 96–116.

CHAPTER 7—BUTTA PECAN MAMIS

1. See *The Source* (February 1998): 36.

2. New York's Hot 97 (WQHT) radio host/rap artist Angie Martínez and actress/singer Jennifer López are the Butta Pecan Ricans of greatest exposure—and loudly celebrated as such.

3. On the aesthetic and representational marginalization of black Puerto Ricans, see Javier Cardona, "Un testimonio para la muestra: revolviendo un oscuro asunto en la escena teatral puertorriqueña," *Diálogo* (April 1998): 11; Angela Jorge, "The Black Puerto Rican Woman in Contemporary Society," in *The Puerto Rican Woman: Perspectives on Culture, History and Society,* ed. Edna Acosta-Belén (New York: Praeger, 1986), pp. 180–187; Deborah Gregory, "Lauren Velez," *Vibe* 3, no. 10 (December/January 1995–96): 129; Celia Marina Romano, "Yo no soy negra," *Piso* 13 1, no. 4 (August 1992): 3; Piri Thomas, *Down These Mean Streets* (New York: Vintage Books, 1967). On perceived phenotypic distinctions between African Americans and Puerto Ricans, see "Satchmo"

Jenkins and "Belafonte" Wilson, "Shades of Mandingo: Watermelon Men of Different Hues Exchange Views," *Ego Trip* 4, no. 1 (1998): 24–26. See also Samara, "Samara," in *Sex Work: Writings by Women in the Sex Industry,* ed. Frédérique Delacoste and Priscilla Alexander (Pittsburgh: Cleis Press, 1987).

4. bell hooks, *Outlaw Culture: Resisting Representations* (Boston: South End Press, 1994).

5. Samara, a dark-skinned African American twenty-six-year-old "veteran of live sex shows," says of her experience looking for work in strip clubs around New York City: "Some clubs did not want to hire me because I was black. . . . Some like black girls, but black girls who have either big tits or light skin, *who tend to look more like Puerto Ricans.*" See Samara in *Sex Work,* p. 37.

6. Frances R. Aparicio, *Listening to Salsa: Gender, Latin Popular Music, and Puerto Rican Cultures* (Hanover, NH: Wesleyan University Press), p. 147.

7. Frances Negrón-Muntaner, "Jennifer's Butt," *Aztlán: A Journal of Chicano Studies* 22, no. 2 (Fall 1997): 185.

8. Aparicio, *Listening to Salsa.*

9. Negrón-Muntaner, "Jennifer's Butt."

10. Ibid.

11. See Teresa Wiltz, "Bottoms Up: Jennifer López's Big Derriere Takes Fanny Fawning to a Higher Level," *Daily News,* October 29, 1998, p. 67.

12. Negrón-Muntaner, "Jennifer's Butt." See also Erin Aubry, "The Butt: It's Politics, It's Profanity, It's Power," in *Adiós Barbie: Young Women Write About Body Image and Identity,* ed. Ophira Edut (Seattle: Seale Press, 1999), pp. 22–31; Theo Perry, "I, Latina," *Vibe* 5, no. 6 (September 1997): 58; Wiltz, "Bottoms Up."

13. dream hampton, "Boomin' System: Bombshell Supreme Jennifer Lopez Is the Biggest Explosion Outta the Bronx Since the Birth of Hip Hop," *Vibe* 7, no. 6 (August 1999): 98–104.

14. Goldie, "Ass Rules Everything Around Us: Some Late Night Thoughts on Jennifer Lopez," *XXL* 2, no. 3, issue 5 (1998): 80.

15. hampton, "Boomin' System," p. 102.

16. Cristina Verán, "Backyard Boogie: An Honest Assessment of Jennifer Lopez's Mo' Cheeks," *Ego Trip* 4, no. 1 (1998): 133.

17. See Perry, "I, Latina"; Wiltz, "Bottoms Up."

18. hooks, *Outlaw Culture,* p. 179.

19. See Paulette Caldwell, "A Hair Piece: Perspectives on the Intersection of Race and Gender," in *Critical Race Theory: The Cutting Edge,* ed. Richard Delgado (Philadelphia: Temple University Press, 1995), pp. 267–277; Lisa Jones, *Bulletproof Diva: Tales of Race, Sex and Hair* (New York: Doubleday, 1994); Jorge, "The Black Puerto Rican Woman in Contemporary Society"; Mayra Santos, "Hebra Rota," in *Pez de Vidrio* (Coral Gables, FL: North-South Center, University of Miami, Iberian Studies Institute, 1995).

20. Aparicio, *Listening to Salsa*, p. 143.

21. Mimi Valdés, "Malibu Dreamin': Who Are Those Video Queens Anyway?" *The Source*, no. 93 (June 1997): 72–79.

22. Shannon, "Bikini Beauties," *The Source*, no. 95 (August 1997): 20.

23. See Arcadio Díaz Quiñones, "Tomás Blanco: Racismo, historia y esclavitud," in *El prejuicio racial en Puerto Rico*, Tomás Blanco (Rio Piedras: Ediciones Huracán, 1985), pp. 15–91; Juan Giusti Cordero, "AfroPuerto Rican Cultural Studies: Beyond *cultura negroide* and *antillanismo*," *Centro* 8, nos. 1 and 2 (1996): 57–77.

24. Ramón Grosfoguel and Frances Negrón-Muntaner, *Puerto Rican Jam: Essays on Culture and Politics* (Minneapolis: University of Minnesota Press, 1997), p. 14. Emphasis added.

25. See Carl N. Degler, *Neither Black Nor White: Slavery and Race Relations in Brazil and the United States* (Madison: University of Wisconsin Press, 1971).

26. See Ana M. López, "Of Rhythms and Borders," in *Everynight Life,* ed. Celeste Fraser Delgado and José Esteban Muñoz (Durham, NC: Duke University Press, 1997), pp. 310–344; Ella Shohat, "Gender and Culture of Empire: Toward a Feminist Ethnography of the Cinema," in *Visions of the East: Orientalism in Film,* ed. Matthew Bernstein and Gaylyn Studlar (New Brunswick, NJ: Rutgers University Press, 1997), pp. 19–66.

27. Shohat, "Gender and Culture of Empire,."p. 47.

28. See López, "Of Rhythms and Borders," p. 317.

29. Ibid.

30. See Shohat, "Gender and Culture of Empire."

31. Jee proudly remarks regarding language use in hip hop culture: "The slang spitters/ standard English quitters/ Ebonics slingers/ Break Language, talk shit, and flip word thinkers. Speaking non-standard English is nothing new to those who are 'non-standard' americans. 'Non-standard' niggas twist words listed in dictionaries, we flip words from movies, we re-create, we innovate." See Jee, "Broken Language," *Stress,* issue 15 (1998): 22.

32. Danny Hoch, *Jails, Hospitals & Hip Hop and Some People* (New York: Villard Books, 1998), p. 73.

33. At least, I hope this song was intended to be tongue-in-cheek. If it wasn't, then it's a prime example of corny Spanish use and *mami*-philia. But I doubt it.

34. It is another sign of Latino relegitimation within rap that Rodríguez is currently editor-in-chief of one of the most popular hip hop music magazines on the market.

35. Antoinette Marrero, "Tribal Council," *Urban Latino Magazine* (June/July 2001): 26–29.

36. Aparicio, *Listening to Salsa*, p. 142.

37. "I'm tired of that shit I hear on the radio and see on MTV, because when I see those beautiful, gorgeous women in little bikinis shaking their ass

like that's all they're good for, that tells me, damn, they don't have no kind of hope. They don't have faith that we can change this world, that something is coming, that something good is waiting for us. That breaks my heart."

38. Danyel Smyth, "Ain't a Damned Thing Changed: Why Women Rappers Don't Sell," in *Rap on Rap: Straight-up Talk on Hip Hop Culture,* ed. Adam Sexton (New York: Delta Books, 1995), p. 126.

39. Rob Marriott, "R(Un)ning Things, *XXL* 1, no. 2, issue 2 (1997): 56–58.

40. "Cocksucker" is a rough equivalent of "*mamao,*" although the Spanish term literally means a man who still sucks his mother's breast.

41. In one of the few published articles that explores male homosexuality in hip hop, R. K. Byers states: "hip hop, which is quite unfairly [and perhaps problematically] seen as the last frontier of real *nigga-ness,* might suffer as an icon of Black masculinity if one of its more hard-core artists revealed himself to be gay." See R. K. Byers, "The Other Side of the Game: A B-Boy Adventure into Hip Hop's Gay Underworld," *The Source,* no. 99 (December 1997): 108.

42. See Thembisa S. Mshaka, "Lesbian Life in Hip Hop Culture," *Blaze,* issue 2 (December/January 1999): 84.

43. Lana Sands, "Whipping Girl," *XXL* 2, no. 3, issue 5 (1998): 31.

44. Rubin Keyser Carasco, "Set Trippin'," *Blaze* (Fall 1998): 206–207.

45. Anne McClintock, "Sex Workers and Sex Work," *Social Text* 37 (Winter 1993): 1–10; Gail Pheterson, "The Whore Stigma: Female Dishonor and Male Unworthiness," *Social Text* 37 (Winter 1993): 39–64.

46. Valdés, "Malibu Dreamin'," p. 73.

CHAPTER 8—NAVIGATING BLACKNESS AND *LATINIDAD* THROUGH LANGUAGE

1. The translation is mine. The original reads: "Los Niuyorricans no se dan cuenta de que su lengua es el inglés y la lengua de los puertorriqueños es el español." Eduardo Seda Bonilla, "El problema de la identidad de los Niuyorricans," *Revista de Ciencias Sociales* 16, no. 4 (December 1972): 457.

2. The translation is mine. The original reads: "Mira, si no hablo bien el español es porque no nací en España; si no hablo bien el inglés es porque no soy hijo de puta." Carmen Dolores Hernández, *Puerto Rican Voices in English: Interviews with Writers* (Westport, CT: Praeger, 1997).

3. See DJ Muggs comments in Chang Weisberg, "Hip Hop's Minority?: Latino Artists Unite and Speak Out," *Industry Insider Magazine* 15 (1998): 54.

4. Main One is a U.S-raised Puerto Rican whose debut album, *Birth of the Ghetto Child,* was released in 1995 by Select Records.

5. See Rob Rivera, "Buena Gente," *Mía* (Summer 1996): 3.
6. Weisberg, "Hip Hop's Minority?" p. 54.
7. Mandalit del Barco, "Latino Rappers and Hip Hop: Que Pasa," National Public Radio documentary aired September 10, 1991.
8. Clyde Valentín, "Big Pun: Puerto Rock Style With a Twist of Black and I'm Proud," *Stress,* issue 23 (2000): 56.
9. What is commonly labeled "Spanglish" is more properly referred to as code-switching. See Edna Acosta-Belén, "On the Nature of Spanglish," *The Rican* 2, nos. 2 and 3 (1975): 7–13.
10. Rigo "Riggs" Morales, "Renaissance Revisited," Urban Latino Magazine 3, no. 2 (1998): 30–33.
11. See the discussion in chapter 4.
12. See Morales, "Renaissance Revisited," p. 33.
13. Other examples include: DJ Tony Touch frequently referring to himself as the Taíno Turntable Terrorist; Mr. Wiggles likening himself to an Arawak in a rhyme he contributed to Tony Touch's mix tape #49; Krazy Taíno's (from Latin Empire) choice of artistic name.
14. See Juan Flores, *Divided Borders: Essays on Puerto Rican Identity* (Houston: Arte Público Press, 1993); Pedro Pedraza, "An Ethnographic Analysis of Language Use in the Puerto Rican Community of East Harlem," Centro de Estudios Puertorriqueños Working Paper Series, Hunter College, New York, 1987; Bonnie Urciuoli, *Exposing Prejudice: Puerto Rican Experiences of Language, Race and Class* (Boulder, CO: Westview Press, 1996); Ana Celia Zentella, *Growing Up Bilingual: Puerto Rican Children in New York* (Malden, MA: Blackwell Publishers, 1997).
15. Edward Sunez Rodríguez, "Why Hip Hop Died," www.ourswords.com, 2002.
16. Edward Sunez Rodríguez, "Sunset Style," *The Ticker,* May 8, 1996.
17. Rodríguez, "Why Hip Hop Died."
18. Vee Bravo, "Moves & News," *Stress,* issue 12 (March/April 1998): 12.
19. Jee, "Broken Language," issue 15 (1998): 22.
20. "Fantastic Freaks at the Dixie," *Wild Style Soundtrack,* Rhino Movie Music 72892, 1982.
21. In 1990, Bushwick's residents were reported to be 70 percent Latino and 17 percent African American. The largest Latino group was Puerto Rican (who made up 62 percent of the neighborhood's Latino population), followed by Dominicans (16 percent). See Christopher Hanson-Sánchez, *New York City Latino Neighborhoods Databook* (New York: Institute for Puerto Rican Policy, 1996).
22. Frances R. Aparicio, "On Sub-Versive Signifiers: Tropicalizing Language in the United States," in *Tropicalizations: Transcultural Representations of Latinidad,* ed. Frances R. Aparicio and Susana Chávez-Silverman (Hanover, NH: Dartmouth College, University Press of New England, 1997), p. 202.
23. Ibid.

24. Hernández, *Puerto Rican Voices in English.*

25. See Javier Santiago, *Nueva Ola Portoricensis: La revolución musical que vivió Puerto Rico en la década del 60* (San Juan: Publicaciones del Patio, 1994).

26. See Juan Flores, John Attinasi and Pedro Pedraza, "'La Carreta Made a U-Turn': Puerto Rican Language and Culture in the United States," in Flores, *Divided Borders,* pp. 157–181; and Urciuoli, *Exposing Prejudice.*

27. See Zentella, *Growing Up Bilingual,* p. 41.

CHAPTER 9—REMEMBERING BIG PUN

1. See Andrea Duncan, "Big Punisher: 'Yeeeah Baby!'" *Vibe* (June/July 2000): 214; Riggs Morales, "Big Pun: The Heavyweight Champion," *The Source,* no. 113 (February 1999): 154–158; Carlito Rodríguez, "Big Pun: Yeeeah Baby!" *The Source,* issue 128 (May 2000): 186; Mimi Valdes, "Pound for Pound: Big Pun and Fat Joe Are More Than Big Poppas," *Vibe* 6, no. 6 (August 1998): 108–111.

2. Clyde Valentín, "Big Pun: Puerto Rock Style With a Twist of Black and I'm Proud," *Stress,* issue 23 (2000).

3. Morales, "Big Pun."

4. Fat Joe, "A Bronx Tale: Big Pun 1971–2000," *Vibe* (May 2000): 128–129.

5. Morales, "Big Pun."

6. James "Chase" Lynch, "Holdin' It Down," *Urban Latino Magazine* 3, no. 2 (1998): 34–35.

7. Edward Rodríguez, *XXL* 4, no. 2, vol. 2 (1998): 174.

8. Valentín, "Big Pun."

9. MTV News Gallery, "López, Fat Joe, Others React to Big Pun's Death," February 8, 2000; www.mtv.com.

10. See Bill Egbert and Leo Standora, "A Big Pun Farewell," *Daily News,* February 11, 2000, pp. 32–33; Juan A. Moreno-Velázquez, "Recordando a Big Pun," *El Diario,* February 11, 2000, p. 37; Kim Osorio, "Big Pun: Hip-Hop Loses a Hero," *The Source,* issue 127 (April 2000): 52.

11. Quoted in Melanie Feliciano, "Hip-Hop Fans Mourn Pun's Death," *LatinoLink,* February 8, 2000; www.latinolink.com.

12. Morales, "Big Pun."

13. Akeenah Thomas and Jennifer Quiñones, "An Artist's Tribute to Big Pun," *Hunts Point Alive!* 2, no. 3 (March/April 2000): 3.

14. Egbert and Standora, "A Big Pun Farewell."

15. The Welfare Poets integrate spoken word and rap with jazz, funk, *rumba* and *bomba,* among other genres. Yerba Buena—for whom I sang backup vocals for over two years—plays *plena, bomba,* and *música jíbara.*

16. Frank Lombardi, "Council KOs Honors for Rapper Big Pun," *Daily News,* May 3, 2001, p. 8.

17. Juan Forero, "Puerto Rican Parade May Ban Some Rap," *New York Times*, August 4, 2000, pp. B1-B4.

18. Bravo is codirector of *Estilo Hip Hop*, a forthcoming documentary on hip hop culture in Latin America.

19. Juan Forero, "Puerto Rican Parade May Ban Some Rap."

EPILOGUE

1. Juan Forero, "Puerto Rican Parade May Ban Some Rap," *New York Times*, August 4, 2000, pp. B1-B4.

2. Carol Cooper, "Angie Martinez: The Queen of Hip-Hop Radio Arrives on Wax," *Interview* (March 2001).

3. *Orishas* are spiritual entities in the Caribbean Regla de Ocha tradition, also commonly known as *santería*.

4. In collaboration with husband DJ G-Bo the Pro, La Bruja independently released her debut album *The Bru* in 2001.

5. The Welfare Poets' 2000 album on Blue Reality Records—with Malcolm X and Pedro Albizu Campos on the cover—is entitled *Project Blues*.

6. "Lenguas Libres," produced by poet Sandra García Rivera and hosted by Mixta Gallery in El Barrio, was a community forum/showcase/open mic featuring visiting Havana-based rap groups Anónimo Consejo, Obsesión and RCA alongside New York–based artists La Bruja, Freddy Skitz, La Bomba and Inti Illimani.

7. "We go on and we are at war. This is our ammunition for the battle: our words, our thoughts, our guiding spirits."

INTERVIEWS AND ARTICLES

FAT JOE

Fat Joe's 1993 debut album, Represent, *was warmly embraced by hip hop music fans. Since then, this South Bronx Puerto Rican's popularity has done nothing but soar.*

Nowadays, Fat Joe (Joseph Cartagena) is one of the better-known Latino rappers, worldwide. He is the leader of The Terror Squad music "family." Other members include Cuban Link, Triple Seis and the late Boricua rap star, Big Punisher. He is also the owner of a popular line of clothing called FJ560, and his fourth album, J.O.S.E., *was released at the end of the summer 2001.*

In the interview that follows, Joe talks about his career and the history of hip hop culture, and debunks some of the existing myths regarding Latino participation in hip hop music.

WOULD YOU SAY THERE IS ANY RELATIONSHIP BETWEEN PUERTO RICAN CULTURE, LATINO CULTURE, AND HIP HOP CULTURE?

Definitely. Puerto Ricans have been part of hip hop culture since day one. It started in the South Bronx, and most of the South Bronx is Latino. They were definitely part of hip hop since day one. They was the breakdancers, the DJs, part of the crews. I don't know where it turned into just Black music. I was so confused of how so many Latinos love hip hop but weren't in the forefront, got lost somewhere. I don't know how that happened. With me trying to become a rapper nine years ago, I had to fill in the void. I wanted to fill in the void. Just like all the *morenos* see their favorite rappers there, people they can relate to, I wanted to do my video with all the Latinos. So that all the Julios and the Josés see somebody they can relate to. Boricuas and Latinos definitely played a major part in hip hop music. And the Dominicans now, very much so.

YOU SAY YOU STARTED AS A RAPPER ABOUT NINE YEARS AGO, BUT
YOUR INVOLVEMENT WITH HIP HOP, LIKE BEING PART OF IT AND
LISTENING TO IT, WHEN DID IT START?

Since a baby. Since I was nine, ten years old. I would stay up all night writing raps
and my mother and father would tell me I'm trying to be a *negro,* trying to be a
moreno. That I better pay attention in school. That's just a dream. It'll never hap-
pen. My parents are very old-fashioned. My father's Cuban and my mother's
Puerto Rican. My father's really old-fashioned so he didn't understand me into
this music right here. But now he supports it. He's the father of Fat Joe and can't
nobody tell him nothing.

THAT WAS IN THE 1980S?

Back in 1981–82. That's when I first started.

IN THOSE EARLY YEARS, WAS THERE THE FEELING ALREADY THAT HIP
HOP CULTURE WAS A BLACK CULTURE, OR DID IT STILL SEEM TO BE
AN INTEGRATED BLACK AND LATINO THING?

It was Black and Latino at that point.

SO WHEN DID YOU START TO SEE A CHANGE?

The more it got commercialized, Latinos were not so involved. And Latinos were
always still involved. They just weren't playing major parts. They were in the back-
ground. They weren't the guys in the rap groups. They were the entourage or they
were the dancers. Even though the dance is very important. The Rock Steady
Crew and all of them were very important in hip hop. But they weren't as vocal so
people noticed them from dancing but they weren't the headliners, the stars.

WHY DO YOU THINK THAT WAS? DO YOU HAVE ANY SENSE WHY
LATINOS WEREN'T UP THERE IN THE FRONT?

I don't have no clue. I just think Latinos chose to do the graffiti and the dance
part of it. But the real money was in the rapping. Even to now, I see problems like
that too. When I go to the parks, Latinos are more interested in playing handball
than basketball. And with basketball, young Black kids are getting $90 million
contracts. And we're never gonna make no money off of handball! You understand
what I'm saying? So the same thing happened with hip hop. The Latinos was
there and always involved, but they chose to specialize in what you don't make
money in—dancing and graffiti. But the people making money were the DJs, the
producers and the rappers.

HAVE YOU EVER FELT PRESSURE FROM THE PEOPLE IN THE MUSIC
INDUSTRY TO RHYME IN SPANISH?

Never. Never me. 'Cause I'm Latino but I grew up with a lot of *morenos* and I
never felt . . . I was content being Puerto Rican and everybody knows that I'm

Latino and I'm representing my culture to the fullest. But I never felt like I had to rhyme in Spanish, none of that. Up to this day, I don't compromise. I don't come running out with a big flag. Everybody knows we're representing the Boricuas, the Latinos. But I'm just making great music. The fact that we're Latino is obvious. I don't have to put in every song "we Boricua," "Cubano," "Dominican." No, we don't have to do that. Even though some of our biggest songs were songs that we did straight-up for Puerto Rico. When Big Pun passed, he made a song called "100%". I'm his executive producer so I chose to make that the last single of his album because I just wanted everybody to remember him representing the Boricuas and the Latinos. His last words to the world. I wanted them to know it wasn't a money thing; it wasn't a marketing thing; it was none of that. It was more of a pride thing.

WHY HAVE YOU DECIDED NOT ONLY TO FOCUS ON YOURSELF AS AN ARTIST BUT TO PUSH THE WHOLE TERROR SQUAD FORWARD?

It's a business thing. Artists ain't gonna be around forever, so you gotta figure out how to make money for years to come. Me, I've always been a businessman. I've always been like an entrepreneur. I've watched my father sell *coquito* [coconut milk with rum and spices], *bacalaitos* [codfish fritters]. Whatever he had to do. In the winter, he would sell toys. I always wanted to be my own boss. That's why we created the label Terror Squad. And also for Latinos to have a voice for years to come. That way when people think that Fat Joe is corny and he's not on top no more, he's not as sharp, we still have somebody representing us and somebody who's taking care of our best interests, behind the scenes.

WHAT DO YOU THINK ABOUT THE WAY IN WHICH LATINO MEDIA COVERS HIP HOP?

Spanish media doesn't do enough for hip hop music.

WHY DO YOU THINK THAT IS?

I mean, honestly, I think that is because what you see on Spanish TV and Spanish newspapers, they like it to be more or less fantasy. There's not enough realness in the Spanish media to me, personally. Spanish media always wanna try to hide the truth and they wanna paint this picture of everything being *fantasía*, better than what it is. But like I explain to people, the truth is gonna come out anyway. The truth is the truth and that's what sells. That's why hip hop music is so big, because it speaks the truth. It speaks about what's really going on in life and what's really going on with youth. A lot of Latinos are old-fashioned, they're not ready to change with our ways right now. They're scared of the youth. They're scared of *juventud.* They're scared of the new things.

(Adapted from Raquel Z. Rivera, "Fat Joe: líder del 'Terror Squad,'" *El Diario/La Prensa*, June 29, 2001, p. 37.)

LA BRUJA

My words could kill / But instead I use them to build
La bandera blanca es la bandera que manda. Paz. (The white flag is the
one that rules. Peace.)

Caridad "La Bruja" de la Luz is a ferocious rapper. And she will fearlessly sing her heart out anyplace, anytime. She takes on R&B tunes as easily as she launches into the sones and guarachas popularized by Cuban legend Celina González.

Her slight but powerful figure commands nothing but respect. Let no one be fooled by her beauty. That is merely the gorgeous exterior of an artist whose merits and purposes run much, much deeper.

Her thunderous voice is purely Boricua Boogie Down Bronx. You may have already heard her in Boogie Boy Delight's (RIP) old-school compilation and in recordings made by DJ G-Bo the Pro (who is also her husband and father of her two children).

She also rapped with Fat Joe and Tony Touch, among others, in the forthcoming album Stop the Bombs! *dedicated to the Vieques struggle and which has yet to be released. She also appears on the song "Fuego" with Cypress Hill's B-Real, which is coming out on the hip hop compilation album* The Ghetto Pros.

But La Bruja is not only a rapper and a singer. She is also a poet, actress and dancer. Her one-woman show, Boogie Rican, *successfully debuted at the Nuyorican Poets Café and has been presented on numerous stages across the United States and Europe. She was featured in Russell Simmons's* Def Poetry Jam *in July 2002. Considered a central figure among the "new" generation of Nuyorican poets, her work was featured in the* Center for Puerto Rican Studies Journal. *She displayed her flamenco skills in Chayanne and Vanessa Williams's "Dance with Me" video, and acted in Spike Lee's movie* Bamboozled. *She also has her own website: www.labrujanyc.com.*

Be it through hip hop, "traditional" music or poetry, La Bruja gives tongue-lashings as readily as she will spread tenderness and inspiration. Listen to her words.

Hip hop is the voice of the millennium in a musical way. It was born here, that's why I know where it's coming from. But kids are getting the wrong message. Because hip hop right now, sadly enough, is selling a lie that the record industry and the United States government wants our people to buy into, which is: "Yeah, you're gonna make money being drug dealers, being thugs, killing each other." We're doing their job for them. And they love it. That's why they put that type of music out there. For me, it's a big challenge.

SO IF THAT'S THE LIE THEY'RE PROMOTING, WHAT'S THE TRUTH?

The truth is that it's a lot harder to be a family-oriented person with morals. That's hard core. That's raw. It's a lot harder to be a parent than it is being a thug in the street not doing shit for your people. You wanna be hard core? Then be an example. There's nothing harder than that. And we have to set that example by being an example. We have to give them role models. 'Cause right now, they're

lost. You need family. Without your family you're nobody. You need to know about your ancestry. You need to know about your history—beyond American history. Because all people of color, we are stripped of history. They tried everything in their power to take it away from us. And thank God we still have some of our resources there that still maintain. That's been through spoken word and that's been through family. Those powerful things that keep our people strong that are passed down through community, family—all of the things that are important. Not the Beamer that rides around the corner doing a hundred and whatever. That ain't shit! I did an event in Orchard Beach on Sunday. It was a community event and this guy wants to come on the mic and the first thing out his mouth is "nigga, fuck, shit, bitch. . . ." You ain't saying anything! I don't need to curse to rip it. I'm not perfect, but I try to be conscious and everyday I learn more and more about what's important.

WHAT ARE SOME OF THOSE RESOURCES THAT YOU SAY WOULD HELP
US BETTER OURSELVES?

First of all, you got your grandmother, your elders in your community, your family, and community centers. And you have the arts. Dance, the music of our elders . . . If you can appreciate something from the past, then you can develop something for the future. You can get that inspiration and carry that torch. And even religion. I am not a very religious person. I am a spiritual person, but I respect religion.

HOW DO YOU DISTINGUISH BETWEEN RELIGION AND SPIRITUALITY?

My spirituality is not rigid. I flow like water. I'm Aquarius. I try to bring the water. I try to flow like water. I try to think of Bruce Lee and I learn what I can about all religions. And I apply what I feel is most beneficial, what I think makes most sense. Because everybody is really trying to attain the same thing with their religion.

SO HOW DOES THAT SPIRITUALITY ADD TO YOUR ART OR GET
EXPRESSED THROUGH YOUR ART?

I wanna inspire the next person that's gonna change the world for the better. I wanna get together that army of consciousness and of light, really looking toward the positive light, reality, Mother Nature, going back to the basics. I wanna create an army that really appreciates the important things, not money, superficial things; but the health of the people, the health of our world, of our earth. What are we gonna leave behind for our children? Wrecked cars and a lot of plutonium? What are they gonna do with that? Are they gonna grow something on that? Can they eat that? Are we gonna be fighting over one drop of water? How are we gonna clean this world? And I'm trying to cleanse people's minds. I'm trying to cleanse people's souls so that they can take that seed and develop it into another cleaning machine. Like Celina González told me when I saw her in Cuba: "*Vamos a limpiar este mundo para poder ser feliz.*" (Let's clean this world so that we can live in happiness).

Considering that "La Bruja," "The Witch," might sound like
an insult to some people, why did you choose that name?

I think we all have that force inside of us, that third eye. I've always felt like I've
had that gift. And if me believing in that gift makes me a *bruja*, then I'm a
bruja. I know I come from a long line of ancestors that believed the same thing
and they were called *brujos*. People suffered because of their spiritual beliefs.
They were called *brujos* and *brujas*. They were pointed at and even killed. Going
by the name La Bruja is an homage to my ancestors. I carry that name in their
honor.

But what do you mean by "third eye"? What is that vision?

Everything I've said about what is important. To see beyond. It's that sight be-
yond sight. You can see beyond what's here. It's having the energy to see the en-
ergy in things, the aura of things, the order of things. To look and see the whole
picture on a universal scale, not just around your block. It goes so far beyond. We
have to start cleansing. And even with our music, our messages, it has to stop: the
lack of romanticism, love, and sensitivity. We're getting all these messages that say
love doesn't exist, that you should be a slut or a pimp. I wanna use my magic to
change the world. I mean, even my name tells me I have a gift and that I have to
share it: Caridad de la Luz. I have to be charitable with my gift and help people
shine. The power's been in the wrong hands for a long time. And if everybody is
listening to hip hop, we'll slowly bring change through it. Even though I'm not
just doing hip hop. Yeah, I love hip hop and I'm focusing on it. But I'm also cre-
ating music that's connected to the past. That way, through the respect that peo-
ple have for me because of hip hop, then maybe they'll start listening to other
stuff.

*And what is that music that La Bruja cherishes so much and which she wants to share
with the hip hop generations? Who has not heard* "Que viva Changó, que viva
Changó señores . . ."? *Or how about* "Yo soy el hijo de Elegua, yo trabajo con
Ogún . . ."? *La Bruja has taken it upon herself to give new life to these musical classics
of* santería *and* espiritismo, *which she describes as "spiritual folkloric music." These are
the songs that, according to her, "inspired me to be La Bruja, the good witch, the witch
of the light."*

*Her participation in the Havana Cuban Rap Festival of 2001 was dedicated to the
woman who popularized these songs: Celina González. La Bruja says: "I asked the au-
dience to help me meet her. And that is how it was. The next day Ezequiel Dueñas took
me to meet her. I cried from happiness and I asked for her blessing. I sang her my favorite
songs and she sang along with me. I kissed her feet when I said good-bye and I ask God,
Changó and Ochún that she wins the Latin Grammy this year [2001]."*

*I recently had the honor of experiencing La Bruja in action and singing backup vo-
cals for her at the Nuyorican Poets Café. Flanked by the* bomba *rhythms of the group
YerbaBuena, she left the audience breathless and uplifted. What started out as a serene
poetry event ended up being an intense spiritual "despojo" night, thanks to La Bruja's*

magic. Be it rapping, singing or witchcrafting, Caridad de la Luz knows how to cast a good spell.

(Adapted from Raquel Z. Rivera, "La Bruja: rapera, poeta, actriz y bailarina," *In the House Magazine,* no. 21 (2001): 58–59.)

ANGIE MARTÍNEZ

It has already been a few years since Hot 97's popular radio DJ began laboring on rap recordings with renowned artists like KRS-ONE, Redman, Missy Elliot and Lil' Kim. But her stakes as an artist just jumped up a couple of notches with the Spring 2001 release of her solo debut, Up Close and Personal.

The adolescent who began her radio career answering the phones at a Miami jazz station is today one of the better-known figures in New York radio. The same young woman that a few years ago started rapping just to pass the time is currently commercial rap's Latina leading lady.

Her sweet and playfully aggressive personality has stolen radio listener's hearts. She keeps them amused with her frisky chatter and occasionally sharp tongue. Her voice is warm and down-to-earth but at the same time sparkles with the indiscreet glamour of fame.

HOW DID YOU GET INTO RADIO DJING?

Well, I started when I was about sixteen, working at a radio station part time answering the requests line, you know, doing all the entry-level stuff. And then I just learned how to run the board and do the engineering. I learned from the inside and worked my way up. When Flex came to be on the radio I already knew how to run the boards, so I used to engineer his show. From there I started making my own little place, my own little position.

WHAT WAS IT ABOUT THAT KIND OF WORK THAT CAUGHT YOUR ATTENTION?

Honestly, when I first started being on the air I wasn't sure that it was something that I really wanted to do long term. I just saw the opportunity and I wanted to try to get as good as I could at it. Then I started getting comfortable on the air and actually really enjoying it. And then I just kept moving up and up, and before you know it you're on the radio for four or five years. That's where I am now.

WHAT IS IT ABOUT BEING A RADIO DJ THAT BRINGS YOU THE MOST JOY OR SATISFACTION?

It's just like life to me. You know, some days you wake up and you go about your day and you have a good day. And then some days you go about your day and you

have a bad day. It's the same thing like being on the radio. It's just part of who I am at this point. I get up every day, I go to work, and I talk to everybody. I've been doing it for so long that it's just a part of who I am. So some days I love it; some days I talk to great people; some days I feel like I did something that somebody might have enjoyed today or whatever. And then some days I have a bad day and I just wanna go home and go to sleep.

BUT THOSE DAYS THAT YOU DO ENJOY IT . . . IS IT ABOUT TALKING TO LISTENERS? IS IT ABOUT PUTTING ON THE MUSIC YOU LIKE?

It might be about a good interview, connecting with somebody, having some fun. It might be somebody calling me on the open mic asking for my advice about something. Or somebody just calling and saying something really nice. I definitely like the fact that I'm a voice to New York. I definitely have pleasure in that.

WHY DID YOU DECIDE TO GO INTO RHYMING?

That kind of was just natural, man. I used to hold parties a lot and I used to do it for fun. I always used to like rhyming but it was always for fun. And then I rhymed on a couple of mixed tapes and KRS-ONE heard me and then he thought that I should take it more serious. And then when he was working on his album, he's like "I got this song, I want you to be on with me and Redman." And, you know, I figured I'd try it.

WERE YOU SCARED TO DO IT?

Not really. It was fun. It wasn't that serious to me. It was just like, all right, cool let's do this. I'm in the studio, KRS-ONE, Redman, ho . . . It was just like a good time. And then from that they asked me to be on "Ladies' Night." Then I started writing more, rhyming more and doing little cameos here and there. Then I started feeling like it was something that I really wanted to do, you know.

DID YOU EVER HAVE SECOND THOUGHTS ABOUT IT?

Maybe for a second. I had to check myself and make sure I was doing it for the right reasons. I felt like if I was gonna do this project it would have to mean something, either to me or to somebody else. I felt like I had to be adding something. I didn't just wanna do an album, make a couple of dollars and call it a day. I wanted it to mean something so I just had to sit with myself and evaluate that. I felt like the only way that it **would** make sense for me to do that is to be real personal with it. And to take the relationship with people who know me already just on the radio or whatever, take that relationship with them to another level. That's what I did with the album, being more personal and putting some of my own story out there.

AND AT THIS POINT, NOW THAT YOU'VE DONE THE ALBUM, WHAT WOULD YOU SAY IS YOUR MAIN PASSION, THE RADIO OR BEING AN ARTIST AND RECORDING?

I can't say one is main. That's like asking someone: "Who do you like better, your sister or your brother?" It fulfills such different . . . It's two totally different things. And I love both. I think right now I'm so focused on this album. But I don't think it's one or the other. I just think it's two different feelings that I have toward each one of those things. They're both part of who I am.

YOU DON'T FEEL MORE AT EASE DOING ONE OR THE OTHER?

I've been on the radio a lot longer than I've been rhyming, so there's definitely a comfortableness about being on the radio that I enjoy. And then there's something about making records that I enjoy. So I can't really pick, I love doing both.

DO YOU SEE HIP HOP CULTURE AND LATINO CULTURE AS BEING RELATED SOMEHOW?

Of course.

HOW SO?

It depends on whose life you're talking about. In my life, absolutely. I come from a Latino family but I was raised in New York. I was raised within hip hop music, so both of those things have been a big influence on who I am and the music that I make. I think it goes the same for a lot of different people, especially second and third generation who grew up in New York, who grew up in the streets. We relate to hip hop and its expression, but at the same time our family, our parents and our blood is Latino so that's never gonna go away.

ON ONE HAND, YOU SAY YOU'RE REPRESENTING PUERTO RICANS AND LATINOS AND, ON THE OTHER HAND, YOU ALSO DON'T WANNA BE CATEGORIZED AS THE "BORICUA RAPPER." SO HOW DO YOU BALANCE THOSE TWO THINGS?

Honestly, I'm just being myself. I am what I am. I'm not trying to be the Latino representation. I'm not trying not to be. I'm just being myself. Like I said, I'm second, third generation, so my Spanish is not great. I never tried to hide that from anybody. I'm working on it, just for my own personal well-being. I don't really think about it in terms of a balance. I am who I am. I mean, me getting love . . . I was on a Spanish radio station the other day and all the callers spoke Spanish. Then when I started speaking it, they started speaking in English to me. They showed me so much love. It's beautiful that because I'm Latina you connect with me, you are inspired or you encourage me. I never deny that or turn my back to that, ever. But it just gets irritating to me when people stereotype. Why do I have to be just that? Why can't I be just a strong woman who is Latina, who is doing her thing as opposed to "the Latina rapper." It's a fine line, I guess. I'm proud of who I am. I'm proud of where I come from, but I also don't wanna use it as some kind of marketing tool. It's a fine line of being disrespectful to it. Like I saw this video the other day and it irritated the shit out of me. This guy is doing a video and part of his footage of the video is at the Puerto Rican Day Parade. And he's

got Puerto Rican flags all over his video and that's great. You're repping that. But his song is disrespecting every woman in the video. He's using that but he ain't really repping that right! And that just irritates me. I don't like to use it. If it's there, and it is what it is, and if you've got love for me for it, then thank you. But I'm not trying to shove it down you throat. It's gonna be in my music 'cause that's part of who I am. You're gonna hear the influence. I got a merengue song on there, a merengue beat that I did a hip hop record to. We did a version of "Suavemente." And that's all natural. That's what's around me. But I'm not gonna be on every TV show with a Puerto Rican flag T-shirt on.

(Adapted from Raquel Z. Rivera, "Angie Martínez: locutora y rapera," *In the House Magazine*, no. 21 (2001): 14.)

DYNASTY ROCKERS'S DIANA

Digging into the roots of breaking, it's inevitable to bump into one of its sources, called "rocking" by those who developed it during the 1970s. Today, it's usually known as "up-rocking" or "Brooklyn rock" in honor of the region where it came up. Young Puerto Rican men were the most influential group in the development of this dance form, cultivated initially not only in clubs and private parties, but also to the beat of live drums in Brooklyn parks.

Rocking combines competitiveness, improvisation, skill, stamina, style, agility and wit. The dancers go up against one another with an arsenal of simulated aggressions that can include kicks, punches, slaps and dicks to the opponent's mouth, or involve knives, bats, guns, bows and arrows, grenades or whatever object is nearby that can be used in the spur of the moment to "hurt" or humiliate one's rival. It incorporates moves from a bunch of different sources: martial arts, funk, rumba, salsa, Gene Kelly and Fred Astaire . . . It's something like a New York capoeira with erotic sprinklings.

The Brooklyn neighborhood known as Bushwick was one of the places where rocking was most passionately cultivated. It was in this mostly Puerto Rican neighborhood that Diana Figueroa grew up.

When talking about rocking's history, people always seem to mention a girl called Diana that was down with Dynasty Rockers during the 1970s and early 1980s. She was such a good dancer that she was known to dance "as good as a guy." Diana was not only one of the few females who danced in this male-dominated zone; she was also openly lesbian. And she got plenty of heat for both things. But the girl could DANCE. She used to "burn" males and females alike. And she made a name for herself.

Here goes a fragment of dance history in New York City, in Diana's words.

I was thirteen, fourteen years old when I first seen the dance [at the park] and I said "Wow, I like that dance, I gotta learn." I'm talking about the early seventies. It was gangs in the neighborhood and they used to dance. The older men used to take out congas and the guys from the gangs just used to dance.

THIS WAS AT A BUNCH OF PARKS OR THIS WAS AT A PARTICULAR PARK?

[Later, when I started to dance] we had PS 116 Park, Bushwick Park, Linden Park. It was all in Bushwick. One-eleven. We would all get together there and dance.

WAS IT BY CREWS OR WAS IT MORE LIKE RANDOM PEOPLE DANCING?

No, there was no groups back then. It was just one on one. And the music would play and they would make two long lines and everybody would get on line and just dance against each other. We were freestyling when we were just getting into the music, then when the break part used to come that's when we used to start dancing against each other, burning.

AND WHAT KIND OF MUSIC WOULD THEY PLAY?

Back then, music that they used to play in a band. It wasn't disco music. There were a couple of songs that were Jackson Five. James Brown, "Sex Machine." "Come Along and Dance" from The Jackson Five, "Listen to Me," "Castles."

SO THE LINES WERE FACING EACH OTHER AND EVERYBODY WOULD DANCE AT THE SAME TIME AGAINST EACH OTHER?

Yeah.

SO IT'S NOT LIKE THE CYPHER IN BREAKING WHERE EVERYBODY'S IN A CIRCLE AND THEY'RE WATCHING PEOPLE BATTLE?

No, only when it really got to when a lot of them got tired, like who was the one really standing. Then they would play three or four songs and you and him just battled it out right there. But usually it was a couple of couples out there dancing, not only two in a circle. They were battles. Burn, they would say. That was back then.

LIKE INSTEAD OF "BATTLING" YOU WOULD CALL IT "BURNING"?

Right, like that.

I'VE HEARD ROCKERS SAY THAT YOU DIDN'T HAVE TO BATTLE THE WHOLE SONG NECESSARILY. WHAT DO YOU CALL WHEN YOU'RE JUST DANCING?

Freestyle. We were freestyling when we were just getting into the music, then when the break part used to come that's when we used to start dancing against each other, burning.

HOW DO YOU BURN SOMEBODY?

To the beat of the music, whatever the records says, beats, you do. Whatever that artist was singing, whatever he was saying, with your hands you do to that person.

If there were cymbals, you know *schksss, schksss, schksss, schksss,* you just go down and do something with your hands or you jump up and you hit 'em. Whatever the record did with the cymbals and the music, you follow with your hands, with your feet.

SO I GUESS KNOWING THE RECORD WAS REALLY IMPORTANT.

Oh yeah.

BUT WERE PEOPLE STILL DANCING TO DRUMS IN THE PARKS?

Yeah, it was both of them going on at the same time. [In the early 1970s] there was a lot of little clubs they used to go to dance. All guys. There was no girls. All guys. That's when my brother . . . he really got a little cold with it when I started dancing. Back then he was like "Diana, this is all guys. You're the only girl. Don't get in there." He didn't care for it too much. Probably . . . you know, younger sister . . . and seeing your sister dance like a guy. But I loved the dance. And I still went in there and burned all of 'em.

SO HOW WERE THE GUYS' [IN OTHER CREWS] REACTIONS?

They would go: "She can't burn me. She's a girl." Or: "She ain't good enough." You know, remarks like that. So I was like: "Let's go. Let's dance." For a while there was no girls uprocking. I remember there was one party my brother was DJing. It was an engagement party. And it was in St. Barbara's. And the whole St. Barbara's was just full of guys. And they played "Sex Machine" from James Brown. I was fidgeting. I was going crazy. I wanted to jump in there. And he was like: "Diana, don't jump in. What are you doing? Don't jump in. Don't get on that line." Not one girl. I jumped in. I started dancing. He didn't like it.

WHY DO YOU THINK HE DIDN'T?

It was all guys! And I guess the whole thing of . . . They were naive. They weren't into the lesbian thing. I was very aggressive, always aggressive when I was young. I mean, you can tell. With some you can. So it was part being embarrassed because "my sister's gay." I don't know what it was. Everybody knew me. Everybody knew him. Everybody knew I was gay. But I guess it was the whole thing that it was out. Everybody felt uncomfortable, all guys dancing, there's one girl there. "There was one girl. Yeah, Diana. You know how she . . ." I didn't know how he was gonna feel about that. But I loved the dance. I didn't care. If it was okay with my parents, then I don't care. I wanted to learn this dance and do this dance. I didn't care what they said.

SO YOU WERE THE FIRST GIRL IN DYNASTY AND THE ONLY GIRL
EVER? OR DID OTHER GIRLS COME INTO THE CREW LATER ON?

They came in when it was fading. You know, when it wasn't the way we used to dance. And not very long. After a while, toward the early 1980s, we just said we were grown, it just wasn't the same. We got tired of running. There was this incident when we went to East New York to dance and we got chased after with guns. I had a gun pointed right there to my stomach.

WHEN WAS THIS, MORE OR LESS?

This had to be the early 1980s.

SO WHEN DID IT START GOING DOWN, THE SCENE?

Of uprocking? Eighty-three. Around there. The dancing, that was a part of my life, my era, upbringing. That's what I can say kept me away from things that were going on in the street. I was too involved in the dancing. I didn't have time to hang out and do drugs and get into a scene like that. I loved to dance too much. We would practice every single day. We would go to the park and practice. Or they would come over to the house.

YOUR HOUSE?

Yeah, my parents were very open like that. And we would dance. We had like wall-to-wall mirrors, my parents had in the house. And we would move the sofa over. And if we could practice all day, we would practice and then get ready for the weekend. I practiced every day till I couldn't walk, till my legs were killing me from practicing. To perform. Dynasty was a group that was together twenty-four hours. That's why I talk about it and I can see it like a movie. It was a thing that they would come call us to the window, you know: "You ready?" And we would be in the house ironing our letters on our shirts, getting ready to go to the battle. The whole scene. Walking to the park, all our friends saying hello to us. It was cool.

DYNASTY WAS MADE UP OF HOW MANY PEOPLE?

There was six of us in the beginning. It was me, Tony, Whiteboy Tony, my brother Manny, Danny my brother-in-law and Carlos, a child we brought up since nine years old. Everybody wanted to battle Dynasty. And we won every battle. That's how we retired. We don't remember losing not one battle. On the weekends we would get ready to perform if they had a dance in the church. You know, trophies, money or whatever it was. It was to a point where we fell asleep in school, you know, like that. We didn't study that often. We would get out of school, drop our books and run straight for practice. That's what we did. That was our life.

(Adapted from Raquel Z. Rivera, "Diana: 'rocking' en el Brooklyn boricua de los 70," *In the House Magazine*, no. 23 (2002).)

HIP HOP MEETS BOMBA AT THE REAL WEDDING OF THE MILLENNIUM

Let no one be fooled. Despite all the media hype, the wedding of the millennium was not Thalía and Tommy Mottola's. Never mind the $350,000 bridal gown, the fourteen-story wedding cake and the thousands of fans gathered outside St. Patrick's Cathedral. The real wedding of the millennium was a much more tender and modest event, brimming with cultural relevance.

Ana García and Gabriel Dionisio's marriage ceremony, aside from having been a beautiful love ritual, was undoubtedly a decisive event in the cultural life of Puerto Ricans in New York. This wedding, which took place on June 17, 2000, was an impressive manifestation of a Nuyorican identity whose referents have as much to do with the Caribbean culture which our parents and grandparents transplanted to this New York soil, as with the urban youth culture out of which comes hip hop.

Not like it was easy. To do a wedding the way one wants it and to go against the usual patterns is to go heads up against the social, familial and ecclesiastical expectations that one should adjust to the mold. One thing may be the culture we live and another to have certain institutions (the church) and traditions (wedding ceremonies) recognize it and reflect it.

Dancing down the aisle toward the altar? Bomba drums thundering at a Catholic church? Rapping the marriage vows? Yes indeed. This couple patiently negotiated with the pertinent authorities. And the product was a wedding like they wanted it and like it had to be.

That day's bride and groom lead the most public side of their lives as breakers Rokafella and Kwikstep. These two friends and life partners are also artistic associates committed to their art as much as to their community. Rokafella and Kwikstep, as leaders of the Full Circle dance crew, have been for years cultural activists who have dedicated a great part of their efforts to cultivating breaking as treasure and legacy, and who have also offered their skills as resources for political activism. You may have seen them in music videos, at b-boy summits and reunions, as part of the cast of the hip hop musical Jam on the Groove, at Free Mumia benefits or giving workshops and classes everywhere from recreation rooms in public housing projects to prestigious Manhattan dance studios.

Their wedding was so perfect in its hybridity and quirkiness that it sounds less like reality and more like the product of a hyperactive imagination. But I swear I didn't make this up. I was only a witness.

The ceremony took place at St. Cecilia's on 106 Street, right in the heart of El Barrio (East Harlem). The history of this church is tightly woven into the history of Boricuas in New York. It was there that the funeral rites for salsa legend Héctor Lavoe took place; it was the childhood church of activist and ex-political prisoner Dylcia Pagán; this is the church that has celebrated masses in solidarity with the people of Vieques, P.R., who are struggling against the abuses of the U.S. Navy. This was the church that Rokafella regularly attended as a child in the company of her parents. And now Rokafella and Kwikstep's spectacular wedding has become a part of that history.

The ceremony was set to start at 2 P.M., but at 1:50 the scene was ghetto-classic: a dozen teenagers and a few older ladies were right up front washing cars, selling *piraguas* and Avon products, and had a radio blasting rap music. The church's fence was decorated with what from far away seemed like a legion of men's briefs drying in the sun, but close up turned out to be the grayish rags for washing the cars.

The guests started to arrive and wondered whether the car wash was going to run its course uninterrupted, indifferent to the wedding celebration. Almost right

at 2 P.M., the car wash crew picked up the rags, buckets, Roller Blades and sneakers thrown all over the church steps and vanished.

As if not to contradict that stuff about "Puerto Rican time," the ceremony started almost an hour late. And it was more than well worth the wait.

The wedding march was anything but a march. The cortege walked down the aisle to the rhythm of the drums and *maracas* of group YerbaBuena which played a *bomba yubá* as Angel Rodríguez sang the hymn "I Feel Jesus." *Maraca* in hand and standing among those singing backup for Angel, I gave a thousand thanks to the universe for the privilege of enjoying that moment. Angel is, aside from a professional percussionist, the dedicated director of musical programs at The Point community center in the Bronx, where Kwikstep and Rokafella also work. He is also the poet that proclaims himself *"cristiano, palero, santero . . . y a veces embustero"* (Christian, a practitioner of *palo* and *santería . . .* and sometimes a liar). And it was his gorgeous voice that guided us through a Protestant hymn in English sung to a *bomba* beat in a Catholic church. What a mess and what a pleasure!

And as if that was not enough, Flaco Navaja's unmistakable voice added all the more power and flavor to the musical mix. Flaco, one of *bomba*'s young voices is also a distinguished hip hop figure, host of a popular rap and poetry night at the Nuyorican Poets Café and member of spoken word group Universes.

The first to go down the aisle were two teenage *bomba* dancers from Las Estrellitas del Caribe, with long ruffled skirts and gingham headwraps. They were followed by two guys from the Full Circle crew in hip hop gear: white sweatpants and blue baggy T-shirts with the crew's name emblazoned over their chests. They carried the Puerto Rican flag. After them came the rest of the crew, uprocking their way down the aisle. Dressed as expected for a wedding, but flipping it by following the drums with their footsteps, came the bridesmaids and ushers.

Then the groom and his father made their way to the altar, followed by the bride and her parents, and what follows is a bit jumbled in my head. What I do distinctly remember is having been fascinated by the fluidity with which the ceremony alternated between English and Spanish. Rokafella's father read from the scriptures in Spanish, Kwikstep's dad did the same in English, the priest spoke in both languages. Kwikstep sweetly read his vows in English, while Rokafella, flowing as if rapping, started hers in English and ended them in Spanish.

I confess being no fan of weddings, but I am deeply grateful for the privilege of having been present at this one. Expressions of real love, devotion and mutual respect are always a delight to witness. And even more in this case where this couple decided to seep the ceremony in roots, history and contemporary realities. English, Spanish, *bomba*, Protestant hymns, Catholic imagery, Afro-Caribbean religious practices, rap, breaking . . . They may seem like disparate elements, but they make us what we are.

And like this quintessentially Puerto Rican wedding, I conclude to the sounds of a *bomba sicá* led by Angel: *"Cuando Dios lo determina. Y no remedia los males. No te valen los collares que te puso tu madrina. Que viva Dios, que viva Dios, que viva Dios, Santa María é"* (When God determines it. And doesn't put an end to your

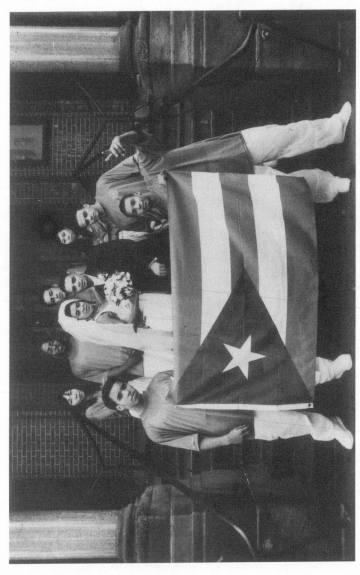

Breakers Rokafella and Kwikstep marry in true Nuyorican style at St. Cecilia's Church in El Barrio, June 17, 2000. Photo by Jerry Ruotolo.

ailments. The beads that your godmother placed on you are worthless. Praise the Lord, praise the Lord, praise the Lord, and Holy Mary).

It might not have been prime time media fodder, but, I assure you, this was the wedding of the millenium.

(Adapted from Raquel Z. Rivera, "Una boda al estilo 'hip hop,'" *Hoy*, December 20, 2000, p. 14.)

OF ARTISTS AND CUTIES

B-girls Don't Care About Messing Up Their Hair

I read Nancy Guevara's essay "Women Writin', Rappin', Breakin'" in late 1995. It was, to me, a powerful document of the 1980s, attesting to women's contributions to hip hop and condemning their being erased out of hip hop history. A few nights later, I saw that erasure—and its rewriting—taking place right before my eyes during the prestigious DMC DJ Competition.

It was the night of the finals, held at the club Limelight. From the stage, DJ Scribble took a few moments to praise the off-Broadway show *Jam on the Groove*, which he described as a milestone in hip hop, featuring legendary b-boys like Crazy Legs, Ken Swift, Mr. Wiggles and PopMaster Fabel. As he paused for breath a young woman's voice rang out from the upper floor: "Honey Rockwell!" All of us on the ground floor looked up to see Rockwell's smile and signature golden locks spilling over the railing. DJ Scribbles chuckled apologetically and repeated after Rock Steady's notorious Puerto Rican b-girl: "Honey Rockwell." Then he went on to talk about the great contributions of b-boys to hip hop culture. Every time he spoke of the dancers, he did so in the masculine. Honey Rockwell's voice cut in once again as he uttered the word b-boy without any allusion to its female counterpart for the fifth or sixth time. "And b-girls!" she shouted in a teasing tone. The crowd laughed at their exchange, which was playful, but had dead serious implications.

Almost a year later, during the fall of 1996, I accompanied Jackie T. Egilee—a New York–raised Puerto Rican woman who as a young teenager in the mid-'80s had been part of a breaking crew—to interview b-boy legend Crazy Legs. He was offering a breaking class at South Bronx community center The Point and Jackie, who was writing an article about him, invited me to tag along.

Six enthusiastic boys around twelve years old showed up to his class that day. Crazy Legs effortlessly commanded their attention the whole time. He demonstrated the proper technique for windmills and backspins, as they looked on and fearlessly imitated his moves. After the class, as Jackie spoke to Crazy Legs, the boys looked on with curiosity while gathering their belongings. "There's no girls that come to the class?" Jackie asked. Crazy Legs replied that there was a girl, six

years old, "who is dope; she just got a scholarship for gymnastics." One of the boys piped up and explained to Jackie that girls are not interested in breaking "because they don't wanna mess their hair up." His comment elicited nods and yeahs from a few other boys, as Jackie and I looked at each other.

Later, as we drove back downtown, Jackie pointed out that, though there was some truth to the boys' understanding that female vanity is responsible for girls' lack of interest in breaking, there are gender-specific obstacles for the girls who do want to participate. She considers herself lucky to have come across a group of boys who actually encouraged her to start breaking with them, for she is aware many girls have had the opposite experience by being discouraged and belittled by the b-boys around them. But while the boys in her crew were supportive, she does remember audiences' skeptical commentaries regarding her participation. "Oh, that's a girl up there? What's she gonna do?" Compared to her friend Rokafella, however, Jackie knows she had it easy.

Rokafella (A. García-Dionisio), today one of the most respected b-girls in New York City, recalls getting less than her fair share of quarters after hours of breaking with her crew during the late '80s and early '90s on Times Square sidewalks. The guys refused to divide the money in equal parts. To add insult to injury, Rokafella also had to deal with snickers and comments from people outside the crew about her being "the group's ho." A lone woman in an otherwise all-male group performing a dance style where women are the minority for many seemed to warrant a sexualized explanation. According to the gossipers, there must have been ulterior motives for her devotion to breaking; love of the dance form was apparently not reason enough.

I once saw Rokafella and fellow crew member Kwikstep—Gabriel Dionisio, who is also her husband—engage in a heated uprock battle with two male dancers of a rivaling group. Both factions held down their own for a while, but eventually Rokafella and Kwikstep started gaining the upper hand. As their rivals began showing signs of fatigue, the wife and husband duo—who were not married then—had barely begun to sweat. As the latter started gaining favor with the crowd of fifty or so gathered around them in a cypher, their opponents resorted to focusing solely on sexually oriented moves directed at Rokafella.

Granted, using sexualized moves to humiliate an opponent—male or female— is a staple in uprocking. However, it was clear in this case that as soon as the power balance started shifting, Rokafella and Kwikstep's contenders, tired and depleted of inventive moves, opted for what they thought was the easy way out: attack who they assumed was, by virtue of her gender, "the weak link"; not confronting her as an artist but as a fuckable female. Her increasingly complex dance moves elicited increasingly childish responses: as one simulated penetrating her from the front, the other did the same from the back; one mimed penetrating her vagina with his fingers; the other repeated the same move in relation to her anus. As the crowd cheered her on, Rokafella continued confronting them, con-

B-girl inspired drawing by Bronx artist Wanda Ortiz, whose earliest notions of aesthetics and artistic success were strongly influenced by graffiti art in her community.

testing their clichéd moves with increasingly witty ones and attempting to get them to battle her for real. But after a few more minutes, it was apparent they would not. With a sweep of her hand she indicated that her rivals were below her and regally stepped outside the cypher.

Okay, so some women don't want to mess up their hair. But what about those b-girls that don't care?

Tidbits on the Gender Tip

During a hip hop panel held in the late 1990s at Barnard College, a young woman in the audience prefaced her comments by marveling at the youthful appearance of the panelists, most of whom were pioneer (male) hip hop artists pushing forty. Though I myself had been struck by how young they looked, and her comment seemed innocent enough, the answer of one of the panelists was loaded with sexualized interest: "Thank you. You live around here?"

Also around that same time, I went to a "Female MC Showcase" held at a prestigious downtown club. At one point, the night's host—a noted hip hop figure—asked the "fellas in the house" to "show your appreciation for these ladies." Warm applause followed his request. But it wasn't until he asked "all the fellas in the audience who appreciate women" to "make some noise" that the crowd—where men outnumbered women approximately 6 to 1—exploded with whistling, hollering and applause. Mind you, the artists featured that night steered clear of the hyper sexual female images ruling the commercial rap arena.

I was already feeling funny, thinking that in an odd way this attempt to "showcase" female talent was not really about taking their artistry seriously but about displaying them for male consumption. That's when another well-known hip hop figure grabbed a microphone and asked a featured MC to introduce him to one of her backup singers. Throughout their set, he continued to shower the object of his lust with "compliments." Yes, I concluded, this is definitely more about the "fuckability" of the cute girls being displayed than about a genuine effort to showcase talented women artists whose voices need to be heard.

In a conversation with one of the executive producers of a successful rap-reggae compilation featuring Puerto Rican artists, I asked why there were no female rap artists on the record. He candidly explained that he wasn't able to include any because he didn't find "a girl who could rap and was pretty." I was shocked, not so much because of his unfortunately all-too-common reasoning, but because of his honesty. I appreciated the truthfulness of his words, though.

Then there was the time I went to a hip hop event at Amsterdam Houses on the Upper West Side of Manhattan. I was then in my mid-twenties. At the door, I was greeted by a guy and a woman, both black, around my same age. She told me: "It's $7 with the flyer, $5 without." I had no flyer, so I started counting out $7. She smiled and said: "Never mind, gimme five; it's good to see more sisters up in here." To which the guy added: "And a cute one too." She shot him a dirty look and said: "I'm not even gonna go there with you." She smiled at me and rolled her eyes in exasperation, as she motioned me inside.

EL BARRIO'S GRAFFITI HALL OF FAME

For over two decades, the colorful walls of the schoolyard at the corner of 106 Street and Park Avenue have attracted graffiti enthusiasts from around the world. Meanwhile, those who by chance come across this monument to New York street creativity are inevitably impressed by the explosion of shapes, colors and ideas that populate what is known as the Graffiti Hall of Fame.

This peculiar open-air gallery has flaunted the work of so-called old-school graffiti masters such as Lady Pink, Zephyr, Doze, Futura 2000, Vulcan, Dez, Skeme and many others. They have been among the pioneers in the development of a complex visual language that was particularly vibrant during the 1970s and early 1980s. New York City trains were for many years graffiti's favored canvas. This graphic movement has been a multiethnic mode of expression, with the participation of Latinos, African Americans and "whites" of various ethnicities, among others.

Joe, who has been involved in graffiti since 1979, has been in charge of the Graffiti Hall of Fame for the last four years. This artist of Puerto Rican descent explains that his interest in graffiti began in high school when he was a student at Art and Design High School in Manhattan. Since then he has been an enthusiastic practitioner and is currently a member of The Death Squad graffiti crew.

Graffiti, however, is not an art form appreciated by all. Some dismiss it as simple scribbles with little artistic merit; others condemn it as an act of vandalism, since the clandestine placement of "pieces" in public and private property has been an integral part of graffiti.

Nowadays, many artists, to avoid run-ins with the law, make sure to get permission before starting to work on a wall. But in the eyes of some, graffiti is intrinsically tied to delinquency.

Even though they had the authorization of school administrators, various artists have been arrested for alleged "vandalism" at the schoolyard where the Graffiti Hall of Fame is located. Part of the problem, according to Joe, is that some people reject graffiti under the assumption that the artists are gang members or violent criminals.

Another obstacle faced by Joe and other artists involved in the Graffiti Hall of Fame have been the controversies and rivalries existing among graffiti writers, which lead certain artists to damage or alter the work of others. To top it off, says Joe, the Hall of Fame is purely a labor of love and does not generate income for its participants; on the contrary, they invest on those walls their money, time and efforts.

Despite the difficulties, Joe still feels passionately about graffiti. "The reason I'm still involved is that this is really an art of the people," he says, adding that "to do this you don't have to be rich, or have connections in the world of commercial art, or have a university art degree."

As an El Barrio resident, I feel privileged to have this impressive open-air gallery in my neighborhood. I have been entranced by the ingenuity and artistic

El Barrio's Graffiti Hall of Fame, ca. 1997. Wall by TATS Cru. Photo by Anabellie Rivera Santiago.

skill of pieces like Nicer's signature resembling a *guayabera*. I have felt invigorated by the Death Squad's depiction of a female figure wrapped in the Puerto Rican flag, not as a symbol of sexiness but of wisdom and strength; instead of flaunting implausibly perfect bodily assets, she had sagging breasts, a third eye, and was flanked by fierce-looking black dogs. The Graffiti Hall of Fame is, to me, living proof of the vibrant creativity of this "art of the people."

(Adapted from Raquel Z. Rivera, "El Salón de la Fama del Graffiti," *Siempre: El Periódico de El Barrio*, March 21-April 10, 2001, p. 14.)

REFERENCES

Abramson, Michael and Young Lords Party. 1971. *Palante: Young Lords Party.* New York: Pantheon.

Acosta-Belén, Edna. [1975]. On the Nature of Spanglish. *The Rican* 2, nos. 2 and 3: 7–13.

Ahearn, Charlie. 1982. *Wild Style.* 90 min. Rhino R3 2367. Videocassette.

Allen, Ernest, Jr. 1996. Making the Strong Survive: The Contours and Contradictions of Message Rap. In *Droppin' Science: Critical Essays on Rap Music and Hip Hop Culture,* ed. William Eric Perkins, 159–191. Philadelphia: Temple University Press.

Allinson, E. 1994. It's a Black Thing: Hearing How Whites Can't. *Cultural Studies* 8, no. 3: 438–456.

Alvarez, Luis Manuel. 1992. La presencia negra en la música puertorriqueña. In *La tercera raíz: Presencia africana en Puerto Rico,* ed. Lydia Milagros González, 30–41. San Juan: Centro de Estudios de la Realidad Puertorriqueña and Instituto de Cultura Puertorriqueña.

Alvarez Nazario, Manuel. 1974. *El elemento afronegroide en el español de Puerto Rico.* San Juan: Instituto de Cultura Puertorriqueña.

Aparicio, Frances R. 1998. *Listening to Salsa: Gender, Latin Popular Music, and Puerto Rican Cultures.* Hanover, NH: Wesleyan University Press.

Aparicio, Frances R. 1997. On Sub-Versive Signifiers: Tropicalizing Language in the United States. In *Tropicalizations: Transcultural Representations of Latinidad,* ed. Frances R. Aparicio and Susana Chávez-Silverman, 194–212. Hanover, NH: Dartmouth College, University Press of New England.

Aparicio, Frances R. and Susana Chávez-Silverman. 1997. Introduction. In *Tropicalizations: Transcultural Representations of Latinidad,* ed. Frances R. Aparicio and Susana Chávez-Silverman, 1–17. Hanover, NH: Dartmouth College, University Press of New England.

Aponte, Lola. 1995. Para inventarse el Caribe: la construcción fenotípica en las Antillas hispanófonas. *bordes,* no. 2: 5–14.

Ards, Angela. 1999. Organizing the Hip-Hop Generation. *The Nation,* July 26, 11–20.

Arlyck, Kevin. By All Means Necessary: Rapping and Resisting in Urban Black America. In *Globalization and Survival in the Black Diaspora: The New Urban Challenge,* ed. Charles Green, 269–287. Albany: State University of New York Press.

Aubry, Erin J. 1998. The Butt: Its Politics, Its Profanity, Its Power. In *Adiós, Barbie: Young Women Write About Body Image and Identity,* ed. Ophira Edut, 22–31. Seattle: Seale Press.

Aubry, Erin J. 1998. Black is Beautiful. *Salon I,* July 15; www.salon.com.

BOM5. 1997. The Bench: Racism in Writing. *Elementary* 1, no. 2 (Spring): 43.

———. 1998. Talk given at Muévete! The Boricua Youth Conference, November 7, Hunter College, New York.

Baker, Soren. 1997. Frost: Family Matters. *The Source,* no. 95 (August): 67.

———. 1997. Hurricane G. *One Nut* (December): 10–12.

Banes, Sally. 1981. Physical Graffiti: Breaking Is Hard to Do. *Village Voice,* April 22, 31–33.

Baxter, Kevin. 1999. Spanish Fly: Latinos Take Over. *The Source,* no. 113 (February): 136–141.

Berman, Marshall. 1988. *All That Is Solid Melts into Air: The Experience of Modernity.* New York: Penguin Books.

———. 1999. Views from the Burning Bridge. *Dissent* (Summer): 77–87.

Bernabe, Rafael. 1996. Rap: Soy boricua, pa' que tú lo sepas. *Claridad,* January 19, 25.

Bernard, James. 1998. Man of the People. *XXL* 1, no. 2, 68–72.

Betances, Samuel. 1972. The Prejudice of Having No Prejudice, Part I. *The Rican,* no. 2 (Winter): 41–54.

———. 1973. The Prejudice of Having No Prejudice, Part II. *The Rican,* no. 3 (Spring): 22–37.

Binder, Frederick M. and David M. Reimers. 1995. *All Nations Under Heaven: An Ethnic and Racial History of New York City.* New York: Columbia University Press.

Blanco, Tomás. 1985. *El prejuicio racial en Puerto Rico.* With an introduction by Arcadio Díaz Quiñones. Rio Piedras: Ediciones Huracán.

Boggs, Vernon. 1992. *Salsiology: Afro-Cuban Music and the Evolution of Salsa in New York City.* New York: Greenwood Press.

Bourdieu, Pierre. 1993. Structures, Habitus, Practices. In *Social Theory: The Multicultural & Classic Readings,* ed. Charles Lemert, 479–484. Boulder, CO: Westview Press.

Bourgois, Philippe. 1995. *In Search of Respect: Selling Crack in El Barrio.* Cambridge: Cambridge University Press.

Bousaada, Gabriela. 1995. Breaking In. *Village Voice,* August 22, 75.

Boyd, Todd. 1997. *Am I Black Enough For You?: Popular Culture from the 'Hood and Beyond.* Bloomington: Indiana University Press.

Bravo, Vee. 1998a. Moves & News. *Stress,* issue 11 (February/March): 14.

———. 1998b. Moves & News. *Stress,* no.12 (March/April): 12.

Brenan, Tim. 1994. Off the Gangsta Tip: A Rap Appreciation, or Forgetting About Los Angeles. *Critical Inquiry* 20 (Summer): 663–693.

Brownmiller, Susan. 1984. *Femininity.* New York: Fawcett Columbine.

Burke, Miguel. 1997. Puerto Rico . . . Ho!!!: Frankie Cutlass. *The Source* no. 90 (March): 60.

Byers, R. K. 1997. The Other Side of the Game: A B-Boy Adventure into Hip Hop's Gay Underworld. *The Source,* no. 99 (December): 106–110.

Cabarcas, Oscar. 1997. Hip Hop 101: Public Enemy. *The Source,* no. 93 (June): 45.

Caldwell, Paulette M. 1995. A Hair Piece: Perspectives on the Intersection of Race and Gender. In *Critical Race Theory: The Cutting Edge,* ed. Richard Delgado, 267–277. Philadelphia: Temple University Press.

Carasco, Rubin Keyser. 1998. Set Trippin'. *Blaze* (Fall): 206–207.

Cardona, Javier. 1998. Un testimonio para la muestra: revolviendo un oscuro asunto en la escena teatral puertorriqueña. *Diálogo,* April, 11.

Carrión, Juan Manuel. 1993. Etnia, raza y la nacionalidad puertorriqueña. In *La nación puertorriqueña: ensayos en torno a Pedro Albizu Campos,* ed. Juan Manuel Carrión, Teresa C. García Ruiz and Carlos Rodríguez Fraticelli, 3–18. San Juan: Editorial de la Universidad de Puerto Rico.

Cartagena, Juan. 2001. Raíces: The Film Special by Banco Popular. *Güiro y Maraca* 5, no. 4 (Winter): 8.

Centro de Estudios Puertorriqueños, History Task Force. 1979. *Labor Migration Under Capitalism: The Puerto Rican Experience.* New York: Monthly Review Press.

Chávez, Linda. 1991. *Out of the Barrio: Towards a New Politics of Hispanic Assimilation.* New York: Basic Books.

Chávez-Silverman, Susana. 1997. Tropicolada: Inside the U.S. Latino/a Gender B(l)ender. In *Tropicalizations: Transcultural Representations of Latinidad,* ed. Frances R. Aparicio and Susana Chávez-Silverman, 101–118. Hanover, NH: Dartmouth College, University Press of New England.

Chenault, Lawrence. 1938. *The Puerto Rican Migrant in New York City.* New York: Columbia University Press.

Cixous, Hélene. 1990. Castration or Decapitation? In *Out There: Marginalization and Contemporary Cultures,* ed. Russell Ferguson, Martha Gever, Trinh T. Minh-ha and Cornel West, 345–356. New York: New Museum of Contemporary Art.

Conway, Dennis and Ualthan Bigby. 1987. Where Caribbean People Live in the City. In *Caribbean Life in New York City: Sociocultural Dimensions,* ed. Constance R. Sutton and Elsa M. Chaney. New York: Center for Migration Studies of New York.

Cooper, Carol. 1988. Latin Hip-Hop Elbows Its Way to the Top. *New York Times,* April 24, H29.

———. 2001. Angie Martinez: The Queen of Hip-Hop Radio Arrives on Wax. *Interview* (March).

Cooper, Martha and Henry Chalfant. 1984. *Subway Art.* New York: Holt, Rinehart and Winston.

Cox, Dan. 1984. Brooklyn's Furious Rockers: Breakdance Roots in a Breakneck Neighborhood. *Dance Magazine* 58 (April): 79–82.

Craddock-Willis, Andre. 1989. Rap Music and the Black Musical Tradition. *Radical America* 23, no. 4: 29–38.

Crespo, Elizabeth. 1996. Domestic Work and Racial Divisions in Women's Employment in Puerto Rico, 1899–1930. *Centro* 8, nos. 1 and 2: 30–41.

Cross, Brian. 1993. *It's Not About a Salary: Rap, Race and Resistance in Los Angeles.* New York: Verso Books.

Davey D. 1999. Why Is Cleopatra White? *The FNV Newsletter,* May 21, www.daveyd.com/fnvmay21.html.

Dávila, Arlene M. 1997. *Sponsored Identities: Cultural Politics in Puerto Rico.* Philadelphia: Temple University Press.

Dawsey, Darrell. 1999. Talk given at hip hop conference, New York University, New York, February 6.

Dawsey, Kierna Mayo. 1994. Caught Up in the (Gangsta) Rapture: Dr. C. Delores Tucker's Crusade Against "Gangsta" Rap. *The Source,* no. 57 (June): 58–62.

Decker, Jeffrey Louis. 1994. The State of Rap: Time and Place in Hip Hop Nationalism. In *Microphone Fiends: Youth Music and Youth Culture,* ed. Andrew Ross and Tricia Rose, 99–121. New York: Routledge.

De Genova, Nick. 1995. Gangsta Rap and Nihilism in Black America: Some Questions of Life and Death. *Social Text* 13, no. 2.

Degler, Carl N. 1971. *Neither Black Nor White: Slavery and Race Relations in Brazil and the United States.* Madison: University of Wisconsin Press.

del Barco, Mandalit. 1991. Latino Rappers and Hip Hop: Que Pasa. National Public Radio documentary aired on September 10.

———. 1996. Rap's Latino Sabor. In *Droppin' Science: Critical Essays on Rap Music and Hip Hop Culture,* ed. William Eric Perkins, 63–84. Philadelphia: Temple University Press.

Dennis, Reginald. 1992. Liner notes in *Street Jams: Hip Hop from the Top Part 2.* Rhino R4 70578.

Denton, Nancy A. and Douglas S. Massey. 1989. Racial Identity Among Caribbean Hispanics: The Effect of Double Minority Status on Residential Segregation. *American Sociological Review* 54: 790–808.

Díaz Quiñones, Arcadio. 1985. Tomás Blanco: racismo, historia y esclavitud. In *El prejuicio racial en Puerto Rico,* Tomás Blanco, 15–91. Rio Piedras: Ediciones Huracán.

———. 1993. *La memoria rota.* Rio Piedras: Ediciones Huracán.

Dietz, James L. 1986. *Economic History of Puerto Rico: Institutional Change and Capitalist Development.* Princeton, NJ: Princeton University Press.

Dooks, Patty. 1997. The Lowdown on Uprock: Birth of the Brooklyn Style. *Mía* (Spring): 17.

Douglas, Mary. 1969. *Purity and Danger: An Analysis of Concepts of Pollution and Taboo.* New York: Praeger Publishers.

Duany, Jorge. 2000. Nation on the Move: The Construction of Cultural Identities in Puerto Rico and the Diaspora. *American Ethnologist* 27, no. 1: 5–30.

Dufrasne González, J. Emanuel. 1994. *Puerto Rico también tiene . . . ¡tambó!: Recopilación de artículos sobre la plena y la bomba.* Rio Grande: Paracumbé.

Duncan, Andrea. 2000. Big Punisher: "Yeeeah Baby!" *Vibe* (June/July): 214.

Dyson, Michael Eric. 1993. *Reflecting Black: African-American Cultural Criticism.* Minneapolis: University of Minnesota Press.

Early, James. 1998. An African American-Puerto Rican Connection: An Auto-Bio-Memory Sketch of Political Development and Activism. In *The Puerto Rican Movement: Views from the Diaspora,* ed. Andrés Torres and José E. Velázquez, 316–318. Philadelphia: Temple University Press.

Egbert, Bill and Leo Standora. 2000. A Big Pun Farewell. *Daily News,* February 11, 32–33.

Egilee, Jackie. 1996. Dance Rocafella. *New Word* (October): 57.

Ehrlich, Dimitri. 1993. Review of Represent, by Fat Joe. *Rolling Stone,* October 28, 83.

El Diario. 1998. The Success of La Mega. July 20, 20.

Fabel. 1997. *Popmaster Fabel Volume 1: Dance Footage 1981 to 1997.* Tools of War. Videocassette.

Falcón, Angelo. 1988. Black and Latino Politics in New York City: Race and Ethnicity in a Changing Urban Context. In *Latinos and the Political System,* ed. F. Chris García, 171–194. Notre Dame, IN: University of Notre Dame Press.

Falcón, Angelo, Minerva Delgado and Gerson Borrero. 1989. *Toward a Puerto Rican/Latino Agenda for New York City.* New York: Institute for Puerto Rican Policy.

Fat Joe. 2000. A Bronx Tale: Big Pun 1971–2000. *Vibe* (May): 128–129.

Feliciano, Melanie. 2000. Hip-Hop Fans Mourn Pun's Death. *LatinoLink.* February 8, www.latinolink.com.

Fernández Kelly, M. Patricia and Richard Schauffler. 1996. Divided Fates: Immigrant Children and the New Assimilation. In *The New Second Generation,* ed. Alejandro Portes, 30–53. New York: Russell Sage Foundation.

Fernando, S. H., Jr. 1994. *The New Beats: Exploring the Music, Culture, and Attitudes of Hip-Hop.* New York: Anchor Books.

Fitzpatrick, Joseph P. 1987. *Puerto Rican Americans: The Meaning of Migration to the Mainland.* Englewood Cliffs, NJ: Prentice-Hall.

Flores, Juan. 1984. Wild Style and Filming Hip-Hop. *Areito* 10, no. 37: 36–39.

———. 1985. Reinstating Popular Culture: Responses to Christopher Lasch. *Social Text* 12 (Fall): 113–123.

———. 1988. Rappin', Writin' & Breakin'. *Centro* 2, no. 3: 34–41.

———. 1992. It's a Street Thing! *Callaloo* 15, no. 4: 999–1021.

———. 1992–93. Puerto Rican and Proud, Boyee!: Rap, Roots and Amnesia. *Centro* 5, no. 1: 22–32.

———. 1993. *Divided Borders: Essays on Puerto Rican Identity.* Houston: Arte Público Press.

———. 1996a. Pan-Latino/Trans-Latino: Puerto Ricans in the "New Nueva York." *Centro* 8, nos. 1 and 2: 171–186.

———. 1996b. Puerto Rocks: New York Ricans Stake Their Claim. In *Droppin' Science: Critical Essays on Rap Music and Hip Hop Culture,* ed. William Eric Perkins, 85–105. Philadelphia: Temple University Press.

———. 2000. *From Bomba to Hip-Hop.* New York: Columbia University Press.

Foner, Nancy. 1987. The Jamaicans: Race and Ethnicity Among Migrants in New York City. In *New Immigrants in New York*, ed. Nancy Foner, 195–217. New York: Columbia University Press.

Forero, Juan. 2000. Puerto Rican Parade May Ban Some Rap. *New York Times*, August 4, B1-B4.

Fox, Geoffrey. 1996. *Hispanic Nation: Culture, Politics, and the Constructing of Identity*. Tucson: University of Arizona Press.

Fredrickson, George. 1981. *White Supremacy: A Comparative Story of American and South African History*. New York: Oxford University Press.

Freidenberg, Judith and Philip Kasinitz. 1990. Los rituales públicos y la politización de la etnicidad en Nueva York. *Desarrollo económico: Revista de ciencias sociales* 30, no. 117 (April-June): 109–132.

Fusco, Coco. 1995. *English Is Broken Here: Notes on Cultural Fusion in the Americas*. New York City: The New Press.

Gaines, Reg E. 1998. When I Grow Up (I Want to Be Just Like John Gotti). *Stress*, issue 15: 22.

Gans, Herbert. 1979. Symbolic Ethnicity: The Future of Ethnic Groups and Cultures in America. *Ethnic and Racial Studies* 2, no. 1: 1–20.

———. 1992. Second-generation Decline: Scenarios for the Economic and Ethnic Futures of the Post-1965 American Immigrants. *Ethnic and Racial Studies* 15, no. 2: 173–192.

García, Anita "Rocafella." 1996. La Lucha—Women in Hip Hop. *El Grito de la Juventud: The Newsletter of Muévete! The Boricua Youth Organization* 1, no. 4: 3.

García, Bobbito. 1996. Breakin' in the Boys' Bathroom: Uprocking Will Consume You. *Rap Pages* 5, no. 8 (September): 12.

———1997. Bobbito Garcia Plays the Tracks, Abiodun Oyewole States the Facts. *Vibe* (August): 46.

García, F. Chris. 1988. Introduction. In *Latinos and the Political System*, ed. F. Chris García, 1–5. Notre Dame, IN: University of Notre Dame Press.

García Canclini, Nestor.1992. Cultural Reconversion. In *On Edge: The Crisis of Contemporary Latin American Culture*, ed. George Yúdice, Jean Franco and Juan Flores, 29–43. Minneapolis: University of Minnesota Press.

George, Nelson. 1998. *Hip Hop America*. New York: Viking.

Gill, John. 1998. Big Pun's Capital Punishment. *The Source*, no. 107 (August): 34.

Gilman, Sander L. 1985. *Difference and Pathology: Stereotypes of Sexuality, Race and Madness*. Ithaca, NY: Cornell University Press.

Gilroy, Paul. 1993. *The Black Atlantic: Modernity and Double Consciousness*. Cambridge, MA: Harvard University Press.

Giusti Cordero, Juan A. 1996. AfroPuerto Rican Cultural Studies: Beyond *cultura negroide* and *antillanismo*. *Centro* 8, nos. 1 and 2: 57–77.

Glazer, Nathan and Daniel Patrick Moynihan. 1964. *Beyond the Melting Pot: The Negroes, Puerto Ricans, Italians and Irish of New York City*. Cambridge, MA: MIT Press and Harvard University Press.

Global Kids. 1998. *I Am Hip Hop*. 20 min. Global Action Project. Videocassette.

Goldie. 1998. Ass Rules Everything Around Us: Some Late Night Thoughts on Jennifer Lopez. *XXL* 2, no. 3, issue 5: 78–81.

Goldstein, Richard. 1998. Generation Graf: Branded as Vandals Graffiti Writers Bomb On. *Village Voice*, January 20, 59.

Gómez, Magdalena. 1991. To the Latin Lover I Left at the Candy Store. In *Puerto Rican Writers at Home in the USA: An Anthology*, ed. Faythe Turner, 234–237. Seattle: Open Hand Publishing, Inc.

Gómez-Peña, Guillermo. 1993. *Warrior for Gringostroika: Essays, Performance Texts and Poetry*. St. Paul, MN: Graywolf Press.

González, José Luis. 1980. *El país de cuatro pisos y otros ensayos*. Rio Piedras: Ediciones Huracán.

González, Lydia Milagros. 1992. *La tercera raíz: presencia africana en Puerto Rico*. San Juan: Centro de Estudios de la Realidad Puertorriqueña and Instituto de Cultura Puertorriqueña.

Gordon, Maxine W. 1949. Race Patterns and Prejudice in Puerto Rico. *American Sociological Review* 14, no. 2 (April): 294–301.

Grandmaster Caz. 1998. Talk given at The Rap Session conference, Spring, Barnard College, New York.

Gregory, Deborah. 1995–96. Lauren Vélez. *Vibe* 3, no. 10 (December/January): 129.

Grosfoguel, Ramón and Chloé Georas. 1996. The Racialization of Latino Caribbean Migrants in the New York Metropolitan Area. *Centro* 8, nos. 1 and 2: 190–201.

Grosfoguel, Ramón, Frances Negrón-Muntaner and Chloé Georas. 1997. Beyond Nationalist and Colonialist Discourses: The *Jaiba* Politics of the Puerto Rican Nation. In *Puerto Rican Jam: Essays on Culture and Politics*, ed. Frances Negrón-Muntaner and Ramón Grosfoguel, 1–36. Minneapolis: University of Minnesota Press.

Grubb, Kevin. 1984. "Hip-hoppin" in the South Bronx: Lester Wilson's Beat Street. *Dance Magazine* 58, no. 4: 75–78.

Guevara, Nancy. 1987. Women Writin', Rappin', Breakin'. In *The Year Left*, ed. Mike Davis, 160–175. London: Verso Books.

Guzmán-Sánchez, Thomas. 1997. Underground Dance Masters, History of a Forgotten Era: Documentary of a Hard-Core Life Style. Statement in press package for *Underground Dance Masters*, produced and directed by Thomas Guzmán-Sánchez.

Hager, Steven. 1984. *Hip Hop: The Illustrated History of Breakdancing, Rap Music and Graffiti*. New York: St. Martin's Press.

Hall, Stuart. 1990. Cultural Identity and Diaspora. In *Identity: Community, Culture, Difference*. London: Lawrence & Wishart.

———. 1992. What Is This "Black" in Black Popular Culture. In *Black Popular Culture*, ed. Gina Dent and Michelle Wallace, 20–33. Seattle: Bay Press.

hampton, dream. 1999. Boomin' System: Bombshell Supreme Jennifer Lopez Is the Biggest Explosion Outta the Bronx Since the Birth of Hip Hop. *Vibe* 7, no. 6 (August): 98–104.

Handlin, Oscar. 1959. *The Newcomers: Negroes and Puerto Ricans in a Changing Metropolis*. Cambridge, MA: Harvard University Press.

———. 1968. Comments on Mass and Popular Culture. In *Culture for the Millions?: Mass Media in Modern Society*, ed. Norman Jacobs. Boston: Beacon Press.

Hanson-Sánchez, Christopher. 1996. *New York City Latino Neighborhoods Databook*. New York: Institute for Puerto Rican Policy.

Hazzard-Donald, Katrina. 1996. Dance in Hip Hop Culture. In *Droppin' Science: Critical Essays on Rap Music and Hip Hop Culture*, ed. William Eric Perkins, 220–235. Philadelphia: Temple University Press.

Hebdige, Dick. 1987. *Cut 'N' Mix: Culture, Identity and Caribbean Music*. New York: Methuen & Co.

Henderson, Errol A. 1996. Black Nationalism and Rap Music. *Journal of Black Studies* 26, no. 3 (January): 308–339.

Hernández, Carmen Dolores. 1997. *Puerto Rican Voices in English: Interviews with Writers*. Westport, CT: Praeger.

Higa, Ben. 1997. Reel Controversy: Underground Dance Masters Documentary Sets the Record Straight . . . Or Does It? *Rap Pages* (June): 20–21.

———. 1998. Wild Things. *XXL* 2, no. 3, issue 5: 35.

Hinckley, David. 1999. Hip-Hop Show Goes National. *Daily News*, August 19.

Hoch, Danny. 1998. *Jails, Hospitals & Hip-Hop and Some People*. New York: Villard Books.

Hochman, Steven. 1990. Hispanic Rappers Stake Out New Turf. *Rolling Stone*, November 15: 36–37.

Hoetink, Harmannus. 1985. "Race" and Color in the Caribbean. In *Caribbean Contours*, ed. Sidney W. Mintz and Sally Price, 55–84. Baltimore: The Johns Hopkins University Press.

Hollinger, David A. 1995. *Postethnic America: Beyond Multiculturalism*. New York: Basic Books.

hooks, bell. 1992. *Black Looks: Race and Representation*. Boston: South End Press.

———. 1994. *Outlaw Culture: Resisting Representations*. New York: Routledge.

Irving, Antonette K. 1998. Pussy Power: The Onerous Road to Sexual Liberation in Hip-Hop. *The Source*, no. 101 (February): 34.

Jackson, Scoop. 1998. Ghetto Darwinism. *XXL* 2, no. 2: 130–134.

Jacobs, Mira. 1998. My Brown Face. In *Adiós, Barbie: Young Women Write About Body Image and Identity*, ed. Ophira Edut, 3–13. Seattle: Seale Press.

Jee. 1998. Broken Language. *Stress*, issue 15: 22.

Jeffries, John. 1992. Toward a Redefinition of the Urban: The Collision of Culture. In *Black Popular Culture*, ed. Gina Dent and Michelle Wallace, 152–163. Seattle: Bay Press.

Jenkins, "Satchmo" and "Belanfonte" Wilson. 1998. Shades of Mandingo: Watermelon Men of Different Hues Exchange Views. *Ego Trip* 4, no. 1: 24–26.

Jiménez, Roberto "Cuba" II. 1997. Vanishing Latino Acts. *The Source*, no. 95 (August): 22.

Johnson, Brett. 1997. From Projects to Boardrooms. *The Source*, no. 94 (July): 32.

Johnson, Laura. 1994. The Compositional Techniques of the Hip Hop DJ in Relationship to Performance, Recording, and Dance. M.A. thesis, Hunter College, New York.

Jones, Lisa. 1994. *Bulletproof Diva: Tales of Race, Sex and Hair*. New York: Doubleday.

Jones-Correa, Michael and David L. Leal. 1996. Becoming "Hispanic": Secondary Panethnic Identification Among Latin American-Origin Populations in the United States. *Hispanic Journal of Behavioral Sciences* 18, no. 2: 214–254.

Jorge, Angela. 1986. The Black Puerto Rican Woman in Contemporary Society. In *The Puerto Rican Woman: Perspectives on Culture History and Society*, ed. Edna Acosta-Belén, 180–187. New York: Praeger.

Kantrowitz, Nathan. 1973. *Ethnic and Racial Segregation in the New York Metropolis: Residential Patterns Among White Ethnic Groups, Blacks and Puerto Ricans*. New York: Praeger Publishers.

Kasinitz, Philip. 1992. *Caribbean New York: Black Immigrants and the Politics of Race*. Ithaca, NY: Cornell University Press.

Kelley, Robin D. G. 1996. Kickin' Reality, Kickin' Ballistics: Gangsta Rap and Postindustrial Los Angeles. In *Droppin' Science: Critical Essays on Rap Music and Hip Hop Culture*, ed. William Eric Perkins, 117–158. Philadelphia: Temple University Press.

———. 1997. *Yo' Mama's Disfunktional: Fighting the Culture Wars in Urban America*. Boston: Beacon Press.

Kelly, Raegan. 1993. Hip Hop Chicano. In *It's Not About a Salary: Rap, Race and Resistance in Los Angeles*, ed. Brian Cross, 65–76. New York: Verso.

Keyes, Cheryl L. 1996. At the Crossroads: Rap Music and Its African Nexus. *Ethnomusicology* 40, no. 2 (Spring/Summer): 223–247.

Klor de Alva, Jorge, Earl Shorris and Cornel West. 1998. Our Next Race Question: The Uneasiness between Blacks and Latinos. In *The Latino Studies Reader: Culture, Economy and Society*, ed. Antonia Darder and Rodolfo Torres, 180–189. Malden, MA: Blackwell Publishers.

Kornblum, William. 1984. Lumping the Poor: What Is the "Underclass"? *Dissent* 31 (Summer): 295–302.

———. 1991. Who Is the Underclass: Contrasting Approaches, a Grave Problem. *Dissent* 38 (Spring): 202–211.

KRS-ONE. 1995. *The Science of Rap*. New York: privately printed.

Lascaibar, Juice (TC-5). 1997. Hip-Hop 101: Respect the Architects of Your History. *The Source*, no. 95 (August): 47–48.

Last Poets. 1992. *The Last Poets: Vibes from the Scribes*. Trenton, NJ: Africa World Press.

Lauria, Anthony. 1964. "Respeto, Relajo and Inter-personal Relations in Puerto Rico. *Anthropological Quarterly*, 37, no. 2: 62.

Lemann, Nicholas. 1991. The Other Underclass. *The Atlantic Monthly* (December): 96–110.

Levine, Joshua. 1997. Badass Sells. *Forbes*, April 21, 142–148.

Levinson, Aaron Luis. 1998. *Urban Latino Magazine* 3, no. 4: 11.

Lipsitz, George. 1994. We Know What Time It Is: Race, Class and Youth Culture in the Nineties. In *Microphone Fiends: Youth Music and Youth Culture*, ed. Andrew Ross and Tricia Rose, 17–28. New York: Routledge.

———. 1997. *Dangerous Crossroads: Popular Music, Postmodernism and the Poetics of Place*. New York: Verso.

Lombardi, Frank. 2001. Council KOs Honors for Rapper Big Pun. *Daily News*, May 3, 8.

López, Ana M. 1997. Of Rhythms and Borders. In *Everynight Life*, ed. Celeste Fraser Delgado and José Esteban Muñoz, 310–344. Durham, NC: Duke University Press.

López Torregrosa, Luisita. 1998. Latino Culture Whirls onto Center Stage. *New York Times*, March 26, E1.

Lott, Eric. 1994. Cornel West in the Hour of Chaos: Culture and Politics in Race Matters. *Social Text* 40 (Fall): 39–50.

Luciano, Felipe. 1994. Black-Latino Pride. *Essence* (November): 60.

Lynch, James "Chase." 1998. Holdin' It Down. *Urban Latino Magazine* 3, no. 2: 34–35.

Mac Donald, Heather. 1998. An F for Hip Hop 101. *City Journal* (Summer): 56–65.

Mack, Freddie. 1997. The Art of Noise: Delfeayo's Feedback. *Elementary* 1, no. 2 (Spring): 5–6.

Mansbach, Adam. 1996. Rap Music and the Four Principles of Baraka, Scott-Heron and The Last Poets. *Elementary* 1 (Summer): 44–51.

Manuel, Peter. 1995. *Caribbean Currents: Caribbean Music from Rumba to Reggae*. Philadelphia: Temple University Press.

Mare 139. 1996. Power Moves. *Rap Pages* 5, no. 8 (September): 15.

Marrero, Antoinette. 2001. Tribal Council. *Urban Latino Magazine* (June/July): 26–29.

Marriott, Rob. 1997. R(Un)ning Things. *XXL* 1, no. 2, issue 2: 56–58.

Marriott, Rob, James Bernard and Allen S. Gordon. 1994. Reality Check. *The Source*, no. 57 (June): 64–75.

Marsalis, Delfeayo. 1996. The Art of Rap? *Elementary* 1, no. 1: 38–40.

Massey, Douglas S. and Brooks Bitterman. 1985. Explaining the Paradox of Puerto Rican Segregation. *Social Forces* 64, no. 2: 306–330.

Massey, Douglas S. and Nancy A. Denton. 1991. Trends in the Residential Segregation of Blacks, Hispanics and Asians 1970–1980. In *Majority and Minority: The Dynamics of Race and Ethnicity in American Life*, ed. Norman R. Yetman, 352–378. Boston: Allyn and Bacon.

Mathews, Thomas G. 1974. The Question of Color in Puerto Rico. In *Slavery and Race Relations in Latin America*, ed. Robert Brent Toplin, 299–323. New York: Greenwood Press.

McClintock, Anne. 1993. Sex Workers and Sex Work. *Social Text* 37 (Winter): 1–10.

———. 1995. *Imperial Leather: Race, Gender, and Sexuality in the Colonial Conquest*. New York: Routledge.

McDonnell, Evelyn. 1999. Fox on the Run. *Village Voice*, February 9, 115.

McDowell, Akkida. 1998. The Art of the Ponytail. In *Adiós, Barbie: Young Women Write About Body Image and Identity,* ed. Ophira Edut, 124–132. Seattle: Seale Press.

McGregor, Tracii. 1997. Mothers of the Culture. *The Source,* no. 97 (October): 114–122.

McLane, Daisann. 1992. The Forgotten Caribbean Connection. *New York Times,* August 23, 22 (Arts and Leisure).

McLaren, Peter. 1995. Gangsta Pedagogy and Ghettoethnicity: The Hip Hop Nation as Counterpublic Sphere. *Socialist Review* 25, no. 2: 9–55.

Menéndez, Marilú. 1988. How to Spot a Jaguar in the Jungle. *Village Voice,* August 9, 20–21.

Miles, Jack. 1992. Blacks Vs. Browns: The Struggle for the Bottom Rung. *The Atlantic Monthly* 270, no. 4 (October): 41–68.

Millner, Denene. 1998. Hip Hop Heads: Ready-for-Rhyme-Time Players. *Daily News,* August 11, 45–46.

Morales, Ed. 1991. How Ya Like Nosotros Now? *Village Voice,* November 26, 91.

———. 1996a. Hip Hop Chatroom: In the Comfort Zone with Angie Martínez. *Village Voice,* December 17, 44–45.

———. 1996b. The Last Blackface: The Lamentable Image of Latinos in Film. *Sí* (Summer): 44–47.

———. 1997a. Original Boricuas: Making the Rounds of Latin Hip Hop. *Village Voice,* December 23, 92.

———. 1997b. The Scarface Myth and the Urban Agenda. *Urban Latino Magazine* 2, no. 3: 34–35.

———. 1998. "Mega" Mania: New York's New Number 1 Radio Station Leads Frenzied Market Drive. *Village Voice,* August 18, 37.

Morales, Riggs. 1999. Big Pun: The Heavyweight Champion. *The Source,* no. 113 (February): 154–158.

Morales, Rigo "Riggs." 1998. Renaissance Revisited. *Urban Latino Magazine* 3, no. 2: 30–33.

Morales, Rigoberto. 1997a. Beatnuts: Nutty Waters. *The Source,* no. 94 (July): 53.

———. 1997b. Unsigned Hype: Thistin Howl the Third. *The Source,* no. 95 (August): 44.

Morales, Robert. 1996. Fat Joe: Heart of Bronxness. *Vibe* (March): 84.

Moreno-Velázquez, Juan A. 2000a. Recordando a Big Pun. *El Diario,* February 11, 37.

———. 2000b. Celebrando una vida . . ."Big Pun." *El Diario,* February 13, 2.

Morgan, Joan. 1996. Fly-Girls, Bitches and Hoes: Notes of a Hip Hop Feminist. *Elementary* 1 (Summer): 16–20.

Mshaka, Thembisa S. 1999. Lesbian Life in Hip Hop Culture. *Blaze,* issue 2 (December/January): 84.

MTV News Gallery. 2000. López, Fat Joe, Others React to Big Pun's Death. February 8; www.mtv.com.

Mullings, Leith. 1994. Images, Ideology, and Women of Color. In *Women of Color in U.S. Society,* ed. Maxine Baca Zinn and Bonnie Thornton Dill. Philadelphia: Temple University Press.

Muñiz, Vicky. 1998. *Resisting Gentrification and Displacement: Voices of Puerto Rican Women of the Barrio.* New York: Garland Publishing.

Negrón-Muntaner, Frances. 1997. Jennifer's Butt. *Aztlán: A Journal of Chicano Studies* 22, no. 2 (Fall): 181–194.

Nelson, Havelock and Michael A. Gonzáles. 1991. *Bring the Noise: A Guide to Rap Music and Hip-Hop Culture.* New York: Harmony Books.

New York City Department of City Planning. 1982. *Puerto Rican New Yorkers: A Recent History of Their Distribution and Population and Household Characteristics.* New York: Department of City Planning.

———. 1994. *Puerto Rican New Yorkers in 1990.* New York: Department of City Planning.

Norfleet, Dawn Michaelle. 1997. "Hip Hop Culture" in New York City: The Role of Verbal Musical Performance in Defining a Community. Ph.D. diss., Columbia University, New York.

Nurse Allende, Lester. 1998. Bantú: Desde el Africa hasta Puerto Rico. *El Bombazo.* Boletín de la Fundación Folclórica-Cultural Rafael Cepeda, no. 1 (June): 7.

Oboler, Suzanne. 1995. Ethnic Labels, Latino Lives: Identity and the Politics of (Re)Presentation in the United States. Minneapolis: University of Minnesota Press.

Ogbu, John U. 1978. *Minority Education and Caste: The American System in Cross-Cultural Perspective.* New York: Academic Press.

Ogunnaike, Lola. 1998. Breakdancing Regains Its Footing. *New York Times,* June 7, 1 (Section 9).

Omi, Michael and Howard Winant. 1994. *Racial Formation in the United States.* New York: Routledge.

Orsi, Robert. 1992. The Religious Boundaries of an Inbetween People: Street *Feste* and the Problem of the Dark-skinned Other in Italian Harlem, 1920–1990. *American Quarterly* 44, no. 3: 313–347.

Ortiz, Raquel. 2001. El especial del Banco Popular. *El Nuevo Día,* December 4, 91.

Osorio, Kim. 1998. Review of Don Cartagena, by Fat Joe. *The Source,* no. 109 (October): 218.

———. 2000. Big Pun: Hip-Hop Loses a Hero. *The Source,* no. 127 (April): 52.

Ostolaza Bey, Margarita. 1989. *Política Sexual en Puerto Rico.* Rio Piedras: Ediciones Huracán.

Owen, Frank. 1998. Breaking's New Ground: Generation Next Spins on Its Head. *Village Voice,* May 20, 61–62.

Pabón, Carlos. 1995. De Albizu a Madonna: Para armar y desarmar la nacionalidad. *bordes,* no. 2: 22–40.

Panda, Andy. 1995. Talk given at Muévete! The Boricua Youth Conference, Hunter College, New York, November 11.

Pareles, Jon. 1995. Review of *Jam on the Groove* by Ghettoriginal. *New York Times,* November 18, 19.

Parker, Mr. 1998. Hip Hop 101: Fantastic Five. *The Source,* no. 106 (July): 64.

Parris, Jennifer. 1996. Freestyle Forum. *Urban Latino Magazine* 2, no. 1: 30–31.

Pedraza, Pedro. 1987. An Ethnographic Analysis of Language Use in the Puerto Rican Community of East Harlem. Centro de Estudios Puertorriqueños Working Paper Series, Hunter College, New York.

Pedreira, Antonio S. 1978. *Insularismo.* Rio Piedras: Edil.

Perdomo, Willie. 1996. *Where a Nickel Costs a Dime.* New York: W.W. Norton & Company.

Pérez, Richie. 1990. From Assimilation to Annihilation: Puerto Rican Images in U.S. Films. *Centro* 2, no. 8 (Spring): 8–27.

Pérez Firmat, Gustavo. 1994. *Life on the Hyphen: The Cuban-American Way.* Austin: University of Texas Press.

Perry, Theo. 1997. I, Latina. *Vibe* 5, no. 6 (September): 58.

Phase 2. 1996. The Realness: Too Hip to Party. *Stress,* issue 2 (Spring): 54.

Pheterson, Gail. 1993. The Whore Stigma: Female Dishonor and Male Unworthiness. *Social Text* 37 (Winter): 39–64.

Pierpont, Margaret. 1984. Breaking in the Studio. *Dance Magazine* 58, no. 4 (April): 82.

Portes, Alejandro and Alex Stepick. 1993. *City on the Edge: The Transformation of Miami.* Los Angeles: University of California.

Portes, Alejandro and Min Zhou. 1993. The New Second Generation: Segmented Asimilation and Its Variants. *Annals of the American Academy of Political and Social Science* 530 (November): 74–96.

Potter, Russell A. 1995. *Spectacular Vernaculars: Hip-Hop and the Politics of Postmodernism.* Albany: State University of New York Press.

———. 1995. Calypso: Roots of the Roots; www.ric.edu/rpotter/calypso.html.

Powell, Kevin. 1995–1996. The Ghetto. *Vibe* 3, no. 10 (December/January): 49.

Quintero Rivera, Angel G. 1998. "Salsa: ¿Desterritorialización?, nacionalidad e identidades. *Revista de Ciencias Sociales,* no. 4 (January): 105–122.

———. 1999. *Salsa, sabor y control: Sociología de la música tropical.* Ciudad de México: Siglo Veintiuno Editores.

Ramírez, Jessie. 2000. Juventud, violencia y música. . . . *El Diario,* June 30, 41.

Reeves, Marcus. 1998. Review of Don Cartagena, by Fat Joe. *Village Voice,* September 8, 61.

Reyes, Jorge. 1997. Lauren Velez: Uncovered. *Mía* (Fall): 49–51.

Rivera, Raquel Z. 1992–93. Rap Music in Puerto Rico: Mass Consumption or Social Resistance? *Centro* 5, no. 1: 52–65.

———. 1996a. Boricuas from the Hip Hop Zone: Notes on Race and Ethnic Relations in New York City. *Centro* 8, nos. 1 and 2: 202–215.

———. 1996b. Para rapear en puertorriqueño: discurso y política cultural. M.A. thesis, Centro de Estudios Avanzados de Puerto Rico y el Caribe, San Juan, Puerto Rico.

———. 1997a. Rap in Puerto Rico: Reflections from the Margins. In *Globalization and Survival in the Black Diaspora: The New Urban Challenge,* ed. Charles Green, 109–127. Albany: State University of New York Press.

———. 1997b. Rapping Two Versions of the Same Requiem. In *Puerto Rican Jam: Essays on Culture and Politics,* ed. Frances Negrón-Muntaner and Ramón Grosfoguel, 243–256. Minneapolis: University of Minnesota Press.

———. 1997c. What the Fuck Are You Doing Here, Puerto Rican?: Has the Hip Hop Nation Failed to Recognize the Contribution of Boricuas? *Stress,* issue 6 (Winter/Spring): 45–50.

———. 1998. Cultura y poder en el rap puertorriqueño. *Revista de Ciencias Sociales,* no. 4 (January): 124–142.

———. 2000. New York Ricans from the Hip Hop Zone: Between Blackness and *Latinidad.* Ph.D. diss., Graduate Center of the City University of New York, New York.

———. 2000b. Una boda al estilo "hip hop." *Hoy,* December 20, p. 14.

———. 2001a. Angie Martínez: locutora y rapera. *In the House Magazine,* no. 21: 14.

———. 2001b. El Salón de la Fama del Graffiti. *Siempre,* March 21-April 10, p. 14.

———. 2001c. Fat Joe: líder del "Terror Squad." *El Diario/La Prensa,* June 29, p. 37.

———. 2001d. Hip Hop, Puerto Ricans and Ethno-Racial Identities in New York. In *Mambo Montage: The Latinization of New York,* ed. Agustín Lao-Montes and Arlene Dávila, 235–261. New York: Columbia University Press.

———. 2001e. La Bruja: rapera, poeta, actriz y bailarina. *In the House Magazine,* no. 21: 58–59.

———. 2002a. Hip Hop and New York Puerto Ricans. In *Latino/a Popular Culture,* ed. Michelle Habell-Pallán and Mary Romero, 127–143. New York: New York University Press.

———. 2002b. Diana: "rocking" en el Brooklyn boricua de los 70. *In the House Magazine,* no. 23.

Rivera, Rob. 1996. Buena Gente. *Mía* (Summer): 3.

Robert, DJ. 1999. Dead Prez. *In the House Magazine,* no. 11: 34.

Roberts, John Storm. 1979. *The Latin Tinge: The Impact of Latin American Music on the United States.* Oxford: Oxford University Press.

Rocafella. 1997. Step into Her World: Full Circle. *Stress,* issue 10 (December): 64.

Rockwell, Honey. 1996. B-Girl Queendom. *Rap Pages* 5, no. 8 (September): 44–45.

Rodríguez, Abraham. 1999. *Urban Latino Magazine* 4, no. 1: 14.

Rodríguez, Carlito. 1998. The Young Guns of Hip-Hop. *The Source,* no. 105 (June): 146–148.

———. 2000. "Big Pun: Yeeeah Baby!" *The Source,* no. 128 (May): 186.

Rodríguez, Cindy E. 1988. Go Loco! *Village Voice,* August 9, 24–25.

Rodríguez, Clara E. 1991. *Puerto Ricans: Born in the U.S.A.* Boulder, CO: Westview Press.

———. 1997a. The Silver Screen: Stories and Stereotypes. In *Latin Looks: Images of Latinas and Latinos in the U.S. Media,* ed. Clara E. Rodríguez, 73–79. Boulder, CO: Westview Press.

———.1997b. Visual Retrospective: Latino Film Stars. In *Latin Looks: Images of Latinas and Latinos in the U.S. Media,* ed. Clara E. Rodríguez, 80–86. Boulder, CO: Westview Press.

Rodríguez, Clara and Héctor Cordero-Guzmán. 1992. Placing Race in Context. *Ethnic and Racial Studies* 15, no. 4 (October): 523–542.

Rodríguez Juliá, Edgardo. 1986. *Una noche con Iris Chacón.* San Juan: Editorial Antillana.

———. 1988. *El entierro de Cortijo.* Rio Piedras: Ediciones Huracán.

Rodríguez, Edward Sunez. 1995a. Hip Hop Culture: The Myths and Misconceptions of This Urban Counterculture. Ms.

———. 1995b. Keeping It Real Sunset Style. *The Ticker,* March 8, 35.

———. 1995c. Veteran Artist Takes "Kurious" Look at Hip-Hop Biz. *The Ticker,* November 8, 25.

———. 1996a. Sunset Style. *The Ticker,* March 6.

———. 1996b. Sunset Style. *The Ticker,* May 8, 26.

———. 1996c. Sunset Style. *The Ticker,* May 22.

———. 1997. Sunset Style. *The Ticker,* March 12, 25.

———. 1998. *XXL* 4, no. 2, vol. 2: 174.

———. 2000. Why Hip Hop Died; www.ourswords.com.

Rodríguez, Marilyn E. 1998. Chairman of the Boards. *Urban Latino Magazine* 3, no. 2: 53.

Rodríguez, Richard. 1990. Complexion. In *Out There: Marginalization and Contemporary Cultures,* ed. Russell Ferguson, Martha Gever, Trinh T. Minh-ha and Cornel West, 265–278. Cambridge, MA: MIT Press.

Rodríguez, Víctor. 1997. The Racialization of Puerto Rican Ethnicity in the United States. In *Ethnicity, Race and Nationality in the Caribbean,* ed. Juan Manuel Carrión, 233–273. Rio Piedras: Institute of Caribbean Studies, University of Puerto Rico.

Rodríguez Cruz, Juan. 1965. Las relaciones raciales en Puerto Rico. *Revista de Ciencias Sociales* 9, no. 4: 373–386.

Rodríguez-Morazzani, Roberto P. 1991–92. Puerto Rican Political Generations in New York: Pioneros, Young Turks and Radicals. *Centro* 4, no. 1: 96–116.

———. 1996. Beyond the Rainbow: Mapping the Discourse on Puerto Ricans and "Race." *Centro* 8, nos. 1 and 2: 150–169.

Romano, Celia Marina. 1992. Yo no soy negra. *Piso 13* 1, no. 4 (August): 3.

Romero, Elena. 1998. No me diga. *Urban Latino Magazine* 3, no. 2: 52.

Rose, Tricia. 1992. Black Texts/Black Contexts. In *Black Popular Culture,* ed. Gina Dent and Michelle Wallace, 223–227. Seattle: Bay Press.

———. 1994. *Black Noise: Rap Music and Black Culture in Contemporary America.* Hanover, NH: Wesleyan University Press.

Rosenwald, Peter J. 1984. Breaking Away 80's Style. *Dance Magazine* 58, no. 4 (April): 70–74.

Ross, Andrew. 1989. *No Respect: Intellectuals and Popular Culture.* New York: Routledge.

Rumbaut, Rubén G. 1996. The Crucible Within: Ethnic Identity, Self-Esteem, and Segmented Assimilation Among Children of Immigrants. In *The New Second Generation,* ed. Alejandro Portes, 119–170. New York: The Russell Sage Foundation.

Salazar, Max. 1992. Afro-American Latinized Rhythms. In *Salsiology: Afro-Cuban Music and the Evolution of Salsa in New York City*, ed. Vernon Boggs. New York: Greenwood Press. pp. 237–248.

Salazar, Rodrigo. 1995. Lauren Velez: Crushing the Color Cast. *Urban Latino Magazine* (May-June): 10–11.

Samara. 1987. Samara. In *Sex Work: Writings by Women in the Sex Industry*, ed. Frédérique Delacoste and Priscilla Alexander. Pittsburgh, PA: Cleis Press.

Samuels, David. 1995. The Rap on Rap: The "Black Music" That Isn't Either. In *Rap on Rap: Straight-up Talk on Hip-Hop Culture*, ed. Adam Sexton, 241–252. New York: Dell Publishing.

Sánchez, Luis Rafael. 1998. La gente de color. In *No llores por nosotros, Puerto Rico*. Hanover, NH: Ediciones del Norte.

Sands, Lana. 1998. Whipping Girl. *XXL* 2, no. 3, issue 5: 31.

Santiago, Javier. 1994. *Nueva Ola Portoricensis: La revolución musical que vivió Puerto Rico en la década del 60*. San Juan: Publicaciones del Patio.

Santiago-Valles, Kelvin. 1994/1995. On the Historical Links Between Coloniality, the Violent Production of the "Native" Body, and the Manufacture of Pathology. *Centro* 7, no. 1 (Winter/Spring): 108–118.

———. 1996. Policing the Crisis in the Whitest of All the Antilles. *Centro* 8, nos. 1 and 2: 42–55.

Santos, Mayra. 1992. Sobre piel o sobre papel. *Piso 13* 1, no. 4 (August): 6.

———. 1995. Hebra rota. In *Pez de vidrio*. Coral Gables, FL: North-South Center, University of Miami, Iberian Studies Institute.

———. 1996. Puerto Rican Underground. *Centro* 8, nos. 1 and 2: 219–231.

Seda Bonilla, Eduardo. 1968. Dos modelos de relaciones raciales: Estados Unidos y América Latina. *Revista de Ciencias Sociales* 12, no. 4: 569–597.

———. 1972. El problema de la identidad de los niuyorricans. *Revista de Ciencias Sociales* 16, no. 4 (December): 453–462.

Serignese, Fab. 1997. Angie Martínez: Blowing Up in the 9-7. *Mía* (Spring): 22–23.

———. 1998. Your Ass Here: The Sexploitation of the Latino Market. *Mía* (Summer): 18–20.

Shange, Ntozake. 1997. *For Colored Girls Who Have Considered Suicide/When the Rainbow Is Enuf*. New York: Scribner Poetry.

Shannon. 1997. Bikini Beauties. *The Source*, no. 95 (August): 20.

Shecter, Jon. 1992. Liner notes in *Street Jams: Hip Hop from the Top Part 1*. Rhino R4 70577.

Shohat, Ella. 1997. Gender and Culture of Empire: Toward a Feminist Ethnography of the Cinema. In *Visions of the East: Orientalism in Film*, ed. Matthew Bernstein and Gaylyn Studlar, 19–66. New Brunswick, NJ: Rutgers University Press.

Shusterman, Richard. 1991. The Fine Art of Rap. *New Literary History* 22, no. 3 (Summer): 613–632.

Smith, Christopher Holmes. 1997. Method in the Madness: Exploring the Boundaries of Identity in Hip-Hop Performativity. *Social Identities* 3, no. 3: 345–374.

Smith, Danyel. 1995. Ain't a Damn Thing Changed: Why Women Rappers Don't Sell. In *Rap on Rap: Straight-up Talk on Hip Hop Culture,* ed. Adam Sexton, 125–128. New York: Delta Books.

Smith, Robert. 1994. "Doubly Bounded" Solidarity: Race and Social Location in the Incorporation of Mexicans into New York City. Paper presented at the Conference of Fellows: Program of Research on the Urban Underclass, Social Science Research Council, University of Michigan, June.

Sosa, Joel Antonio. 1999a. The Arsonists: Hip Hop Firestarters. *Urban Latino Magazine* 4, no. 1: 32.

————. 1999b. Station Zero: Animation for the Hip Hop Nation. *Urban Latino Magazine* 4, no. 2: 50–51.

The Source. 1999. The Source '98 Yearbook. *The Source,* no. 113 (February): 67–111.

Stampa Alternativa and IGTimes. 1996. *Style: Writing from the Underground, Revolutions of Aerosol Linguistics.* Italy: UMBRIAGRAF.

Stavans, Ilan. 1996. Race and Mercy: A Conversation with Piri Thomas. *The Massachusetts Review* (Autum): 344–354.

Stearns, Marshall. 1958. *The Story of Jazz.* Oxford: Oxford University Press.

Steinberg, Stephen. 1989. *The Ethnic Myth: Race, Ethnicity, and Class in America.* Boston: Beacon Press.

Sundiata, Sekou. 1998. The Latin Connection. Essay in playbill for the Black Rock Coalition's music performance *The Latin Connection,* BAM Majestic Theater, Brooklyn, New York, June 27.

Sutton, Constance R. 1987. The Caribbeanization of New York City and the Emergence of a Transnational Socio-Cultural System. In *Caribbean Life in New York City: Sociocultural Dimensions,* ed. Constance R. Sutton and Elsa M. Chaney. New York: Center for Migration Studies of New York. pp. 15–29.

Sutton, Constance R. and Susan R. Makiesky-Barrow. 1987. Migration and West Indian Racial and Ethnic Consciousness. In *Caribbean Life in New York City: Sociocultural Dimensions,* ed. Constance R. Sutton and Elsa M. Chaney, 92–116. New York: Center for Migration Studies of New York.

Tate, Greg. 1995. Bronx Banshee. *Vibe* 3, no. 9 (November): 44.

————. 1997. Wu-Dunit. *Village Voice,* June 24, 63.

Thomas, Akeenah and Jennifer Quiñones. 2000. An Artist's Tribute to Big Pun. *Hunts Point Alive!* 2, issue 3 (March/April): 3.

————. 2000. Hunts Point Youth Express Sadness at the Loss of Big Pun. *Hunts Point Alive!* 2, issue 3 (March/April): 3.

Thomas, Piri. 1967. *Down These Mean Streets.* New York: Vintage Books.

Thompson, Robert Farris. 1991. *Dancing Between Two Worlds: Kongo-Angola Culture and the Americas.* New York: Caribbean Cultural Center.

————. 1996. Hip Hop 101. In *Droppin' Science: Critical Essays on Rap Music and Hip Hop Culture,* ed. William Eric Perkins, 211–219. Philadelphia: Temple University Press.

Tokaji, András. 1995. The Meeting of Sacred and Profane: Robert Moses, Lincoln Center, and Hip-Hop. *Journal of American Studies* 29, no. 1 (April): 97–103.

Tompkins, Dave. 1996. Hollywood Shuffle. *Rap Pages* 5, no. 8 (September): 16–17.

Tony Bones, Queen Heroine and MFW. 1997. The Cypher: Add Water and Stir. *Stress,* issue 10 (December): 44.

Toop, David. 1991. *Rap Attack 2: African Rap to Global Hip Hop.* London: Serpent's Tail.

Torres, Andrés. 1995. *Between Melting Pot and Mosaic: African Americans and Puerto Ricans in the New York Political Economy.* Philadelphia: Temple University Press.

Torres, Carlos "Tato." 2001. "Cocobalé": African Martial Arts in Bomba. *Güiro y Maraca* 5, no. 1 (Winter): 9–12.

Torres, Carlos "Tato" and Ti-Jan Francisco Mbumba Loango. 2001. Cuando la bomba ñama . . . !: Religious Elements of Afro-Puerto Rican Music. Ms.

Touré. 1994. Review of Constipated Monkey, by Kurious Jorge. *Rolling Stone,* April 7, 73.

Troyano, Ela. 1993. *Once Upon a Time in the Bronx.* 30 min. Videocassette.

Udovitch, Mim. 1993/1994. I, Latina. *Vibe* (December/January): 64–69.

Upski (William Upski Wimsatt). 1994. *Bomb the Suburbs.* Chicago: The Subway and Elevated Press.

Urciuoli, Bonnie. 1996. *Exposing Prejudice: Puerto Rican Experiences of Language, Race and Class.* Boulder, CO: Westview Press.

Valcárcel, Francisco. 2001. An Introduction to Afro-Caribbean Martial Arts. *Güiro y Maraca* 5, no. 1 (Winter): 4–6.

Valdés, Mimi. 1997. Malibu Dreamin': Who Are Those Video Queens Anyway? *The Source,* no. 93 (June): 72–79.

———. 1998. Pound for Pound: Big Pun and Fat Joe Are More Than Big Poppas. *Vibe* 6, no. 6 (August): 108–111.

Valentín, Clyde. 1997. Bringing Dead Records to Life: Ivan Doc Rodríguez. *Stress,* issue 10 (December): 47.

———. 2000. Big Pun: Puerto Rock Style with a Twist of Black and I'm Proud. *Stress,* issue 23: 41–56.

Valentín, Clyde and Kwikstep. 1996. Up Rockin': Hardrocks, Props & No Glocks. *Stress,* issue 4 (Fall): 44–47.

Vázquez, Blanca. 1990–91. Puerto Ricans and the Media: A Personal Statement. *Centro* 3, no. 1: 4–15.

Verán, Cristina. [1991]. Many Shades of Our Culture: A History of Latinos in Hip Hop. *Word Up!:* 24–26.

———. 1996a. Knowledge Droplets from a B-Boy Brainstorm. *Rap Pages* 5, no. 8 (September): 40–42.

———. 1996b. Past, Present, Future: Ken Swift Is the Quintessential B-Boy. *Rap Pages* 5, no. 8 (September): 36–38.

———. 1996c. (Puerto) Rock of Ages. *Rap Pages* 5, no. 8 (September): 46–49.

———. 1996d. That's the Breaks. *Rap Pages* 5, no. 8 (September): 6.

———. 1997. ¿What's Up Doc?: A Decade of Getting Jerked in the Game as Told by Engineer Extraordinaire Ivan "Doc" Rodríguez. *Ego Trip* 3, no. 3: 34.

———. 1998. Backyard Boogie: An Honest Assessment of Jennifer López's Mo' Cheeks. *Ego Trip* 4, no. 1: 133.

Wallace, Deborah and Rodrick Wallace. 1998. *A Plague on Your Houses: How New York Was Burned Down and National Public Health Crumbled.* New York: Verso.

Waterbed Kev (Kevie Kev Rockwell). 1998. Talk given at The Rap Session conference, Spring, Barnard College, New York.

Waters, Mary. 1996. Ethnic and Racial Identities of Second-Generation Black Immigrants in New York City. In *The New Second Generation,* ed. Alejandro Portes, 171–196. New York: Russell Sage Foundation.

Weisberg, Chang. 1998. Hip Hop's Minority?: Latino Artists Unite and Speak Out. *Industry Insider Magazine* 15: 50–51.

White, Armond. 1996. Who Wants to See Ten Niggers Playing Basketball? In *Droppin' Science: Critical Essays on Rap Music and Hip Hop Culture,* ed. William Eric Perkins, 192–208. Philadelphia: Temple University Press.

Williams, Sherley Ann. 1992. Two Words on Music: Black Community. In *Black Popular Culture,* ed. Gina Dent and Michelle Wallace, 164–172. Seattle: Bay Press.

Williams, Terry and William Kornblum. 1994. *The Uptown Kids: Struggle and Hope in the Projects.* New York: G.P. Putnam's Sons.

Wilson, William J. 1980. *The Declining Significance of Race: Blacks and Changing American Institutions.* Chicago: University of Chicago Press.

———. 1987. *The Truly Disadvantaged: The Inner-City, the Underclass, and Public Policy.* Chicago: University of Chicago Press.

Wiltz, Teresa. 1998. Bottoms Up: Jennifer Lopez' Big Derriere Takes Fanny Fawning to a Higher Level. *Daily News,* October 29, 67.

York, Malachi Z. *The Melanin-ite Children.* Eatonton, GA: Holy Tabernacle Ministries.

Yúdice, George. 1992. Postmodernity and Transnational Capitalism. In *On Edge: The Crisis of Contemporary Latin American Culture,* ed. George Yúdice, Jean Franco and Juan Flores, 1–28. Minneapolis: University of Minnesota Press.

———. 1994. The Funkification of Rio. In *Microphone Fiends: Youth Music and Youth Culture,* ed. Andrew Ross and Tricia Rose, 193–217. New York: Routledge.

Zenón Cruz, Isabelo. 1975. *Narciso descubre su trasero.* Humacao: Furidi.

Zentella, Ana Celia. 1997. *Growing Up Bilingual: Puerto Rican Children in New York.* Malden, MA: Blackwell Publishers.

DISCOGRAPHY

A Tribe Called Quest. 1993. *Midnight Marauders.* Jive 41490. Compact Disc.

Arsonists. 1999. *As the World Burns.* Matador OLE 343–2. Compact Disc.

Beatnuts. 1994. *The Beatnuts.* Relativity/Violator 88561–1179–2. Compact Disc.

———. 1997. *Stone Crazy.* Relativity 88561–1508–2. Compact Disc.

Big Pun. 1998. *Capital Punishment.* Loud/RCA 07863 67512–2. Compact Disc.
———. *Yeeeah Baby.* Loud Records CK 63843. Compact Disc.
Black Star. 1998. *Mos Def & Talib Kweli Are Black Star.* Rawkus 1158–2. Compact Disc.
Blades, Rubén and Willie Colón. 1978. *Siembra.* Fania JM 00–537. LP.
Boogie Down Productions. 1986. *Criminal Minded.* B-boy CA1–4787. Cassette.
Boricua Guerrero. 1997. *Boricua Guerrero: First Combat.* Boricua Guerrero 002–1. Compact Disc.
Capone -N- Noreaga. 1997. *The War Report.* Penalty PENCD 3041–2. Compact Disc.
Chino XL. 1996. *Here to Save You All.* American 9 43038–4. Cassette.
Cocoa Brovaz. 1998. *The Rude Awakening.* Priority Records 50699. Compact Disc.
Cold Crush Brothers. 1995. *Fresh, Wild, Fly and Bold.* Tuff City 4006. Compact Disc.
Cru. 1997. *Da Dirty 30.* Violator 314 537 607–2. Compact Disc.
De la Soul. 1996. *Stakes Is High.* Tommy Boy 1149. Compact Disc.
Doo Wop. [1997]. *The New Testament.* Stress Entertainment. Cassette.
Edward Rodríguez and Mr. Wor. [1996]. *The Best of the E & J Show: Fall 1995 to Summer 1996.* Cassette.
Fat Joe da Gangsta. 1993. *Represent.* 88561–1175–4. Cassette.
Fat Joe. 1995. *Jealous One's Envy.* Relativity 88561–1239–4. Cassette.
———. 1998. *Don Cartagena.* Mystic 92805–4. Cassette.
———. 2001. *J.O.S.E. (Jealous Ones Still Envy).* Atlantic 83472–2. Compact Disc.
Foxy Brown. 1996. *Ill Nana.* Def Jam 314 533 684–4. Cassette.
Frankie Cutlass. *Politics and Bullsh*t.* Relativity 88561–1548–2. Compact Disc.
Funkdoobiest. 1995. *Brothas Doobie.* Sony ET 64195. Cassette.
———. 1997. *The Troubleshooters.* RCA 07863 67550–2. Compact Disc.
Funk Master Flex. The Mix Tape vol III. 1998. RCA 07863–67647–2. Compact Disc.
Guataúba. [1996]. *Guataúba/Tony Touch/Nico Canadá.* Guataúba. Compact Disc.
Hurricane Gee. 1997. *All Woman.* H.O.L.A. Recordings 341 022. Cassette.
K-7. 1993. *Swing Batta Swing.* Tommy Boy 1071. Cassette.
KRS-ONE. 1995. *KRS ONE.* Jive 01241–41570–4. Cassette.
———. 1997. *I Got Next.* Jive 01241–41601–2. Compact Disc.
Kurious Jorge. 1994. *A Constipated Monkey.* Sony CT 53223. Cassette.
Latin Alliance. 1991. *Latin Alliance.* Virgin 0777 7 86216 2 1. Compact Disc.
Latin Empire. 1990. *Así es la Vida.* Culebra Records. Cassette.
Latin Kings. 1996. *Kingism.* 12–1167. Cassette.
Lopez, Jennifer. 2002. *J To Tha L-O!* Epic EK 86399. Compact Disc.
Martínez, Angie. 2001. *Up Close and Personal.* Elektra 62366–2. Compact Disc.
Noreaga. 1998. *N.O.R.E.* Penalty 3077–2. Compact Disc.
No More Prisons. 2000. *No More Prisons.* Raptivism 1. Compact Disc.
Outkast. 1998. *Aquemini.* La Face 73008–26053–4. Cassette.

Puff Daddy & The Family. 1997. *No Way Out.* Bad Boy 78612–73012–4. Cassette.

Q-Unique. [1995]. *Rice and Beans.* Unreleased. Cassette.

———. [1998]. *Beats for the Breakers.* Cassette.

Raekwon. 1995. *Only Built for Cuban Linx.* RCA 66663–4 07863. Cassette.

Ras Kass. 1998. *Rasassination.* Priority P2 50739. Compact Disc.

The Real Roxanne. 1988. *Roxanne.* Select Records 21627. Compact Disc.

———. 1992. *Go Down But Don't Bite It.* Select Records 21668. Compact Disc.

Redman. 1994. *Dare Iz a Darkside.* Rush Associated Labels 314 523 846–2. Compact Disc.

Rhino Records. 1992. *Street Jams: Hip Hop from the Top Part 1.* Rhino R4 70577. Cassette.

———. 1992. *Street Jams: Hip Hop from the Top Part 2.* Rhino R4 70578. Cassette.

Soul in the Hole. 1997. *Soul in the Hole.* RCA 07863 67531–2. Compact Disc.

Stretch and Bobbito. 1996. *Freestyles 1996–1996 Vol. 12.* Fat Beats. Cassette.

Thirstin Howl III. 2000. *The Polorican* [Maxi Single]. Game 2007. Compact Disc.

Tommy Boy. 1993. *Freestyle, Vol. 1.* Tommy Boy 1084. Compact Disc.

Tony Touch. [1995] *Live 45.* Cassette.

———. 1998. *The Rican-Struction EP.* Touch 001. Compact Disc.

———. 2000. The Piece Maker. Tommy Boy Music TBCD1347. Compact Disc.

Xzibit. [1997]. *At the Speed of Life.* Loud/RCA 66816–4 07863. Cassette.

Wild Style. 1982. *Wild Style Soundtrack.* Rhino Movie Music 72892.

INTERVIEWS

Báez, Alano, vocalist for Ricanstruction. 1998. Interview by author, June 15, East Harlem, Manhattan, New York. Transcript.

Batista Sterling, Jainardo, hip hop enthusiast and Afro-Caribbean percussionist. 1995. Interview by author, September 8, Lower East Side, Manhattan, New York. Transcript.

B-Boy Omega (Orlando). 1998. Interview by author, April 23, Baruch College, New York. Transcript.

BOM5 (Norman Ray Abrahante), graffiti artist. 1996. Interview by author, April 15, Corona, Queens. Tape recording.

B-Unique (Robert Beckett), rapper and member of Brooklyn Bandits. 1998. Interview by author and Kahlil Jacobs-Fantauzzi, March 26, Williamsburg, Brooklyn, New York. Tape recording.

Bravo, Virgilio "Vee," *Stress* magazine senior editor. 1997. Telephone interview by author, July 2. Transcript.

Bruja, La (Caridad de la Luz), rapper, poet and singer. 2001. Interview by author, August 27, Soundview, The Bronx, New York.

Chase, Charlie (Carlos Mandes), hip hop DJ and member of the Cold Crush Brothers. 1996. Interview by author, March 26, Lower East Side, Manhattan, New York. Transcript.

Coo-Kee, producer and rapper. 1998. Interview by author, January 26, No Mel Studio, Carolina, Puerto Rico. Transcript.

Crazy Legs, b-boy and Rock Steady Crew president. 1996. Interview by Jackie Egilee, October 22, The Point community center, Hunts Point, Bronx, New York. Transcript.

Cutlass, Frankie, DJ and producer. 1995. Interview by author and Khalil Jacobs-Fantauzzi, July 21, Canóvanas, Puerto Rico. Tape recording.

De León, Elías, producer. 1997. Interview by author, Power Play Studios, Long Island City, Queens, New York. Transcript.

Diana (Diana Figueroa), rocker and member of Dynasty Rockers. 1998. Interview by author, August 1, Canarsie, Brooklyn, New York. Tape recording.

Díaz, Pete, breaker. 1998. Interview by author, June 1, East Harlem, Manhattan, New York. Tape recording.

Don Gato, rapper and member of Brooklyn Bandits. 1998. Interview by author and Kahlil Jacobs-Fantauzzi, March 26, Williamsburg, Brooklyn, New York.

D-Stroy, rapper and member of the Arsonists. 1995. Interview by author and Kahlil Jacobs-Fantauzzi, August 5, Rappers Discotheque, Carolina, Puerto Rico. Video recording.

————. 1995. Interview by author, October 12, Lower East Side, Manhattan, New York. Tape recording.

Egilee, Jackie T., b-girl and journalist. 1996. Interview by author, October 22, The Point community center, Hunts Point, Bronx, New York. Transcript.

Enemigo (Juan Matos), rapper. 1994. Interview by author, December 15, Manhattan, New York. Tape recording.

————. 2000. Interview by author, Summer, Manhattan, New York. Tape recording.

Fabel, Jorge Pabón, popper and locker. 1998. Interview by author, Spring, Barnard College, New York. Transcript.

Fat Joe (Joseph Cartagena), rapper and producer. 2001. Telephone interview by author, May 9, 2001.

Feliciano, Teddy, manager of rap duo Fam Ties. 1998. Interview by author and Pete Díaz, May 28, East Harlem, Manhattan, New York. Tape recording.

Freestyle (Robert Wallace), rapper and member of the Arsonists. 1998. Telephone interview by author, July 30. Transcript.

G-Bo the Pro, hip hop DJ and producer. 1998. Interview by author, May 18, studio in Midtown Manhattan, New York. Tape recording.

González, José Raúl "Gallego." 1994. Interview by author, March 17, Hato Rey, Puerto Rico. Tape recording.

Hurricane G (Gloria Rodríguez), rapper. 1995. Telephone interview by author, November 10. Transcript.

————. 1997. Interview by author, Manhattan, New York. Tape recording.

Ill Will (William Fratacci), DJ. 1998. Interview by author, April 21, Downstairs Records, Manhattan, New York. Transcript.

Jamalski, reggae artist. 1995. Interview by author and Kahlil Jacobs-Fantauzzi, August 5, Rappers Discotheque, Carolina, Puerto Rico. Video recording.

J.K., rapper. 1998. Interview by author, January 26, No Mel Studio, Carolina, Puerto Rico. Transcript.

Jo-Jo, b-boy and one of the founders of the Rock Steady Crew. 1998. Interview by author, July 26, Rock Steady Crew Anniversary at Manhattan Center, New York. Tape recording.

King Uprock (Ralph Casanova), rocker. 1998. Interview by REALS, July 27, Bushwick/Ridgewood, Brooklyn/Queens, New York. Tape recording.

Krazy Taíno (Anthony Boston), rapper and member of Latin Empire. 1994. Interview by author, May 6, Bronx, New York. Tape recording.

Larson, Lacy (Chris), rapper and member of Fam Ties. 1998. Interview by author and Pete Díaz, May 28, East Harlem, Manhattan, New York. Tape recording.

Martínez, Angie, radio disc jockey (WQHT) and rapper. 2001. Telephone interview by author, May 3, 2001. Tape recording.

Nicer (Héctor Nazario), graffiti artist, member of TATS Cru. 2001. Interview by author May 9, 2001. Tape recording.

Panamasta, reggae artist. 1995. Interview by author and Kahlil Jacobs-Fantauzzi, August 5, Rappers Discotheque, Carolina, Puerto Rico. Video recording.

Power (Michael Viera), rapper. 1995. Interview by author and Damaris Estrada, May 6, Washington Square Park, Manhattan, New York. Tape recording.

———. 1995. Telephone interview by author, October 31. Transcript.

Puerto Rock (Rick Rodríguez), rapper and member of Latin Empire. 1994. Interview by author, May 6, Bronx, New York. Tape recording.

Q-Unique (Anthony Quiles), rapper and member of the Arsonists. 1995a. Interview by author, October 12, Lower East Side, Manhattan, New York. Tape recording.

———. 1995b. Interview by author, October 13, Lower East Side, Manhattan, New York. Tape recording.

———. 1995c. Interview by author, October 18, Lower East Side, Manhattan, New York. Tape recording.

———. 2002. Interview by author, Spring, Bedford-Stuyvesant, Brooklyn, New York. Tape recording.

Rase, manager of rapper Main One. 1995. Interview by author, Demerara's nightclub, Manhattan, New York. Tape recording.

Rokafella (Anita García), b-girl and member of Full Circle. 1996. Interview by author, May 20, Manhattan, New York. Transcript.

———. 1998. Interview by author, June 30, Manhattan, New York. Transcript.

Rodríguez, Edward Sunez. 1995. Interview by author, Hunter College, Manhattan, New York.

———. 2002. Interview by author, Harlem, Manhattan, New York.

Stephenson, Stan "Cash," producer. 1997. Interview by author, Power Play Studios, Long Island City, Queens, New York.

Tony Touch, DJ. 1995a. Interview by author and Kahlil Jacobs-Fantauzzi, August 5, Rappers Discotheque, Carolina, Puerto Rico. Video recording.

———. 1995b. Interview by author, October 12, Lower East Side, Manhattan, New York. Tape recording.

Torres, Monse, rapper, poet and Angie Martínez's assistant. 2000. Interview by author, August 21, Kingsbridge, Bronx, New York. Tape recording.

Vega, Chino (Omi), rapper and member of Fam Ties. 1998. Interview by author and Pete Díaz, May 28, East Harlem, Manhattan, New York. Tape recording.

INDEX

ABOUT THE AUTHOR

Raquel Z. Rivera is a freelance journalist and has a Ph.D. in Sociology from CUNY. Her articles have appeared in a number of diverse publications both regionally and nationally, from *Mambo Montage: The Latinization of New York,* a book of essays published by Columbia University Press, to newspapers like *El Diario/La Prensa* and *Hoy* in New York; *El Nuevo Día, The San Juan Star* and *Claridad* in Puerto Rico, and in magazines like *Críticas, One World, In the House* and *Stress.* Those who are interested in Ms. Rivera's work can view her website, www.geocities.com/raquelzrivera.